Great Museums of Italy

Great Museums
of Italy

SKIRA

Cover
Prometheus Room
Palatine Gallery
Florence, Pitti Palace

Scientific Editor
Valerio Terraroli

Design
Marcello Francone

Editing
Marco Abate

Translations
Lawrence Jenkens
Language Consulting, Milan

Iconographical Research
Massimo Zanella

*Author of The Brera Gallery
entries*
Mauro Bonetti

First published in Italy
in 2001 by
Skira Editore S.p.A.
Palazzo Casati Stampa
via Torino 61
20123 Milano
Italy

© 2001 Skira editore, Milano
© 2001 Gruppo Bancario
Sanpaolo IMI
© 2001 Carlo Carrà
by SIAE 2001
Tutti i diritti riservati

Printed and bound in Italy.
First edition

ISBN 88-8491-017-X

Distributed in North America
and Latin America by Rizzoli
International Publications,
Inc. through St. Martin's
Press, 175 Fifth Avenue, New
York, NY 10010.
Distributed elsewhere in the
world by Thames and
Hudson Ltd., 181a High
Holborn, London WC1V
7QX, United Kingdom.

The first edition of this book
has been published for

Contents

Introduction

The term museum refers to a place for the conservation, cataloguing and exhibition of objects of interest linked to artistic creativity, scientific, technical and ethnographic research, and historical research and documentation.

In Greek culture the name referred to temples dedicated to the Muses, divinities who protected the arts, poetry, music and writing, where the gifts and votive offerings of the faithful were collected and displayed. Classical sources recall that a *pinakotheca* was set up in the building next to the Propylaeum of the Acropolis of Athens to exhibit works by important Greek painters, but the first real museum was the *Museion* of Alexander the Great, in the Third century B.C. This, together with the legendary Library, served to collect and classify the artistic and cultural heritage of humanity known at the time, but also as a centre for research and study as well as the place for a community of illustrious scholars.

The end of the Roman Empire in the West and the radical transformations that throughout the Middle Ages gave shape to European civilization, delegated to monasteries and cathedrals the task of hoarding the precious goods and remains of the wreckage of ancient civilization. Thus churches and places of worship were transformed into important collections of works of art, and although they had no explicit cultural purpose, they contributed to the conservation of a heritage from the past.

In the sense of a collection of art, the word museum began to be used in the Fifteenth century, in the Humanist era, when the Italian and European courts acquired rich collections of objects and materials from ancient sculpture, contemporary paintings, scientific instruments, gems and engraved stones, ancient and modern coins and medals, *naturalia* (highly varied objects from the natural world), *artificialia* (machines), usually gathered and arranged in small and precious enclosures, the *cabinets*, or in cupboards and large rooms, the *Wunderkammern* of central European culture: these were places containing the wonders in which nature and art blended to create a fantastic vision of the world.

However, these private places were difficult to visit and only shown to select guests, while the distinctive feature of modern museums, from the Eighteenth century on, is that they are public places, not only because they are open to all and are managed by public institutions, but also because they almost always originate from a public act of acquisition of a single art work or entire collections, either through donation, legacy, appropriation by the State, expropriation or purchase.

This new kind of museum appeared in an isolated and limited case at the end of the Seventeenth century, when in 1683 Oxford University granted open access to its students to the art collection donated to the English university by E. Ashmole, which later became the Ashmolean Museum of Oxford. This event was followed by the opening of the Capitoline Museum in Rome in 1734, when the last descendant of the Medici family, Maria Luisa de' Medici, donated the entire family collection of art to the State of Tuscany in 1743, on the condition that it was accessible to the public,

and the inauguration in London of the British Museum in 1753 with the explicit purpose of creating a scientific museum containing evidence of all human civilization.

An unstoppable momentum to the phenomenon of museums came from the circulating of Enlightenment ideas, whose strong points were education as a means of freeing the individual, a classification-based approach to any natural or cultural phenomenon, and the consolidation of a general awareness of the public's interest in the conservation and protection of the artistic heritage as evidence of universal history and knowledge. These positions found radical confirmation in the profound political transformations that characterized the end of the Eighteenth century: in 1793 a Jacobin decree opened the royal palace of the Louvre in Paris to the public with all the art collections of the Bourbons, dethroned by the French Revolution, enriched during the Napoleonic era with an enormous quantity of art seized from the conquered nations with the explicit purpose of recreating in Paris the Universal Museum of Alexandria. At the same time, especially in Italy, the Napoleonic laws of suppression of monastic communities and the subsequent secularisation of the clergy definitively interrupted the stratification and accumulation of artistic treasures in places of worship and convents that had taken place for centuries. This led to a vast quantity of works of art being passed into the public domain, which allowed the creation of national museums that displayed the history of Italian art, such as the Brera Gallery in Milan, and the Academies of Venice, Bologna, Turin and Naples.

The Vienna Congress sanctioned the irreversibility of public access to art and the restitution of works of art seized by Napoleon's army and officials from individual nations. This provoked a transformation in the great European imperial, royal and princely collections, created mostly in the Sixteenth and Seventeenth centuries, which around the middle of the Nineteenth century became museums open to the public: the Prado in Madrid, the Hermitage in St. Petersburg, the Rijksmuseum in Amsterdam, the Alte Pinacothek in Munich and Berlin, the Vatican Museums (whose history of collections is much more ancient), and the National Roman Museum in Rome. In Italy, immediately after unification, the revolutionary laws of 1866 granted provincial institutions ownership of the objects of art and libraries belonging to the religious congregations, prompting the setting up of numerous local museums, soon to be flanked by the municipal or civic museums which were to receive not only important private collections given in donation, but also a precious artistic heritage (fragments of plaques, family crests, inscriptions, portals, wooden ceilings, sculptures, paintings, frescoes, etc.) from the knocking down of entire portions of historical buildings due to slum clearance, rebuilding of roads, opening of new roads and squares.

At the end of the Nineteenth century and the beginning of the Twentieth, European museums were flanked by American museum foundations, all created through private initiatives with an artistic heritage acquired through purchase from the antiques market or through the bequeathing of important collections of industrial or financial magnates. At the same time new institutions were created, usually linked to universities and research centres, dedicated to cataloguing, comparative study and the teaching of natural sciences, technology, ethnography and history.

The book is divided into eight sections of different lengths, each dedicated to a museum chosen for its exemplariness. Although these museums and their contents are well-known, their historical and cultural complexity has never really been fully visited and understood.

First comes the Egyptian Museum of Turin, one of the most important in the world for the extraordinary collections it allows the public to see (everyday objects, the papyrus section, monumental statues, the funerary goods, and the Nubian temple of Ellesija), followed by the National Archaeological Museum of Naples, which completes the panorama of ancient Mediterranean civilizations presenting copious artifacts of Greek culture, from Magna Graecia, and Roman culture from the archaeological sites of Pompeii, Herculaneum and Stabia. The Neapolitan museum also bears important witness to all classical sculpture with the works it houses from the Farnese collection.

The history of the immense collections of the Renaissance and late Renaissance aristocracy is re-

counted in the collections of the Uffizi Gallery, which, starting from the Buontalenti Tribune, codified the first form of art museum, with the extraordinary masterpieces of Italian painting from Cimabue to Giotto, from Botticelli to Michelangelo and Caravaggio, and the Palatine Gallery in Palazzo Pitti (the two buildings are joined by the Vasarian corridor that contains important collections of artists' self-portraits) where the works of Raphael and the Florentine Mannerists can be seen in all their glory.

The great collections of dukes and grand dukes are accompanied by the wonderful private collection of the prince Cardinal Scipione Borghese hung in the magnificent Villa Borghese on Pincio hill in Rome. Here exceptional examples of Roman statues are united with masterpieces by Bernini, Caravaggio, Titian and Raphael.

With the passing of time, buildings that represented centres of power have been associated with collections of art. A good example of this is the National Gallery of Capodimonte in Naples where the functions and character of a royal palace (royal apartments) blend with the ancient art collection boasting works by Masaccio, Martini, Titian, Correggio, Ribera, Giordano, Solimena etc. and the Nineteenth and Twentieth century collection.

The network of museums in Italy is the result of the Napoleonic laws that closed convents, and the outline given to Italian art history by Vasari and codified in the Eighteenth century by the Abbot Luigi Lanzi. This book ends with two fundamental national museums that document the development of painting in Italy from the Thirteenth century to the beginning of the Nineteenth: the Brera Gallery and the Accademia Galleries in Venice. The collections and the paths visitors follow in the museums are organized by dividing the paintings into the regions they come from. Within this order the paintings by the masters and their disciples are organized chronologically. The collections are particularly rich in paintings from the regions in which they are located.

The wealth of variety in the Italian artistic heritage and the widespread presence of around three thousand museums throughout the country is documented in the list of institutions at the end of this book. The intention is to provide a guide to the discovery and knowledge of a widespread heritage which is one of the treasures of our country.

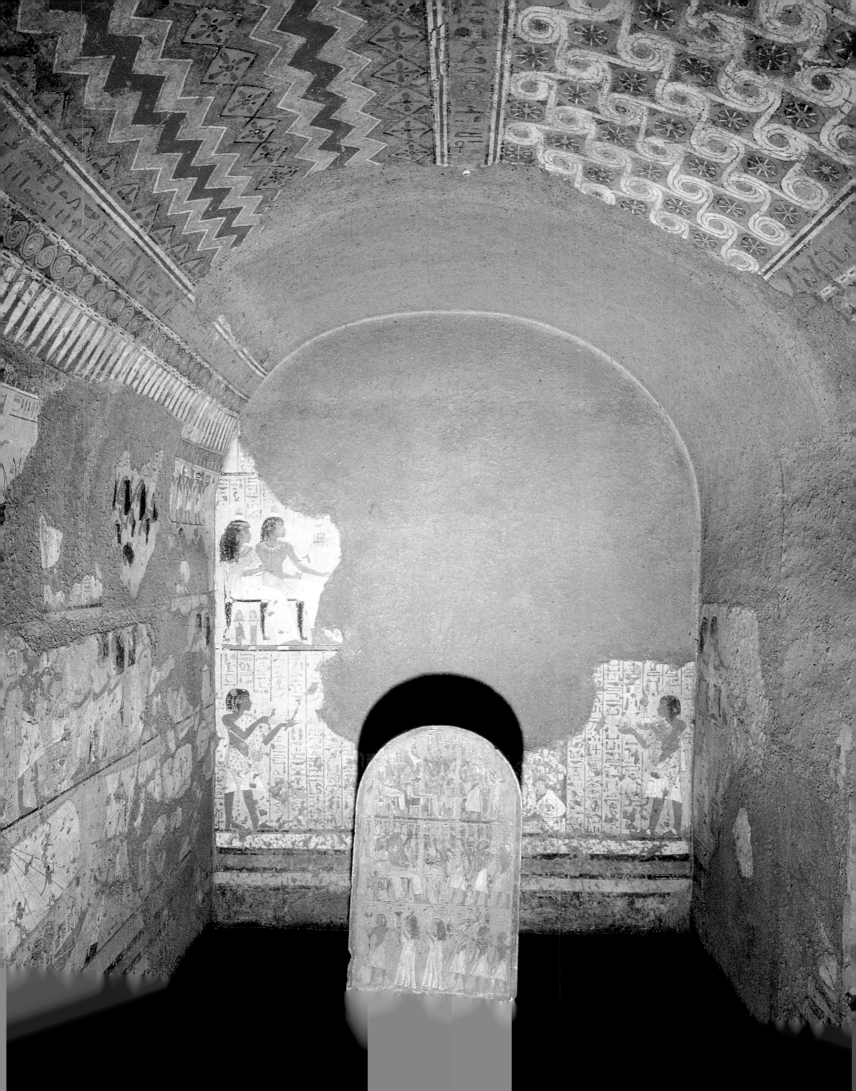

Turin, the Egyptian Museum

Anna Maria Donadoni Roveri

The origins of the Turin Egyptian Museum [Museo Egizio] can be traced to around 1630, when the dukes of Savoy acquired the so-called *Mensa Isiaca*, an altar table in bronze with agemina inlay in silver and copper. Rediscovered in 1527 during the Lanzichenecchi sack of Rome, it had come into the hands of Bembo, and subsequently found its way into the Gonzaga collections. The piece is important not only for its stylistic features (it is a Roman work in the Egyptian style, probably connected with the Iseum Campense), but also for the part it plays in the history of Egyptology. It was the interest aroused by this particular "fa-mous monument" which in 1759 prompted Carlo Emanuele III to send the Royal University's professor of Botany, Vitaliano Donati, to Egypt to acquire antiquities for the University Museum which had been established shortly before (1724). As a result of this mission, three splendid statues arrived in Turin, the finest being a basanite one of the goddess Isis from Coptos, dating from the time of Amenhotep III. Interest in Egypt remained lively in the decades that followed, not least due to energetic disputes among scholars over the attribution of a female head, with markings as yet undeciphered (later shown to be Seventeenth-century).

Facing page
General view, interior.

Mensa Isiaca, from Roman times, bronze and damask in silver and copper, found in Rome in 1527

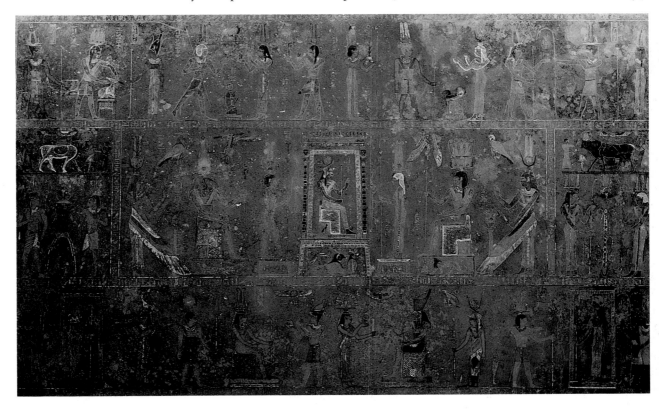

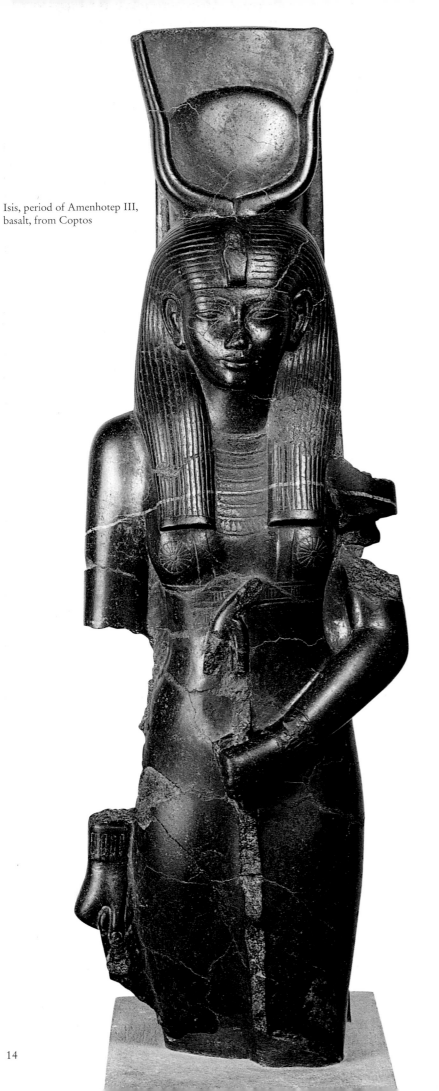

Isis, period of Amenhotep III, basalt, from Coptos

The Napoleonic campaign in Egypt: "Egyptomania" was born

Napoleon's Egyptian venture, launched in 1798, brought the civilisation of ancient Egypt to the attention of European culture, sparking off an Egyptomania which has recurred periodically since, sometimes in quite acute form. As well as his Army and whole military expedition, another was organised, of scholars and draughtsmen, to which we owe the first large-scale documentation of the monuments, the sculptures and the writings of the Egypt of the Pharaohs. Among those who followed his military campaign was the lively and enterprising Dominique Vivant Denon, later to become Director of the Louvre Museum, to whom we owe the creation of the most important work on Egyptian civilisation produced in the first half of the Nineteenth century, *Description de l'Egypte*, published between 1809 and 1813 in twenty-four volumes, illustrated with splendid colour plates; and the earlier *Voyage dans l'Haute et la Basse Egypte*, [Travels in Upper and Lower Egypt], a record of the Napoleonic campaign, which he brought out in 1802.

The arrival of the statue of Isis in Turin coincided with the creation of the Egyptian Museum. In fact, in 1759 King Carlo Emanuele III sent Vitaliano Donati, professor in botany at the Royal University, to Egypt to purchase antiquities for the university Museum. This expedition resulted in the arrival of three splendid statues in Turin, among which the one in basalt depicting the goddess Isis stands out.

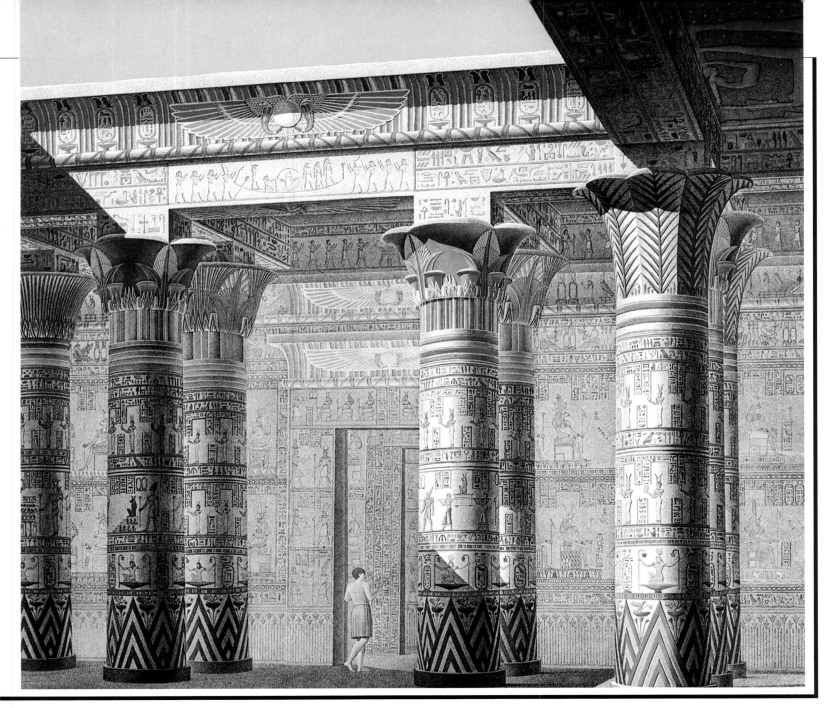

Reconstruction of the interior of a Ptolemaic temple, watercolour, from *Description de l'Egypte*, 1809-13

The Drovetti collection

It reached its height in 1824, when, at Carlo Vidua's earnest prompting, King Charles Felix acquired the collection of Bernardino Drovetti, a Piedmontese who had followed Napoleon in his Italian campaigns and in 1802 become French consul in Egypt, a post he retained through various changes of régime until 1829, amassing great influence with the viceroy Mohammed Ali.

This was the period of intense striving among the consuls of various foreign countries, merchants and adventurers to ransack the soil of Egypt for antiquities to sell to the museums of Europe, riding the wave of interest aroused by the *Description de l'Egypte*.

The Drovetti collection, one of the richest, was made up of more than 8000 pieces, including some 100 large statues, the most noteworthy of which are the archaic statue of the Princess Redi, the New Kingdom ones of Thutmose I, Amenhotep II and Thutmose III, that of Rameses II, the sphinxes of Amenhotep III, the colossal statue of Sethi II, the groups of Amun and Tutankhamun, of Horemheb and Mutnegemet, numerous sarcophagi with their mummies, funerary and votive steles, and papyri which include not only many Books of the Dead, but also the famous *Canone Regio* [the Royal Canon of Turin], the papyrus of the mines and caves of Wadi Hammamat (the oldest known map), the records of the Rameses III assassination trial, the plan of the tomb of Rameses IV, and a papyrus with sketches of a satirical and erotic nature. There were also many bronze statuettes of gods and goddesses, pots, and lesser objects, chosen with a particular concern for their illustration of everyday life.

15

Bernardino Drovetti (1776-1852)

It is to Bernardino Drovetti that we owe the great collection of Egyptian antiquities which formed the first nucleus of the nascent Egyptian Museum. Born in 1776 at Barbania, in the Canavese district, he took a law degree at the University of Turin, but on the arrival of Napoleon in Piedmont in 1796 he joined the French army in enthusiasm for the ideals of the Revolution, and took part in the Italian Campaigns.

He fought at Marengo where he had one hand mutilated, and became in rapid succession lieutenant, captain, and then aide de camp to Joachim Murat.

In 1801 at the age of 25 he was Chief of Staff of the Piedmontese division, and was then appointed commissar of the Provisional Government in Piedmont after its annexation to France. In 1802 we find him French consul (later Consul-General) in Alexandria (Egypt belonged at that time to the Sublime Porte of the Turkish Empire and would not, accordingly, receive an ambassador; such functions were exercised by consuls). In this office, which he resumed after an interruption between 1814 and 1820 due to the Bourbon Restoration,

Drovetti managed to gain the confidence of the viceroy Mohammed Ali, to whom he offered his wholehearted cooperation in the great work of modernising the country. They began with measures for improving public health, for irrigation of the soil, and for an effective educational system; one of the means they used was to invite Italian and French doctors, engineers and teachers to Egypt.

At the start of the Nineteenth century Egypt was the object of quite extraordinary interest in Europe, aroused by Napoleon's campaigns there in 1798-1801, and most of all by the work of the hundred

Lorenzo Delleani, *Interior of the Egyptian Museum*, 1881

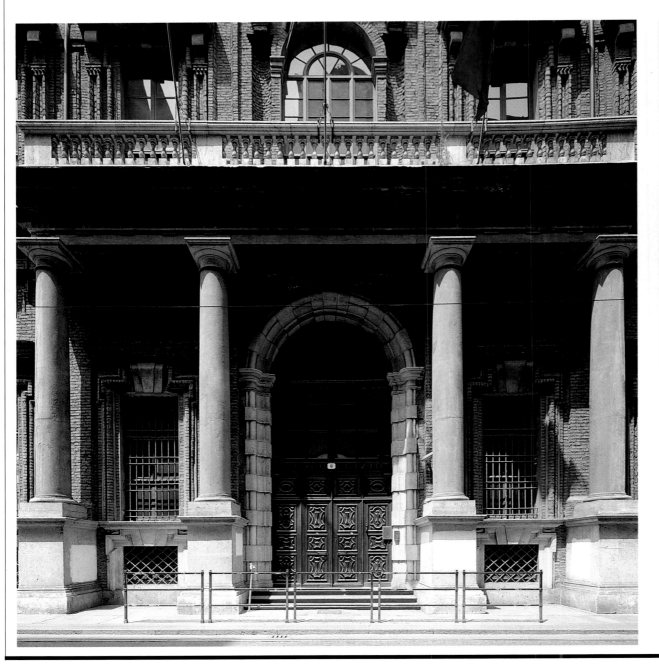

View of the entrance to the museum

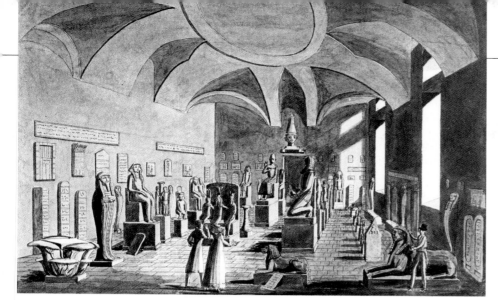

False cover of the sarcophagus of Bayun, stuccoed and painted wood, XXI Dynasty

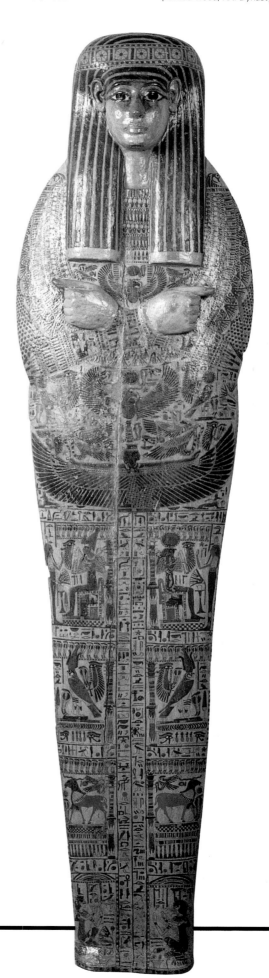

and fifty "*savants*" who had followed the expedition to document all the country's features, not only ancient monuments but also flora, fauna, and the customs and practices of the inhabitants. The labours of this committee of scholars were concentrated in an admirable work, the *Description de l'Egypte*, which brought to European attention all the treasures of a land unknown until then. The "Return of Egypt" became quite the fashion, and appears to have had a great influence on the culture of those years. This was the beginning of the great monument hunt, carried on especially by foreign consuls. Drovetti was one of the most active and, through his collaborators Rifaud, Lebolo and others, excavated in the most fruitful areas, above all at Thebes; later he began negotiations for selling the works found to European museums. A first nucleus of his collection was acquired by Piedmont, a second by the Louvre, and other smaller ones found their way to Berlin, Vienna, and Lyons. A collaboration project between the Turin Museum and the Louvre is currently being brought to completion, consisting of a reassembling of virtually the whole of the ROM, sponsored by the Compagnia di San Paolo, which will also recreate the atmosphere of the first collection campaigns and the very birth of our own subject.

The Drovetti collection, the world's first of its genre, installed in the palace of the Academy of Sciences since its arrival, made, through the work of J.F. Champollion, a fundamental contribution to the development of the newly founded subject of Egyptology.

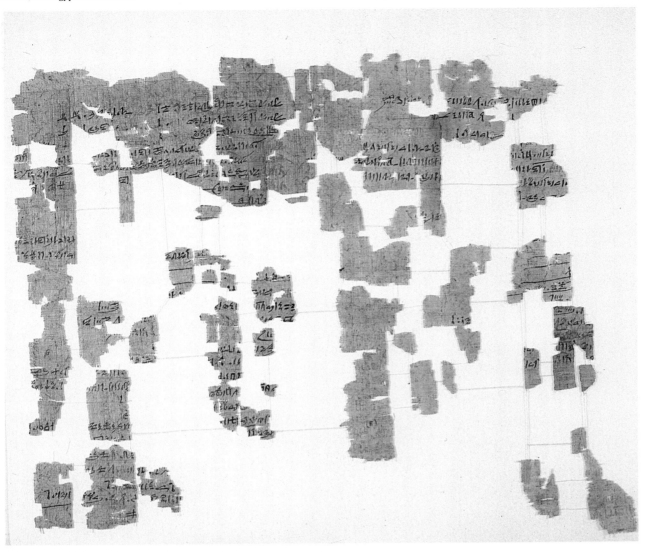

Statue of Princess Redi
III Dynasty

The statue (black granite, 83 × 32 × 45 cm), belonging to an extremely small group of works dated to the III Dynasty, reached Turin by way of the Drovetti collection (1824), but its original provenance is not known. It is of a princess – the base has her name inscribed, and the title "daughter of the king" – sitting on a cube-shaped throne, with arched relief panels showing in stone the construction of wooden benches of the Archaic period. The throne has a low back, and stands on a rectangular base with a rounded front. The princess is wearing a clinging, V-necked tunic down to her ankles; her left arm is bent and held chest-high, while her right rests on her leg. The feet and ankles are massive. The most remarkable feature is her hair, which falls from a parting on the top of her head to her shoulders, and the back of the throne, in a voluminous mass framing a heavy, severe face. The style, both in the figure and in the throne, with its rigorous arrangement of the volumes, is intended to convey with authority the physical presence of the person – in Egyptian art, the statue does not represent the person: it *is* the person – identified with name and attributes. In this it is akin to the statue of the Pharaoh Gioser from Saqqara, now in Cairo.

The Turin Royal Canon, or King List
XIX Dynasty

An immense corpus of papyri came to the Museum of Turin through the Drovetti collection. This included, as well as a number of versions of the *Book of the Dead*, (the book accompanying every dead person of importance to the World Beyond), some unique and noteworthy pieces, such as the map of the mines of Wadi Hammamat, and the plan of Rameses IV's tomb. There is one papyrus, however, which is truly outstanding, and provides an indispensable landmark, a cardinal point for any historical reconstruction of Egypt's rulers and their dynasties.

The recto contains an administrative text, while the verso gives a list of rulers from legendary times up to the XVII Dynasty. The kings' names are set out in columns (of which we have only eleven, and those are fragmentary), and each is accompanied by the number of years, months and days of his reign. Though the text came to him in fragments, Jean François Champollion nevertheless instantly recognised its extraordinary importance. A letter from the "Decipherer" to his brother already speaks of a "chronological table" and of "a list of kings", comparing it with the Abydos Tables, and describing how he had picked out of the dust the wretched fragments that bore the names of the Pharaohs. His language fired with romance, he tells of his despair before the ruins of this "grand cadaver of history": "I saw running through my fingers the names that belonged to years whose record had been utterly lost to history; the names of those whose altars had been no more these Fifteen centuries; I picked out, scarce daring to breathe for fear of reducing it to dust, a tiny fragment of papyrus, last sole refuge of the memory of a king for whom, in life, the immense Palace of Karnak was probably not room enough."

The laborious reconstruction, begun by Champollion himself and carried on by Seyffarth, continued in the years that followed and was completed by Giulio Farina and, latterly, Alan Gardiner. Even today, painstaking research enables us to place – or replace – this or that tiny fragment.

The text is evidently a copy of an official text. The royal names are not grouped in dynasties under the canonical arrangement made by Manetho in the Third century BC, but in Periods, with the total years' duration given after each.

The Drovetti collection was one of the richest, consisting of more than 8000 pieces, about 100 large statues including the Archaic statue of princess Redi, numerous sarcophaguses with relative mummies, funerary and votive steles and papyri, including the famous Royal Canon.

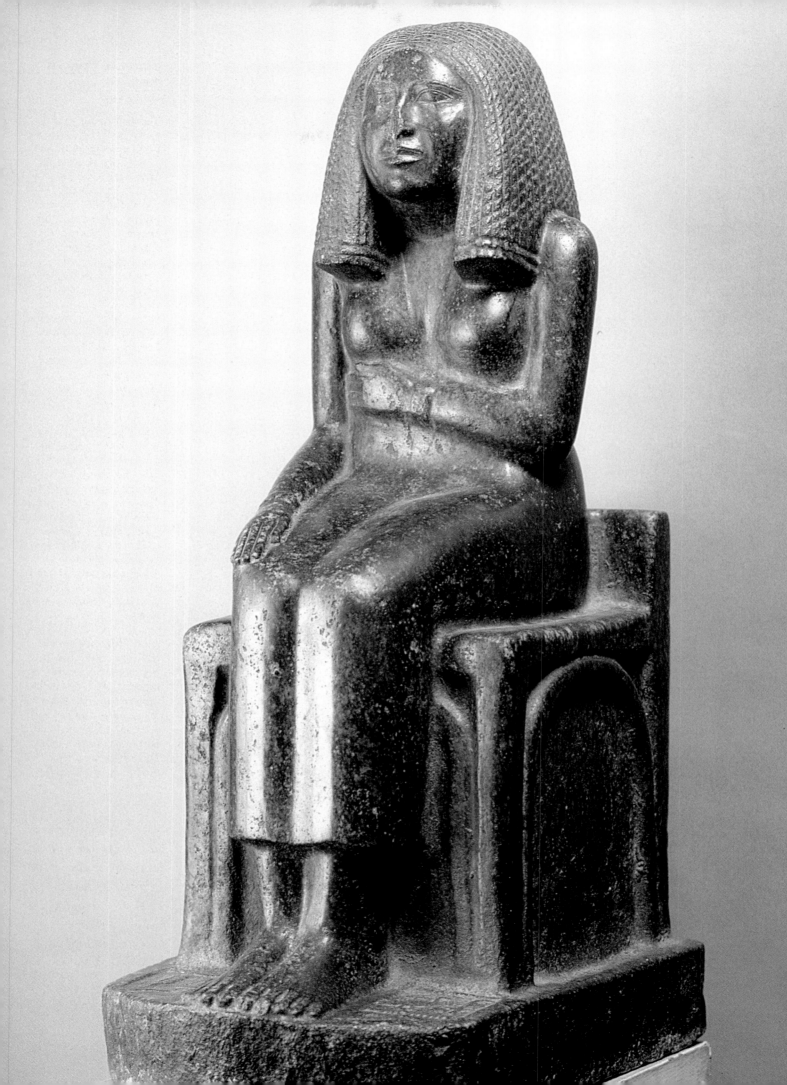

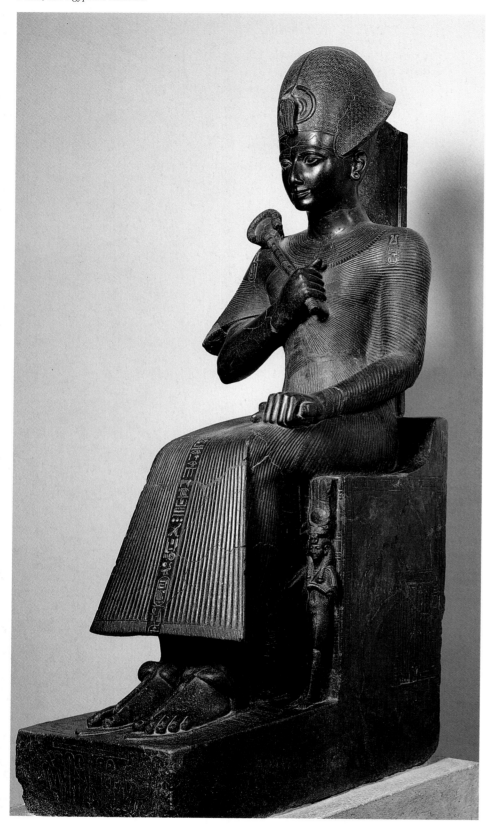

Statue of Rameses II
XIX Dynasty

The statue (basanite, h. 194 cm.), one of the most famous works in the whole history of Egyptian art, represents the Pharaoh Rameses II, of the XIX Dynasty.
Rameses II was one of the most long-lived of Egyptian rulers, dying at an age of more than ninety. During the first years of his reign a famous battle was fought at Qadesh on the Orontes against the Hittites. The battle was in fact an inconclusive affair, although its Egyptian protagonist celebrates it as an extraordinary victory, worthy to be immortalised in grandiose reliefs on the walls of many temples and made into the theme of a grandiloquent poem. The battle, and a series of lesser skirmishes, was followed, in the twenty-first year of his reign, by a peace treaty between the Egyptians and the Hittites, the text of which, in the two languages of the contracting parties, is the earliest treaty in the history of the human race that has been preserved. There followed a long period of peace, spent mostly in intense building activities all over the country, of which the Ramesseum and the two temples of Abu Simbel are particularly famous; the smaller of these is dedicated to Rameses' consort, Nefertari.
He had four wives (and an indeterminate number of concubines), and fathered more than a hundred children, most of whom he outlived.

The statue came to Turin with the Drovetti collection, we do not know in what state, for Champollion speaks of it first as in need of restoration, but later on is singing its praises as "the Egyptian Apollo del Belvedere". According to information from Rifaud (the sculptor from Marseilles who carried out excavations at Drovetti's orders), it was found in the temple of "Amun Heeder of Prayers", a small sanctuary located behind the great temple of Karnak, which is also the source of the great obelisk of Thutmose III, now in Rome beside the church of San Giovanni in Laterano.
The Pharaoh is represented on his throne, robed in a long folded gown, sandals on his feet and in his hand the symbols of power: the sceptre (*heka*) and the whip. On his head he has a helmet – the so-called "blue crown" – probably a war helmet. Somewhat smaller, on either side of the throne are his two heirs (though neither was in fact to succeed him) and his consort Nefertari: the name of each is inscribed.
The face of the sovereign, which we could describe as an idealised portrait (the Pharaoh's mummy, perfectly preserved, is on display in the Cairo Museum), seems to be turned benevolently downwards, most probably (as Silvio Curto has acutely suggested) so that he may carry out his function as intermediary between "Amun Heeder of Prayers" and the faithful.

The Pharaoh is represented on his throne, robed in a long folded gown, sandals on his feet and in his hand the symbols of power: the sceptre (heka) and the whip. On his head he has a helmet – the so-called "blue crown" – probably a war helmet. Somewhat smaller, on either side of the throne are his two heirs (though neither was in fact to succeed him) and his consort Nefertari: the name of each is inscribed.

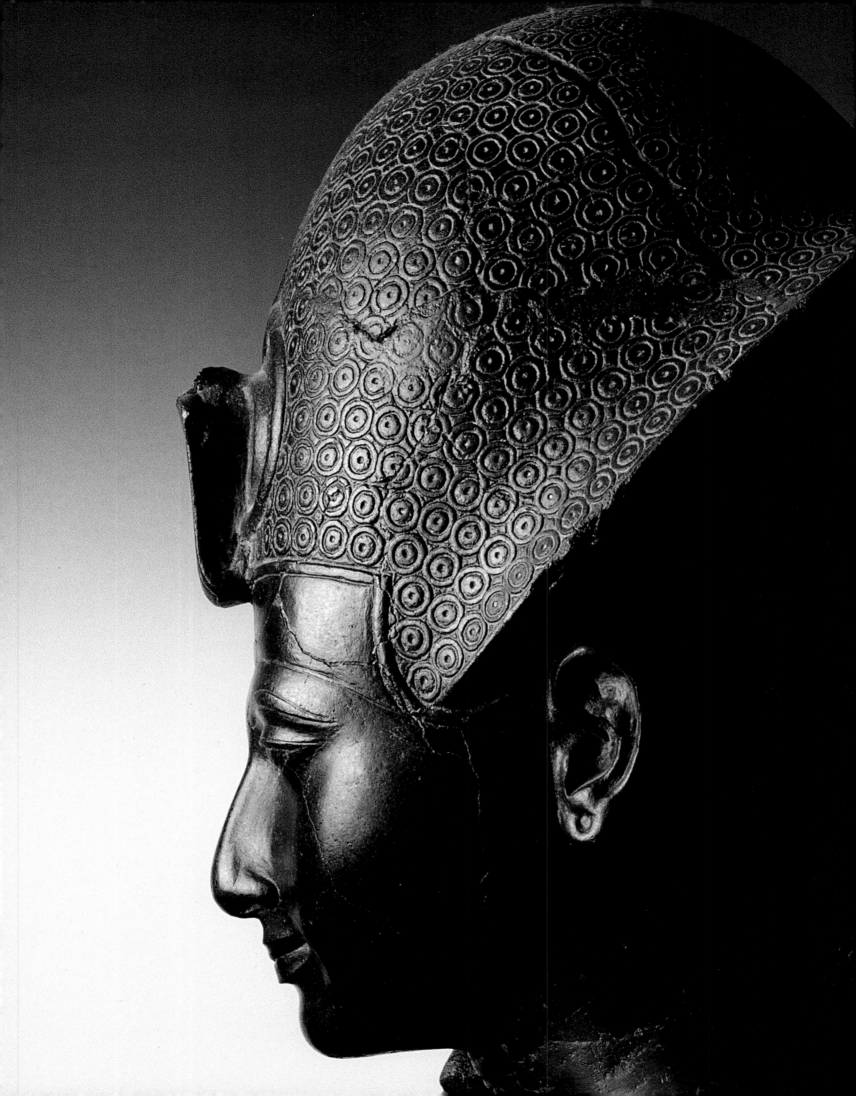

The "Book of the Dead"

Of all the peoples of antiquity, the Egyptians were without doubt the most fascinated by and concerned with the mystery of death; so much so that their political, social and religious life was organised around this enigma and their attempts to master it. It is to this attitude that the whole set of rituals linked to the dead belong, including certainly those which consist of particular uses of writing. The so-called *Book of the Dead*, as well as providing the clearest example of ritual or sacred writing, is also one of the papyrus documents which looks most like a forerunner of what we call a book. It is a magical-religious text for funerary use, placed in tombs near at hand to the deceased, inside a wooden box or terracotta vase. The volume's contents, though marked by a degree of systematic arrangement and a tendency to adopt canonical formulas, were not rigorously uniform, but could include a varying number of magic formulas (or chapters), hymns and prayers of which there are 165 in total, without counting other texts which might or might not also be added in association. These formulas, according to Egyptian belief, had the virtue of guiding and protecting the soul in its journey through the region of the dead.

The first funerary texts we know of were found inscribed in hieroglyphs on the inside walls of the pyramids of kings of the V and VI Dynasties (Old Kingdom, ca. 2575-2134 BC), which have become famous as the "Pyramid texts". It was from the XVIII Dynasty (ca 1550-1307 BC) onward that they came to be written on papyri and placed inside the protection of the mummy. The Turin example, published first in 1842, extends to nineteen metres in length: it is this example that is used as the basis for the modern numbering of the chapters.

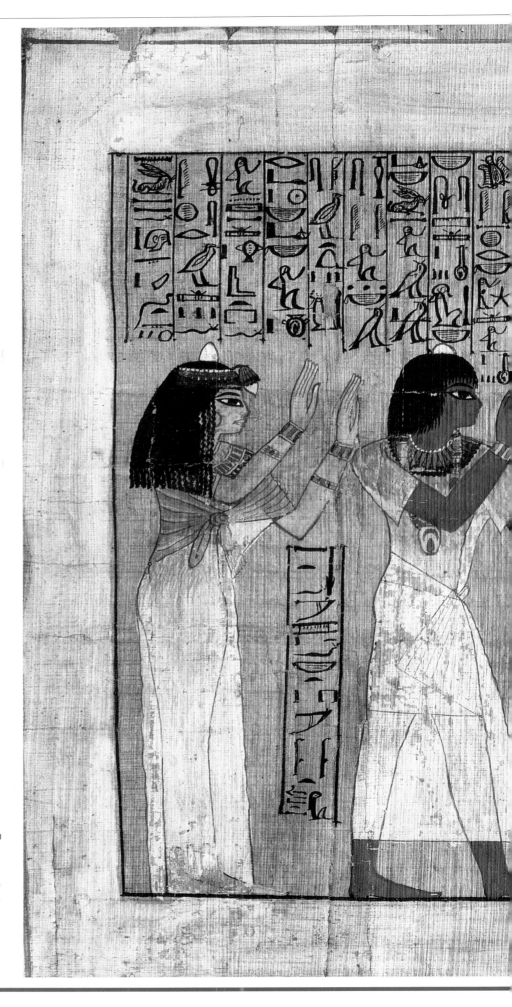

The deceased pray before Osiris, from the *Book of the Dead*

A vast series of papyri arrived at the Museum of Turin via the Drovetti collection. Among them we find an exceptional copy of the Book of the Dead, *the guide which was to accompany every deceased in the afterlife, decorated by vignettes of rare beauty.*

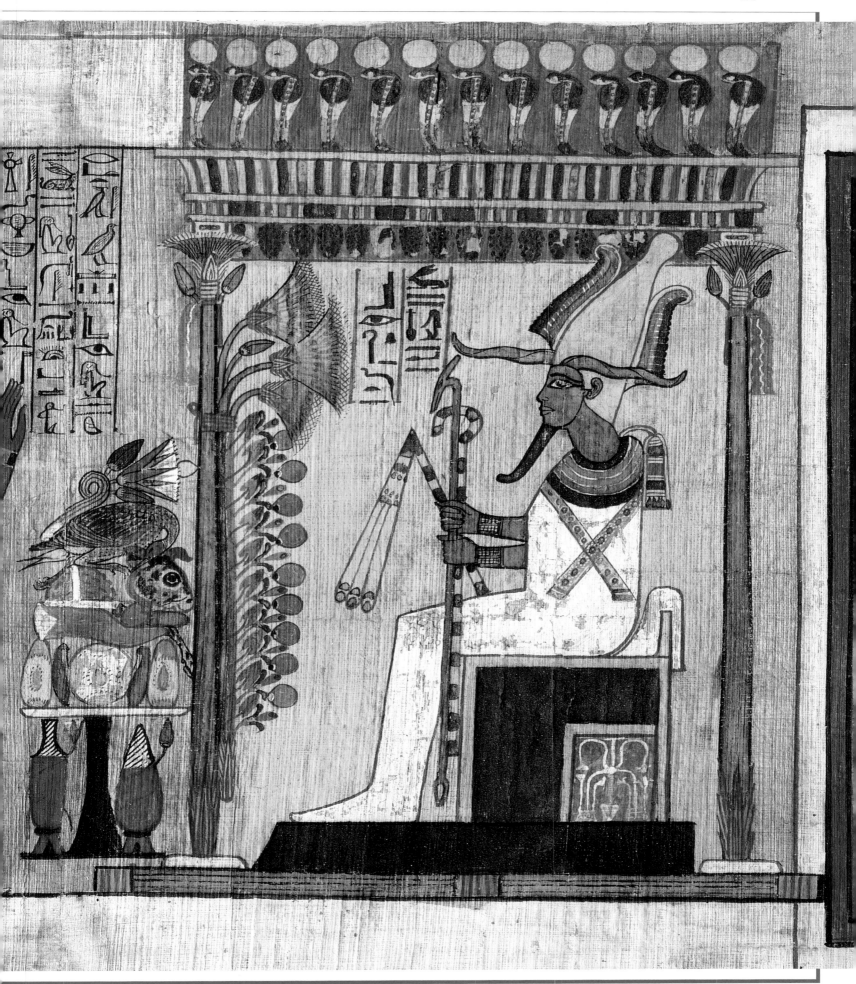

Ernesto Schiaparelli (1856-1927)

Director of the Museum from 1894 to 1927, the year of his death. He is responsible for the second great wave of additions to its collection, through a series of acquisitions and, above all, his excavation campaigns in Egypt, in places deliberately chosen so as to fill the gaps in the records of the Drovetti collection.

Schiaparelli was born at Occhieppo, near Biella, on 12 July 1856, into the family which also produced the astronomer Giovanni, the Arabic scholar Celestino, and the diplomat and palaeography student Luigi. Their father was professor of Ancient History at the University of Turin.

His studies, first at Turin with Francesco Rossi and then in Paris with Gaston Maspero (later the Director General of the Antiquities Department in Egypt), gave him a firm grounding in Egyptology. He began his career working with the Egyptian collection of the Archaeological Museum in Florence (1890-94) and edited its catalogue. During this period he also carried out missions to Egypt, mainly for the purpose of acquiring material and exploring areas for archaeological sites. In 1894 he was appointed Director of the Turin Museum and at the same time Superintendent of Archaeology for Piedmont and Liguria, a task he performed with great energy, seeing to the carrying out of excavations and restorations in these regions.

The excavations in Egypt were done through the specially-created Italian Archaeological Mission, financed partly by the Ministry of Public Education (which at the time also covered Superintendencies and Museums), partly by the Foreign Ministry, and partly from the personal funds of King Vittorio Emanuele. We have already spoken, in the paragraph on the Museum's history, of the marvellous results of these missions of his, which brought Turin more than 17,000 additional objects.

Our most important remaining task is to give a brief account of his methods of excavation, which although not comparable, of course, with present-day ones, nevertheless introduced some major innovations, such as the extensive use of photography, and the addition to the team of two fellow-workers who would nowadays be considered indispensable, an anthropologist (Giovanni Marro) to study the human remains, and a restorer (Fabrizio Lucarini), who took care of the detaching and reassembly of the paintings of Iti from Gebelein and those of Maia from Deir el Medina. Schiaparelli also surrounded himself with many other excellent collaborators, first and foremost Francesco Ballerini, from Como. Schiaparelli's scholarly activities were also remarkable, above all in the years before his arrival in Turin; for afterwards, under the pressure of his practical duties within the region, of the excavations, and of the rearrangement of the Museum, he did not manage to complete publication of his Egyptian missions, though just two splendid volumes did appear, one devoted to the Valley of the Queens and the other to the tomb of Kha. His extraordinary energies as an organiser were not limited to his work as an archaeologist and Museum Director: prompted by a deep religious conviction, he also turned his hand to works on behalf of religious missions and the Italian expatriate community; he founded a society for the protection of Italians abroad; he supported Catholic missions, and founded a number of hospitals in the Near East, and as far afield as China, following their development with extraordinary assiduity and interest.

In 1924, in recognition of his services, he was made a Senator of the Realm.

Under the directorship of Ernesto Schiaparelli the Museum grew considerably.
The director, first with acquisitions and then, between 1903 and 1920, with excavations in wisely chosen sites such as the plain of Giza, Heliopolis, Thebes (Valley of the Queens and Deir el Medina), succeeded in enriching the Museum with more than 17,000 pieces.

The Valley of the Queens, photograph taken by Ernesto Schiaparelli in the 1920's

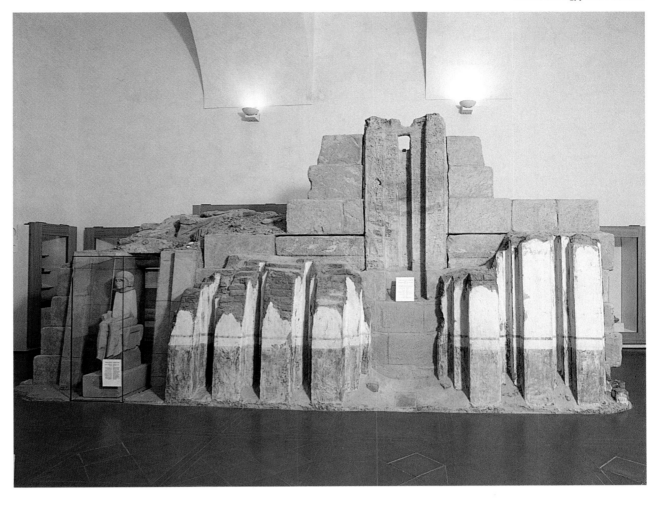

Mastaba of Iteti from Giza
IV Dynasty

The plain of Giza, close to modern-day Cairo on the west bank of the Nile, was chosen by the IV Dynasty rulers Cheops, Chefren and Mykerinos as the site of their tombs, the three great pyramids. Around these there grew (and continued to grow under later dynasties) a large cemetery for the king's family and the royal officials. The tombs, known as "mastabas" from the Arabic word for the benches that stand outside houses of that area, are regularly aligned in a rectangular grid of streets and alleys, and are composed of massive oblong slabs with sides tapering upwards, and a hollowed-out shaft or shafts leading below ground to the funerary chambers. On the wall there is usually a stele, in the form of a false door, which is the site of offerings and prayers. At the beginning of the Twentieth century this necropolis was savagely ransacked by clandestine excavators, leading the Director of the Antiquities Department, Gaston Maspero, to decide in 1903 to invite three celebrated archaeologists (the Italian Schiaparelli, the American, Reisner, and the German, Steindorf) to put the scientific exploration of this very extensive archaeological site into their hands.

The necropolis was divided into three sections, and the archaeologists drew straws out of a hat to allocate them. The southern section east and west of the Pyramid of Cheops, fell to Schiaparelli. Work started in 1903, but Schiaparelli was not able to continue here in later years because of other commitments in the area around Thebes. Though brief, that digging season was fairly rewarding and among the mastabas that were explored the most remarkable is that of Iteti, "Inspector of the Priests of the Pyramid of Cheops", in the eastern cemetery, a little distance from the others. It consists of a massive structure clad in limestone blocks, with two shafts carved into it and funerary chambers aligned from north to south. Another two shafts were added at a later time, and, in one of these, late-period pottery was found. On the east facade of the mastaba was a monolithic false door whose supports show representations of people bringing offerings. On the sides are two slabs with paintings of winged creatures.

At some subsequent time, possibly commissioned by the same owner, the mastaba was extended on the east side with a structure in sun-dried brick composed of a narrow hallway accessed by a staggered entrance, which came out in front of the false-door stele. The west wall (that backing onto the mastaba) was decorated with a series of niches painted with geometric motifs and imitation wood. These decorations, portraying a structure of wood and matting, began originally in the great "palace facade" mastabas of the Tinita period. On the south side, the original mastaba has been extended with a chapel made of stone blocks, decorated with reliefs showing the deceased person and scenes of everyday life. In the south-west corner, a false-door niche communicated with a *serdab* that contained the statue of the deceased himself. This statue, though, is badly damaged, including damage to its face, probably for the sake of the copper capsules which contained the eyes made of semi-precious stone. Though it is in pieces, its stylistic qualities enable us to recognise it as the product of a royal workshop, with its characteristic care over precise definition of the shapes and masses.

Painting of the tomb of Iti from Gebelein
XI Dynasty (2130-1990 BC)

In 1910-11 Ernesto Schiaparelli began the exploration of the necropolis of Gebelein, already extensively pillaged by clandestine excavators. At the end of his first season, he began to reveal the precinct wall of a tomb which was fully brought to light the next year under the direction of a pupil of Schiaparelli's: Virginio Rosa. What was revealed was a structure (typical of the area, it was later found as other tombs were discovered) consisting of a pillared hallway in sun-dried brick, leading to a series of niches or chapels standing against the cliff face. The funerary chambers were cut into the ground beneath. The central chapel, larger than the others, was composed of an antechamber and a chapel proper, both painted with scenes connected with funerary ritual: the deceased, accompanied by his consort, looks on as a bull is ritually slaughtered, watches the funeral dances of the temple girls, and receives the leg of the sacrificial bull.

The other paintings are on the walls of the hallway and on the pillars; they portray scenes of everyday life: stock-rearing, a calf being born, goods carried in boats and on asses, and the punishment of disobedient servants.

The largest and most complex scene shows a file of servants bringing grain to the granaries. The picture is divided into three parts, according to the Egyptian design conventions, under which each element must be shown for maximum recognition, even if this means a breaking down of the ensemble in terms of ideas. Thus the eye is seen full-on with the face in profile; the torso is shown in full while the legs are drawn sideways-on; figures are aligned in bands one above another, and there is no perspective, because what is

further off is drawn as large as what is near. Even the donkey's pannier on the side that cannot be seen and has to be imagined is shown above.

In one scene, which could be regarded as the characteristic example of all these paintings, the tomb's owner appears seated on a couch similar to the present-day *anghareb*, with one leg raised in a pose unknown to formal Egyptian art, which is always careful to compose its figures as we see them in the halls surrounding the royal court. These paintings in fact belong to a culture, like that of the so-called "provincial halls", in which less strict conformity with the classical rules results in a singularly lifelike observation of everyday situations.

The tomb, which also yielded two steles showing persons armed with bow and arrows, dates from the end of the First Intermediate Period, and more precisely to the XI Dynasty; it belongs to a personage by the name of Iti, "Treasurer to the King" and "Leader of the Squadrons", and gives an example of painting from this period, of which we have very few indeed. The paintings were prised from their walls of sun-dried brick and reassembled in Florence in a labour of many years by Fabrizio Lucarini, one of the finest restorers of the time, who reconstructed the original substrate with mortar and straw. The tomb itself, which Schiaparelli had covered over again after his excavation, was once more uncovered in 1999 during excavations by the Museum of Turin, and we have been able to get better details of the features of its construction.

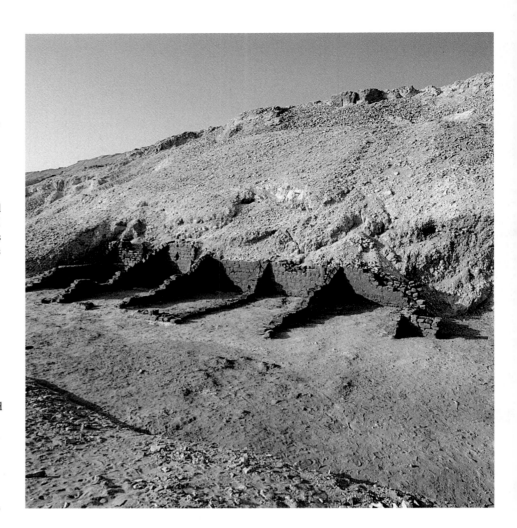

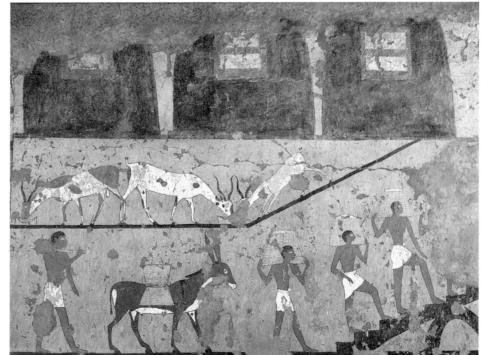

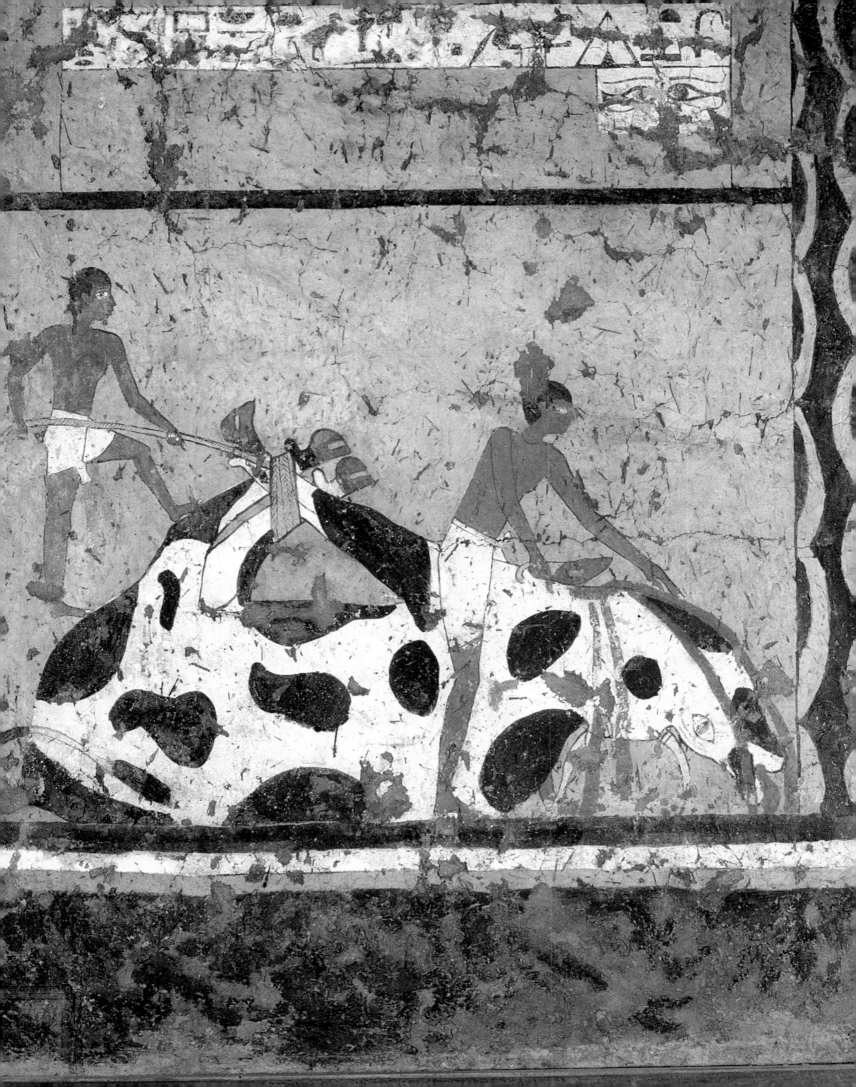

Tomb of Kha

mid XVIII Dynasty (around 1500 BC)

The tomb of Kha was discovered during Schiaparelli's 1906 excavations in the necropolis of Deir el Medina (the village located in the necropolis of Thebes, home of the workers who laboured in the royal necropolis). The superstructure, as in the case of the other tombs of Deir el Medina, consisted of a chapel with a Pyramid on top, and had been known of for a long time; so long, indeed, that the stele which belonged to it had already been in the Museum since acquisition of the Drovetti collection. The funerary chamber, which was not accessible from the court-yard as usual, but situated under the flank of the hill, was one of Schiaparelli's most important finds, his "Rachel", as he liked to call it. It was reached by way of a shaft, a flight of stairs and a hallway leading to a sturdy door guarding the inner chamber where the sarcophagi of the owner lay, an architect and "Head of Works" by the name of Kha, and his wife Merit (the Beloved) with all their goods and furnishings.

Once brought to Turin, although the Museum was at that time arranged by object type, it was kept as a single composite exhibit. (Most fortunately so, for at that time other tombs, even if they arrived as a whole like that of Sennegem, were sadly dispersed to a number of museums; today an effort is being made to bring them back together again, "virtually"). For this reason the tomb of Kha is a unique treasure, and one of the most extraordinary ensembles in our Museum.

As well as the sarcophagi, of which there were three for Kha and two for Merit (the outside ones rectangular with vault lid, and the inside ones mummy-shaped), the tomb contained a set of objects, from beds to stools and from laundry boxes to a cupboard for storing the lady's wigs

(made of human hair); food, drink, Kha's work tools, and dressing-table objects for both him and her.

The statuette of the deceased, its throat adorned by a necklace of real flowers, had been placed on a chair painted yellow, white and black in imitation of the materials of the costlier chairs of royalty: gold, ivory and ebony.

There were other garlands, too, adorning Kha's sarcophagi with flowers recognisable even now, more than 3500 years later. On the chair were draped two small rugs, with a decoration of lotus flowers, woven with what is one of the first (and best preserved) examples of the Arras tapestry technique. The most noteworthy items of food and drink (the latter preserved in terracotta vases, still sealed) are the various kinds of bread, all lined up on low tables made of papyrus reed stalks; small fowl, salted; dates, jujubes, and cakes of salt. Special mention should be made of the papyrus found rolled up inside Kha's second sarcophagus, for it is one of the most ancient versions of the *Book of the Dead*, and decorated with small drawings of rare beauty. Remarkable objects, some given by the rulers Kha worked for (from Thutmose III to Amenhotep III), include a cubit (linear measuring instrument) and a box containing pieces for a game similar to chess.

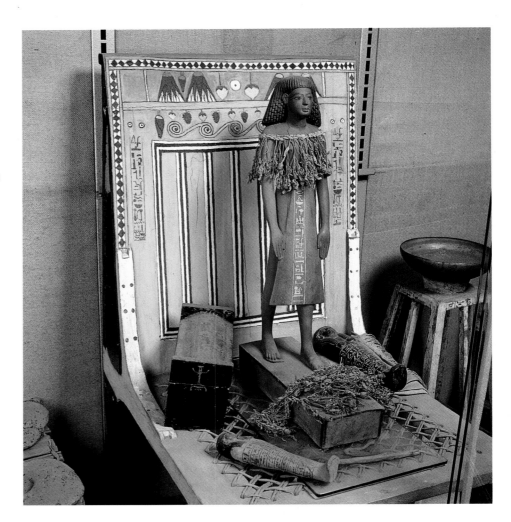

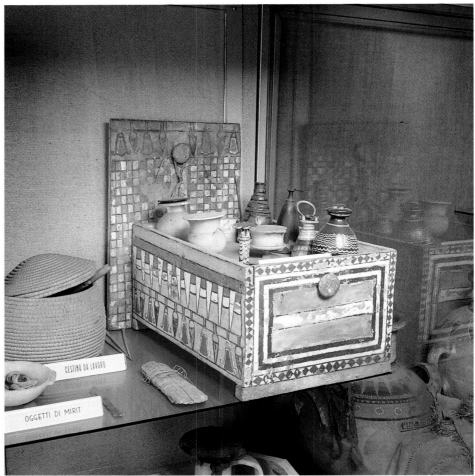

28

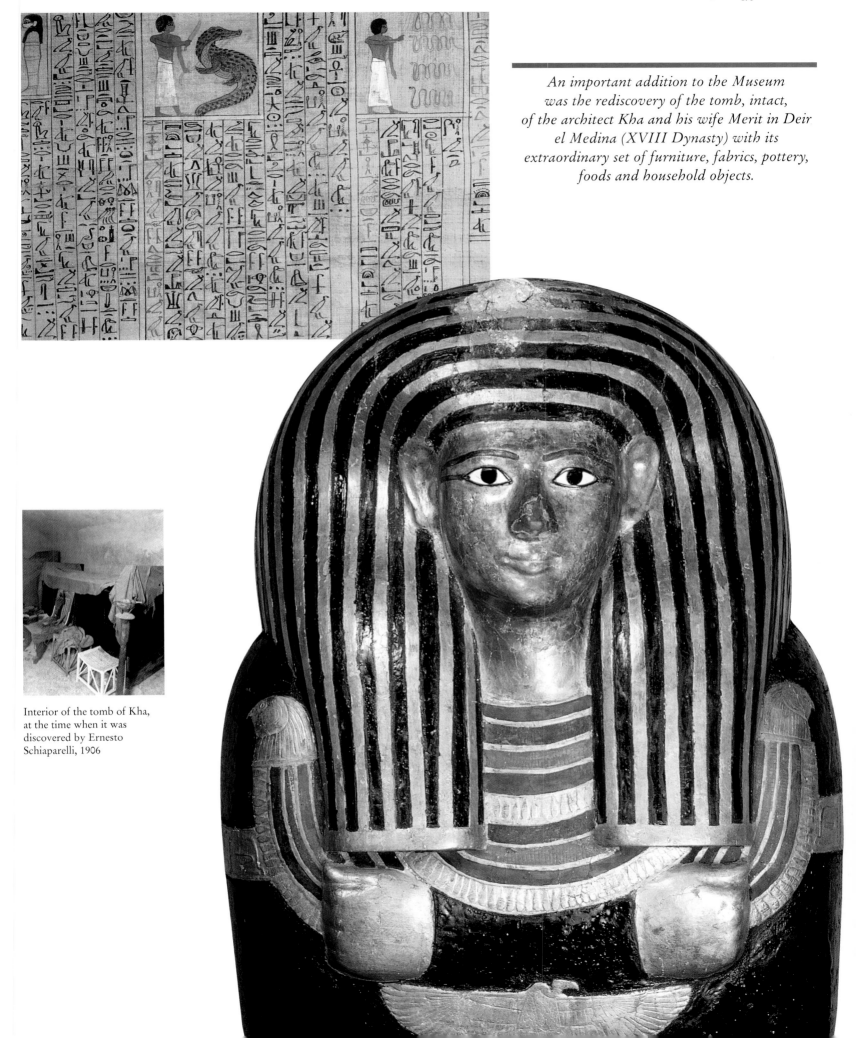

An important addition to the Museum was the rediscovery of the tomb, intact, of the architect Kha and his wife Merit in Deir el Medina (XVIII Dynasty) with its extraordinary set of furniture, fabrics, pottery, foods and household objects.

Interior of the tomb of Kha, at the time when it was discovered by Ernesto Schiaparelli, 1906

The birth of Egyptology

The collection, the first of its kind in the world, was housed in the Palazzo Guariniano of the Academy of Sciences from the time of its first arrival, and it was here that J.F. Champollion worked on his fundamental contribution to the nascent science of Egyptology, which appeared as early as 1824 (two years after the decipherment of hieroglyphs had been published). Champollion himself acknowledges his debt to this collection, declaring: "For me, the gateway to Memphis and Thebes was Turin". In the second half of the Nineteenth century the Museum, though enriched with other gifts and acquisitions, showed serious gaps as a collection of record in comparison with others which were being brought together at that time: it relied on material belonging almost exclusively to the New Kingdom and the Late Period and coming for the most part from the area of Thebes. Ernesto Schiaparelli, appointed Director in 1894, set about making good these deficiencies, first by means of acquisitions (1898) and later, between 1903 and 1920, with excavations at sites he personally had picked out. He managed to procure for the Museum more than 17,000 pieces, partly from famous sites connected with the royal court, such as Giza, Heliopolis and Thebes (Valley of the Queens and Deir el Medina), and partly from provincial areas (Gebelein, Assiut, Qau el Kebir, Ashmunein). Among his major finds,

now on display in the Museum, we should mention the intact XVIII Dynasty tomb of the architect Kha and his wife Merit from Deir el Medina, with its extraordinary complement of furniture, textiles, pottery, cibaria, and everyday objects; the Gebelein complexes, with the tombs of an unknown personage (V Dynasty), of Iti (VI Dynasty), and of Ini (X Dynasty) and their furnishings, the paintings from the tomb of another Iti (XI Dynasty), with scenes of ritual and of everyday life (of great interest for their remarkable figurative treatment, a most lively departure from the formal compositions of the classic designs), of Assiut and Qau el Kebir. This latter site yielded the remains, still impressive although in fragments, of monumental tombs belonging to local princes contemporary with the last rulers of the XII Dynasty. The excavations at Gebelein were carried on by Giulio Farina between 1930 and 1937, bringing to Turin a prehistoric painting on canvas with pictures of ships and funeral dances.

The latest addition to the Museum, a gift from Egypt to Italy in token of gratitude for the active part she played in the UNESCO campaign to save the Nubian monuments, is the cliff temple of Ellesija, carved on the orders of Thutmose III, and set up anew in the Museum. Major restructuring works were carried out between 1985 and 1991 thanks to the support of the San Paolo Foundation. Additional large halls (Prehistory and Old Kingdom) were completed in 2000.

Gebelein, tomb of Iti, photograph taken in 1930 during its discovery by Giulio Farina

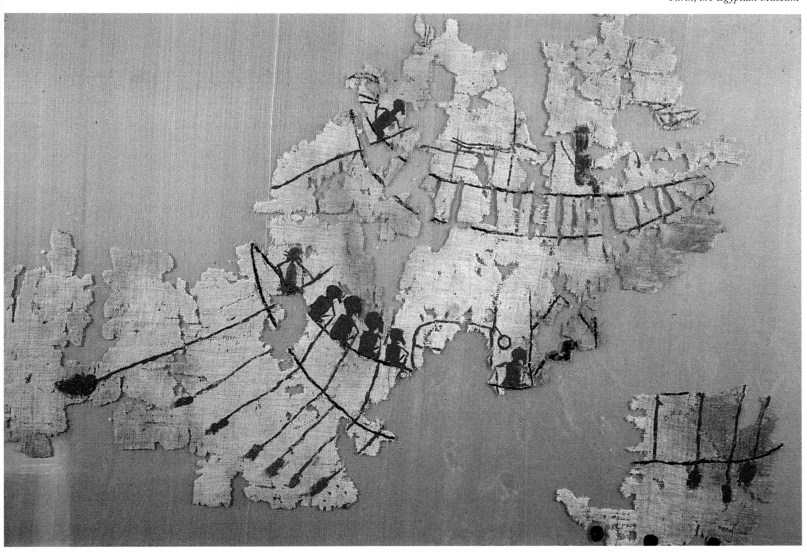

The painted cloth of Gebelein
Era of Naqada II (3500 BC)

This painted cloth (200 × 100 cm, dimensions of the two framed assemblages) comes from a tomb of the predynastic period discovered in 1930 at Gebelein (Upper Egypt) by Giulio Farina, then Director of the Egyptian Museum. The excavation data are somewhat sparse and do not afford a ready explanation of its function. The finder says he found it "folded at the side of a mummy". This was in fact a corpse in the customary huddled posture of the prehistoric period and the cloth, at the time it was discovered, was no more than a heap of fragments which damp and sand had made unrecognisable.
It took long years of patient work on the part of Erminia Caudana, an outstanding

restorer of papyri and codices on vellum, for the fragments to be put back together at last. The result is now on display in two frames and what we have is a fine-woven cloth, made at the loom, with an ornamental fringe on one side. The largest and best-preserved fragment has a picture of boats, with rowers arranged in a way we know already from vase decorations of the same period.
The boats, drawn in black, each carry a number of rowers and a helmsman who seems to be seated on the poop. The human figures are in red, with the "bird's-head" shape characteristic of other representations from the same time. In the middle of the boats there are two deck huts, and on the largest boat, under a pavilion drawn in black, a person of importance is seated on the poop: probably the deceased being

conveyed with his retinue to his final resting-place.
On a set of other fragments we see a group of bare-breasted women in long black skirts in the attitudes of the funeral dance, arms lifted above their heads. Similar postures can be seen in our Museum, in another painting, also from Gebelein, from more than a thousand years later.
There is another scene, hard to interpret, which probably represents a hippopotamus-hunt and a snare for animals (or a pool of water).
The importance of hunting in the economy of prehistoric populations in Egypt is further confirmed by this cloth. In between the various scenes we can make out plant features. The cloth is unique in all of ancient Egyptian painting. The only parallel, apart from the plant motifs, is one of which only the merest traces remain, on a

tomb from Hierakompolis, now preserved in the Cairo Museum.

Between 1930 and 1937 the new director Giulio Farina continued the excavations at Gebelein, bringing a prehistoric canvas with paintings of boats and funeral dances, a document of extraordinary importance, to Turin.

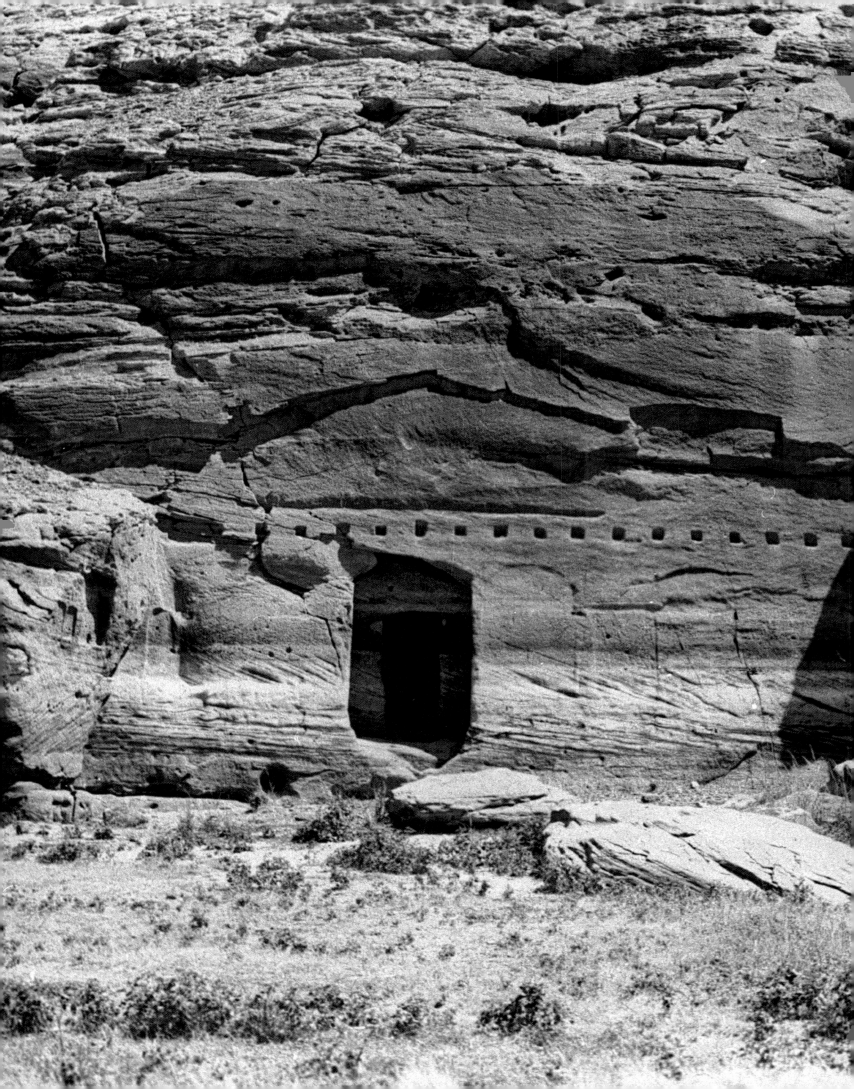

Temple of Ellesija
XVIII Dynasty,
era of Thutmose III

This small temple, detached from its hillside in Nubia and reconstructed in the Museum during the years 1965-70, is the most recent arrival here. It is in fact a gift of the Egyptian government to Italy as a token of gratitude for the work done by the Italians for the monuments threatened by the construction (between 1960 and 1970) of the new dam at Aswan, the Sadd el-Aali.

It was dedicated by Thutmose III to the divinities of Egypt and of Nubia, and is the first of the rock temples of the region, later joined by the monumental ones of Rameses III at Abu Simbel. It was carved out of the very substance of the cliff which bounds the eastern side of the course of the Nile, and consists of a chapel in reversed T shape, its walls adorned with reliefs, and with an altar at the far end, behind which sat, at the side of the Pharaoh himself, two divinities: Horus of Miam and Satet, subsequently changed to Amun-Ra and Horus of Miam.

Three monumental steles were carved on the smoothed cliff-face: two, to the left and the right of the entrance, commissioned by Thutmose III himself and one, further to the right, of Rameses II, who had restored the chapel after the erasures of the Amarnian [Akhnaton] period.

Other, lesser inscriptions tell of dedications by various commissioning parties and visitors. A portico of wood was placed in front of the door, possibly at a later period; at least that would seem to be the implication of the square holes high up on the facade.

Inside was a succession of various scenes in which the Pharaoh Thutmose III pays homage to the divinities of Egypt (on the north wall) and those of Nubia (on the south wall). Especially noteworthy is the homage

paid to a Pharaoh of the XII Dynasty, Sesostris III, one of the most energetic colonisers of Nubia. Below, two frames record the dedications of Setau, the viceroy of Nubia who had restored the temple. The cutting away of the temple, its transport to Turin, and its reconstruction under the direction of Silvio Curto, are recorded as a work worthy of the epic international campaign for the salvage of the Nubian monuments, launched in 1958 by UNESCO, at the urging, first and foremost, of Christiane Desroches Noblecourt.

The blocks, detached from the cliff face by excavating around a tunnel, were first set down onto a raft (the work had to be done at the last minute, as the waters of the Nile were already inexorably rising); then by lighter as far as Alexandria; from there to Genoa by ship, and finally to Turin by lorry. Here they were brought together and reinstalled using the designs of the architect Cesare Volpiano. The soffit and pavement, already too far damaged when cutting had started, were reconstructed, and around the vault, made of light material and donated by Pininfarina, a narrow crack was left to allow the reliefs to be lit by radiant light and, at the same time, to mark the boundary between what was original and what was reconstruction. In the same way, at the bottom a narrow squared channel shows the boundary between the original section and the reconstructed base. The restoration, which has removed all the (faint) traces of cutting, has however left intact the original cracks in the rock, so as to reproduce as fully as possible the way the temple looked in Nubia, while still letting it be seen what vicissitudes it passed through to arrive at its present resting-place.

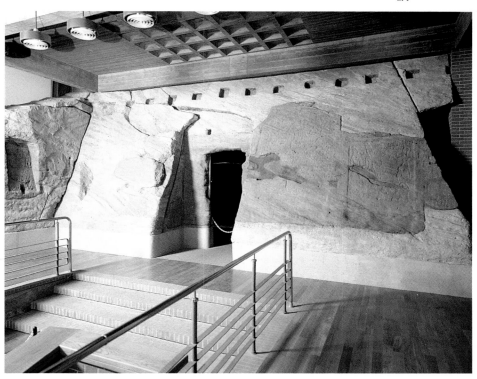

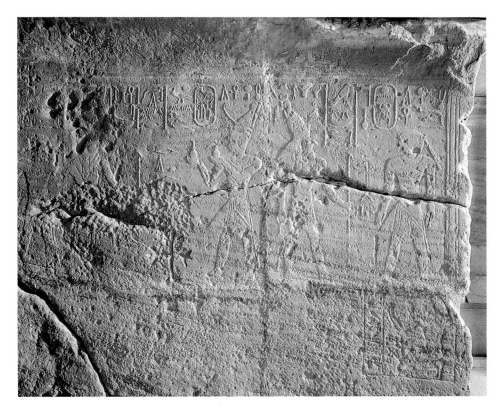

*The Museum acquired a very
important heritage with the arrival,
in the years from 1965 to 1970, of an entire
temple donated by the Egyptian government
and now entirely reconstructed in the Museum.
It is the rock temple of Ellesija,
erected on the order of Thutmose III.*

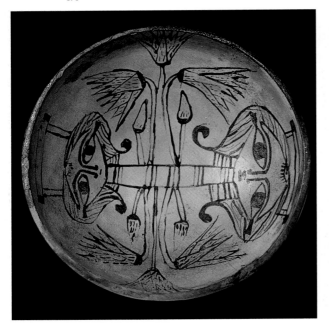

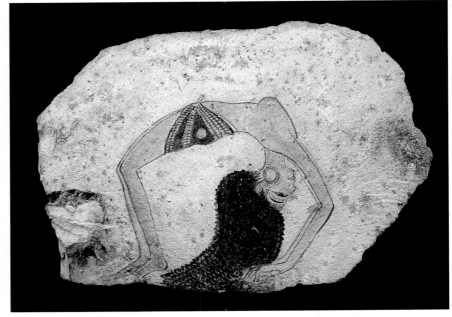

Cup in faience with images of the goddess Hathor

New Kingdom

The cup (h. 5 cm; diam 16.5 cm), on which are shown two Hathor heads surrounded by lotus flowers and buds, is one of a set of receptacles (cups, caskets, chalices, and small ointment vases) whose particular refinement and elegance shows that they were for use not only at table and toilette, but also on special ritual occasions, above all in connection with the furnishing of funerary chambers.

The decorations, generally in a slip of black or dark blue subsequently fired, are generally of lotus flowers, fishes, or waterfowl. In some cases humans are represented, girls especially, and these too are shown against a river or wetland landscape . There are also often images of the goddess Hathor. All these images refer to a complex symbology in which in the lotus flower (and the oldest cups have the shape of an open lotus flower) is a promise of life and of rebirth. The youthful Sun is in fact born from a lotus blossoming in the primordial Ocean, and the images of the goddess Hathor, goddess of motherhood and of the West, or setting sun (the site of the

necropolis), are also connected with the concept of rebirth. The female figures themselves probably belong to this complex world of regeneration which also involves the so-called "concubines".

The example shown here is one of the most beautiful we have, in its mastery of design in the mirror arrangement of the two heads of Hathor and the lotus flowers inside the cup.

The outside shows an open lotus flower.

Ostrakon with figure of ballerina

New Kingdom, XIX Dynasty

The name *ostraka* (singular *ostrakon*) (painted limestone, h. 10.5 cm; w. 16.8 cm) denotes the potsherds or small chunks of limestone often used in Egypt instead of the more expensive papyrus for minor note-taking, often for administrative or accounting purposes.

As well as these, there are others with writing exercises that were clearly used in schools. School use – of a special kind – probably also accounts for a whole series of figurative *ostraka* which often show evidence of being the exercises of drawing pupils: sketches or drafts, on which we can see the later corrections in the master's hand. Others again are copies of, or studies for, reliefs and paintings done by the artists themselves. Most of them are drawn only in black or red ink, though some are painted as well; and almost all belong to the New Kingdom.

The Museum of Turin has a remarkable set of these. The subjects are extremely varied: representations of human figures, of divinities, of animals; harem scenes; scenes from animal fables. In some cases we recognise the hand of a great artist, as in the

ostrakon shown here, which is, quite rightly, one of the most famous even of this rich collection. It shows a young lady with a fine head of hair and a very small black petticoat, decorated with embroidery or appliqué, bending in the shape of some dance or acrobatic exercise. The pose is well known from reliefs and statuettes but there is no other representation which achieves the grace and extraordinary freshness of the Turin image, the result of the self-confident fluidity of the outline, and the contrast between the weight of the jet-black hair and the lightness of the pink body. The profile of the face shows not the slightest trace of effort in the barely-hinted mouth and in the elegant elongation of the eye, while the long, long fingers end in the merest sketch of an arabesque.

In the presence of such refinement and mastery of composition, it really seems absurd to complain, as some have, of a lapse of realism in the earring that has refused to obey the laws of gravity!

Portrait of a young person

The portrait (encaustic on panel, h. 41.9 cm, w. 13.3 cm) is of a young person with the face turned slightly to the right, with rounded cheeks, long dark eyebrows and short black hair. He wears a violet tunic, and a necklace of gold, while a round medallion is kept in place on the chest by a strip of what had been gilded material. From the earlobes hang two earrings made of a gilded ball and a pearl. The hairstyle and facial expression would lead one to suppose that this was the portrait of a young man, but the jewels, above all the earrings, are generally female attributes.

The work dates from around 130/140 AD and the provenance is perhaps Antinoe, the city Hadrian founded for his favourite, who was drowned there in the Nile.

The work is part of a clearly-defined group of portraits on board (and also, but more rarely, on canvas), dated between the First and the Fourth century AD, known as "the Fayyum portraits", from the place where the first were found at the end of the Nineteenth century. They were painted on small wooden panels, for the most part with the encaustic technique, i.e. mixing the pigments with beeswax and applying hot. In some cases a tempera technique is used as well, or instead. The panels, generally rectangular and measuring approximately 40 × 20 cm, would be set up over the face of the deceased after mummification, and remained visible through a kind of window cut in the criss-cross of the bandages. Stylistically similar in spite of the diversity of medium were the whole-figure portraits painted on the so-called "shrouds". The function of these portraits, in terms of the funerary ritual, was the one that in pharaonic times had been performed by the mask, either the one that completed the mummy-shaped sarcophagus, or the

one placed in contact with the face of the deceased, which stood for the transformation of the deceased into Osiris. There are also certain indications which warrant the view that these portraits served a double purpose: that they were commissioned during the life of an important person to be kept in their house and then, when death came, were inserted into the mummy. Also, we know that in some cases the mummies themselves were kept in the house for a shorter or longer period, in a kind of lararium in which the images of ancestors were replaced by the ancestors themselves in mummy form.

What we have here, then, is a wealthy Greco-Roman and Egyptian élite with a mingling of rites, in which the Roman cult of ancestors' images, the *imagines maiorum*, is combined with Egyptian beliefs connected with a survival in the next world, through the careful preservation of the body. What distinguishes this present work, though, from the pharaonic masks, and also from those of the Ptolemaic and first Roman periods, is their particular figurative language, which favours a kind of portrait no longer idealised (earlier, the identification of the deceased had been based on other elements, such as the name or attributes), but drawn from study of real physiognomic features (and in particular the clothes, hairstyles, and jewellery) with an exceptionally lively style, helped by vibrant brushwork, in which the material thickness of the encaustic technique creates extraordinary light effects. What we have is in fact an instance of contemporary Roman portrait-painting, which we know from our written sources was widespread but which has been totally lost, only a few examples remaining in the painted murals. In Egypt, by contrast, thanks to the favourable climate, many examples have survived.

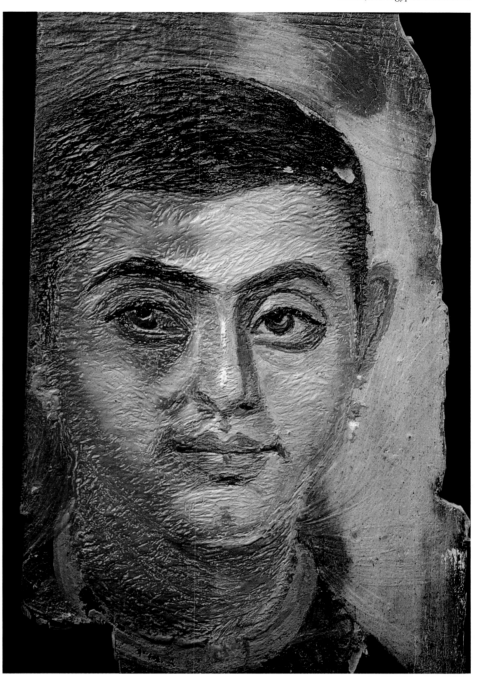

The Museum still boasts a large number of decorated objects, as well as paintings such as the "Fayyum portraits" which enable us to observe figures and moments of everyday life. Between 1985 and 1991 extensive reconstruction works were completed, thanks to the contribution of the San Paolo Foundation. Two new large halls were completed in 2000 and works are in progress to make it possible to arrange the finds according to modern museology criteria.

Naples, the National Archaeological Museum

Stefano De Caro

"It is a fitting homage offered by the Nation and in a century enlightened by the works of fine art we have inherited, the brilliance of which has given a new lustre to Italy and to modern Europe." Thus the erudite Abbot of Saint-Non described, in his celebrated *Voyage picturesque ou description des Royaumes de Naples et de Sicilie* (a description of the kingdoms of Naples and Sicily), the King of Naples' decision in 1778 to found a large, new museum to house his various art collections together in one place.

The history of public collections of art and especially of archaeological artifacts in Naples began, however, about a half century earlier in 1734 when the Spanish crown prince, the Infante Charles Bourbon, ascended to the throne of the Kingdom of Naples. The young monarch came from a family which owned some of the most famous collections of art in Europe—those the Farnese and Medici for example; for the Bourbons the collecting of art and antiquities was not only a centuries old tradition but also a symbol of their prestige and power. It is not at all surprising, then, that the new king very quickly included the arts in his plans for his kingdom and the modernization of the city of Naples. Charles brought his large collections of books, art and antiquities from Parma, his ancestral seat, as well as from Rome, and he immediately began a project to build, in Naples, a "Museo Farnesiano" or Farnese Museum. He needed an appropriate building, and in 1738 he commissioned the architect Giovanni Antonio Medrano to design and construct the Royal Villa at Capodimonte.

The year 1738 also marked the second event which

is crucial to the history of the Royal Museum. The King ordered that an archaeological dig be undertaken at Portici where, in 1711, during the Austrian occupation, Prince Elboeuf had found several marble statues.

The excavations of this city at the foot of Mt. Vesuvius began with the fortunate discovery of an extraordinary series of statues and inscriptions from the stage of the theatre in Herculaneum; ten years later the exploration of Pompeii began and then, a year later, that of Stabiae. The king's collections were flooded with extraordinary new objects—a prodigious quantity and variety of ancient artifacts that document every aspect of life in the cities that were buried suddenly and entirely by the eruption of Mt. Vesuvius in 79 AD. There were statues, inscriptions, mosaics, objects for everyday use, arms, glass and, for the first time in such large numbers, paintings. The latter emerged from the earth intact, their colours brilliant and as lovely "as something from the hand of the Graces." In order to accommodate this flood of objects the royal villa in Portici was converted into the Herculaneum Museum (Museo Herculanense) in 1750. The fame of the museum as the essential source for things classical, as well as good taste, spread quickly throughout Europe through travel diaries and studies by antiquarians like J.J. Winckelmann. It was yet another reason that Naples became an obligatory stop on the Grand Tour.

The King left Naples in 1759 for Spain where he was crowned Charles III, and work on the Farnese Museum at Capodimonte slowed down with his departure.

Charles Bourbon

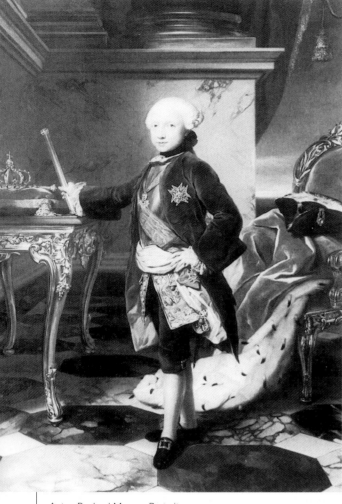

Anton Raphael Mengs, *Portrait of Ferdinand IV Bourbon*, Naples, National Gallery of Capodimonte

On 20 January 1731 Antonio Farnese, Duke of Parma and Piacenza, the last descendant in the male line of Pope Paul III, died heirless; and the government of the Duchy devolved upon his fifteen-year-old nephew Charles Bourbon, son of his sister Elisabeth and Philip V of Spain, who in 1732 entered on his inheritance not only of the territories but also of the large collections of art and antiquities, coins, books, and furnishings collected over the course of some two hundred years by the Farnese family. On also acquiring, in 1734, the Kingdom of the Two Sicilies, Charles III had this whole inheritance of artifacts transferred from his palaces of Parma, Piacenza and Colorno, via

the port of Genoa, all the way to Naples, there to furnish the Royal Palace, not least in contemplation of his marriage with Maria Amelia of Saxony. The collection was subsequently moved again, to the palace of Capodimonte, continuing a tradition that the Farnese themselves had begun with the Ducal Gallery at Parma, following the example of the Medici and the Uffizi in Florence: it was an initiative of the Enlightenment to make the celebrated art collections in royal ownership available for public use, and it was visited by Johann Joachim Winckelmann on a number of occasions in 1758. Charles' son, Ferdinand IV, moved beyond and eventually abandoned the original project for a "Farnesian Museum" at

Capodimonte, in favour of a new museum institution with extremely complicated and involved connections with civil and cultural life; in 1785 he adopted a project that had been drawn up by the architect Ferdinando Fuga as early as 1777 for re-arranging the "Herculaneum Museum" in the Palace of the Royal Library. To this new site were transferred, between 1787 and 1800, all the statues from antiquity that had been kept in the Palazzo Farnese in Rome: and this was the historic nucleus of the present-day National Archaeological Museum.

Francesco Liani, *Portrait of Charles II Bourbon*, Naples, National Gallery of Capodimonte

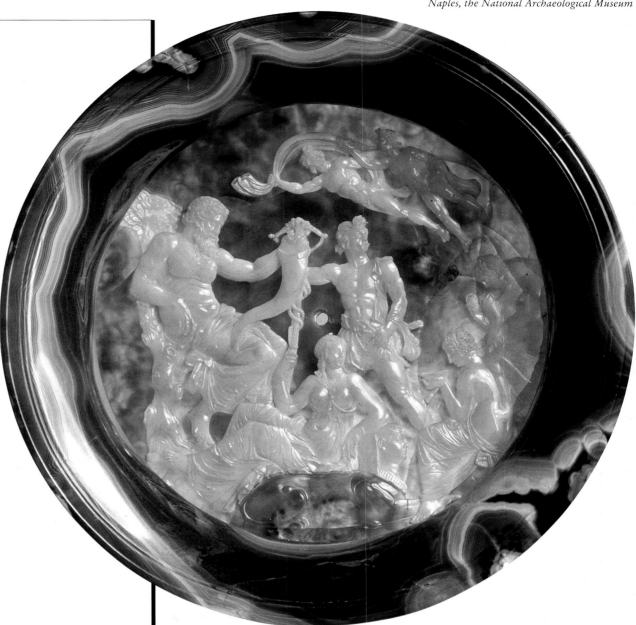

The story of the public artistic collections of Naples, and the archaeological ones in particular, commenced in 1734, when the Infant of Spain, Charles Bourbon, became king of Naples. The young king belonged to a dynasty which had entered into possession of very famous art collections, for example, the Farnesina and the Medicea ones, and to which collecting art and antiquities had been a symbol of prestige and power for centuries.

The Farnese Cup

A cameo cut from a single, large piece of sardonyx (20 cm. in diameter), the Farnese Cup is without a doubt the most famous surviving antique gem. On its exterior there is an exquisite relief image of the Medusa who shows her terrible, apotropaic face to the viewer when the cup is raised for drinking. The interior shows eight figures who make up an allegorical scene which is certainly set in Egypt as is indicated by Isis astride a sphinx. The most credible interpretation of the scene, first suggested by Ennio Quirino Visconti and then by Furtwängler, is that it is a celebration of the fertility of the Nile. The river is

represented as the principal figure, robed and holding a cornucopia; he is an old, bearded man seated on a throne on the left welcoming Triptolemus, who, tutored by Demeter, was the first human to learn the arts of agriculture. The Horai and the Etesii winds flying above complete the scene. The dating of the cup is no less varied or problematic than the identification of the historical figures represented on it, the Lagidi Kings who ruled in Alexandria and who behind the allegory of mythological figures. It is certain, however, that this object, which in the Fifteenth century was valued at the enormous sum of 10,000 florins, was made for the court of Ptolomey III

between the Second and First centuries BC. It must then have passed into the Roman imperial treasury. The cup is mentioned in medieval documents only sporadically but then reappears in Rome where Lorenzo de' Medici bought it in 1471 (he called it "our scudella" in his autobiography). A Persian drawing of the Fifteenth century that faithfully reproduces the cup suggests that it had made its way back to the East, perhaps to Herat or Samarkand, and recently rediscovered documents indicate that in the Thirteenth century it was most likely in Italy where it was purchased by Frederick II of Swabia.

The Farnese Atlas

The myth of Atlas tells us that the giant participated with his brothers in their rebellion against the Olympian gods; as a punishment, Zeus gave him the task of carrying the heavens on his shoulders. This statue (1.93 m. high) is famous because it is one of the most complete antique representations of the zodiac to have survived. The colour on the statue suggests a date in the late First or early Second centuries AD, and it was most likely originally part of the decoration of the library in Trajan's Forum in Rome. There are a number of copies of this Atlas figure, and they allow us to identify the original as a famous Hellenistic statue that must certainly have been created in some centre of Greek learning such as the Museum in Alexandria where astronomy was at the height of its popularity.

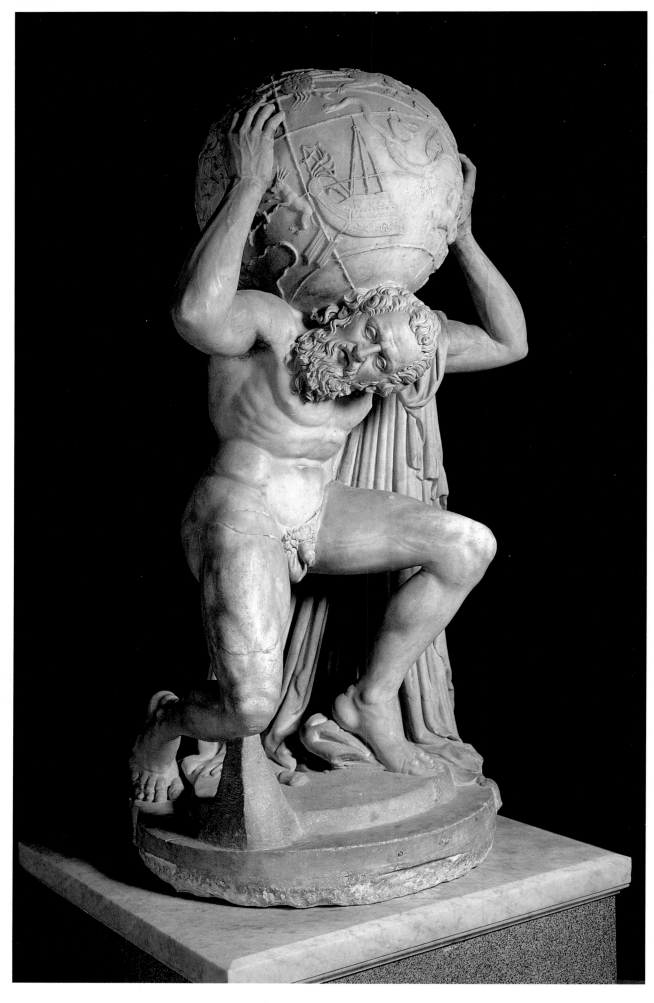

The Sundial Salon.

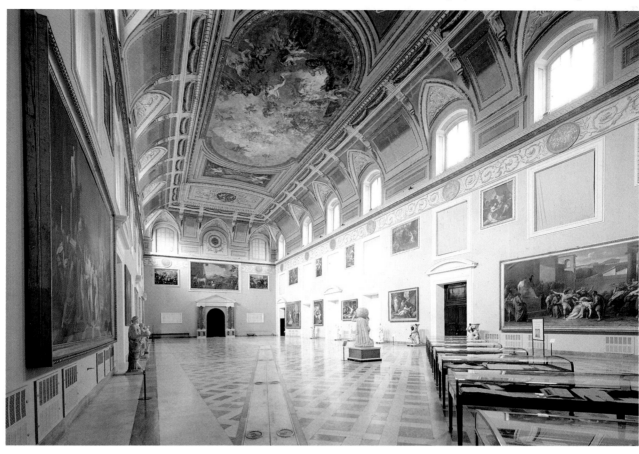

The project of the new museum

In 1791 it was also decided to add, to the facilities planned for the Studies Building, an astronomic observatory, which was to be created in the Great Hall; however, only a small sundial, which still gives the hall its name, was actually completed.

At the same time the Museum at Portici had reached the limit of what it could hold of the archaeological materials excavated from the cities of Mt. Vesuvius, and it also seemed too exposed to the danger of a volcanic eruption. Thus the project to combine the royal art collections—both from Portici and Capodimonte—in a single, new museum in Naples was born. The choice for a site fell on the old Palazzo degli Studi (the seat of the university) at the foot of the Collina di Santa Teresa. Occupying the site of a riding academy established in 1586, the palace had been designed for the Spanish viceroy, Don Pedro Fernando de Castro, Duke of Lemos, by Giulio Cesare Fontana to house the Neapolitan Athenaeum. The university was then housed there, with only brief interruptions, for more than a century and a half (G.B. Vico taught rhetoric there from 1697-1701). The idea to use the site of the Palazzo degli Studi for the museum to house the library and the collection of antiquities from Herculaneum was already afoot when the university was transferred to the former Jesuit complex at Salvatore in 1777 and the initial decision was made to demolish the crumbling, old building. A year later the famous plate showing the "moving of the antiquities of Herculaneum from the Museum at Portici to the Palazzo

degli Studi in Naples" appeared in Saint-Non's *Voyage picturesque*; it portrayed the as yet unaccomplished event as if it were an ancient triumphal parade, indicating the idea itself was well-received. The plans for the new Museum was extremely ambitious. Charles Bourbon had hesitated in bringing to Naples the extraordinarily famous collection of sculpture which decorated the Farnese Palace and other residences in Rome and had been exhibited by popes and princes; Ferdinand IV, on the other hand, showed no such trepidation, the protests of papal officials notwithstanding. He ordered in 1787 that it all be brought to Naples, and he gave the job of checking, restoring and transporting the numerous statues in the Farnese Palace to Naples to Philipp Hackert and Domenico Venuti. This transfer took years, and the statues, once they arrived in Naples, waited for a long time before they were finally installed in the museum. The Farnese Bull, for example, was placed as a fountain ornament in the garden of the Royal Villa at Chiaia in 1791 and was only brought to the museum in 1826. A decision was made in 1791 to expand the original function of the Palazzo degli Studi to include an astronomical observatory in the Great Hall. Of this project only a meridian line was built, but the room that was to house it is still named after the observatory.

The Farnese Collection

This collection, amongst the most famous group of antiquities in Rome, was initiated by Alessandro Farnese who, in 1534, became Pope Paul III. At first he followed the traditional papal policy of enriching the public museums in Rome, but after 1541, when work on the Palazzo Farnese began again and on a grandiose scale, he instituted a new and wholly private approach towards collecting ancient works of art. After having the statues of the Dacian prisoners moved from the Colonna Palace at Santi Apostoli to his own residence, Paul issued an edict which gave his family the right to operate excavations to recover stone and marble for the construction and decoration of the Palazzo Farnese as well as exclusive rights to any sculptures found there; Ippolito d'Este had done the same thing at Hadrian's Villa in Tivoli and so had the Della Valle family on one part of the Forum. Fortune smiled on the Farnese excavations; many extraordinary sculptures were uncovered at the site on the Aventine Hill (opened in 1545-1546) and at the Baths of Caracalla; these works formed the nucleus of the collection. Thus the Farnese *Bull*, excavated in 1545, and a year later the *Hercules*, a signed work by Glykon, once again came to light. They were accompanied by numerous other statues and were arranged theatrically around the palace, after 1546, by the great Michelangelo himself. Paul III's nephew, the "Grande Cardinale" Alessandro Farnese and one of the greatest patrons of his time, greatly enlarged the family's collection; his additions, which mark the zenith of the collection, included works commissioned from contemporary artists, such as Titian's *Danae*, and important bequests. In 1587, for example, the Farnese inherited the collection of Margarita of Austria who was the widow first of Alessandro de' Medici and then Ottavio Farnese. It included many extraordinarily famous pieces, many of which had belonged to Lorenzo de' Medici, including the Farnese *Cup*. Alessandro's acquisitions were also significant. He made them with the expert help, from 1566 to 1589, of Fulvio Orsini, the best antiquarian of his time. Odoardo Farnese inherited Orsini's own collection of gems, coins and portrait busts in 1600.

This enormous quantity of ancient and modern work of art—marble statues, paintings, gems, books and drawings—were for the most part located in the Palazzo Farnese, in the arcades of the courtyard, the Gran Salone, the Sala degli Imperatori, the Sala dei Filisofi and the Carracci gallery. More sculpture had been installed at other residences, at the Villa Farnesina and in the famous gardens—the Horti Farnesiani—which Vignola designed on the Palatine Hill. The decline of the Roman collection began at the end of the Seventeenth century when the family shifted its seat to Parma. Duke Ranuccio II took more than 100 paintings from the Palazzo Farnese, and eleven years later some twenty-seven ancient sculptures followed him to Parma. Duke Francesco brought the extraordinary colossal figure, carved in basalt and discovered in the excavations on the Palatine Hill, to Parma in 1720. When Elisabetta Farnese died in 1731, the family became extinct and its patrimony passed to the Bourbons of Spain. Three years later the Bourbon's own power centre moved to Naples when young Prince Charles became the ruler of that kingdom. Very quickly he transferred the Parma collections to Naples, and his son Ferdinando asked the pope's permission in 1770 to move the Roman collections there as well. Several years of diplomatic negotiations followed and then, in 1787, the process of shifting the collection began despite the injunction in Alessandro Farnese's will that the collection always stay in Rome and over the objections of P.E. Visconti, the antiquarian in charge of conserving papal antiquities. This was a traumatic blow to Rome and all the cultured world at the time, but it also makes sense within the logic of dynastic art collections. Furthermore, hindsight and the huge number of Roman art collections sold to foreigners in the Nineteenth century, puts this transfer in a more positive light. It permitted the collection to be preserved in Naples, and allows us the possibility of appreciating this extraordinary example of Italian Renaissance culture.

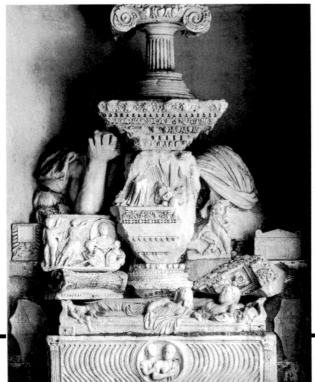

Composition of antique fragments, referred to as the *Farnese Trophy*. Palazzo Farnese, Rome

Moving the great collections of books, works of art and antiquities from the ancestral Duchy of Parma and partly from Rome, Charles Bourbon immediately began to carry out his plans to create a "Farnesian Museum" in Naples; it was decided to build a specific new building for this purpose, the Royal Villa of Capodimonte, and architect Giovanni Antonio Medrano was entrusted with its construction in 1738.

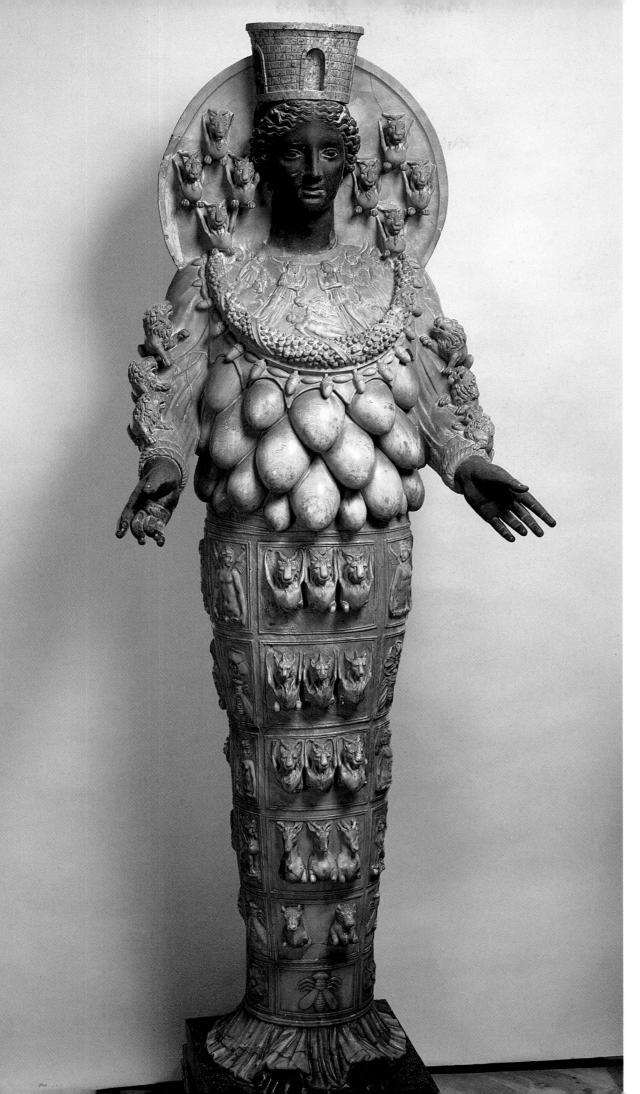

Artemis of Epheseus

This is perhaps the most famous surviving copy (2.03 m. high) of the cult statue of Artemis from Epheseus which is known through innumerable replicas in every format and material and especially on coins struck at the mint in that city. In his hymn to Diana, Callimachus tells us that it was the Amazons who founded the cult, and we also know that it was of extraordinary importance throughout Asia Minor in the period of the ancient kings of Lydia. The famous sanctuary still enjoyed real prosperity in the period of the Roman Empire. The form of the *xoanon*, of which this statue is a sumptuous Roman copy, most certainly dates to the Archaic period of Greek sculpture. The general figural type clearly recalls the geometric quality of Archaic female figures from the Ionic coast, while the symbolism of the decoration can be ascribed to the Hellenistic period when the ancient cult statue was restored. The goddess is crowned with a *kalanthos*, which sometimes comes in the form of a temple, and the drapery pulled her head, once decorated with along its edges with griffins, creates the sense of a circular halo. Artemis's robe is covered with ornamentation; she wears a necklace on her bust and below it there are several rows of breasts, evidently a symbol of fertility (some have suggested here the scrota of sacrificial bulls). The lower part of her robe, which follows the contours of her body, is decorated with pairs of animals and harpies, flowers, sphinxes and nymphs.

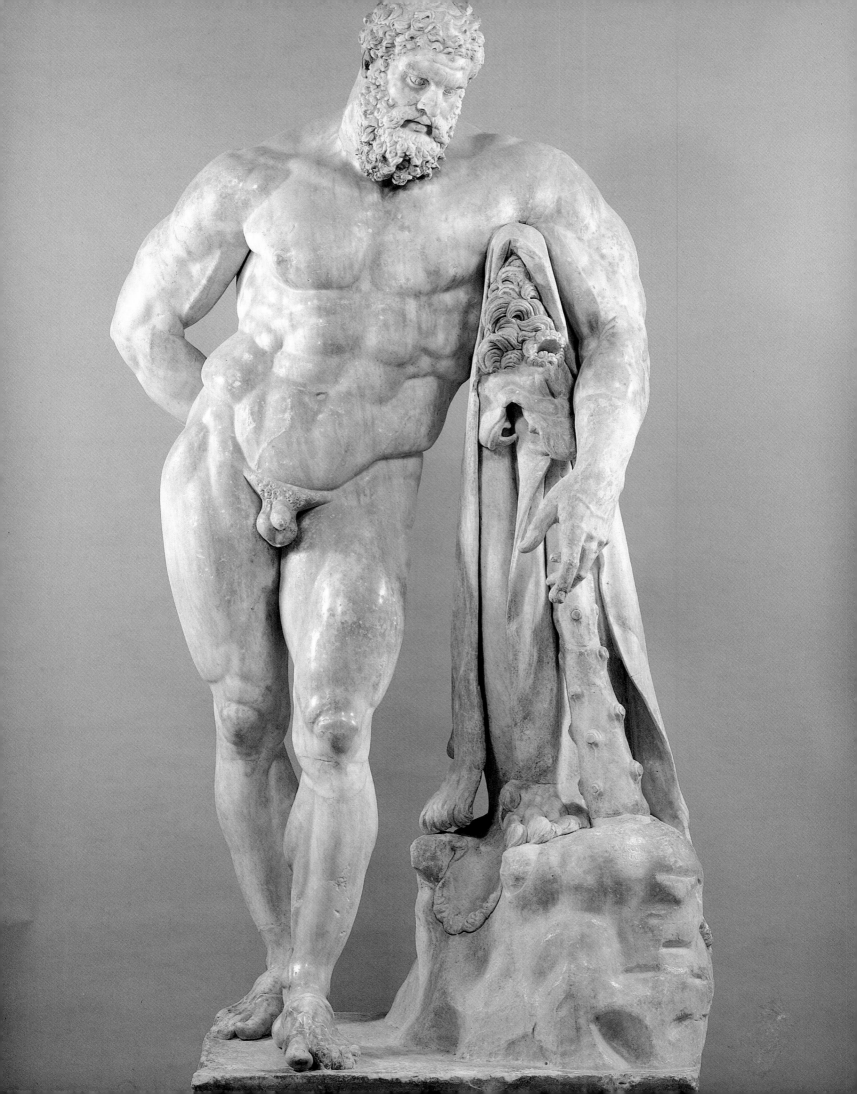

The Farnese Hercules

This was one of the most famous ancient sculptures for the Renaissance and Baroque artists who admired it for more than two centuries in the courtyard of the Farnese Palace in Rome, where it stood with a similar figure, the so-called *Latin Hercules* (which was moved, in 1788, to the royal palace in Caserta). The statue is the work of Glykon, a Severan period sculptor (his signature, "Glykon Athenaios epoien"—Glykon the Athenian made this). It is a copy (3.17 m. high), although with colours typical of its own time and on a giant scale appropriate for the Baths of Caracalla, of a famous bronze sculpture by Lysippos, one of the great masters of the Fourth century BC. This meditative and almost melancholy image of the hero, represented after he finished his last labour, having gathered three of the golden apples of the Hesperides (seen in his right hand against his back), offers a contrast to the traditional representation of the hero in the Archaic and Classical periods which show him triumphant and proud of his strength.

This statue was discovered without its left arm (now reproduced in plaster) and its legs which were restored by Guglielmo della Porta. When the original antique legs were found some time later, Della Porta's were judged to be superior, and they were left in place until Albacini restored the figure.

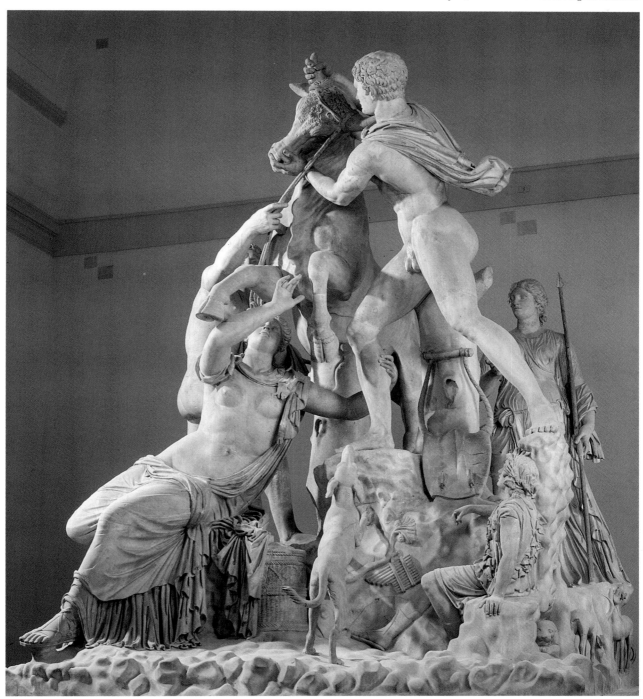

The Farnese Bull

Discovered in the gymnasium of the Baths of Caracalla where it was perhaps part of a fountain, this group represents the myth of the punishment of Dirce. Dirce tortured Antiope and was later punished by her sons, Amphion and Zethus, who tied her to the horns of a an enraged bull. Literary sources record a famous work of this subject, dating from the late Second century BC, as a masterpiece of the sculptors Apollonius and Tauriscus, both from Rhodes. It was taken to Rome from Rhodes where it was exhibited as a work of Asinius Pollionus. This huge figure (3.70 m. high), one of the largest to survive from antiquity, is identified today either as the original late-Hellenistic work cited in the source or as a copy, of either the Julio-Claudian or Severan period. Comparisons with painted versions of this work suggest that if it is indeed a copy it closely follows the pyramidal composition of the original, although it is broken by the addition of other figures—Antiope, who watches the scene immobile, and the young shepherd who represents Mount Cithaeron where this event took place. The group was heavily restored in the Sixteenth century when Michelangelo intended to make it into a fountain at the center of the garden between the Farnese Palace and the Villa Farnesina. It remained stored in a shed until it was moved to Naples where it was placed on the Royal Promenade at Chiaia before it passed, with other works, into the Museum in 1826.

The Farnese Bull Group was installed on the Royal Promenade at Chiaia in Naples before being moved to the Museum, along with the other sculptures, in 1826.

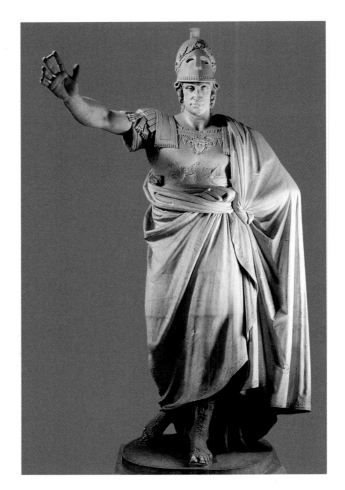

Antonio Canova, *Portrait of Ferdinand IV Bourbon as Athens*, 1821

The Royal Bourbon Museum was
inaugurated in 1816. A statue of King
Ferdinand IV, "Protector of the Arts",
was sculpted by Canova
to celebrate the event.

A problematic accomplishment

The execution of the actual plan was less fortuitous.
The architect Pompeo Schiantarelli enlarged the
plan of his predecessor, Ferdinando Fuga, but he
encountered serious engineering and financial dif-
ficulties. The latter are not surprising in a period
of political turmoil; the King, for example, fled twice
to Palermo, in 1798 and 1806, taking a number of
works of art with him each time (moreover the
French had, in 1799, packed up the Farnese Her-
cules and were about to send it to Paris).
Despite these problems, the Royal Library of Naples
opened to the public in 1801 in the Gran Salone of
the palace and work began on transferring and in-
stalling the materials from the museum at Portici
(1805-1822) as well as the antiquities from Capodi-
monte and the Palazzo Cellamare. The museum was
finally inaugurated in 1816, at the time of the Bour-
bon restoration, and was named the Royal Bour-
bon Museum; its inventory now included important
collections like that of the Borgia and Vevenzo fam-
ilies as well as the collection Carolina Murat had per-
sonally assembled in Naples. To celebrate, Ferdinand
IV, now Ferdinand I and a protector of the arts, sum-
moned Antonio Canova to Naples to sculpt a mar-
ble statue of the king as a new Athena, a work

intended to stand at the foot of the great staircase
on the palace's ground floor.
The Museum's collections continued to grow
throughout the first half of the Nineteenth centu-
ry, due in large part to the excavations at Pompeii
as well as those throughout the Terraferma (the
province of the kingdom which included all of
southern Italy except Reggio Calabria). Important
personalities of the day included the director,
Francesco Maria Avellino (1837-1849), and the
young numismatic and liberal thinker, Giuseppe
Fiorelli, whose political ideas landed him in the
Bourbon prison. It is interesting, too, that includ-
ed among the initiatives of the short-lived govern-
ment of 1848 was the creation of a "commission for
the reform of the Royal Bourbon Museum and the
archaeological excavations of the realm." Before it
was suppressed, the commission produced both im-
portant reflections on the state of the Museum and
the Bourbon archaeological service as well as pro-
posals to reform them.
Although ultimately unsuccessful, the findings of the
1848 commission were fundamental to the future of
the institution. After Garibaldi took Naples and
briefly appointed A. Dumas as director of the mu-
seum, Fiorelli was called back as its head, a position
he held from 1863 to 1875.

The Farnese Tyrannicides

In 514 BC two Athenian youths, Harmodios and Aristogeiton, murdered Hipparchus, the younger son of the tyrant Pisistratus, and paid with their lives for their deed. The Athenians paid homage to this event as a symbol of their quest for liberty, and immediately after the Tyrants were expelled from the city in 510 BC, they erected two bronze figures by the sculptor Antenor on the Agora to honour the tyrannicides. The Persians, who occupied the city in 480 BC, took the statues as booty to Susa (they were restored to the Athenians a century and a half later by the successors of Alexander the Great). In the meantime, and immediately after defeating the Persians, the Athenians commissioned a new figural group of the Tyrannicides from Kritios and Nesiostes (447 BC). Our knowledge of this second group, which had become a symbol of patriotism and the cult of Attic virtue, comes from ample evidence on coins and painted vases as well as in reliefs, images which allowed these two figures in Naples to be correctly identified for the first time.

Hadrian installed these figures, Roman copies (1.95 and 2.03 m. high) of the Second century AD, at his villa in Tivoli amongst the *opera nobilia* (the noble works) collected there. They seem to have been instantly frozen in the manner of the Classical "severe style." Their bodies, tense and powerful, are fully in motion; Harmodios, the beardless youth, attacks with his arm raised, and Aristogeiton, his arm extended, makes himself into a human shield for his friend. Aristogeiton's head is a plaster copy made from a head at the Vatican; a splendid antique copy of it, made after the original bronze, was found on the rubbish heap of a sculptor's workshop at Baia and is exhibited there at the Museo dei Campi Flegrei at Castello.

47

The Collection of Objects and Works of Art from Magna Graecia and Campania

In addition to the great Renaissance and more recent collections of antiquities (the Borgia Collection is an example of the latter and is, after the Egyptian Museum in Turin, the second largest collection of Egyptian objects in Italy), the Museum in Naples also contains a large collection of antiquities from the areas of Campania and Magna Graecia. Painted vases, coins and inscriptions (as well as funerary portraits) form a core collection of immense interest, and its installation is being organized around the Greek cities of the Bay of Naples, pre-Hellenic Campania and Magna Graecia.

Scenes from the Ilioupersis, Attic Red-Figured Hydria

The Etruscan city of Nola, where the Vivenzio brothers accumulated one of the most important collections of figured Greek pottery, has yielded an impressive number of vases of excellent quality, and indeed an Athenian amphora is still referred to as a Nolana today. This hydria is the loveliest in the Vivenzio Collection; it was used to hold the ashes of an Etruscan of noble rank from Nola. The work of the great Attic vase painter Kleophrades, it is dated to about 480 BC. It represents one of the most famous scenes from the fall of Troy: on the left Aeneas flees the city with his young son, Ascanius; the Locrian Ajax assails Cassandra who clutches at a statue of Athena; Neoptolemus kills Priam on the altar while holding the bloody body of the boy Astyanax on his lap; and finally the women of Troy are taken prisoners by the Greeks.

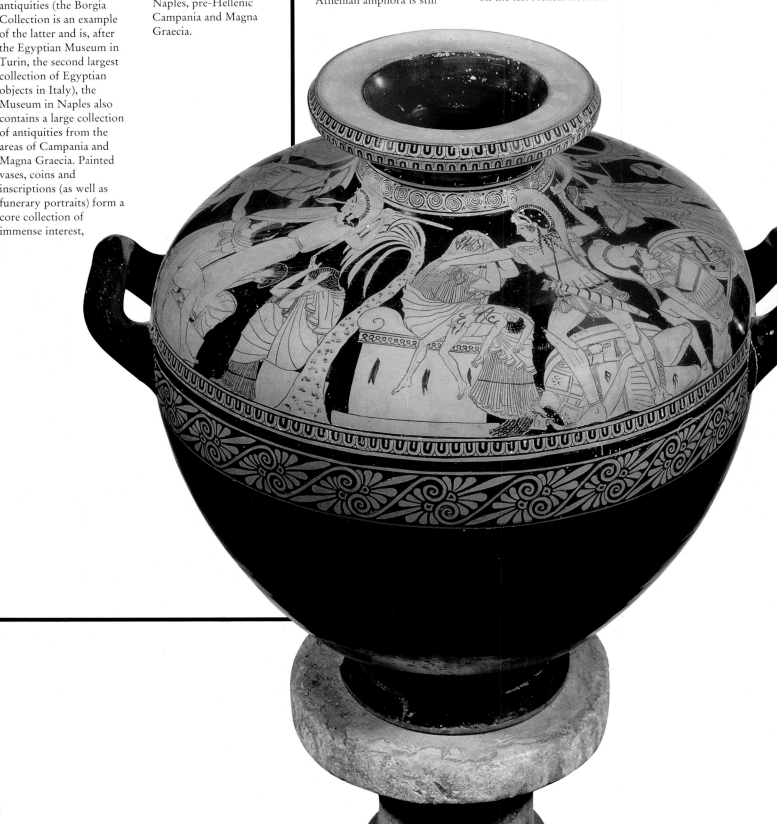

48

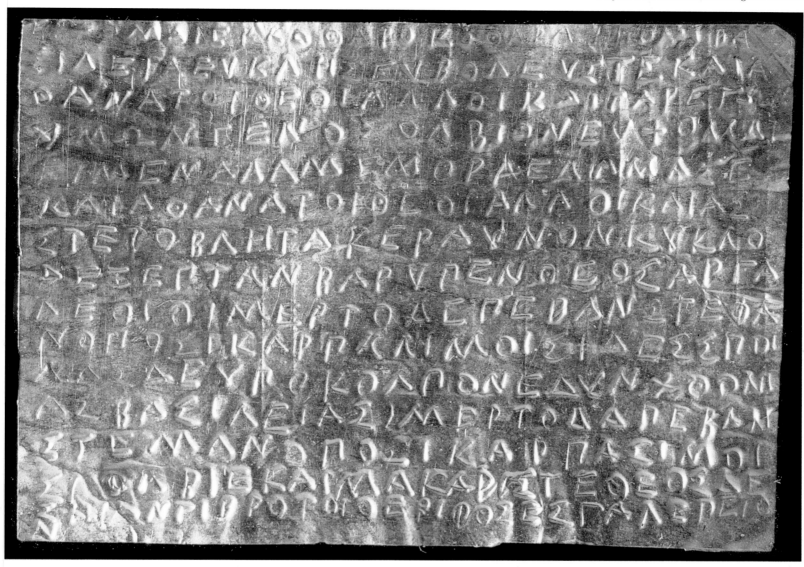

Gold Blades

The inscriptions on the gold blades of these two groups of knives, which come from two Fourth century BC tombs in the territory of Thurii, belong to a rare type discovered in Greek tombs in Magna Graecia, Crete and Thessaly. They contain the instructions by which the deceased, followers of the Orphic cult founded by Orpheus himself and then enthusiastically embraced by Pythagoras of Samos and his disciples, might end the cycle of reincarnation and achieve the promise of eternal bliss. Orphism encompassed numerous and diverse beliefs that derived from religious doctrines of the so-called "medieval Hellenic" period, i.e. in the Mycenean period and thus before the cult of Olympus had been codified. These

Thurian blades were made for a popular Orphic sect the beliefs of which were close to orthodox Pythagoran Orphism. The longest of the inscriptions in Naples contains a prayer to Persephone, Hades and Dionysus (inv. 111625): "I come from amongst the pure, Oh pure Queen of the Lower Regions, Oh Eukles and Eubuleus, and you other immortal gods; and I too declare myself to come from your blessed lineage. Yet Destiny and the dazzling, heavenly Archer subdues me. I would fly away from this cycle of pain, laden with sorrows, to ascend with swift feet to the crown I long for; I would immerse myself in the womb of the Queen of the Lower Regions; I would come down with swift feet from the desired crown. Oh

happy and most blessed, I would be divine rather than mortal. Goat Kid, I throw myself towards the milk."

By now also the installation of the numismatic collection and the one related to Magna Graecia were imminent.
The latter theme was to represent an addition to the sector on the cultures of ancient pre-Roman Campania (Greeks, Etruscans, Italic peoples) which was supposed to serve, also with finds from new excavations, as a general historic introduction to the various cultures, and a reference to the more extensive exhibitions of museums which were by then being created at Baia, at S. Maria Capua Vetere, at Nola, at Teano and at Piano di Sorrento.

The excavations at Herculaneum and Pompeii

When the youthful and lively Maria Amelia Christina, daughter of Augustus III of Saxony, a great art collector, arrived at the Neapolitan court as consort to Charles Bourbon, she found, in the salons and gardens of the palace, statues and fragments of sculptures that had come to light prior to the 1737 eruption of Vesuvius, some by chance and others due to the initiative of Prince Elboeuf around 1711. The Queen enthusiastically launched new investigations in the area of the earlier excavations; the difficulty lay in getting through the fifteen metres or so of solidified volcanic rock, by means of shafts, tunnels and narrow passages. This resulted in the discovery of three fragments of bronze horses, some male figures in togas, and some painted columns; the royal couple visited the excavations; and on 11 December 1738 an inscription was discovered showing that what had been found was the theatre of Herculaneum. These precious finds were the start of the Portici Museum, but the King and Queen wanted to open a second front in their excavations, in the area that had always been thought to be the site of Pompeii, described by ancient writers. Excavations began in April 1748 and quickly began to reveal frescoes, and the first skeletons. In 1754 the town's southern part was found, with some graves and a stretch of the town wall. We have evidence of the enormous stir that re-echoed around Europe at these excavations of Herculaneum and Pompeii (and of other archaeological sites in Campania, such as the Greek city of Paestum), in the mass of works published in the second half of the century: in 1762 the paintings of Herculaneum were reproduced in splendid folio volumes entitled *The Antiquities of Herculaneum Exhibited*, and between 1764 and 1784 eight illustrated series on the temples of Paestum saw the light of day.

In 1738 the King had ordered the commencement of excavations at Portici, in an area where marble statues had been discovered in 1711. With the fortunate discovery of the extraordinary series of statues and inscriptions from the theatre stage of Herculaneum, excavations of the Vesuvian cities began; due to these discoveries, the King of Naples saw his collection enriched by a prodigious quantity and variety of antique objects.

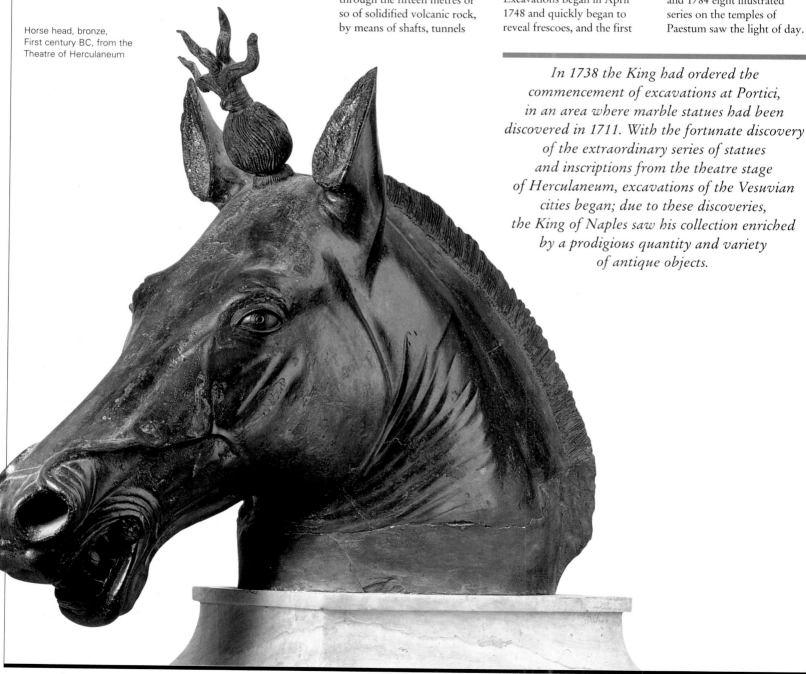

Horse head, bronze, First century BC, from the Theatre of Herculaneum

Female figure with toga, bronze, First century BC, from the Theatre of Herculaneum

Male figure with toga, bronze, First century BC, from the Theatre of Herculaneum

The eruption of Vesuvius

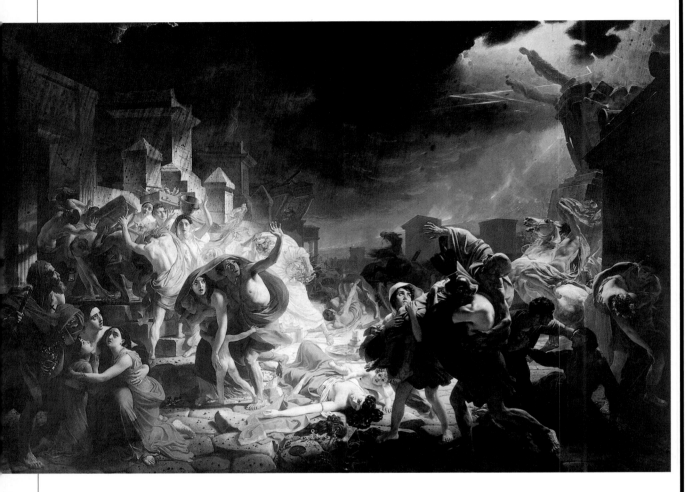

Hercules and Telephus

An extraordinary group of sculptures and wall paintings were discovered in the middle of the Eighteenth century in the building known as the Basilica at Herculaneum. The most important amongst the paintings is this representation of the mythical hero and founder of the city that bore his name discovering his young son being suckled by a deer. It has been suggested that this is a copy of a famous image of Hercules by Apelles, described by Pliny the Elder and well-known in Rome because it was exhibited in the Temple of Diana on the Aventine Hill. The scene takes place in the presence of an allegorical figure which represents Arcadia (it can be compared with a similar figure in the frieze on the Altar in Pergamon), a small satyr who alludes to the pastoral nature of the setting, and a winged figure which represents Mount Partenion where Telephus was born. The eagle of Zeus, Hercules's father and thus Telephus's grandfather, stands between father and son. The powerful figure of the hero, seen from behind, is clearly reminiscent of a Lysippan type represented by the Farnese Hercules. The painting was probably Apelles's homage to Telephus, father of the famous poet and philologist Fileta, who founded a literary centre on Coo, the island where the great painter settled. The extraordinary still-life of a basket of fruit was probably also in the original work.

The catastrophe which struck the Bay of Naples in the First century AD, covering and preserving under metres of solidified ash and lapilli the life of two towns and many villas and farmsteads scattered over the slopes of Vesuvius, has always excited artists' imaginations and people's collective memory. In the romantic period, in particular, the decline of the Roman empire and the destruction of Pompeii and Herculaneum became allegorical themes to describe the destructive power of nature and the hubris of mankind: the 1833 paintings of Karl Brjullov (St. Petersburg, Red Museum), successfully shown in 1838 both at the Brera Accademia in Milan and at the Paris Salon, was based precisely on the romantic lines of the story constructed with the guidance of the ancient authors' descriptions (Pliny the Younger, Tacitus). Towards the middle of August, 79 AD, signs of an imminent eruption of Vesuvius had been noted, and indeed the phenomena were fairly frequent; but in the early hours of 24 August there were clear indications that these were the beginnings of an exceptionally serious catastrophe. With a roar, the top of the mountain was ripped away, and with lightning strokes and explosions the slopes and coastal plain began to be covered by a hail of lapilli and ash. The towns were buried during the course of the day; but Herculaneum was covered by a wave of mud composed of ash, lava and torrential water that drowned all the inhabitants to a depth of fifteen metres and then solidified, with the result that wooden objects and structures and even, to some extent, papyri were preserved, while Pompeii was covered by ash, lapilli and masses of pumice stone, and the population was killed by sulphurous pyroclastic exhalations.

Karl Brjullov, *The last day of Pompeii*, 1833, Russian Museum, St. Petersburg

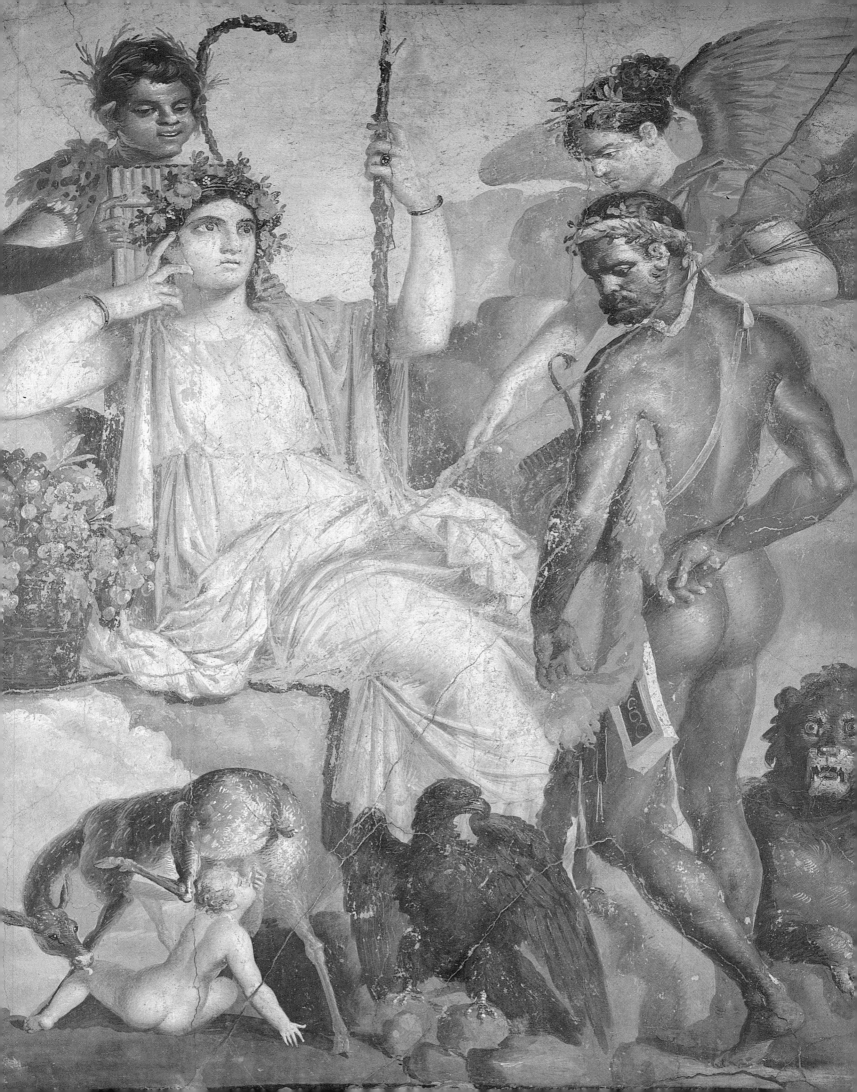

The Vesuvius Collections

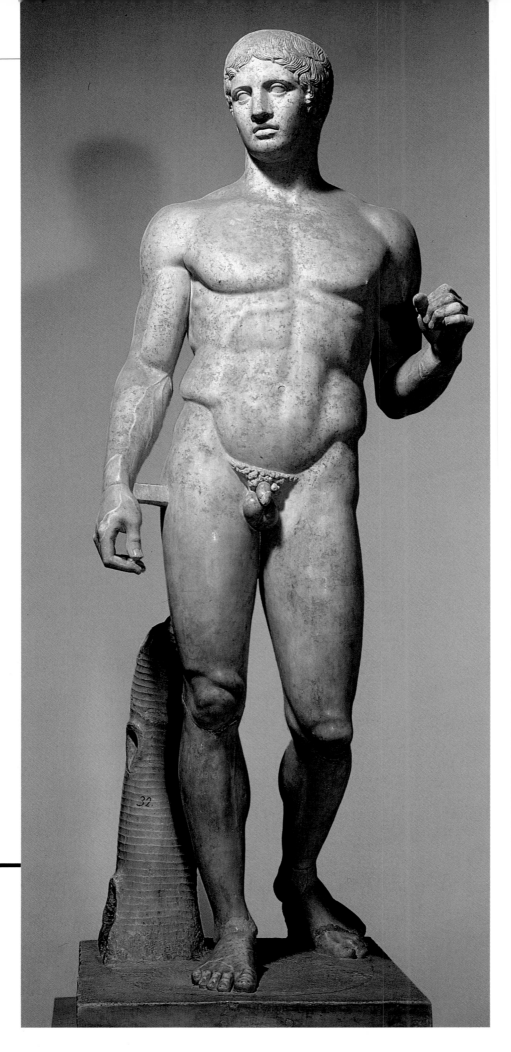

The buried cities of Mount Vesuvius were, however, the real source upon which the King of Naples relied to make his museum amongst the largest in Europe. They provided an immense resource of paintings, mosaics and objects of everyday use. Sometimes, too, they yielded true masterpieces of ancient art and craft, reflecting the prosperity of Pompeii and the luxury of the villas of Roman aristocrats built around the Bay of Naples.

Doryphorus (The Spear Bearer)

Tradition tells us that the original of this figure, known as the *Spear Bearer* (*doryphoros*) and probably representing Achilles, was cast in bronze in about 440 BC by the great Polyclitus of Argos. This work was renowned in antiquity as the *Kanon*, that is the canon or standard of human proportions that were based in the rules of rhythm and music. This Pompeiian copy (2.12 m. high) is the best that survives of the lost original, and here the principles used to construct the body are particularly evident. This figure demonstrates the principal of *contrapposto* (an X-shaped form based on the Greek letter *chi*) which determines the figure's stance with his right leg locked and bearing his weight and his left arm flexed but, in contradistinction, his left leg is relaxed and his right arm extended. The real fascination with this statue, however, lies in the more subtle movement of the head and torso which breathe life into the figure, certainly one of the most coherent attempts to represent the ideal harmony of Greek man—*kalòs kai agathòs* (beautiful of body and capable of mind).
It is particularly significant that this copy was placed in the Large Palaestra in Pompeii in the early Imperial period. There it reminded the aristocratic youth of the city that they belonged to the larger Classical world and shared the Hellenic ideals to which the Romans believed they were the true heirs.

Three Obsidian Cups

Datable to between the end of the First century BC and the first half of the First century AD, all three of these cups have the traditional form of a silver *skyphos*. They are decorated in a pseudo-*pharaonic* or at least an Egyptianizing style which recalls Ethiopia, the source of Roman obsidian. Obsidius (from which the name of the stone derives) had discovered deposits of it there which yielded great quantities of large blocks. The two larger cups are decorated with the same pharaonic scenes comprised of pink and white coral inlays, lapis lazuli, malachite and gold leaf. On one side two figures, perhaps a Pharaoh and wife, make an offering to a bull (Apis) placed in an *aedicula* decorated with a solar disc and flanked by two urei on its pediment; in the background two priests kneel before an altar holding flasks for perfume. The other side of the cup repeats the same scene with only small variations in details and well as in the animal being venerated—here a ram rather than a bull (Mendes or Amon). The smallest vase is decorated with a motif of polychrome leaves and flowers which grow in spirals out of a single container. A bird is placed on the central stalk. The *phiale*, finally, allows us to recognize in the surviving fragments a Nilotic scene with the remains of aquatic flowers, a papyrus boat, a hippopotamus and an aquatic bird.

Installation of the Vesuvian finds

Fiorelli became an indefatigable and enthusiastic sponsor of many of the fundamental reforms outlined in the report of the 1848 commission. Now called the Museo Nazionale—the National Museum—it was expanded to include the noted Santangelo collection and was completely reorganized by Fiorelli. His work, which is also very important for the history of the excavations at Pompeii, was at least in part completed by his protogés: Giulio De Petra, who succeeded him as director in 1875; and the architect Michele Ruggiero. The period at the end of the Nineteenth and the early Twentieth centuries was particularly turbulent. There was a series of scandals over the theft of important ancient works which were then exported outside the jurisdiction of the museum (the painting and silver treasures of Boscoreale and the Capua tile are two examples). Ettore Pais's reorganization of the Neapolitan collections (1901-1904) raised violent debates and charges of excessive modernism. Nonetheless the installation of the collections and the criteria which inspired it—for example the importance of context and the emphasis placed on the new field of prehistorical studies as well as the strong historical and chronological nature of the guides to parts of the permanent collection—remained a cornerstone of the Museum's organization through the first half of the Twentieth century (G. Gattini, 1906-1910, V. Spinazzola, 1910-1924 and A. Maiuri, 1925-1961). The Museum survived the violence of World War II with little serious damage. A new phase in the Museum's history began in 1957 when the *pinacoteca*—the picture gallery—was separated from the rest of the collection and transferred to Capodimonte. This decision by B. Malajoli ended the vision of a single, great Neapolitan museum of art and antiquities (as, for example, the Louvre in Paris still is) and created some regrettable gaps in some of the great historical collections like that of the Farnese family, which had united ancient and modern art. At the same time, however, the decision liberated space for the vast collection of antiquities and allowed for plans to be made to reinstall it differently which was particularly important since much of it was visibly out-of-date in terms of the concepts that underlay the way the works were exhibited.

A view of the "Secret Study"

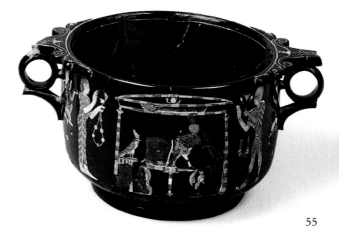

55

The Brawl in the Theatre of Pompeii

In addition to the courtly and mythological paintings copied from famous Greek works, the cities around Mount Vesuvius, and Pompeii in particular, have also yielded a number of popular paintings that depict scenes of everyday life with a simple but effective means of expression. It is hard to say why the owner of the house where this work was discovered commissioned a sign painter to make this mural representing the famous episode of a brawl between the Pompeiians and the Nucerini which took place in the amphitheatre in Pompeii in 59 AD. This riot, rooted perhaps in the ancient rivalry between Pompeii and its powerful neighbour, was one of the more exciting events in the life of this otherwise peaceful city in the first century AD. Roman sources tell us that the fight led to the closing of the arena in Pompeii for ten years and the disbanding of several illegal societies. This representation of the event (1.69 m. high × 1.85 m. wide) is vivid and largely faithful; we have a bird's-eye *view* of the amphitheatre in which small figures are rioting and, in the background, the walls of the city and the *palaestra* to the left.

Io at Canopus

This work (1.50 × 1.375 m.) was brought to light, in the presence of King Ferdinand IV, on November 18, 1764. It represents the rather unusual subject (only one other copy is known, and it, too, is from Pompeii) of Io's arrival in Egypt where she fled to escape the jealous wrath of Hera who was displeased over Zeus's love for the nymph. Io was sheltered by the goddess Isis at her sanctuary at Canopus in the Nile Delta. There Io gave birth to Epaphus, founder of the royal family of Egypt and Argos by the brothers Egypt and Danao. This subject was likely elaborated in Alexandria itself as a result of a desire to lend legitimacy to the Ptolemaic dynasty, which ruled a united Egypt and Macedonia, by suggesting that it could trace its roots to mythic times. Thus the original of which this work is a copy should be dated to Alexandria in the Third century BC.

The scene depicts the moment when a divine flood deposits Io on the rocky shore of Canopus. Isis, with curling hair and the attributes of the cobra in her hand and a crocodile at her feet, which clearly identify her, takes the pale nymph by the hand. The altar with horns and the priests of the goddess's cult identify the location as a sanctuary.

The riches of the Villa of the Papyri at Herculaneum

Herculaneum, a town by turns Greek, Samnite and Roman, was destroyed, like Pompeii, in the eruption of Vesuvius in 79 AD. The part of the ancient town first rediscovered in 1738, on the initiative of Charles Bourbon, is no less interesting than Pompeii, though there are differences in some details: the streets are narrower, and many have colonnades; the houses are smaller, but often more magnificently decorated, and the upper storeys are better preserved. To the north-west of the town is the celebrated Villa of the Papyri, extending along the coast from south-east to north-west, where work has just come to an end involving the atrium and the area towards the NW corner.

The villa takes its name from the nearly two thousand papyri found in the Eighteenth century, of which only some are kept today in the National Archaeological Museum in Naples. These papyri, many of them half charred, have acquainted us with the work of Philodemus of Gadara, a Greek philosopher who propounded Epicurean views.

The villa was a sumptuous home, the largest in Herculaneum, built beside the sea and following in part the design of a Hellenistic school/gymnasium; it almost certainly belonged to one Lucius Calpurnius Piso, politician, Epicurean, and Julius Caesar's father-in-law. Recent excavations have enabled us to work out that it rose four storeys high, of which three are still unexplored.

The Villa of the Papyri is the richest private building excavated so far, in its wealth of sculptures. Its front was not on the seaward side, but the opposite. The atrium, with a portico in front as in the seaside villas, served for reception and relaxation; the bedrooms were partly in a section around the first of the square peristyles which was crossed by a long narrow pond, and partly to the side of a courtyard on the east. West of the first peristyle, with a *tablinum* before it, was a second great peristyle, rectangular this time, surrounded by a portico and half-portico and crossed likewise by a monumental pond. Beyond this peristyle and running west was a gravel walk leading to a small tower which served as a belvedere, decorated with a sumptuous pavement of inlaid marble,

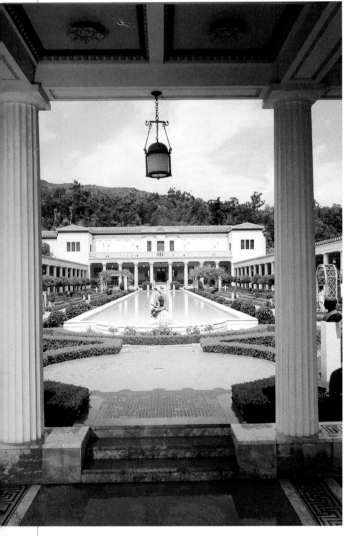

Malibu (California),
Paul Getty villa-museum,
peristyle

Malibu (California),
Paul Getty villa-museum,
southern porch

Malibu (California),
Paul Getty villa-museum,
vestibule

now in the National Archaeological Museum . Most of the statues were arranged around the garden; others were in the *tablinum*, in the square peristyle and in the atrium. Among them we can find copies, excellent in some cases, of masterpieces of sculpture from the Archaic, Classical and Hellenistic periods; portraits of famous persons; animal groups and decorative sculptures of nymphs; and fountains. The numerous sculptures in marble and bronze, and the many fragments of mural paintings, are displayed today in some of the rooms of the National Archaeological Museum. Though the villa is still largely buried under twenty metres of volcanic material, the finding of these sculptures has made it possible to work out the exact plan of decoration that governed the siting of the core sculptures which, brought together again in these rooms, form one of the very few examples known to us from antiquity of a private art collection. The collection consists of portraits of philosophers, orators and military leaders; of great statues and of small sculptures for fountains. The marbles and bronzes of the villa are mostly attributable, in style and subject, to the artistic culture of Greece, and so bear witness to the radical Hellenisation of the Roman world at the end of the First century AD.

One of the rooms with items from the Villa of the Papyri in the National Archaeological Museum in Naples

As an alternative to the installation of the Museum in the Villa of the Papyri, initiatives of doubtful taste have been planned, such as the reconstruction wanted by millionaire collector Paul Getty, at Malibu in California, of the villa on the basis of the old plans, but with completely invented ornaments "in style".

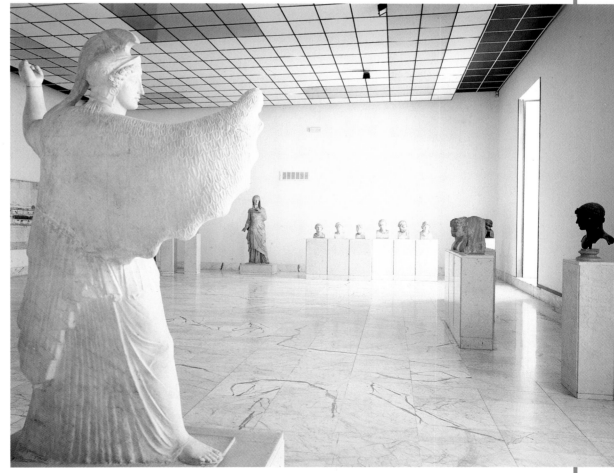

Alexander Mosaic

The House of the Faun was the most sumptuous residence in Pompeii in the late Hellenistic period and perhaps also in all of Italy at that time. The house was filled with mosaics in opulent *opus vermiculatum*, and this is the most famous of them. Once located in the most elegant and public part of the house, the mosaic (3.13 × 5.82 m.) shows Alexander on Bucephalus, his favourite mount, battling the Persian king, Darius III. The dead tree in the background—the only landscape element in this otherwise generic setting—most likely indicates that this is the Battle of Issus which was fought in 333 BC. Later Arabic sources, which Marco Polo, having heard of it on the caravan routes of Central Asia, repeats in his *Milione*, refer to this battle of that of the dead tree. The mosaic is impressive both for its monumentality and its virtuoso craftsmanship; it must certainly derive from a painting by a great master of the early Hellenistic period. There are copies of it known in different media. This work was most likely the *Battle of Alexander* which Pliny the Elder (*Naturalis Historia* 35, 110) tells us was commissioned by Alexander's successor in Macedonia, Cassandro (died 298 BC), from Philoxenos of Etreria.
This magnificent cavalry encounter puts the sacrifice of the Persian prince at the centre of the dramatic story.

He puts himself between his lord and Alexander, who was threatening him with a lance. The wounded Prince falls from his horse and then pierced by Alexander while one of his soldiers, a member of the *Aristoi*, the famous royal guards, tries in vain to give him his horse and thus seals his own fate. The scene is full of dramatic effects such as the foreshortened horse at the centre of the composition and the long spears of the Macedonians that penetrate the empty space at the centre of the work—a device which also reminds us of Paolo Uccello's *Battle of San Romano*—and fine details such as the sumptuous, historiated garments, the light glinting and reflecting off the arms, the flaring nostrils of the horses, and the possessed or terrified expressions of both men and animals. The overall effect is a sense of impetuous movement, of the noise of battle, the crash of arms and the neighing of horses.

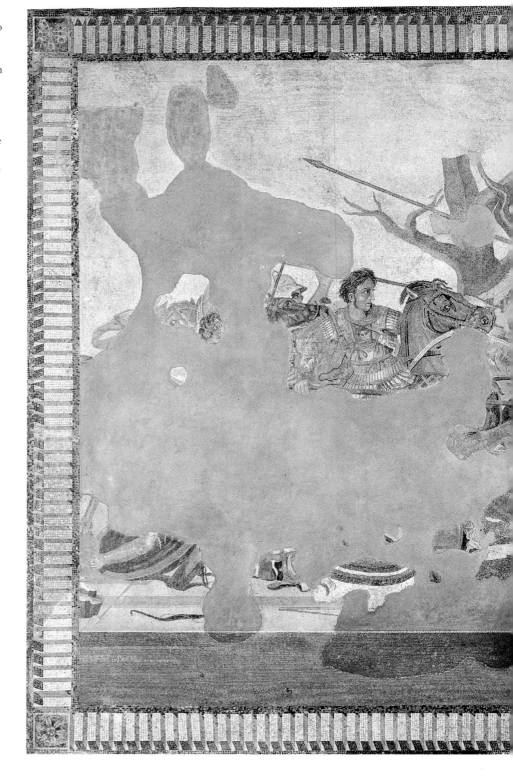

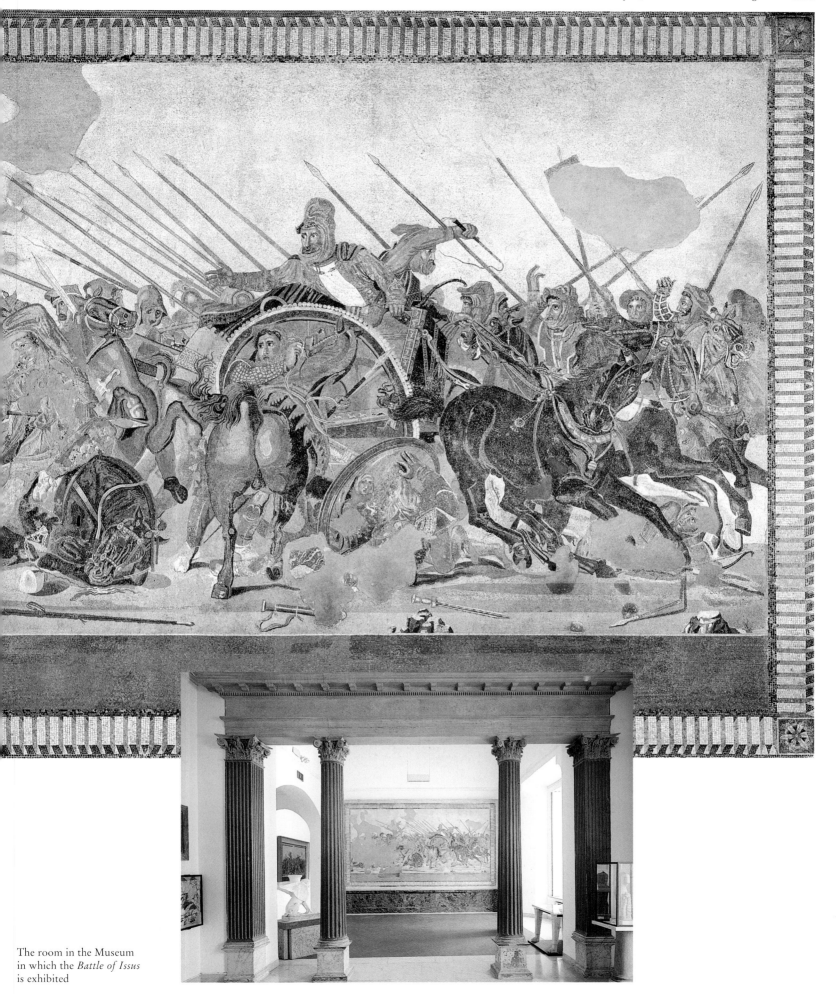

The room in the Museum
in which the *Battle of Issus*
is exhibited

The postwar Reorganization

Abandoning the Nineteenth century criteria of typology and materials (silverware, glass and small bronzes, for example) and substituting for them a concern both for the object's place of origin and provenance—and using the model of the exhibits at the Villa of the Papyri at Herculaneum (A. de Franciscis-De Felice, 1973)—the new installation of works was organized to give all areas of the museum equal weight (the Farnese collection and objects from Pompeii, Flegrea, Magna Graecia and Etruria) and to integrate the other threads that are part of the history of the museum (the Borgia and Santangelo collections and the collection of inscriptions, coins, vases and copper plates from the Bourbon printing-works among others). Using the same criteria, the Baths of Caracalla were proposed to house the Farnese and glyptics collections, and the Temple of Isis in Pompeii, refitted, has been suggested as a home for the Pompeiian objects, the collection of "pornography" or mosaics. The newly designed exhibition spaces for the collections of inscriptions, and prehistoric artifacts from Ischia and Neapolis have just been finished, and those for Magna Graecia and coins are almost completed. The collection of objects from Magna Graecia documents the history of the peoples of ancient, pre-Roman Campania (the Greeks, Etruscans and Italic tribes), and this section of the Museum, enriched with material from recent excavations, is intended to be a general introduction to the history of these cultures; more detailed exhibitions are being installed at the many and interesting museums at the important individual sites in the region (at Baia, Santa Maria Capua Vetere, Nola, Teano and Piano di Sorrento to name some of those already open). The National Museum of Naples is the natural centre of this ambitious network of museums and archaeological parks.

The new exhibition project aims at enhancing all the spirits and parallel genres interwoven in the history of the Museum, with the ambitious objective of creating a network of museums and archaeological parks centring on the National Museum of Naples.

Gold Lamp

Discovered in 1863 in the most important sanctuary in the Roman colony of Pompeii, this gold lamp (23.2 × 15.1 cm.), worked in repoussé with lotus leaves, and its tall reflector decorated with the same motif, is absolutely unique. Evidence preserved in inscriptions and the ancient literature tell us that golden objects were considered a worthy offering to the principal sanctuaries from the Classical period onwards. This lamp, like the one Pausanius tells us burned night and day at the Erechtheum, the sanctuary of Athena Poliàs on the Athenian Acropolis, was certainly an exceptional votive offering. A couple

of graffiti discovered in the house of Julius Polibius indicate that this Pompeiian lamp was almost certainly part of the gift from Nero and Poppea when the imperial couple visited the city and sanctuary, perhaps during their famous trip to Naples in 64 AD. The first text, written in popular Latin, in fact records with some emphasis that "Caesar had just come to the Temple of the most holy Venus when, Oh Augustus, your heavenly feet carried you inside, there was there thousands of pounds of gold." The second text describes the gifts from Poppea, the Emperor's wife, who seems not to have herself been present, "Poppea sent as a gift to the most holy Venus a [berillo]

and a drop-form pearl, and together it was a large pearl." The shape of the lamp corresponds to a date during the reign of Nero.

Pan and a Goat

This famous group (44.4 cm. high) stands out amongst the numerous sculptures which made the sumptuous Villa of the Papyri a true museum house. Its owner put it, without any hesitation, in his garden amongst the other figures of gods, philosophers and military heroes. In reality the garden was not just a sanctuary of the Muses but also a world, beyond the place created by humans to reproduce the natural world, of the mysterious and divine beings of the forest—satyrs, nymphs, Pan, Dionysus and the Maenads—which were adopted in Roman art as anthropomorphic representations. Vanvitelli judged this work "extremely lascivious but

beautiful," and it was rigorously censored until only recently. The openly erotic subject, however, is diluted by the humour in the play of glances between the languid goat and the small figure of Pan, the god whom Horace called *aigibates* or "the one who lies with the goats."

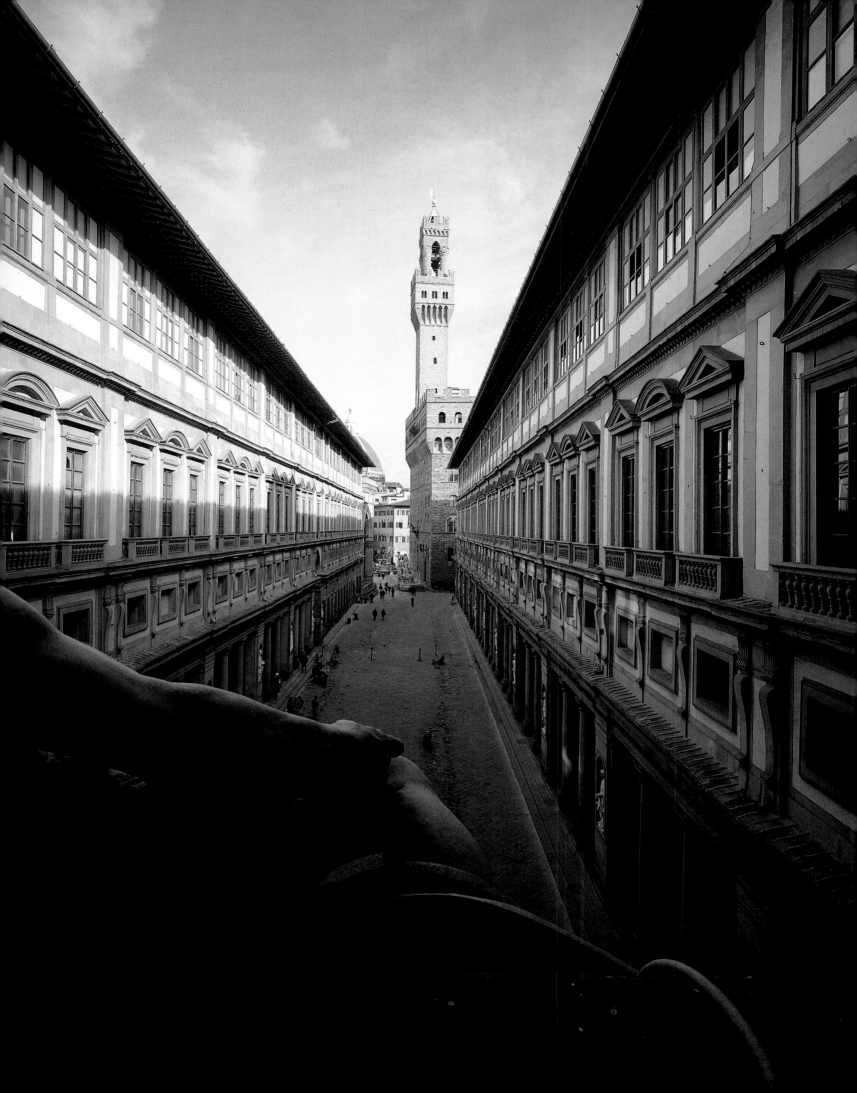

Florence, the Uffizi

Annamaria Petrioli Tofani

The history of the Uffizi now spans more than 400 years. It is a story characterized by constant growth and an evolving mission rooted in the reordering of the priorities and the intellectual aspirations of the society this institution served, both as a repository of its culture and a significant symbol of its prestige.

As a result the Uffizi today has the most comprehensive documentation of the history of Italian figurative art (as well as good collections of the other principal schools of European painting), from paintings to drawings and prints and even tapestries. Its collection of sculpture is also very important; the majority consists of works of the Classical past, but it also has a significant group of later pieces.

The contemporary Uffizi faces many challenges in its daily operations, from cramped exhibition space to a limited infrastructure. Nonetheless the museum continues to incite the collective imagination of its public and admits several thousand people of different nationalities, ages and social and educational backgrounds through its doors every day. This attraction cannot be explained by the size of the museum alone, for, even when work on the project begun in 1989 to enlarge the museum by recouping unused parts of the building is finally finished, the Uffizi will still be smaller than many similar institutions in Europe and America. Instead it is an interest which is justified by the knowledge that a visit to the Uffizi will be a very special experience, not only because of the richness of the collection, which contains many of the most famous masterpieces of Ital-

ian and European art, but also because going inside the museum means entering a building that is, in itself, a true work of art. It was designed and built by Giorgio Vasari in the middle of the Sixteenth century and is one of the most original and beautiful works of architecture of its period.

The building enjoys, furthermore, a special relationship with the city around it, and it has, to an extent, become a sort of observatory from which the principal monuments of Florence look particularly distinguished; the panorama offered to the viewer is like a beautiful painting on the wall of a room.

One can also say that it was in this building, the Uffizi, where the whole notion of a museum was born in 1581—that is, of a carefully planned institution conceived to exhibit objects to the public in surroundings which stress their importance.

These works have been chosen very carefully as objects worth becoming acquainted with and also as potential sources of new culture.

The building

The Uffizi was built by Vasari for Cosimo I de' Medici (1519-1574) shortly after the middle of the Sixteenth century. The building was to house the magistracies and other state offices that had outgrown the available space in the adjacent Palazzo Vecchio. It was born, thus, as a pratical building and public in character, and its name—*uffizi* means literally offices—identifies it as such.

View of the Piazzale degli Uffizi looking from the Arno towards the Palazzo Vecchio.

65

The Gallery

View of the Piazzale degli Uffizi
from the Piazza Signoria,
looking towards the Arno.

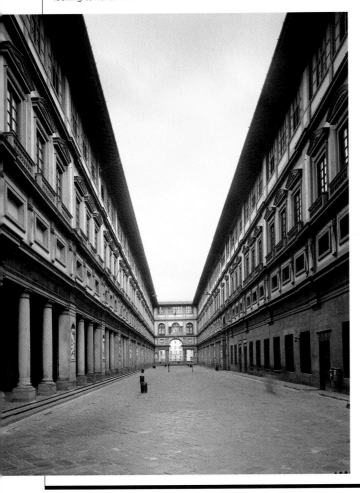

The name of the museum, the Uffizi Gallery, traces its origin to the real gallery that runs uninterrupted around all three sides of the building on its uppermost floor and faces the lovely, internal piazza which is the fulcrum of the entire construction. The fundamental role of the gallery in the birth and development of today's museum has led, over the past years, to a comprehensive restoration of that area that has salvaged, as accurately as possible, the gallery's original appearance. The early features of the gallery had been completely lost over the centuries both because of curatorial decisions (such as the dividing up of the collection under the Lorenese Dukes) and because of circumstances linked to the chronic lack of space.
In 1580-1581 Grand Duke Francesco I incorporated Vasari's open loggia into the exhibition space he wanted for the most famous examples of classical sculpture in the Medici collection; he had the arcades closed, installed windows and commissioned the ceiling frescoes. The sculpture was arranged so that it fit into the rhythm of the architecture, marking the cadence of lines of the elegant structure. Thus the large statues were arranged in two rows along the walls that corresponded to the piers of Vasari's original loggia, while the smaller busts were fitted, with a sense of visual coherence, into the tripartite rhythm of the bays which corresponded to the more slender columns. The busts of Roman emperors were placed on the side with the doors and those of their consorts on the window side opposite them.
This extraordinary exhibition of sculpture, which at the time included masterpieces from a variety of periods, from the Etruscan *Chimera of Arezzo* to Michelangelo's *Bacchus*, that were later moved to other museums, provided the most dignified setting to celebrate the Medici dynasty. It was present in the large painted portraits that hung above each statue. These portraits were then juxtaposed with images of famous men and women from every historical period arranged in a continuous line on the uppermost part of the walls. The oldest elements of this "Jovian" series were commissioned by Cosimo I and painted by Cristofano dell'Altissimo after the famous examples assembled by the humanist, Paolo Giovio, in his villa in Como.

View of the southern arm of the
Gallery in an Eighteenth-century
drawing by Vincenzo De Greyss.

Opposite
View of the east Gallery or Corridor
after its restoration in 1996.

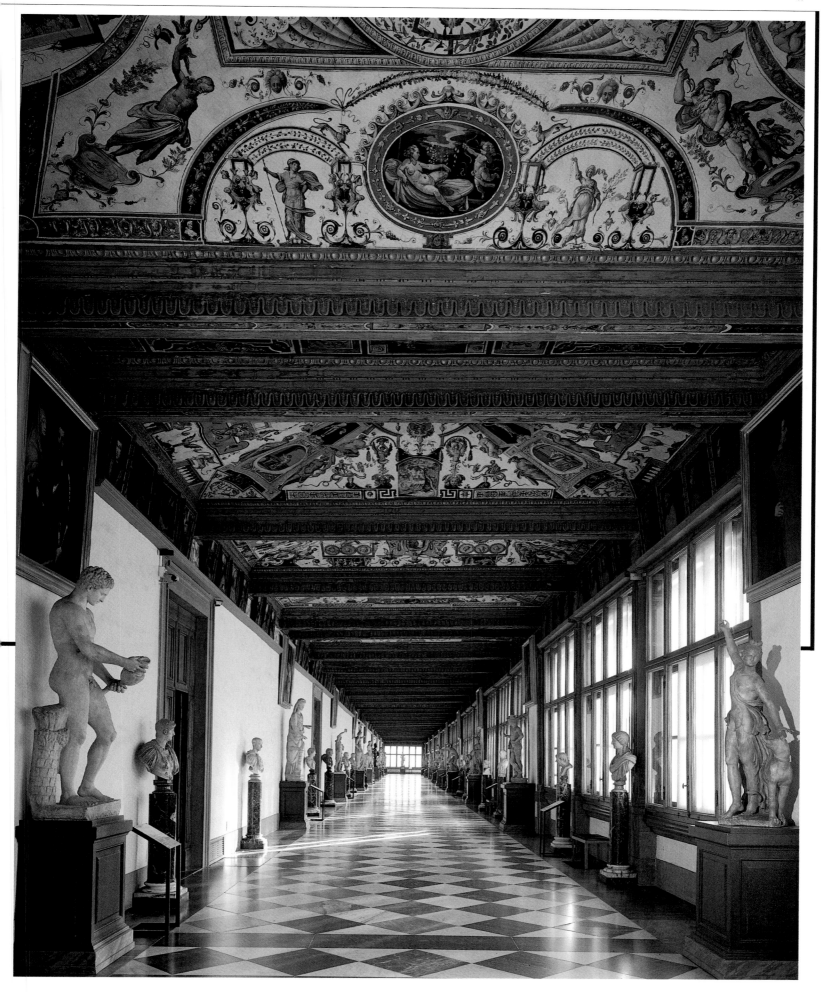

The origins of the Uffizi

Grand Duke Francesco I began to move groups of objects that were chosen because they were among the most conspicuous of the family's immense collection to the Uffizi in 1580, first to the upper floor of the east galleries and then to the appropriately renovated room called the Tribuna, and thus the history of the museum began. With the transformation of the Uffizi into a museum, Francesco achieved an important cultural goal. He created a useful place to house his collection and at the same time promoted the image and prestige of his dynasty with an institution worthy of the spotlight of international attention.

The success it achieved was such that an official occasion to show off the museum was never missed. Objects, too, were constantly being transferred to Vasari's building, both unique works of art of special importance and whole categories of objects. As a consequence there was an ever growing need for more space.

At the end of the Sixteenth and in the Seventeenth centuries, for example, there was an important collection of scientific instruments, including some that had belonged to Galileo Galilei in the room known as the Terrace of the Maps or the Mathematics Hall (now Sala 17), while the prestigious collection of arms and tournament weapons were displayed in the rooms to the right of the Tribuna (Sale 19-22; it was unfortunately sold off or melted down for the precious metals in the Nineteenth century). There is reason to think that even these rooms were arranged with a sense of the principles of a museum since one can still identify the original decorations of the ceilings that refer, in the first case to the great scientific discoveries in antiquity, from Ptolomey to Archimedes, and in the others represent allegories and battle scenes or jousts and tournaments.

The Medici collections

A passion for collecting marked the whole history of the Medici dynasty and produced remarkable results—most of which eventually ended up in the Uffizi. It is worth making special note of the contributions of Ferdinando I (1549-1609), an avid collector of both ancient sculpture and contemporary painting, of Cosimo II (1590-1621), who was responsible for most of the museum's Caravaggio holdings, and of Ferdinando II (1610-1670) who inherited through his wife, Vittoria della Rovere, the collection from Urbino—most famous for its masterpieces by Piero della Francesco, Raphael and Titian. Cardinal Leopoldo de' Medici (1617-1675), Ferdinando's brother and Cosimo III's uncle, was also a cultured and intelligent collector of many things but especially of self-portraits and drawings; Cosimo III (1642-1723) also made important contributions to the family's collection in the area of North European art, and Grand Prince Ferdinando (1673-1713) was responsible for bringing some of the best artists of his day (from Giuseppe Maria Crespi to Magnasco) to Florence where they made a variety of important works for him.

*The Uffizi building complex was built to house
a magistrate's court and state offices.
Only between 1580-81 were the first selections
of art works to arrive from the vast Medici
family collections, and a museum was born.*

Piero della Francesca

This extraordinary *Diptych with the Portraits and Triumphs of Battista Sforza and Federico da Montefeltro* (tempera on panel, 47 × 33 cm. each) is the only work by Piero della Francesca (Borgo Sansepolcro, 1416/17 – 1492) in the Uffizi collection. It became part of the Medici collection in 1631 when Vittoria, the last of the Della Rovere family, married Grand Duke Ferdinando II and brought a number of works of art that had belonged to her family to Florence. This work, today displayed in a fixed, neo-Renaissance style frame, was probably originally a folding diptych which, when open, displayed the two portraits of the Duke and Duchess of Urbino and, when closed, the allegorical triumphs of both painted on the reverse of the panels—Battista accompanied by the Theological virtues and riding in a chariot pulled by two unicorns, the symbols of marital fidelity, and Federico, with the cardinal virtues and a winged victory, in a chariot pulled by two white horses.

This diptych is one of the best examples of Piero's complex figural synthesis which combined the spatial framework and rigorous perspective of the Florentines with the jewel-like colour of the Sienese and the analytical realism of the Flemish masters. The result is something wholly original where light is the unifying agent. We know nothing about the circumstances of this work—neither when nor why it was painted. An analysis of the diptych, however, suggests a relatively late date and certainly after the fresco cycle of the *Legend of the True Cross* painted in Arezzo in 1452-1462. It might be dated circa 1472, the year of Battista's death, if we imagine that it was commissioned by Federico to preserve, in an image evidently meant for private use, the memory of a happy marriage.

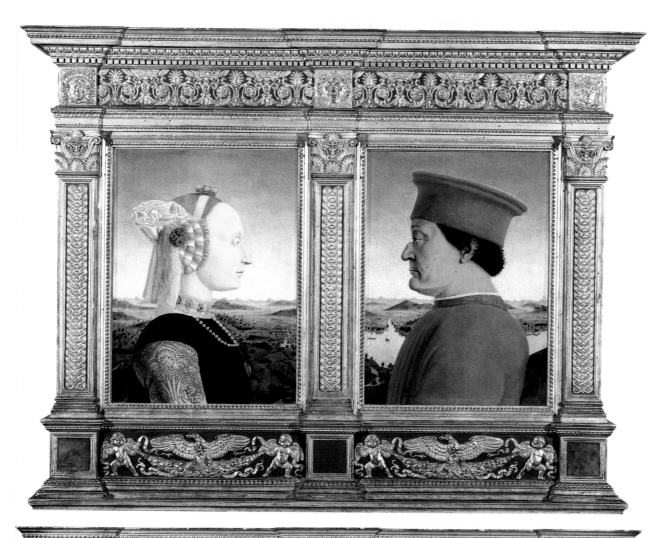

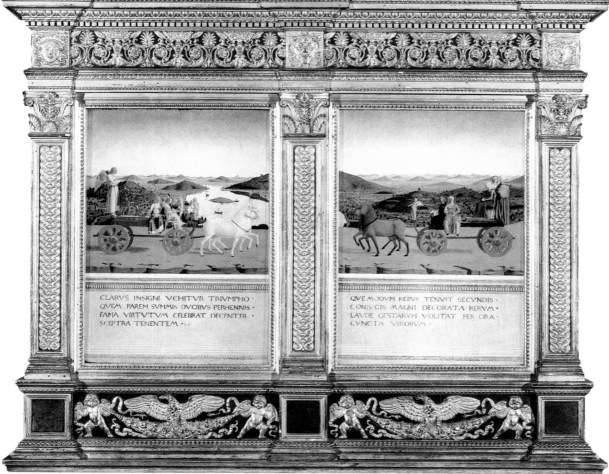

CLARVS INSIGNI VEHITVR TRIVMPHO ·
QVEM · PAREM · SVMMIS · DVCIBVS PERHENNIS ·
FAMA VIRTVTVM CELEBRAT DECENTER ·
SCEPTRA TENENTEM ·

QVE MODVM REBVS TENVIT SECVNDIS ·
CONIVGIS MAGNI DECORATA RERVM ·
LAVDE GESTARVM VOLITAT PER ORA ·
CVNCTA VIRORVM ·

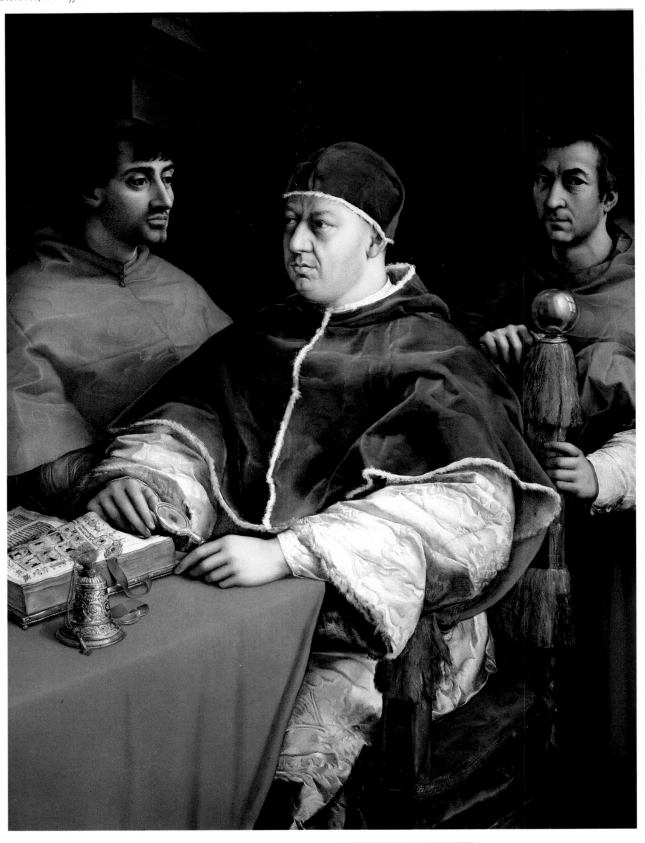

Raphael

The marriage of Lorenzo de' Medici, the Duke of Urbino, to Maddalena de la Tour of Auvergne was celebrated in Florence in September 1518. The groom's uncle, Giovanni de' Medici—the son of Lorenzo the Magnificent and Clarice Orsini and, from 1513, Pope Leo X—sent this portrait *(Pope Leo X with the Cardinals Giulio de' Medici and Luigi de' Rossi,* oil on panel, 155 × 119 cm.) by Raphael from Rome so that he, pleased with this family allegiance to the French royal family, might be present, at least in spirit, at the marriage. The painting was hung above the Duchess's table at the sumptuous banquet held in the Palazzo Medici Ricciardi to celebrate the occasion. This portrait is one of the masterworks of Raphael's later career, and it shows the pope with the cardinals Giulio de' Medici and Luigi de' Rossi both of whom were related to Leo. Giulio, who himself would reign as Pope Clement VII, was the son of Giuliano de' Medici, murdered during the Pazzi conspiracy, and Luigi was the son of one of Lorenzo's illegitimate sisters.
Vasari saw this portrait in the Palazzo Vecchio in 1550 which had become the family's official residence. He described it with great admiration and was especially moved by the strength of the depiction of the three figures, the extraordinary sense of detail such as the splendid illuminated manuscript and the very fine work on the silver bell.
This work was displayed for many years in the Tribuna at the Uffizi, where it was hung in 1589. In 1697 it was moved to the family residence at the Pitti Palace, and it was then taken by the French. After it was returned to Florence it hung once again at the Pitti until 1952 when it was finally moved permanently to the Uffizi during the post-war reorganization of the Gallery.

The portrait of pope Leo X, painted by Raphael in Rome between 1517 and 1518, was an official portrait of the Florentine pope at the wedding of Lorenzo de' Medici, duke of Urbino and Maddelena de la Tour d'Auvergne, in Florence in 1518. It became part of the Grand Duke's collection.

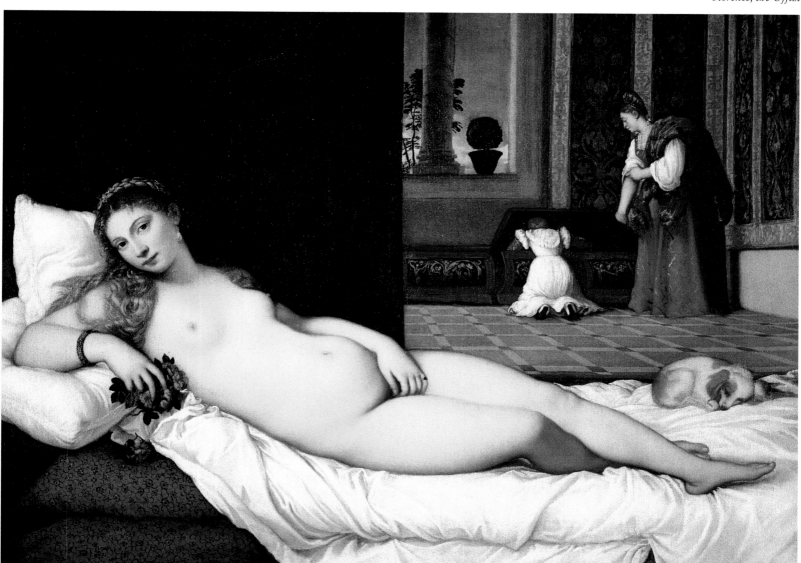

Titian

Titian painted this *Recumbent Female Nude with a Small Dog* (oil on canvas, 119 × 165 cm.) work in Venice for Duke Guidobaldo of Urbino, and we know it was finished in 1538. It is, therefore, a masterpiece from the artist's mature period. Already in his fifties, Titian also made portraits of Guidobaldo's parents, Francesco Maria della Rovere and Eleonora Gonzaga, in the same period. All three paintings entered the collections of the Uffizi in 1631 as part of the inheritance of Grand Duchess Vittoria della Rovere, Ferdinando II de' Medici's wife.
This work is commonly referred to as the *Venus of Urbino* because of its provenance, but opinions about the meaning of its

subject matter have varied. All the older sources, including the correspondence between the patron and Gian Giacomo Leonardi, his ambassador in Venice, refer to it generically as a "nude woman" with no mention of the ancient goddess, symbol of profane love, whose presence is suggested by the sensual depiction of the female figure. It has been noted, furthermore, that the bouquet of roses and myrtle she holds in her right hand—and which are directly in the foreground of the picture—are a symbol of constant love as well as attributes of Venus. The small dog at the foot of the bed is an explicit and very common allusion to marital fidelity. It is possible, then, and especially given the domestic setting and the two women in the background who attend to routine chores, that this work is not a

mythological subject but rather an allegory of conjugal love. It might thus make specific reference to the happy marriage between Francesco Maria and Eleonora.
This work demonstrates at its best Titian's ability to use colour to recreate a sensual reality. It has always been a famous work. The frequent requests to copy it (and one should note amongst others the version by Ingres in Baltimore and Manet in Paris) put the picture at a certain risk, and it seems that the decision to put an iron metal cage around it in the Gallery at the end of the Eighteenth century was made to protect it, as was the idea to replace it with a copy.

With the arrival in Florence of Vittoria della Rovere as bride of the Grand Duke Ferdinando II de' Medici, an important part of the art collections from the Urbino court was transferred to the Uffizi.
Apart from Piero della Francesca and Raphael, there was the splendid nude of the so-called Venus of Urbino *painted by Titian in 1538.*

The study of Francesco I in the Palazzo Vecchio

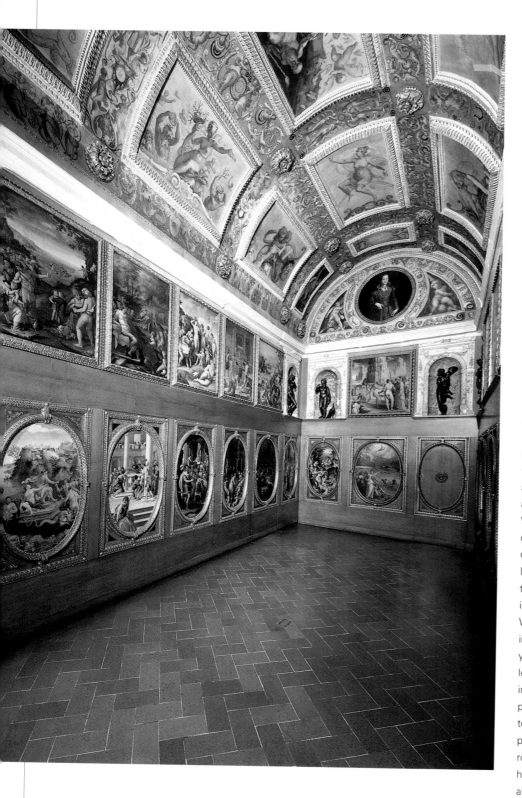

The study, as architectural history understands it, flourished during the Renaissance at the main courts of Italy, being a place for studying, for collections or conservation, but also for recollection, and above all as a special, almost sacred, place which concerned the dimensions of the mind rather than of physical space. Its character as a special place meant that from the very start its function was mixed, including use for the conservation of valuable, rare or secret objects or documents. Francesco I de' Medici's study in the Palazzo Vecchio signals the petering out of this tradition, as the room's functional aspect alters in conception from a place for study to a space devoted to a collection. Starting in August 1570, Francesco I converted the original bedchamber next door to the "Tesoretto", or little Treasury, in his apartments on Via della Ninna into a study; his choice of designer was Giorgio Vasari, who in turn availed himself of the assistance of his friend Vincenzo Borghini, the cultivated Benedictine prior of the Ospedale degli Innocenti: his, then, was the "invention" of the entire iconographic plan. Work began on the ceiling in September of the same year, and all the city's leading painters were involved at once in the preparation of the panels to adorn the walls. The paintings, arranged in two rows one above the other, hide cupboards behind, but allude symbolically to their contents by their choice of subjects. At the level

of the upper row, two niches open at each corner, with eight bronze statues of ancient gods and goddesses, patrons of materials and of the arts: Amphitrite and Venus, Juno and Aeolus, Apollo and Vulcan, Pluto and Opi. The curved portion of the ceiling, barrel vaulted, is divided into nine large fields and six small ones, all rectangular. Finally, in the rounds within the lunettes appear the painted portraits of Francesco I's parents, Cosimo de' Medici and Eleonora of Toledo. The idea behind the iconographic plan is an emulous comparison between the creations of Man and those of Nature, a clear demonstration of a cast of thought that is typically Humanist. The parallels between macrocosm and microcosm are set up within a system of reference involving the four elements (earth, water, fire and air), the seasons, the qualities that arise from bonding among the different elements, represented by young couples embracing, the humours (phlegm, blood, choler and melancholia), and the ages of Man. Francesco's interest in curios both of nature and of art link his study to the *Wunderkammern*, the "chambers of the marvellous" that were widespread in central and northern Europe; but this room in the Palazzo Vecchio reflects not so much their love of the marvellous but rather the character of The Collector, and above all the intellectual outlook, here satisfied through artistic transfiguration and the symbolism of the images. It was not long before the

Tommaso Manzuoli
called Maso di San Friano
The diamond mine

Girolamo Macchietti
The baths in Pozzuoli

ruler's rising enthusiasm as a collector and the encyclopaedic nature of his collection made more room a necessity. As early as 1586 Francesco I, now Grand Duke, found himself obliged to disassemble his study in the Palazzo Vecchio. The collection, and one part of the decorations were then transferred to the Tribuna degli Uffizi, a new kind of structure for collectors, furnished and arranged by Bernardo Buontalenti from 1584 onwards, on the east side of the Uffizi, which for centuries was the most famous museum in all Europe.

The present state of the study's decoration dates from a reconstruction of the early Twentieth century based on philological research into the detailed descriptions that have come down to us, and paintings and sculptures that were by that time scattered among various Florentine collections. Only the wooden panelling is modern.

Mirabello Cavalori
The wool-mill

Giovanni Stradano
The alchemists' laboratory

*Francesco I de' Medici had gathered
an important nucleus of objects
in his own cabinet in Palazzo Vecchio
built about 1570 by Giorgio Vasari.
The aim was to relate the natural elements
(water, earth, fire, air) with the art collections
according to the model of the chamber
of wonders (known as* Wunderkammern)
from the preceding era.

A new conception of the museum

The Medici collectors placed few limits on what they collectied, and this was reflected in the universality of the museum's displays—not surprising given that it was the official repository of the family collection. The early enthusiasm in the early days of the Uffizi, however, for accumulating and for variety gradually disappeared in the Eighteenth and Nineteenth centuries. During the reign of Hapsburg-Lorraine dynasty (1737-1859) and then in the first years of a unified Italy a number of groups of objects, defined by type, left the museum to become the seed collections of specialized museums such as the Museum of Natural History, the galleries at the Accademia, the Bargello (the National Sculpture Museum), the Archaeological Museum, the Museum of San Marco as well as the collections of silver and porcelain at the Pitti Palace. This was the result of the politics of culture, the significance of which went beyond a need for space for the objects which the house of Lorraine continued to collect. Instead it reflects a new and enlightened philosophy which sought to order culture in systematic categories and aseptic, specialized subdivisions. In light of the encyclopedic historicism which was then current in European culture—a philosophy which numbered amongst its adherents the famous antiquarian, Luigi Lanzi, and Giuseppe Bencivenni Pelli, director of the Uffizi—the museum redefined its purpose with respect to the artifacts of the past and in recognition of the educational function, of vast social importance, it could serve. This new and un-tried approach provides the context for the transfer of the responsibility for the Uffizi in 1769 to the Ministry of Finance which definitively recognized it as a public institution.

Despite the dismembering of some of the collection discussed above, the huge expansion in the remaining areas required further enlarging of the exhibition space which, even before the end of the Eighteenth century, included some twenty rooms. The most important additions of this period in terms of their prestige and museographical interest included the gem collection (Sala 24), acquired by Zanobi del Rosso in 1782, and the impressive space constructed by Gaspare Paoletti in 1779-1780 to exhibit the ancient figures of the Niobids which had been moved to Florence from the Villa Medici in Rome (Sala 42). The current director of the museum believes that monumental paintings such as Rubens's *Scenes from the Life of Henry IV* were also to be displayed in Paoletti's hall. The interest the Lorenese dynasty had in the museum is further demonstrated by the attention it paid to the functional aspects of the building in this same period. The construction of a new entrance, for example, abandoned the narrow, steep stairs in the west wing and took advantage of Vasari's monumental staircase in the eastern part of the building. The visitor now went up to the main floor of the Uffizi via the landing of the dismantled Medici Theatre. Zanobi del Rosso built the ramp that connects the two upper floors in 1780 as well as the pretty, oval vestibule which marks the entrance to the galleries themselves.

The facade of the *ricetto* of the former Medici Theatre, on the landing of the Vasarian staircase

Pages 76-77
The entrance of the Gallery and the Niobe Room.

Hugo Van der Goes

This masterpiece of Flemish Renaissance art is also a good example of the richness of the Uffizi's non-Italian collection. Unusual in its size and shape, Tommaso Portinari, the representative of the Medici Bank in Bruges, commissioned this *Adoration of the Shepherds* (oil on panel, 253 × 586 cm.) from Hugo van der Goes; it was intended for the high altar of the Florentine church of Sant'Egidio which was part of the hospital complex of Santa Maria Nuova founded, in 1288, by Folco Portinari. Although the painting is most commonly referred to as the *Portinari Triptych*, it is in fact an altarpiece with doors. When it is open it shows the adoration of the Shepherds on the central panel, and the scene is extended onto the side panels with portraits of Portinari's family. When the doors are closed we see a monochromatic scene of the Annunciation on the reverse side of the lateral panels. The painting arrived in Florence on May 28, 1483, after an eventful sea voyage which took it to Sicily and then Pisa and finally up the Arno to its final destination. Its arrival at what was the heart of the early Renaissance movement made a big impression on the artists who were now able to see, at first hand and in such a fine example, the Flemish version of what was a shared desire to represent the real world. Flemish artists, when compared to the expressive synthesis with which the Florentines who abandoned the abstract tendencies of the Gothic style to tackle the representation of the world and individuals, offer an analytical realism which is almost obsessive in its description of each and every detail—in the landscape as well as the figures, and in the architectural elements as well as in textiles and jewels. The extraordinary still-life in the foreground is worthy of particular attention in the exacting handling of the flowers with their complex, symbolic meanings—the red lilies alluding to the blood of Christ, the columbines to the sorrows of the Virgin and the irises to the arrows which pierce the heart of Mary in a *Mater dolorosa* iconography. In 1871 the painting was moved to the gallery of the Arcispedale of Santa Maria Nuova and then, in 1900, it was installed at the Uffizi.

75

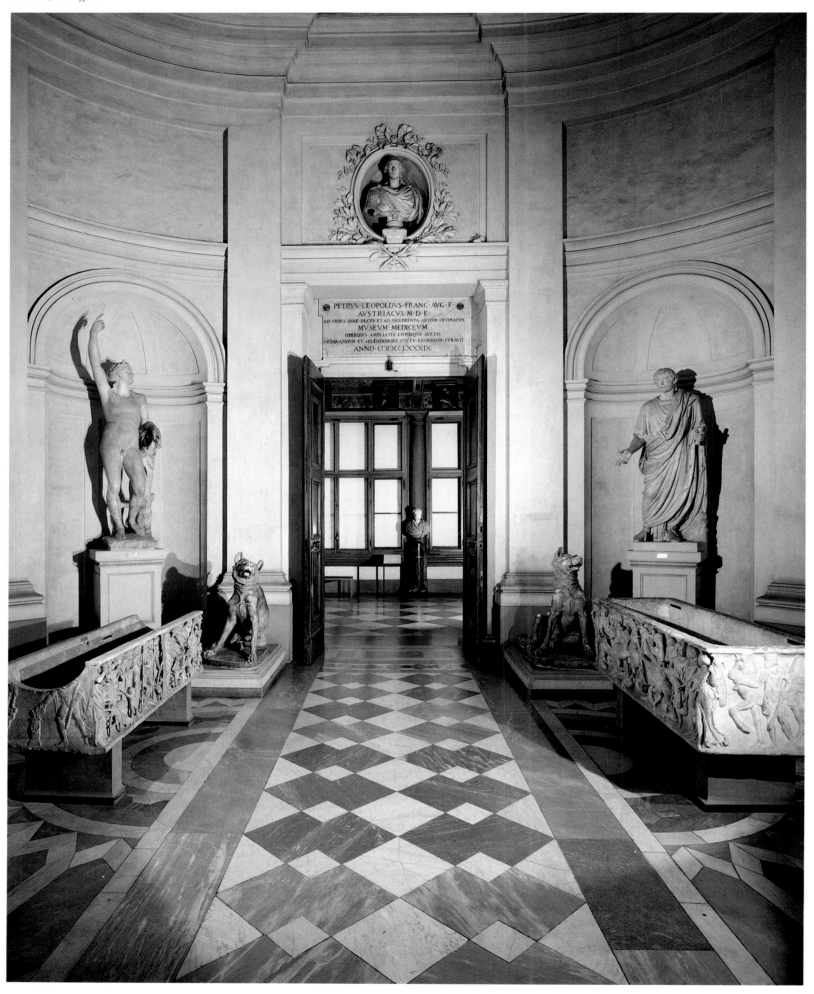

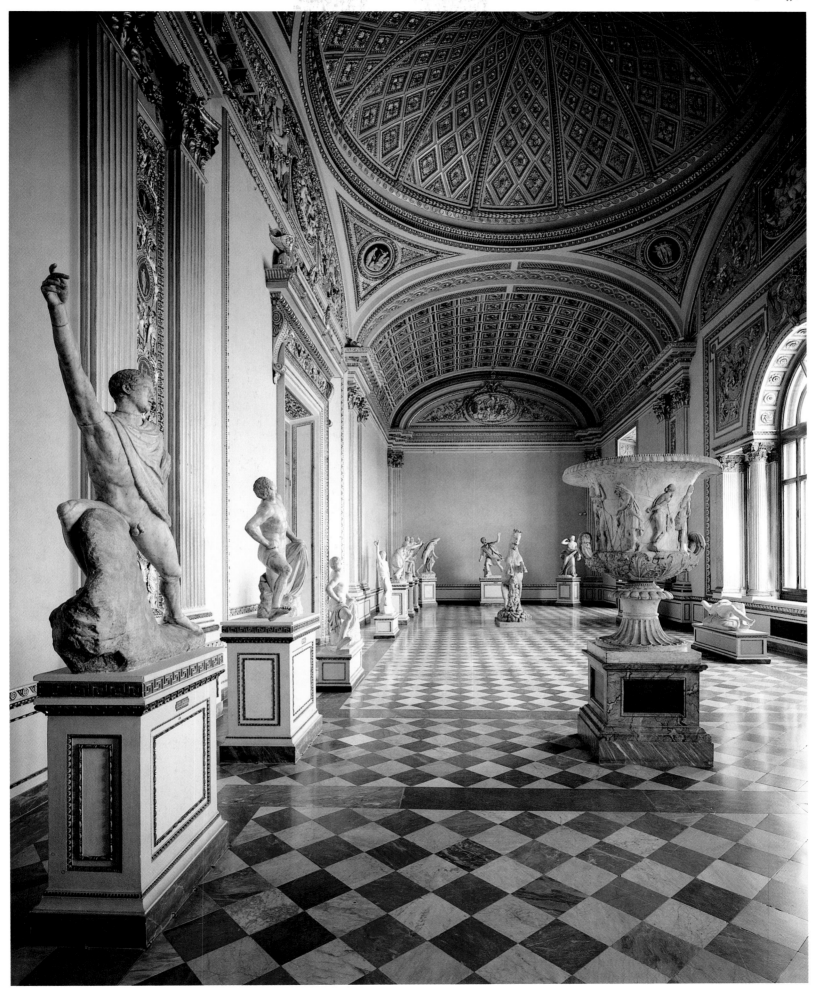

The Tribuna and the birth of the Modern Museum

The Tribuna is an octagonal room entered either from the west gallery or Vasari's Corridor, and it constitutes the nucleus of what would become the present day museum. Bernardo Buontalenti, who succeeded Vasari as court architect after the latter's death in 1574, designed the space for Grand Duke Francesco I in 1584.

Intended from the beginning as a place to display special objects—items that combined nature and art in a conscious way, the Tribuna was planned as a complex allegory of the Universe broken down into its constituent elements. Air is suggested by the opening at the centre of the vault, enclosed by a lantern, with a wind vane that used a mechanical device to indicate the direction of the wind; water is represented by the mother-of-pearl that covers the entire surface of the vault, creating a breathtaking effect; fire is evoked by the red upholstery on the walls and earth by the floor pavement in which marbles and semi-precious stones are arranged into a sophisticated design. It is not unlikely that Francesco himself, a spirited and tremendously erudite man, was the source of this bold decorative concept, the product of the Sixteenth-century principle of the universality of the sources of knowledge. The works of arts collected there were gathered without making distinctions in type or period; curiosities of nature were placed next to sophisticated scientific instruments. Yet it is also a prototype of the museum in a modern sense, a visible testament to knowledge displayed in a way that allows it to be transmitted and perpetuated. It is clear, in fact, that once the items destined for the Tribuna were installed there, they lost their sense of belonging to a private collection and become instead cognitive instruments. They were afforded a highly unusual degree of visibility given that the Tribuna was accessible not just to illustrious guests of the Medici family but also to scholars, artists, travellers and learned people who more and more often asked to see it.

The octagonal room of the Tribuna was built by Bernardo Buontalenti in 1584 commissioned by Francesco I. It was an architectural extension of the cabinet in Palazzo Vecchio, from which it inherited the double reference to Art and Nature, and it became the initial heart of the future museum.

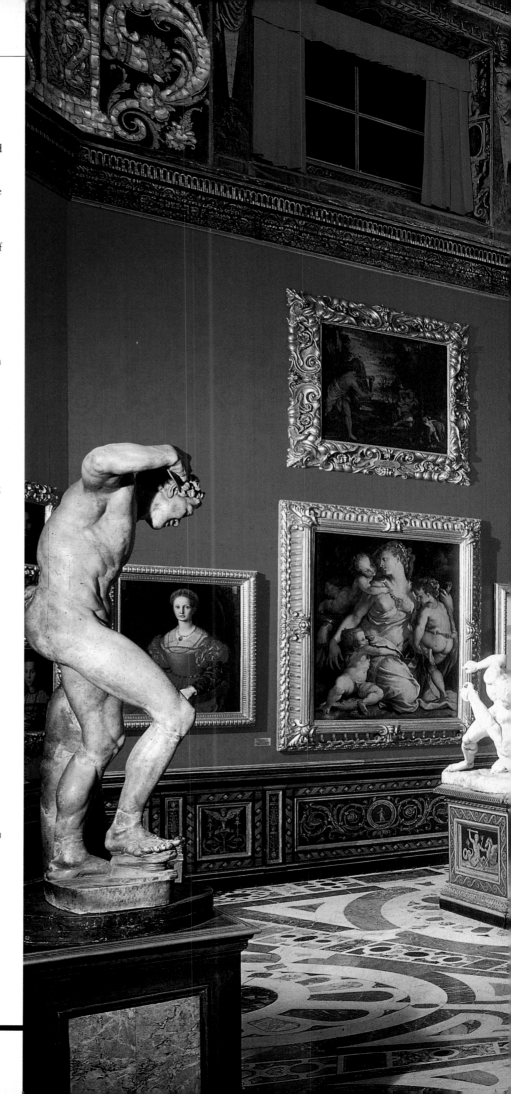

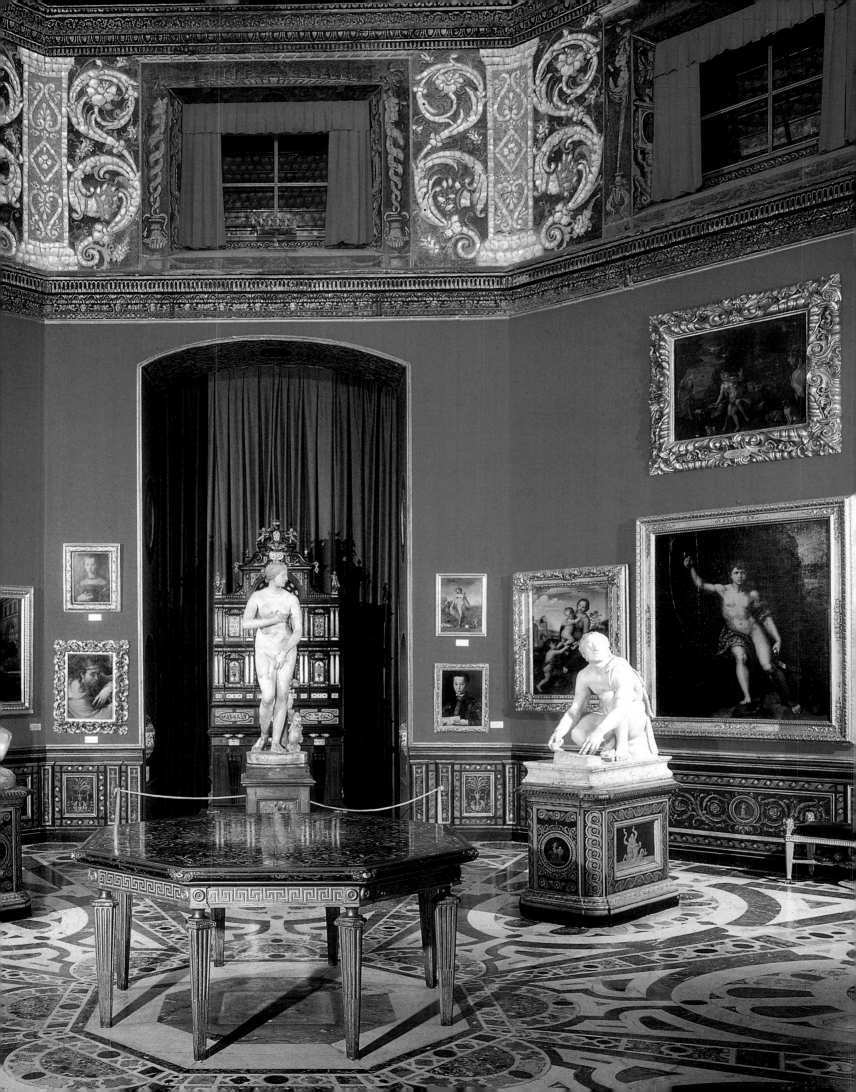

Simone Martini

The Nineteenth-century frame of this painting (*The Annunciation*, tempera on panel, 184 × 210 cm.) has an inscription transferred to it from the original—"Simon Martini et Lippus Memmi de Anno Domini MCCCXXXIII Senis me pinxerunt"—which tells us that the work was a collaboration between Simone Martini, the most important exponent of the Gothic style in Siena and amongst the most important in Europe, and his brother-in-law, Lippo Memmi. Lippo's intervention, however, must have been minimal and largely decorative and perhaps included the now lost frame. Payment documents which record that he earned small sums compared to Simone support this thesis.

The surviving figural elements including the central scene of the Annunciation, the lateral figures of Saints Ansano and Massima and the small tondi above with representations of the prophets Isaiah, Daniel, Ezechial and Jeremiah all show both a similar style and an extraordinarily high quality of execution leaving little room for a hand other than the great master's. Simone worked on this altarpiece shortly before he moved to Avignon in 1336 to join the papal household. He was thus a fully mature artist, and it was his style to elaborate his images—the vase of flowers as well as the human figure—using abstract and symbolic abbreviations that require an extraordinary intellectual and aesthetic involvement.
The painting was commissioned by the Opera of the Sienese cathedral for the Saint Ansano altar, one of four dedicated to the patron saints of the city. It was removed from its original location in 1596 when the altars were modernized in accordance with the new ideas of the Counter-Reformation; it was moved to a much less prestigious spot at the Oratory of Sant'Ansano in Castelvecchio di Siena. The work was offered for sale to the Uffizi in 1798 because the Opera needed funds to repair the cathedral after an earthquake; the transfer took place the following year, although it was an exchange of works decreed by the Grand Duke.

The masterpiece by Simone Martini, painted in 1333 for the Cathedral of Siena, became part of the Grand Duke's collection around 1798. The acquisition was part of a phase of enrichment of the Grand Duke's collection as a result of purchases or exchanges.

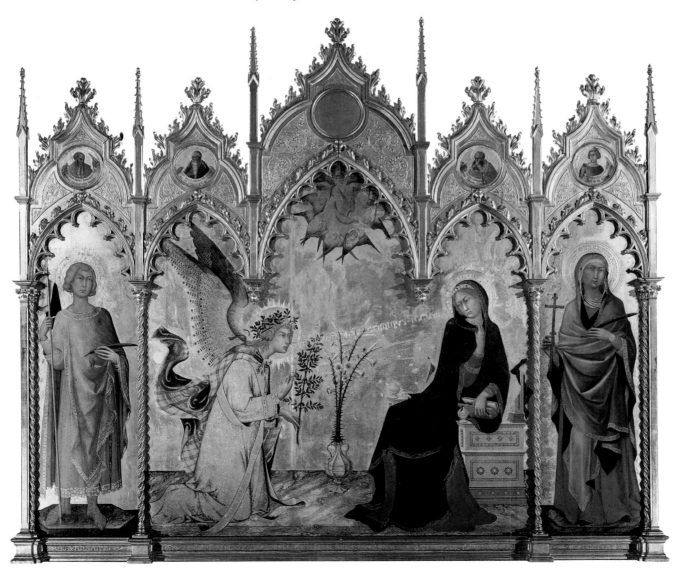

Gentile da Fabriano

The wealthy Florentine banker, Palla Strozzi, paid some 150 gold florins for Gentile's *Adoration of the Magi* (tempera on panel, 301 × 283 cm.) which he painted between 1420 and 1423 for the Strozzi family chapel in the church of Santa Trinita. The cost was certainly very high, but the prestige of the painter from the Marches, whom Palla brought to Florence and who was then at the height of his career, and the perfection of the painting justified it. This work represents the epitome of the international Gothic style that dominated Europe in the early part of the Fifteenth century and of which Gentile was amongst the best exponents. The principal scene represents the procession of the Magi, thick with a throng of figures, but it takes on more of the air of a court festival with idealized figures dressed in costly materials and with fashionable coiffures; each and every decorative detail is carefully worked and emphasized. The same fairy-tale atmosphere can be found in the predella scenes of the *Nativity*, the *Flight into Egypt* and the *Presentation in the Temple*, the last of which is a good copy of the original plundered by Napoleon's troops and now in the Louvre in Paris. The carved and gilded frame is also very important to the impact of the work, and it was likely designed by Gentile himself since he also painted the beautiful floral friezes that decorate its lateral piers. The altarpiece, which is signed "Opus Gentilis de Fabriano/MCCCCXXIII Mensis Maii" on the frame just below the principal scene, remained in its original location in the Strozzi Chapel until 1810 when it was moved to the gallery of the Accademia and then, in 1919, to the Uffizi.

The monumental altarpiece painted by Gentile da Fabriano in 1423 for Palla Strozzi had always been conserved in the family chapel in Santa Trinita. It was transferred to the gallery in 1810 during the Napoleonic plundering of convents and churches.

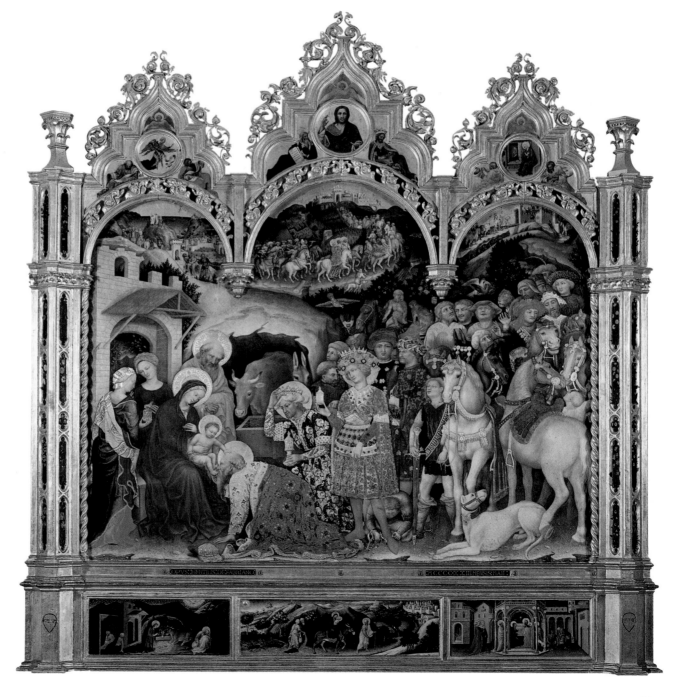

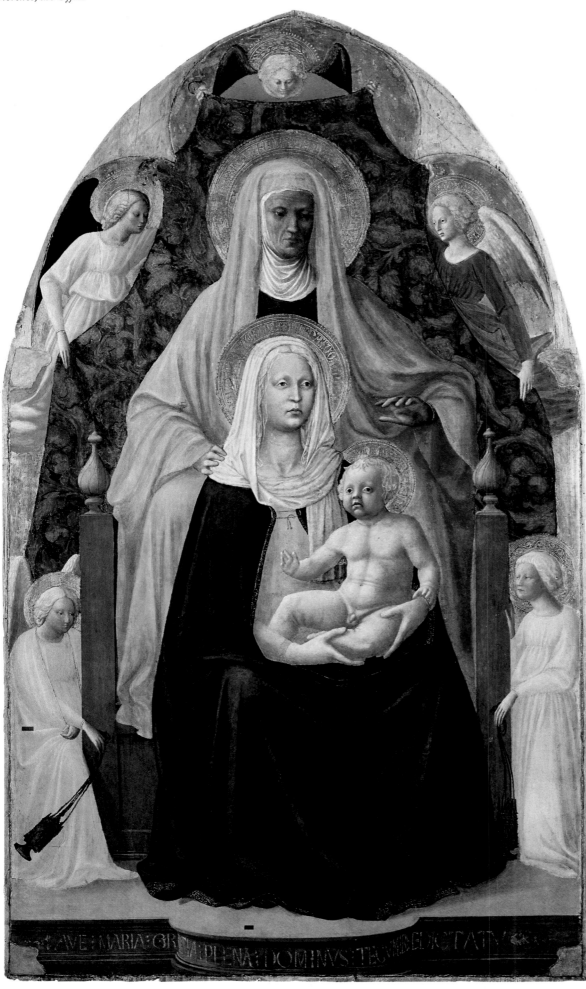

Masolino and Masaccio

The Madonna and Child with Saint Anne and Angels symbolizes the intersection of two great figural styles and then the victory of one over the other. The first is the Gothic which found, in its last phase in Florence, an artist—Masolino— particularly sensitive to its florid possibilities; the second is that of the Renaissance, still in its infancy, and it was Masaccio himself who would codify its essential principles. The iconography of the work is that of the traditional Saint Anne Metterza (or *messa terza*, i.e. with the Virgin and the infant Christ).

It was especially common in Florence where the cult of Saint Anne had been particularly popular since July 26, 1343, her feast day, when the populace rose up and expelled the tyrant Gualtieri di Brienne. It is possible that it was made for the church of Sant'Ambrogio where Vasari, describing it as a work by Masaccio, saw it in the Sixteenth century. Roberto Longhi, after a careful stylistic analysis of the painting in 1940, concluded that the panel was in reality a collaboration between Masolino, the mature master, and Masaccio, his young collaborator. This painting (tempera on panel, 175 × 103 cm.) is likely dated to 1424-1425, just before this pair began to fresco in the Brancacci Chapel in Santa Maria del Carmine. By this time Masolino was a well-known and successful artist and likely the master who received the commission. The painting was moved from Sant'Ambrogio to the gallery of the Accademia and then, in 1919, to the Uffizi.

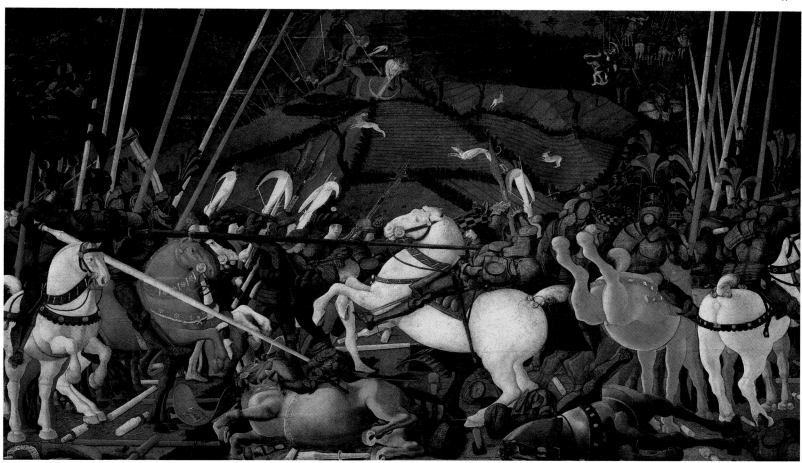

Paolo Uccello

The Battle of San Romano was part of a series of three large panels (tempera on panel, 185 × 220 cm.) (the other two are at the Louvre and the National Gallery in London) by Paolo Uccello representing the battle on June 1, 1432, in which the Florentines, led by Niccolò da Tolentino, defeated the Sienese, commanded by Bernardino della Ciarda. Uccello likely executed the work not long after the battle itself. It has recently been shown that the three paintings originally hung in the Florentine residence of Leonardo Bartolini Salimbeni who probably commissioned them. In about 1480 Lorenzo the Magnificent managed to acquire them by coercion and installed them in his room on the ground floor of the Palazzo Medici Ricciardi where they are mentioned in the inventory made at the time of his death in 1492. It is likely, based on the violent diatribes, which had some legal ramifications, between Lorenzo and the Bartolini

Salimbeni family, that they were valued as much for their extraordinary artistic quality as for their historical significance. And indeed Uccello, a visionary artist of great creativity, offers us one of the most original interpretations of the rules of Renaissance perspective—completely contradicting the contemporary conventions—and thus pushes meaning in the opposite direction from Masaccio's realism.
The three panels, which have been cut down at the top, were in Cardinal Carlo de' Medici's collection at the Casino of San Marco in the Seventeenth century. They came to the Uffizi between 1769 and 1784 and were separated in the early Nineteenth century when two of them made their way onto the art market. The central panel, signed "Pauli Ugieli opus," on the lower left, remained in Florence; it is thought to represent the decisive moment of the battle when the Sienese general was knocked off his horse.

During the drive to acquire works of art to add to the Grand Duke's collection in the second half of the Seventeenth century, important works entered the Uffizi, such as the three canvases with Battles painted by Paolo Uccello, two of which were later put onto the antiquities market.

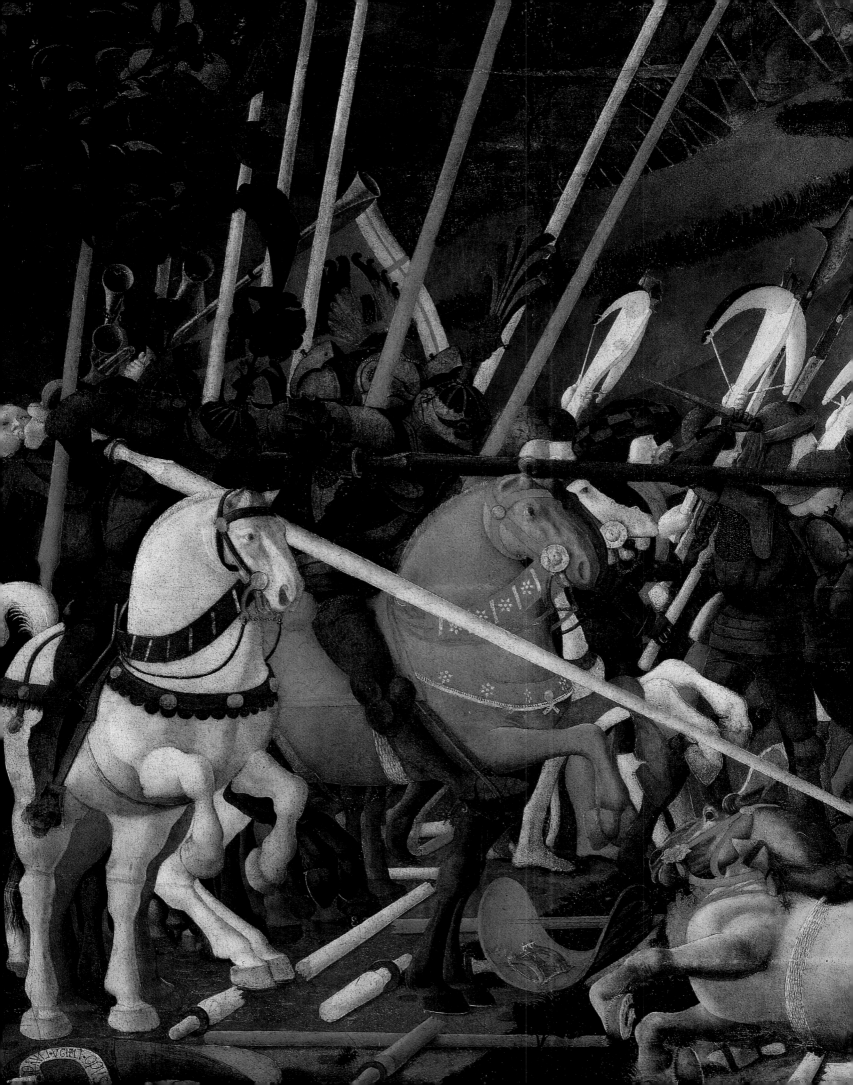

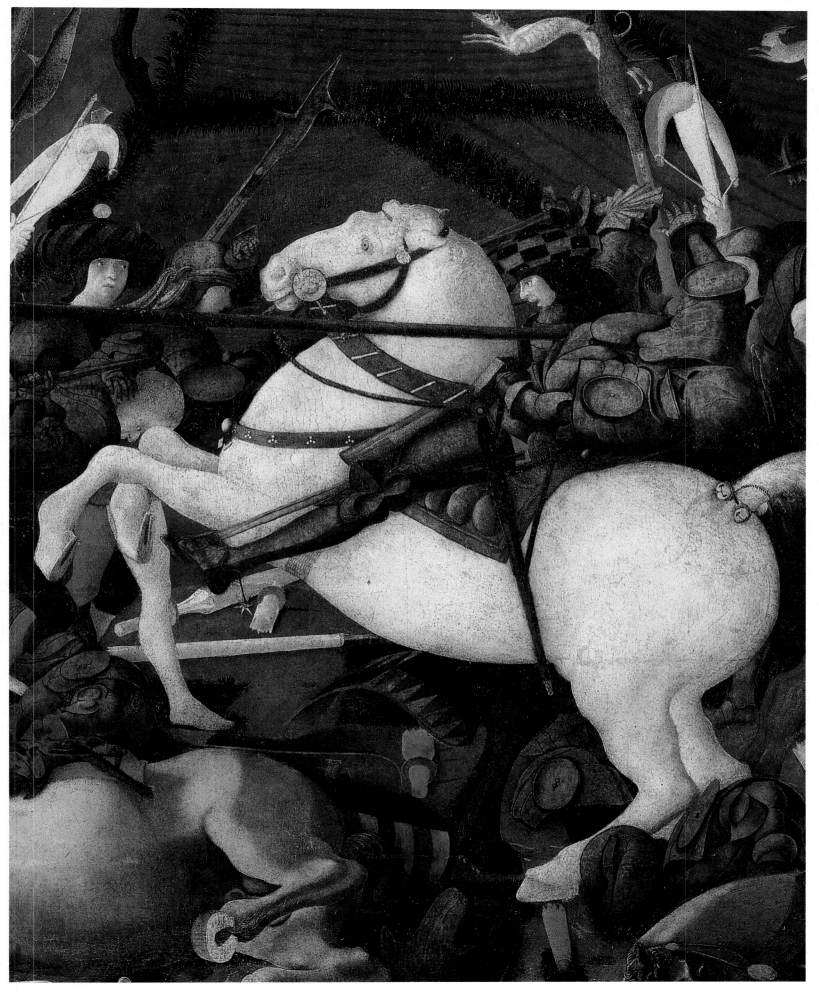

The Prints and Drawings Department

Raphael, study for the
Madonna del Granduca

*The creation of one of the greatest
collections of drawings in the world
today was thanks to the efforts
in the Seventeenth century
of a skilled collector, Cardinal Leopoldo,
brother of the Grand Duke
Ferdinando II.*

The enormous collections of prints and drawings at the Uffizi also owe their origin to the Medici family's passion for building its private collection. We know that the family owned drawings as early as the time of Lorenzo the Magnificent and that during the Sixteenth century various family members, including Cosimo I and his son, Francesco, continued to add the collection of graphic works.

It was, however, Cardinal Leopoldo, Grand Duke Ferdinando II's brother and a collector of great acumen, who really provided the definitive impulse for the collection which is, today, one of the principle holdings of graphic art in the world. Leopoldo was a man of unusual intelligence and profound Humanistic and scientific learning, and he spent vast sums over the course of his life to gather an extraordinary collection of works of art including about 12,000 drawings by

Old Master and contemporary artists, both Italian and foreign. He chose them with an eye for both their artistic quality and historical value. Leopoldo's collection, which was later enlarged by other family members and their circles, was moved from the private apartments in the Palazzo Pitti to the museum in the Uffizi in 1687. It thus became available to a larger public beyond the Medici and their court. The Lorraine branch of the Hapsburg family, which succeeded the Medici in 1737, also added significantly to the collection. Pietro Leopoldo in particular acquired whole collections of enormous importance such as that of the Gaddi, the Highford and the Michelozzi families. After the unification of Italy in the Nineteenth century, the collection of prints and drawings attracted something new— private donations—which had been relatively modest

before. Donations came both from collectors (such as the exceptional gift of some 13,000 Old Master drawings by Emilio Santarelli in 1866) and artists themselves. Indeed the latter began to recognize that public institutions were the most appropriate place for their graphic work since they were well aware of the special significance that it would have, and especially when preserved together and in a place equipped to conserve it and allow it to be consulted, in documenting their artistic development.

Gifts continued to be the principal means by which the collection grew in the Twentieth century. Several very important acquisitions came to the museum in this way including a group of Giorgio Morandi's aquatints given to the Uffizi by his sister.

Facing page
The Miniatures Department

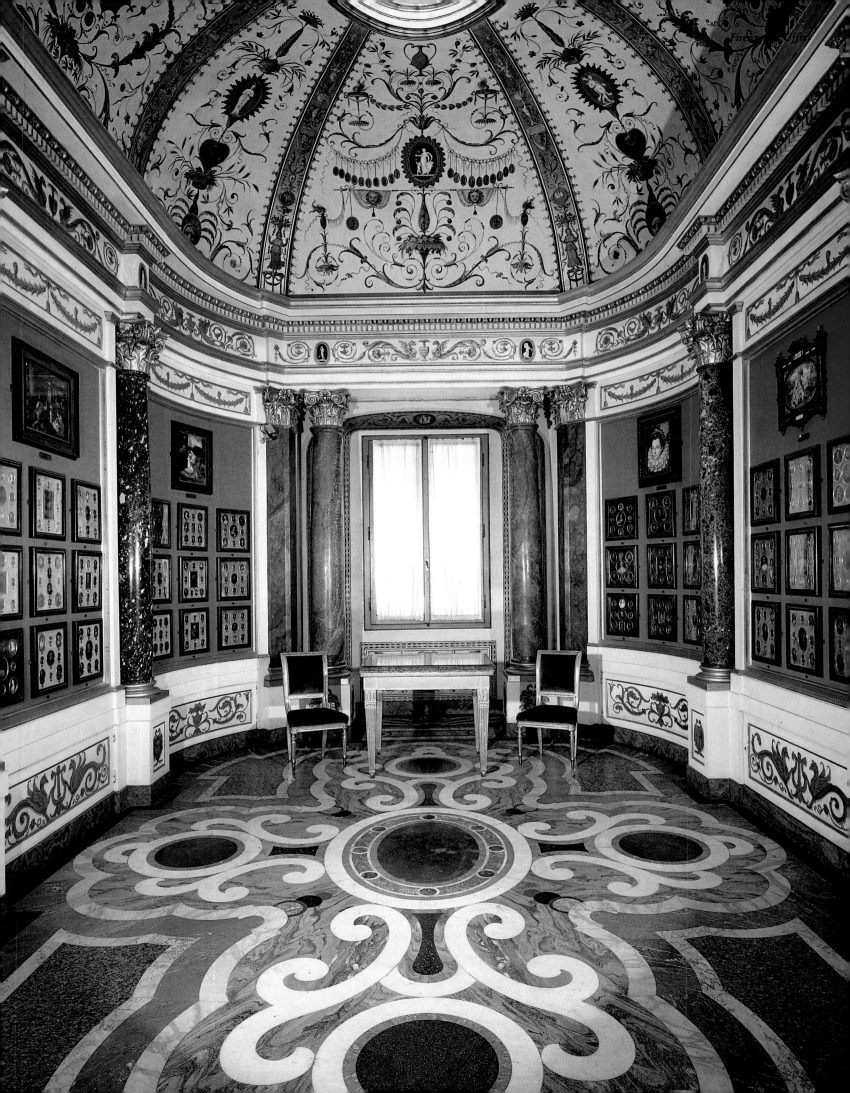

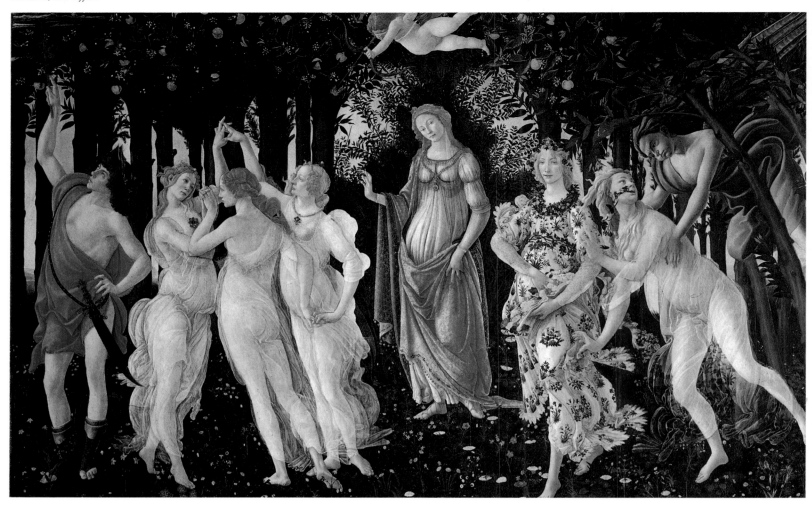

Sandro Botticelli

Lorenzo the Magnificent's cousin, Lorenzo di Pierfrancesco de' Medici, played an important role in the cultural life of Florence in the second half of the Fifteenth century. His house on the Via Larga, as well as his villa at Castello, were meeting places for artists, literati, philosophers and scientists of extraordinary calibre. Botticelli seems to have been his preferred artist, and we find him working for Lorenzo di Pierfrancesco on a variety of works of art from the extraordinary illustrations for the *Divine Comedy*—today divided between Berlin and the Vatican—to several well-known paintings including this *Allegory of Spring* (tempera on panel, 203 × 314 cm.), which is the most famous of all. Botticelli executed it during the most intensely creative period in his long artistic career, just before he went to Rome where he was called in 1482

to participate in the frescoing of the walls of the Sistine Chapel.

The subject of the painting, a typical expression of the complex cultural underpinnings of Laurentian Florence, can no longer be explained in every detail. There are some references to literary texts, including Ovid's *Fasti*, Apuleius's *Golden Ass* and Poliziano's *Stanzas* written for a Medici tournament as well as to Humanist philosophical theories and especially those of Marcilio Ficino. The composition, which moves from figure to figure with the harmony of a musical or poetic phrase, suggests more a symbolic presentation of images than the telling of a story. The proposed identification of the central figure as Venus seems convincing. In Humanist thought, and again especially in Ficino's work, she separates the spiritual world (represented on the left by the Graces and Mercury

who, with a gesture of his hand, dissipates the clouds of ignorance) from that of instincts, personified by the wind god Zephyr who pursues Flora. As he catches her she transforms into Spring and strews the ground with flowers, symbols of beauty and fertility.

This painting was documented in Lorenzo di Pierfrancesco's house in 1498 and it was only later moved to the villa at Castello. At his death the villa and its contents passed to Giovanni delle Bande Nere de' Medici and then, in 1526, to Cosimo de' Medici, future Grand Duke Cosimo I of Tuscany. Vasari saw and described the picture at Castello in 1550, and it remained there until 1815 when it was moved to the Uffizi. It was then hung at the gallery of the Accademia before returning definitively to the Uffizi in 1919.

The Allegory of Spring, *painted by Sandro Botticelli around 1481 for Lorenzo di Pierfrancesco de' Medici, is one of the works that is a symbol of the Uffizi. It has always been part of the Florentine family's heritage, and came to the museum only in 1815 from the Grand Ducal residence of Castello.*

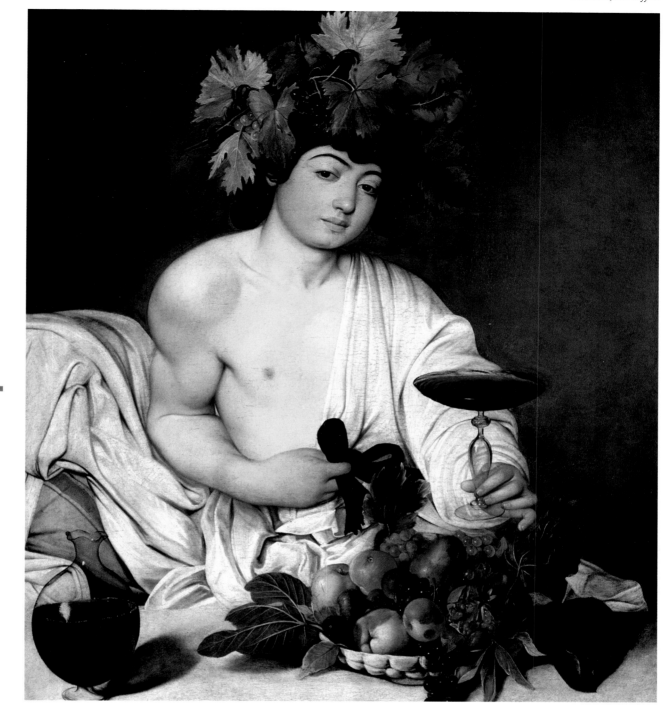

*The Uffizi
has three important
paintings
by Caravaggio.
They testify
to the museum's
ability to document
eras and schools
different from those
of the Renaissance.*

Caravaggio (Michelangelo Merisi)

The Uffizi has three examples of the work of Caravaggio, the artist who at the end of the Sixteenth century brought about an extraordinary change both in Italian and European art. Their presence in the collection is a good reminder that the museum has good examples of work outside the Renaissance period including this lovely *Bacchus* (oil on canvas, 95 × 85 cm.) which, with the *Sacrifice of Isaac* and the *Head of Medusa*,

represent the best of Caravaggio's production. This is a youthful work executed before the end of the century and probably while the artist was working in Rome for his patron and protector, Cardinal Francesco Maria del Monte. It is one of a group works executed during a particularly happy time in the artist's life and career; others include the *Boy with a Basket of Fruit* in the Borghese Gallery and the *Basket of Fruit* at the Ambrosiana in Milan. These works completely abandoned contemporary trends in

painting, including both the late Mannerist style which had come to value decoration as an end in itself and Counter-Reformation pictures which were heroic in content and form but also weighed down by a didactic quality that overshadowed any expressiveness. Here instead Caravaggio recreates a reality on his canvas that justifies its own existence. Nor do the references to Classical antiquity, apparent in the boy's anatomy and the position of his body, detract from the detailed truth of the image.

It is likely that this painting entered the Grand Duke's collection early in its history, perhaps as a gift from Cardinal Del Monte to Ferdinando dei Medici shortly after it was made. It was permanently installed at the Uffizi in 1916.

Reorganisation of the museum

The Uffizi survived the looting of its treasures by Napoleon's armies, and the determined efforts of its director at the time, Tommaso Puccini, averted a more drastic outcome. Afterwards and over the course of the Nineteenth century both the Egyptian collection (which today, after a variety of homes, is now in the Archaeological Museum) and the department of Modern Art, which became the seed collection for the museum of Modern Art in the Pitti Palace, were definitively removed from the Uffizi. Other important events included the conversion of Vasari's corridor into museum space and its subsequent renovation. It was opened to the public in 1866 with an exhibition of the Uffizi's Etruscan collections on the two landings and tract along the Lungarno Archibusieri, a huge selection of drawings in the section on the Ponte Vecchio, Medici portraits and mythological paintings inside the Torre dei Mannelli and finally, the collection of Jacopo Ligozzi naturalistic *bozzetti* and temperas in the Via Guicciardini.

As the Galleries were developing and changing, so too were other parts of the building. The State Archives were moved to the Uffizi in 1852 and occupied most of its two lower floors and created, for more than a century, a real obstacle to the further expansion of the museum.

The exceptional circumstances around the post-war reconstruction and restoration of the Uffizi and then the exponential growth in the number of tourists who visit it are two of the significant challenges the museum has faced in the Twentieth century. Perhaps the most important event was the renovation of the early Italian galleries, completed by Giovanni Michelucci, Carlo Scarpa and Ignazio Gardella in 1956. The criteria they used, which were very much of their time, tended to create an intense and almost emotional relationship between the viewer and the work on display. Sala 2, which houses Thirteenth century works, is especially interesting because the vertical proportions of its architecture, the trusses visible beneath the roof and the other structural and decorative elements were intended to evoke a sense of the medieval churches that originally housed the masterpieces by Cimabue, Duccio and Giotto exhibited there.

The two monumental canvases of Majesty, painted by Duccio di Buoninsegna (1285) and Giotto (1306-10), alongside Cimabue's canvas, represent the visual and thematic fulcrum of the new Thirteenth Century room.

The Thirteenth Century room, laid out by Giovanni Michelucci, Carlo Scarpa and Ignazio Gardella (1956)

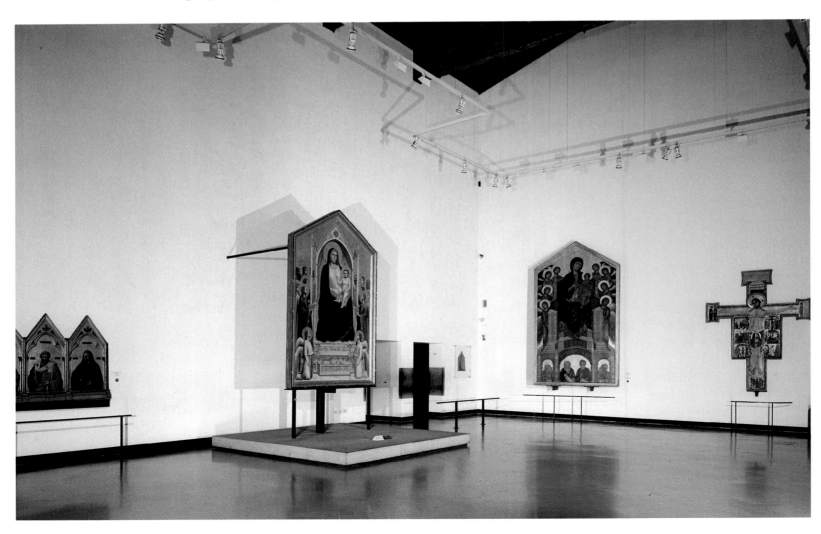

Duccio di Buoninsegna

Madonna and Child Enthroned with Angels (tempera on panel, 450 × 293 cm.) is one of the most important Tuscan works of the Thirteenth century and is evidence of the important interchange between Florence and Siena. It represents a time of productive contacts between the two schools which can be seen in similar stylistic qualities and physiognomies. This work was long attributed to the Florentine artist, Cimabue, even after the discovery at the end of the Eighteenth century of the contract for the painting. It mentions the artist specifically—"Duccio quondam Boninsegne pictori de Senis"—and was signed on April 15, 1285 by Father Vincenzo Fineschi on behalf of the Confraternity of the Laudesi which intended it to be used for decoration of their chapel in the Dominican church of Santa Maria Novella.

Although there is a certain sense of Cimabue's influence in the rigorously symmetrical composition and in the suggestion of volume in the head and right knee of the Virgin, the style of the work is typically Sienese and Duccio-esque. It represents a purely transcendent world through expressive form that plays on the jewel-like quality of the palette and the refined use of line. The panel represents the moment when the angels place the throne of the Virgin in its rightful place in paradise. The painting survives with its original and very beautiful frame—an extraordinarily rare occurrence for a picture of this period. The chapel of the Laudesi was sold in 1335 to the Bardi di Vernio family, and the altarpiece was then moved several times within the church until it was finally placed in the Rucellai chapel in the Seventeenth or Eighteenth centuries. It remained there until 1948 (and it is still called the *Rucellai Madonna*) when it was installed in the Uffizi. Duccio's altarpiece is one of the pivotal images in the famous arrangement of Sala 2, designed by Giovanni Michelucci, Carlo Scarpa and Ignazio Gardella.

In the 1950s major renovation and reorganisation of exhibits were carried out in the Uffizi. Much of this was the result of the project by the architects Giovanni Michelucci, Carlo Scarpa and Ignazio Gardella. In 1956 they completed the work on the Primitives room, with the works of Cimabue, Duccio and Giotto. The wide spaces covered with beams evoked the atmosphere of medieval churches.

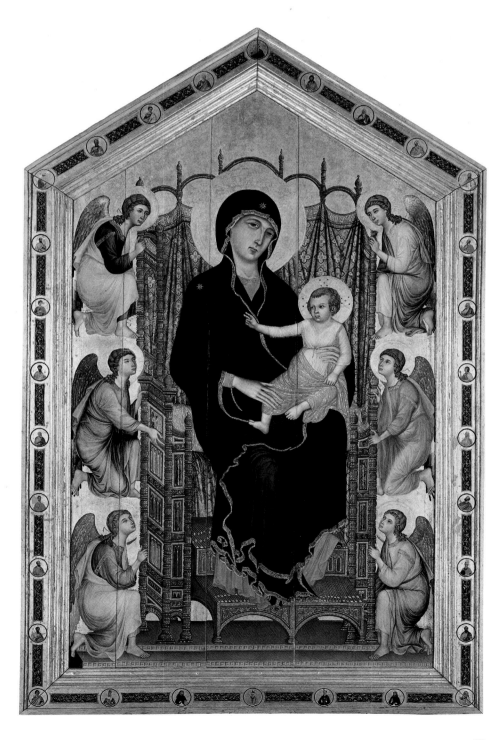

The new layout

It is worth noting that the early Italian galleries as well as the Department of Prints and Drawings below them, admirably renovated by Edoardo Detti in 1960, and the restoration of the Leonardo Room (Sala 15), laid out by Michelucci and finished in 1989, all fit very nicely, their unequivocal modernity notwithstanding, into the layered history of the Uffizi. This is true not simply because the traditional Florentine building materials of white plaster, *pietra serena* and brick were used but also because of the sobriety of the structure and the lucid equilibrium of the spaces it defines. These examples continue to serve as models for the current interventions which the museum's directors are now undertaking. The goal is simply structured spaces with diffused lighting (preferably zenithal) and no hot spots; they are to be characterized by understated furnishings and equipped with fixtures compatible with the special nature of the surrounding architecture. These were the principles which guided both the restoration of sixteen rooms on the main floor of the west wing—part of the Nuovi Uffizi , or New Uffizi, project—for the major exhibitions held in 1992 and 1996 and in the renovation of the Lippi Room (Sala 8), completed in 1997. They also underlay the restoration of the rooms in the west wing damaged as a result of the 1993 bombing, from the so-called Sixteenth Century Corridor (Sala 33), completed in 1998, to the Counter-Reformation Room (Sala 35) which was refurbished in 1999 and from the Rubens Room (Sala 38) to the last rooms in the Gallery (Sale 43-45) which were reopened just last year (2000).

The New Uffizi

As a result of the process described above, the Uffizi is now ready today to face another fundamental change which will put it on the same plane as the major European museums. This plan calls for the completion of the now famous project for the Nuovi Uffizi (New Uffizi) which was finalized by the Museum's administration in 1989 (and with some logistical changes made in 1993 in the wake of the bombing attempt on Via Georgofili) but then became mired in a series of unsuccessful efforts to block it. This project proposes ways to expand the museum but within the confines of Vasari's palace. It would allow for both a vital increase in exhibition space and for a series of important services and infrastructure which are, at the moment, either non-existent or are inadequate for the needs of the institution.

The Leonardo Room, laid out by Giovanni Michelucci (1989)

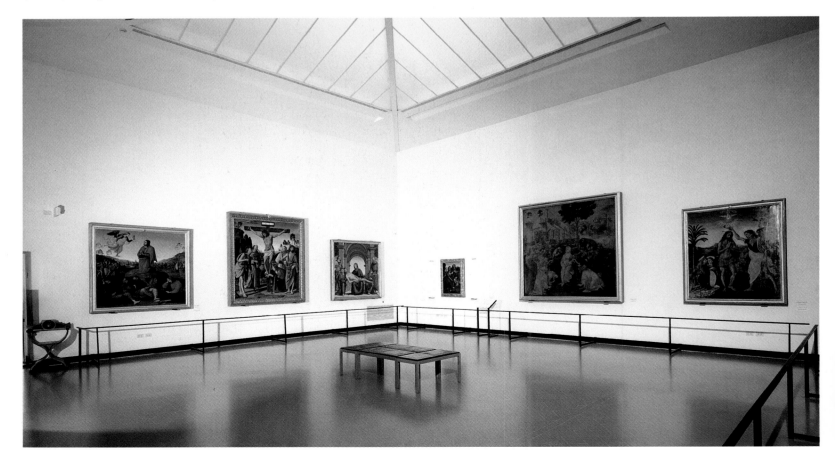

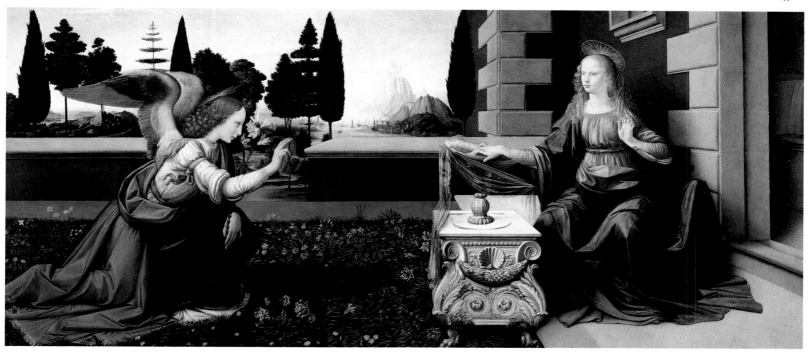

Leonardo da Vinci

The *Annunciation* (oil on panel, 98 × 217 cm.), one of the most famous masterpieces of Florentine Fifteenth-century painting as well as of Leonardo's own rather small *oeuvre*, is an important document of one of the most problematic chapters in the history of Italian art. There is no contract nor any payment documents for this work, and it is never mentioned in the older literary sources, including Vasari's *Lives*. Furthermore its shape and size, while excluding the possibility that it was an altarpiece, give no clue to its original function. The first mention of the painting describes it in the church of San Bartolomeo in Monteoliveto, which was perhaps where it was intended to go, and it stayed there until it was moved to the Uffizi in 1867. It came to Florence with a dubious attribution to Domenico Ghirlandaio and was later given to Verrocchio, Ridolfo Ghirlandaio and finally Lorenzo di Credi with Leonardo's assistance. Today most scholars agree that Leonardo himself executed this panel; Liphard first made this attribution when the picture arrived at the Uffizi. Amongst the uncertainties that accompany the attribution of this work is the presence of several "mistakes" in the perspective construction of the scene, basic mistakes that one hesitates to attribute even to a young Leonardo. These errors can be found, for example, on the right side of the panel where the walls and the stone blocks of the building seem to have different proportions; the Virgin's right arm, too, seems over long in order that her hand can reach the open book on the lectern. Yet these anomalies correct themselves, as the recent cleaning which has restored the proper relationships in the play of light and shadows makes clear, when one realizes that the picture was intended, in its unknown original location, to be seen from the right and from below. This aligning, unusual for the period, of the fictive space of the picture with the position of the viewer can only further reinforce the panel's attribution to Leonardo.

The ability to render the material quality of objects and surfaces by means of just the right amount of light vibrating on the colours is another quality that belonged exclusively to Leonardo. We see it in the natural fullness of the flowers and grass in the field, the realistic rhythm in the drapery folds and in the transparency of the veils, in the porous quality of the brick pavement beneath the Virgin, which was a detail not uncommon in Verrocchio's workshop where Leonardo worked as a young artist and just at the moment, it seems, when he painted the *Annunciation*.

The Vasari Corridor: the link beetween the Uffizi and the monumental complex of the Pitti Palace

The stairs from
the west Gallery
to the Vasari Corridor.

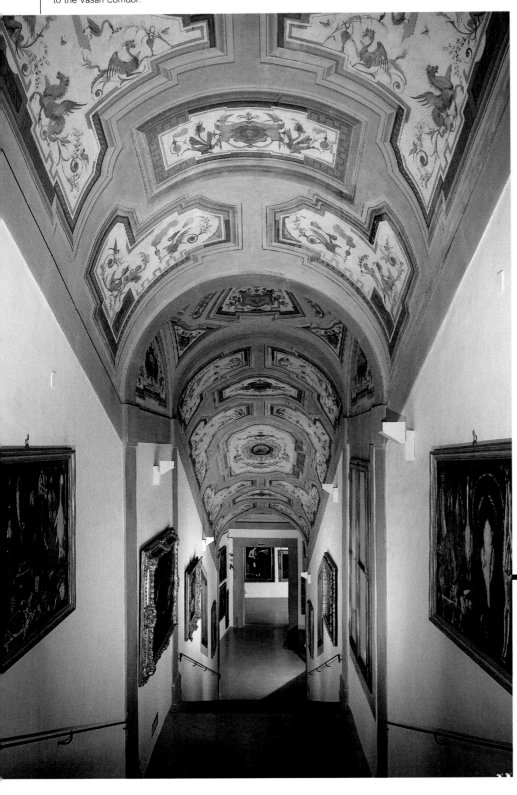

Cosimo I commissioned Vasari in 1565 to build a corridor, a sort of private pathway that linked the Medici residence at the Palazzo Pitti to the Palazzo Vecchio, the seat of the city's government. On its way the Corridor crossed the Arno on the Ponte Vecchio and then passed through the Uffizi by way of the gallery on the third floor and into the Palazzo Vecchio via an overpass that soars high over the Via della Ninna. Scholars have interpreted the significance of this unique architectural work—an extraordinary aerial road which runs for more than a kilometre through the heart of Florence, partly hidden by blocks of buildings and in parts open to some of the most lovely panoramas of the city, in a variety of ways. When one walks through it, for example, one tends to see its function as a museum—the corridor as a natural extension of the gallery which, for logistical reasons (its architectural form forces the visiting public to be treated hierarchically), cannot be included as part of the normal tour of the collection. There were more than 800 works on display in the Corridor, including a huge selection from the famous collection of self-portraits begun by Cardinal Leopoldo de' Medici in the Seventeenth century and now, after centuries of additions and aquisitions, a collection of extraordinary importance.

Others might also appreciate the Corridor for its design which is a marvel of engineering for its time. Crossing the Arno, for example, posed a real problem which Vasari was able to work out in only a few months. The contract for the project was finalized on March 12, and the first pier was built on the Lungarno Archibusieri on the 19th of the same month. By September the whole of the corridor was passable and by November the finishing work was complete. It also had strategic importance given that the Grand Duke was able to move from one side of the river to the other safely. There were social functions as well; the court, for example, could participate in religious services at Santa Felicità from the corridor as if it were a theatre box. It also caused problems; the passage narrows significantly to pass around the medieval Torre dei Mannelli which that family refused to cede to Cosimo and its destruction. The Corridor might also be interpreted as a symbol of absolute power, a tool by which the prince can watch, without being seen, the movements of his subjects. It cannot be an accident, then, that the windows of the corridor allow broad views of some of the principal streets in the centre of town.

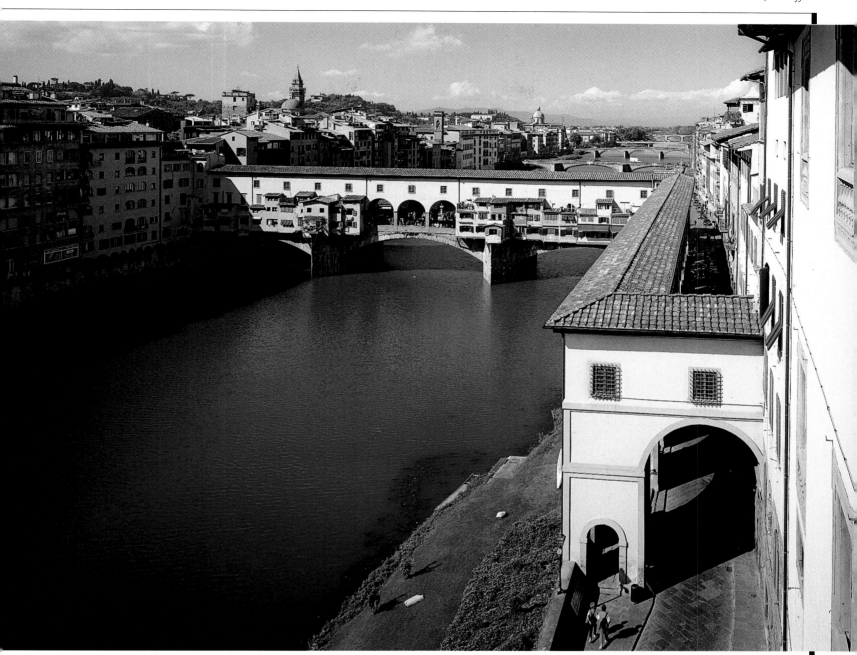

The Vasari Corridor along
the Lungarno Archibusieri
and the Ponte Vecchio.

*For the creation of the Vasari Corridor,
Cosimo I engaged Vasari to design
an internal route that united the seat
of the Grand Ducal government
(Palazzo Vecchi and Uffizi)
with the new princes' residence
of Palazzo Pitti, by means of a covered passage
way crossing the Arno.*

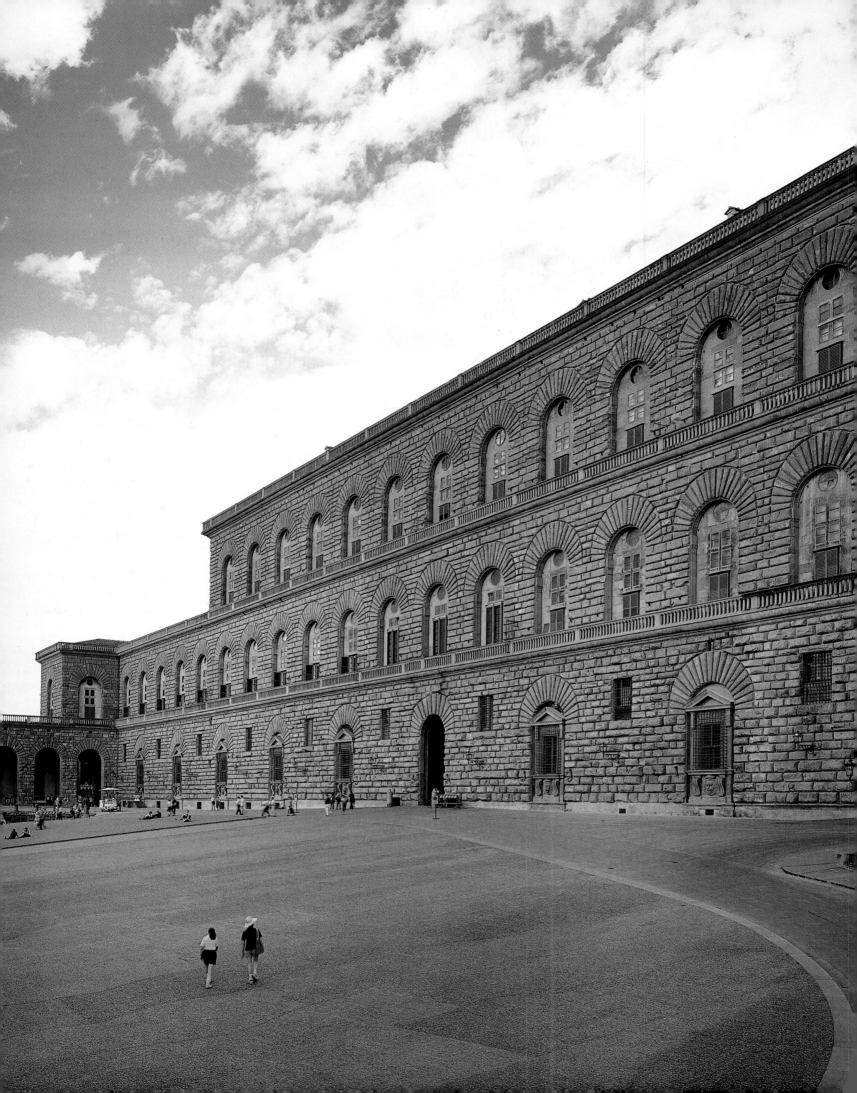

Florence, the Palatine Gallery at the Pitti Palace

Serena Padovani

The Palazzo Pitti takes its name from Luca Pitti, the Florentine merchant who built his palace at the foot of the Boboli Hill amidst gardens and cultivated fields in the middle of the Fifteenth century. Despite the glory it would achieve as the residence of the Grand Dukes of Tuscany, the building has always been known by its original name. Luca Pitti's residence, traditionally attributed to the great architect Brunelleschi, grew into the grandiose palace we see today over the course of several centuries, changing and expanding to meet the needs and tastes of three reigning dynasties: the Medici who acquired the building from the heirs of the Pitti family in 1549 and then lived there until 1743; the Hapsburgs of Lorraine who succeeded them and governed until 1860; and finally the Savoia kings of Italy who kept it as a crown possession until it was donated to the Italian State in 1919. At that time the Pitti Palace became home for three museums. The Silver Museum on the ground floor houses what survives of the precious objects from the collection of the Grand Dukes (Lorenzo the Magnificent's famous vases, the German carved ivories commissioned by the Medici in the Seventeenth century, vases of the Sixteenth through Eighteenth century made from semi-precious stones and rock crystal, cameos and jewels, and the so-called "Salzburg Treasure" as well as exotic objects imported from the New World and the Far East. The Palace or Palatine Gallery on the *piano nobile*—the first floor—abuts the Royal Apartments and is the subject of this essay, and finally the Museum of Modern Art on the second floor which was founded by King Vittorio Emanuele II with the pictures he had acquired at the great Expositions

around Europe. This collection is noteworthy for its Neoclassical and Romantic masterpeces, an important group of works by the Macchiaioli and its exhaustive documentation of the work of Tuscan artists up until 1950. In addition to these institutions, the Boboli Gardens were made into a museum in 1990 to safeguard and underscore their historical and artistic importance in the history of garden architecture and sculpture.

Although each museum has its own administration and admissions tickets, they all share a common history. The collections they house are more logically arranged, but the majority of the objects they contain have always been in the royal residence connected by way of Vasari's Corridor to the Palazzo Vecchio, the seat of government, and the Uffizi which housed its bureaucracy. The palace was defended by the Belvedere fortress on top of the Boboli Hill which itself had been transformed into a garden behind the palace.

There are several reasons why the Palatine Gallery, the picture gallery of the palace, is the heart of the complex reality that is the Pitti Palace. It is located in the most impressive part of the *piano nobile*; it was, at the time of the Medici, the apartments of the Grand Duke. In about 1640, Ferdinando II had Pietro da Cortona decorate these rooms with stuccoes and frescoes that celebrated the glory of his family. This decoration remains the greatest example of Baroque painting in Florence. The Gallery's collection of masterpieces of Italian and European art of the Sixteenth and Seventeenth centuries, extraordinary both in its size and quality, is unique in the world.

View of the facade of
the Palazzo Pitti in Florence

View of the interior court
of Palazzo Pitti and a glimpse
of the Boboli gardens with
the Amphitheatre and the
Artichoke Fountain

The Medici collections

The works of art collected by the Grand Dukes formed the core of the collection of the Palatine Gallery at the beginning of the Twentieth century; these pictures had for hundreds of years been hung throughout the palace, moving from place to place according to the needs of each succeeding generation of the ruling families. Cosimo I commissioned Bartolomeo Ammannati to make the Palazzo Pitti into the residence of the Grand Dukes of Tuscany, and work on it began soon after the building had been acquired from the Pitti family. Some areas of the building were finished quickly and used during occasional visits Francesco I and his courtiers made to the palace, and the Sala delle Nicchie (Room of the Niches) at the centre of the first floor had been made into an *antiquarium* for Cosimo I. Yet the Palazzo Pitti was not occupied permanently until 1587 when the third Grand Duke, Ferdinando, moved into the north wing of the *piano nobile* facing the central courtyard. The rooms next to his were renovated in 1589-1590 for his wife, Christina of Lorraine. The project to decorate the "Apartment for Foreign Cardinals and Princes" (today the Appartamento degli Arazzi and the mirror image of the Grand Duke's quarters but in the south wing of the palace) began at the same time and continued until Ferdinando's death in 1609.

The Palace as it expanded over the next century was the ideal setting for the Medici collection. The inventory of "all the furnishings in the Palazzo Pitti," today preserved in the State Archives in Florence, meticulously describes the locations of paintings, sculptures, furnishings and household objects from the ground floor to the attics. The furnishings in the palace altered with the changing tastes of its residents and the times in which they lived, but the rather dry registers made by the *guardaroba* do indicate the extraordinary richness of the spaces which served as backdrops to life at the Tuscan court. These lists record the contents of the summer and winter apartments of the Grand Duke and Duchess, located on the ground floor and *piano nobile* respectively (the winter quarters were adorned with tapestries), and it also inventories the apartments occupied by relatives, those of the children on the second floor for example, as well as the mezzanine rooms for the majordomos, pages and servants. It lists both the objects of varying value and the great masterpieces of painting in the family collection.

Andrea del Sarto

The Florentine merchant,
Bartolomeo Panciatichi,
commissioned Andrea del
Sarto to make this
Assumption of the Virgin
(panel, 326 × 209 cm.) for his
chapel in the church of
Notre-Dame-du-Confort in
Lyons. The work, however,
was never delivered to the
city and remained unfinished
in the painter's studio. The
painting passed to the
patron's son in 1536, and it
was later installed in the
chapel of the former
Baroncelli villa which the
Grand Duchess Maria
Maddalena of Austria,
Cosimo II's wife, had
transformed into the Villa
del Poggio Imperiale at the
beginning of the Seventeenth
century. Grand Prince
Ferdinand took this work
for his collection at the Pitti
in 1687; he hung it with the
similar *Passerini Assumption*
having first enlarged it so
that it would fit into the late
Baroque frame that matched
the other.

Archival research has
documented that the
Panciatichi Assumption is,
contrary to longstanding
opinion, the earlier rather
than the later of the two
works. Recent cleanings of
the paintings confirm this
finding.

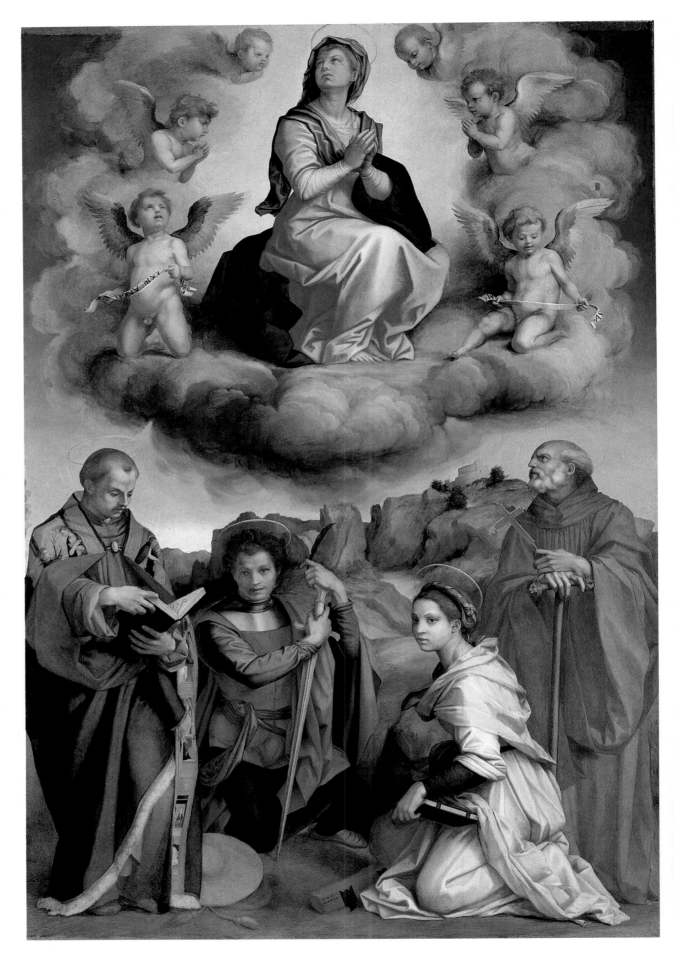

Andrea del Sarto

This composition of the *Assumption of the Virgin* (*Passerini Assumption*, panel, 379 × 222 cm.), reworks that of the *Panciatichi Assumption*, and the two kneeling apostles in the earlier work have been replaced by the figures of Saint Nicholas and the donor, Margherita Passerini, represented as Saint Margaret. Margherita, the mother of Cardinal Silvio Passerini, bishop of Cortona, commissioned this work in her will. Grand Duke Ferdinando II acquired it in 1639 for his collection at the Pitti where the work was made a pendant to the other *Assumption* hanging in Grand Prince Ferdinando's apartment.

The two Assumptions bought in 1639 and 1687 were placed together in the Palazzo Pitti collection by the Grand Prince Ferdinando.

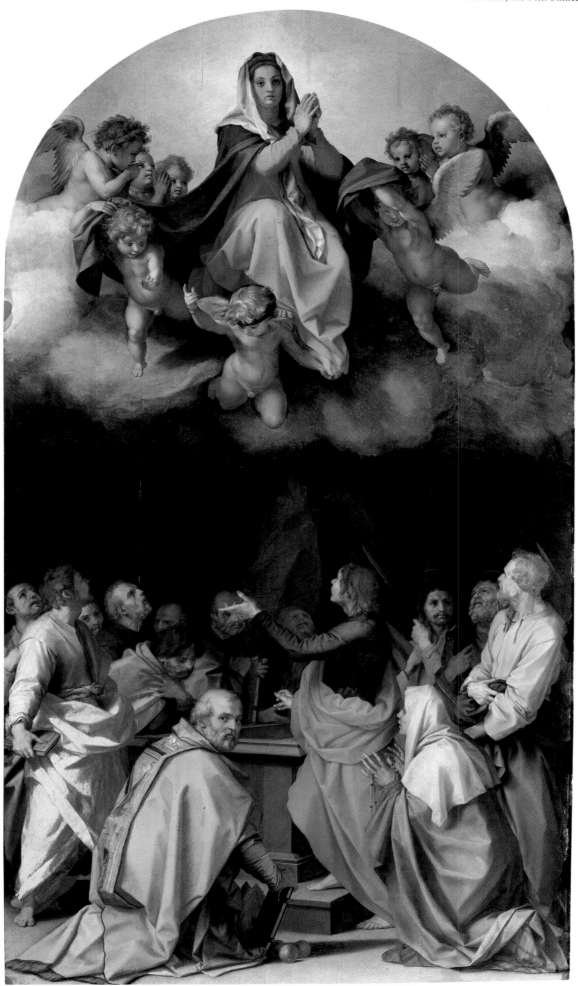

101

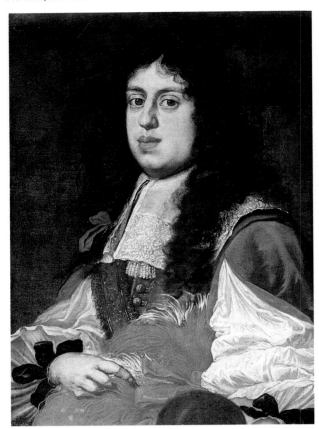

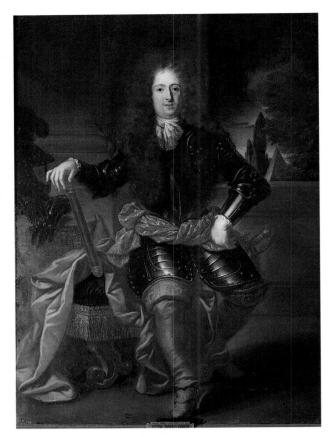

Portraits of *Granduca Cosimo III* (by Giusto Suttermans) and *Gran Principe Ferdinando de' Medici* by Anton Domenico Gabbioni

Facing page
The Gallery of Statues

The collections of the Eighteenth Century

When the owner of a collection died it went to the *Guardaroba Generale* which protected the integrity of the Grand Duchy's artistic patrimony. The results of two centuries of Medici collecting thus became the property of Cosimo III at the beginning of the Eighteenth century. He oversaw the reorganization of the Uffizi gallery, the collection of which was greatly enhanced by significant additions of Dutch and Flemish paintings Cosimo himself had acquired during his travels to the Low Countries and England. He also reordered the works he had inherited from his father, Ferdinando II, his mother, Vittoria della Rovere, his uncles Carlo, Giovan Carlo and Leopoldo as well as the extraordinary collection of his son, Ferdinando, who died before his father in 1713, within the Pitti Palace itself. The inventory of 1716-1723 documents the paintings in the Palazzo Pitti and notes which of the three core collections they came from—that of Grand Duke Cosimo III, of His Serene Highness Cardinal Leopold (who died in 1675) or of Grand Prince Ferdinando. Portraits of famous people and artists religious paintings for private devotions (such as Raphael's *Madonna della Sedia*) and large altarpieces, acquired despite the objections of the clergy (Andrea del Sarto's two versions of the *Assumption of the Virgin*, Raphael's

Madonna del Baldacchino and the *Sacre Conversazioni* by Fra Bartolomeo and Rosso Fiorentino), as well as still-life and landscape paintings, covered the walls both of the Audience Hall and other public rooms in the palace and its more private areas.
Pietro Leopoldo of the Hapsburg-Lorraine dynasty succeeded to the Grand Duchy of Tuscany in 1765. At that time he decided not to live in the left wing of the *piano nobile*—for two centuries the Grand Duke's apartment—but chose the right wing, formerly the apartment of the Grand Prince Ferdinando, as his private residence. This decision offered the perfect opportunity to create the Palatine Gallery. Pietro Leopoldo had Ferdinando's apartment redecorated with silk wall hangings, elegant gold and white stuccoes on the ceilings and furniture in the Neoclassical style. The extraordinary masterpieces which had hung there were rehung throughout the sumptuous rooms of the other half of the *piano nobile* under the vaults frescoed by Pietro da Cortona. This was the beginning of the picture gallery.
This process continued slowly over a fifty year period from about 1770 to 1820, and it reflects the nuances of changing tastes as well as the more dramatic impact of Napoleon's occupation of Florence. Sixty-three of the collection's most famous masterpieces were plundered from the Pitti Palace between 1799 and 1815; they were all taken to Paris, destined for the Napoleonic Museum.

Fra' Bartolomeo

The inscription on this *Madonna and Child with Saints* (Pitti Altarpiece, panel, 356 × 270 cm.), next to the date, which says "Orate pro Pictore" ("Pray for the painter") is a tell-tale characteristic of Fra Bartolomeo's so-called San Marco workshop. The work represents the *Mystic Marriage of St. Catherine* since the Christ Child places a wedding ring on the finger of a kneeling Saint Catherine of Siena. Fourteen saints, not all of whom can be precisely identified but who must have been important to the Dominican order, are placed around the central group of figures. The first impression is one of apparent disorder, but on second glance it becomes clear that the figures are carefully placed to create a contrapunctual symmetry. This work was painted for the Saint Catherine altar in San Marco, the church of the Dominican monastery where the artist-monk lived. Grand Prince Ferdinando acquired it in 1690 and had it enlarged to fit a frame that matched that of Rosso Fiorentino's *Dei Altarpiece*.

*The careful search for works to enrich
the Grand Ducal collection lead
to the acquisition by Prince Ferdinando
in 1690 of the monumental* Wedding
of Saint Catherine *by Fra' Bartolomeo (1512).
From then on it took the name
of Pitti Altarpiece.*

Rosso Fiorentino

This *Madonna and Child with Saints (Dei Altarpiece,* panel, 350 × 260 cm.) was intended for the altar of the Dei Chapel in the Florentine church of Santo Spirito to replace Raphael's never-delivered *Madonna del Baldacchino.* And indeed this work is the same size as Raphael's altarpiece (at least until it was enlarged in the Seventeenth century), and it contains the same figures. They are, however, placed differently, and Rosso added other saints to make a *sacra conversazione* that recalls Fra Bartolomeo's *Pitti Altarpiece.* The use of an intense *cangiante,* or colour-change modeling, and the rapid, synthetic construction of the heads recalls Rosso's famous *Volterra Deposition* painted a year earlier. This work remained in its original location and in its stupendous carved and gilded frame, itself most likely designed by Rosso, until the end of the Seventeenth century when Grand Prince Ferdinando took it for his collection. After Sabatelli finished decorating the ceiling of the Iliad Room, executed between 1815 and 1819, the four great altarpieces in the collection were moved to the centre of each of the room's walls and then surrounded by rows of small and medium-sized paintings. The result was a sensational of the Florentine Renaissance. This arrangement changed as works were moved in and out of the room throughout the Nineteenth and Twentieth centuries, but it is now being restored to its early-Nineteenth-century state. Fra Bartolomeo's *Pitti Altarpiece* was returned here from the Accademia in 1996 and Rosso's *Dei Altarpiece* will be rehung in its original location after the current cleaning is finished.

The Dei Altarpiece, *painted by Rosso Fiorentino in 1522, alongside three other monumental altarpieces, became the centre pieces of the Iliad room decorated in 1815-19. They represented the most extraordinary synthesis of the Florentine Renaissance.*

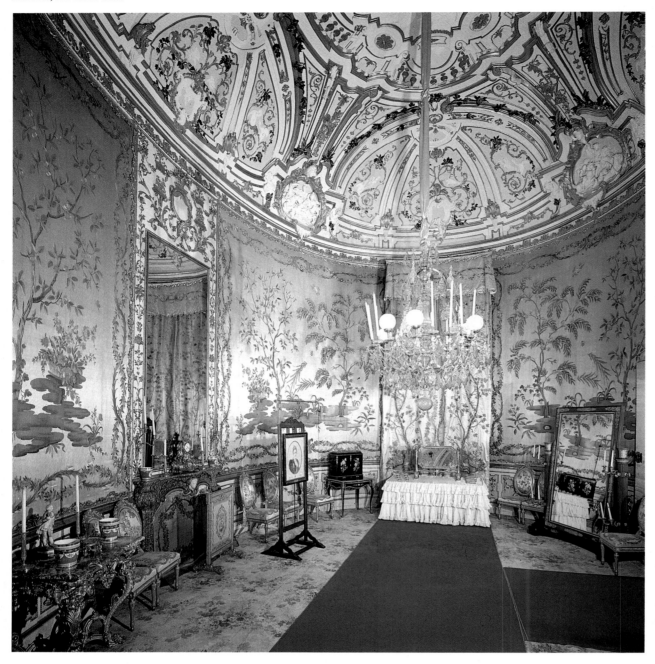

The Pitti Palace has always maintained its function as a residence, unlike the Uffizi. It has therefore never been reorganised according to museum criteria with works grouped according to schools. It has instead conserved its highly decorative quality with paintings hung in ornate frames specially designed to decorate the formal rooms accessed by the Gallery of statues.

From palace to museum

After Napoleon's fall and Ferdinando III's return to Florence, these works were reunited with the collection which had also expanded considerably with the addition of paintings taken by the State after the suppression of the churches and monasteries (such as Andrea del Sarto's *Assumption* from Poppi) or by the Hapsburgs (Raphael's *Madonna del Granduca* and his *Portraits of Agnolo and Maddalena Doni* as well as Murillo's *Madonna*).

Francesco Inghirami's small catalogue of the Palazzo Pitti's collection, published in 1819, listed the paintings exhibited in six rooms of the Palatine Gallery; the new edition in 1828 described works in ten rooms including those hung in the "Volterrano" wing, and the 1834 edition inventoried the definitive collection in the Gallery (497 paintings) and marked its opening to the public.

Unlike the Uffizi which had been reordered several decades earlier to highlight the important works it had from a variety of schools of painting, the Palatine Gallery was not arranged didactically. It began with the sumptuous Gallery of Statues that housed the ancient statues brought from the Villa Medici in Rome to Florence. The paintings followed, but they were not arranged by school or genre or in any chronological order. Instead they were hung in gilded frames and arranged according to a logic dictated by their decorative value and a sense of symmetry and what matched.

Ignazio Pellegrini, Oval Study, 1763-65

Facing page
Jupiter Room, Palatine Gallery

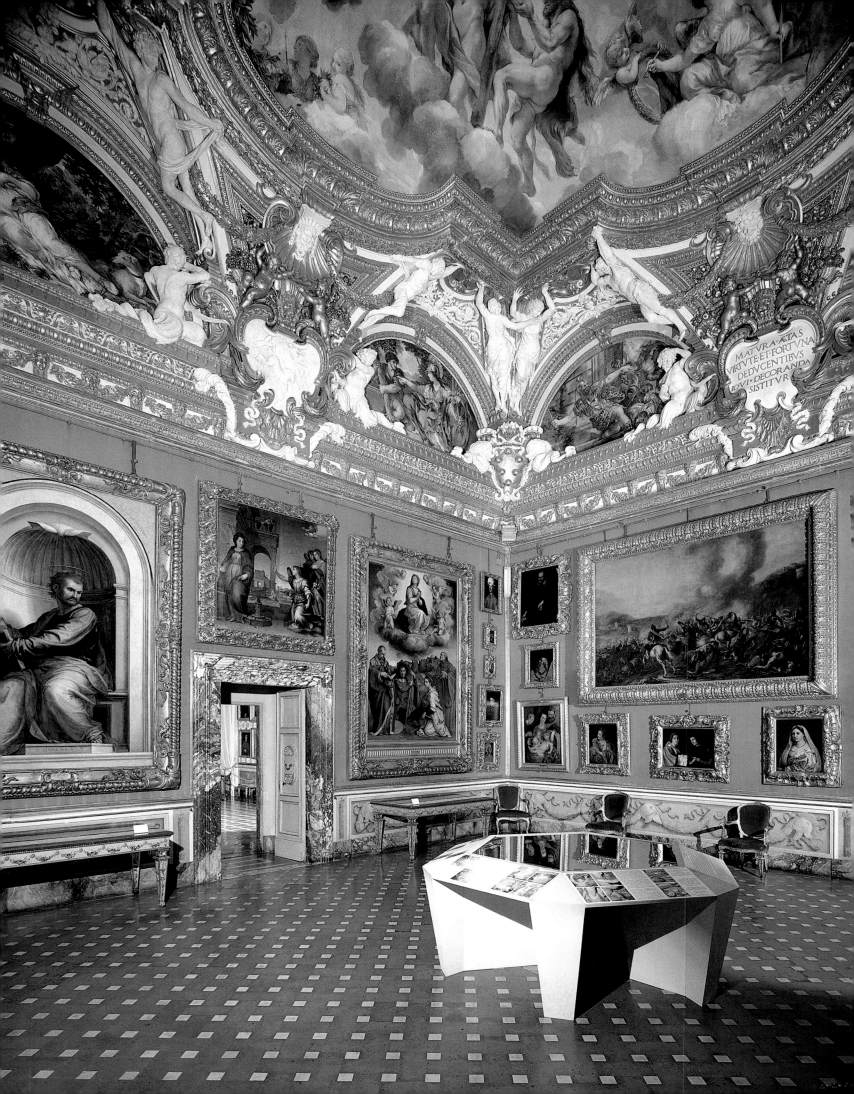

The Venetian Sixteenth Century

The Grand Dukes' collections were greatly enriched throughout the Sixteenth century with the very best examples of Venetian art. This interest in Venetian painting can be explained in three ways including the political and cultural contacts between the two cities at the time, the dowry of pictures from the collection of the Dukes of Urbino that Vittoria della Rovere brought with her to Florence and also the great passion Cardinal Leopoldo and the Grand Prince Ferdinando had for the art of Venice. The Pitti has paintings securely attributed to Titian (such as the *Portrait of Pietro Aretino* which the sitter commissioned from Titian in 1545 and then sent as a gift to Cosimo I), works that were acquired as either Giorgione or Titian but which modern scholars now recognize as one rather than the other, and works acquired with prestigious attributions to Titian, Veronese or Tintoretto but which Twentieth century scholars have attributed to shop assistants or followers of these masters. These works still offer tremendous material for further study and are a significant gauge of taste of the period.

Giorgione

The three figures gathered around a musical score correspond to the description of a painting by Giorgione that was in Gabriele Vendramin's collection in Venice in 1567. This reference was lost, however, and *The Singing Lesson* (or *The Three Ages of Man, p*anel, 62 × 77 cm.), acquired in Venice by the Grand Prince Ferdinando, was listed in his inventories after 1698 as a painting "in the best Lombard style." Modern scholars have attributed this extraordinary masterpiece, damaged by old restorations but still masterful in its execution and for the humanity of its three figures, to Giovanni Bellini, Lorenzo Lotto or other minor artists. This is, however, now almost unanimous agreement that it is by the young Giorgione, circa 1500, and directly influenced by Leonardo, who was present in Venice in 1500.

Raphael

The standing Virgin, seen in three-quarter profile, holds the Christ Child in her arms against a dark ground. X-rays and other tests performed during the 1983 restoration of the painting revealed traces of an arched window and a landscape beneath the black. This motif is also visible in the preparatory drawing for the painting (now in the Uffizi) where the Madonna and Child are enclosed in an oval frame with a glimpse of a landscape in behind them. Yet the masterful handling of the paint itself and the fact that the delicate brush strokes that define the Virgin's veil as well as Christ's blond curls are painted over the black suggest that the dark ground was not a later addition but rather Raphael's own rethinking of his composition. The black background recalls examples of Flemish painting which were so much appreciated in Florence at the end of the Fifteenth and the beginning of the Sixteenth centuries, and Raphael himself uses it again (at the Pitti in the *Portraits of a Lady - La Gravida* and *Fedra Inghirami*). Perugino's influence is still visible in the works of Raphael's Florentine years, although it becomes fainter as Raphael is ispired by Leonardo and especially Fra Bartolomeo. The impact of the latter can be found in the slow, tapering spiral of the figural which Raphael brings to life through his impeccable mastery of design and the dense, enameled quality of the painted surface. Nothing is known about the provenance of this *Madonna and Child* (*Madonna del Granduca*, panel, 84.4 × 55.9 cm.). A Florentine dealer showed it to Tommaso Puccini, director of the Uffizi, 1799, immediately after Napoleon's troops left the city. Grand Duke Ferdinando III, still in exile in Vienna, authorized Puccini to buy it, and it was then immediately and secretly shipped to Palermo along with other works from the Uffizi to protect it from an anticipated return of French troops. The picture stayed in Sicily with the others until 1803, and when they returned to Florence, Ferdinando III asked that this work be sent to his residence in Würzburg. Once he returned to Florence, he kept it in his private rooms thus giving it its nickname, the *Madonna del Granduca*—the Grand Duke's Madonna. This painting was only moved to the galleries and made available to copyists when the Grand Duke was away; it was not exhibited there permanently until the end of the Nineteenth century. Raphael's paintings in the Palatine Gallery represent each phase of his brilliant career (and it did it better before several portraits by Raphael were moved to the Uffizi, where his work was not well represented, over the course of the Twentieth century). The *Portrait of a Woman (La Gravida)*, near in date to the *Madonna del Granduca*, is closely related to the portraits of *Angolo and Maddalena Doni*, executed in 1506-1507, for the same patron who commissioned Michelangelo's tondo in the Uffizi. Raphael's *Portrait of Maddalena Doni* in particular is a response to Leonardo's work (the *Mona Lisa* in the Louvre), and it recalls, too, Flemish portraiture and the work of Perugino and Fra Bartolomeo in what is a splendid synthesis of sources. Raphael's Florentine period (1504-1508) came to an end with the *Madonna del Baldacchino* which hints at the grandiosity of the frescoes he would execute in the Vatican Stanze.

The Grand Duke's Madonna, *painted by Raphael around 1506, is one of the paintings that symbolises the Palatine Gallery. It became part of the collection in 1779. Ferdinando III ordered its acquisition, even though he was in exile in Vienna.*

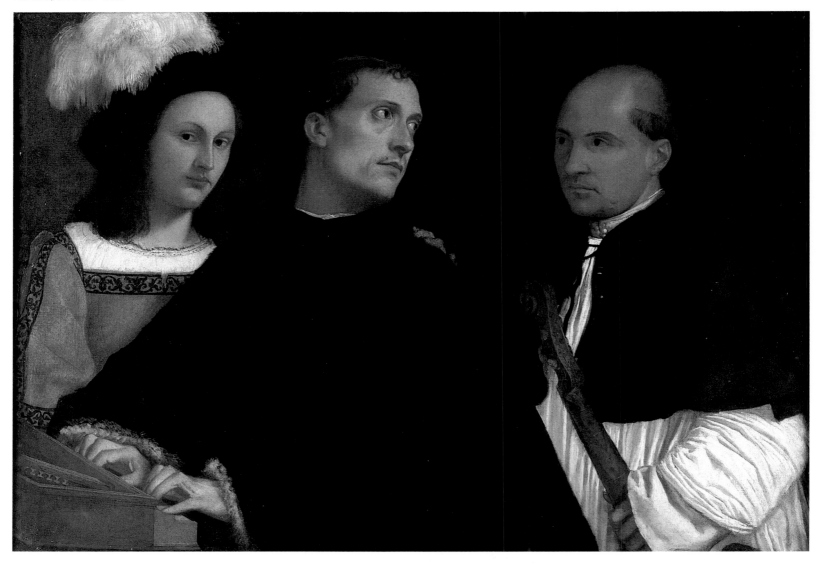

Titian

Cardinal Leopoldo acquired *The Concert* (canvas, 86.5 × 123.5 cm) in Venice in 1654; it was attributed to Giorgione, and that attibution survived until the early Twentieth century when it was widely given to Titian. Although close to the *Singing Lesson* and strongly influenced by Giorgione's style, this work is painted with a more dramatic touch characteristic of the young Titian while he was still working in Giorgione's circle. The restoration freed the painting from dense layers of varnish, established the original size of the canvas which Leopoldo had had slightly enlarged to fit the Baroque frame he wanted for it and, above all, it provided important information that confirmed the authenticity of this masterpiece which the figure of the young page had thrown into some doubt.

The portrait of Ippolito de' Medici, painted by Titian in 1533 while he was in Bologna in the court of Charles V, has been part of the Medici collection since 1553. The fascinating Concert, *again by Titian (c. 1510), was acquired in Venice as a work by Giorgione in 1654 for Cardinal Leopoldo de' Medici.*

Titian

Ippolito, the son of Giuliano de' Medici, Lorenzo the Magnificent's nephew and Duke of Nemours, was raised in Rome by his uncle, Pope Leo X, and then, after Leo's death, by Pope Clement VII. The latter made him a cardinal in 1529 while he was still very young and before he had taken any religious vows. A cultured prince and a sophisticated patron, Ippolito died suddenly in 1535 (poison was suspected) at Itri in the palace of his lover, Giulia Gonzaga. Ippolito commissioned his portrait *(Portrait of Ippolito de' Medici*, canvas, 139 × 107 cm.) from Titian in Bologna in 1533. He had arrived there after a victorious military campaign against the Turks in Hungary and the artist had come to Bologna to join the court of Emperor Charles V. The cardinal is dressed in a Hungarian costume which covers his armour, and he holds an iron mace in his right hand and a sword in his left. His hat is decorated with three feathers held in place by a clasp decorated with a comet and the motto "Inte(r Omn)es," which alludes to his love for Giulia Gonzaga. This portrait is first listed in the Medici *guardaroba* in 1553.

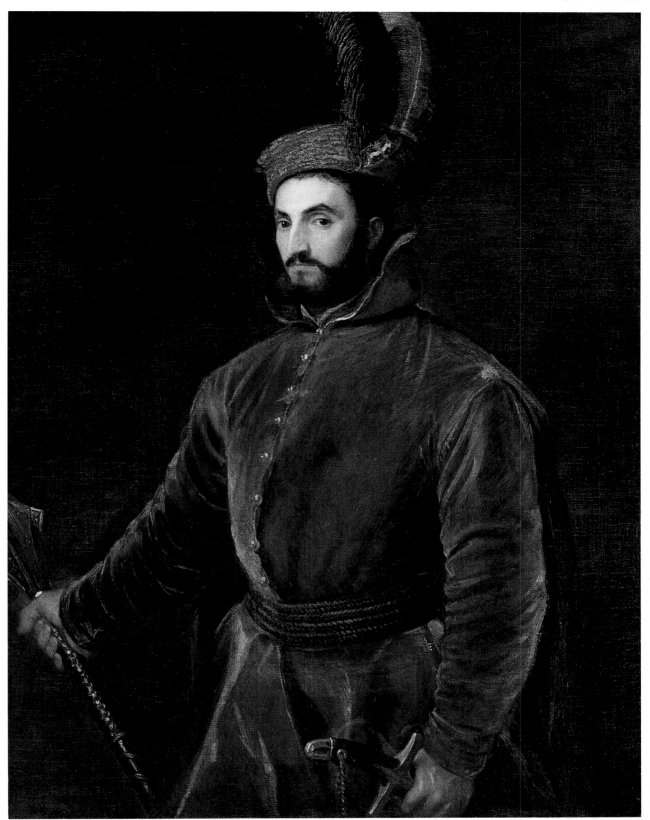

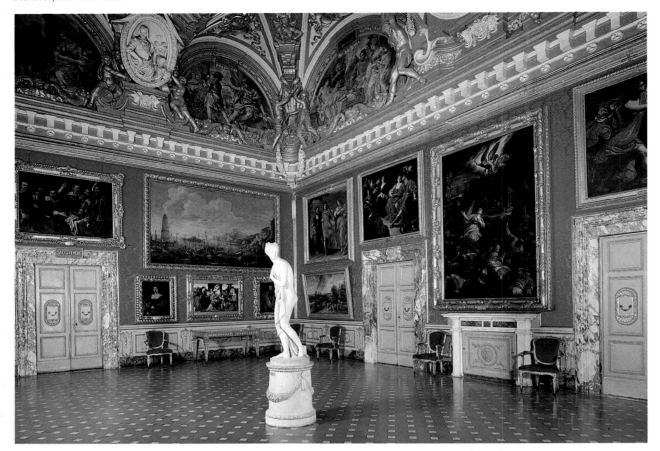

A special arrangement

Works by different artists and of different periods and subjects were resized in order to fit into valuable frames, and paintings not intended as pairs were transformed into pendant pieces and then installed either next to or facing one another in the same room. Works of similar subjects were hung together (such as the *Holy Families* by Fra Bartolomeo and Domenico Puligo, or Raphael's and Ridolfo del Ghirlandaio's *Portraits of a Lady*). This ensemble of works has, in addition to the intrinsic value of the individual paintings, real importance from an historical and artistic point-of-view. It is also enormously interesting for the history of museums.

The gallery's Renaissance collection begins with Filippo Lippi's famous tondo of the *Birth of the Virgin* and includes later Fifteenth century artists such as Filippino Lippi, Signorelli, Botticelli and their schools. Their works were originally hung together in the so-called "Sala dei Tondi" (now the Prometheus Room). Florentine painting of the early Sixteenth century is represented by eleven famous works by Raphael and by those of Andrea del Sarto, the most beloved artist of all generations of the Medici family, Fra Bartolomeo, Pontormo, Rosso Fiorentino and Ridolfo Ghirlandaio. Works by Vasari, Salviati, Peruzzi, Bronzino, Alessandro Al-

lori, Jacopino del Conte and Maso da San Friano mark the Mannerist period; their legacy can still be discerned in the more didactic paintings of Counter-reformation artists like Empoli and Santi di Tito as well as in the more proto-Baroque pictures by Cigoli. The work of Sixteenth century Venetian artists is another important part of the collection, and it includes absolute masterpieces by Titan, Tintoretto and Veronese as well as a large number of works by their students and followers. Cardinal Leopoldo de' Medici and his nephew, the Grand Prince Ferdinando, were especially interested in the art of Venice. The Seventeenth-century collection begins with three works by Caravaggio—the fascinating *Sleeping Cupid*, the much-discussed *Tooth Puller* and the *Portrait of a Knight of Malta*. It includes examples of the most important Italian and European schools of painting.

The Bolognese school is represented by artists from the Carracci to Guercino, Guido Reni and Lanfranco and the Neapolitans by Salvator Rosa, Ribera, Cavallino and Luca Giordano. Northern painting is represented by Flemish artists from Rubens to Van Dyck and Pourbus, landscape and genre artists such as Filippo Napoletano, Callot and Poelenburgh—all of whom were brought to court by Cosimo II—and the Dutch masters so beloved by Cosimo III.

In the Neoclassical period the Prometheus Room took on the name of Round Room thanks to the many paintings on circular canvases. These works represent the tradition of the Florentine rennaissance, and they include the Birth of Mary *by Filippo Lippi.*

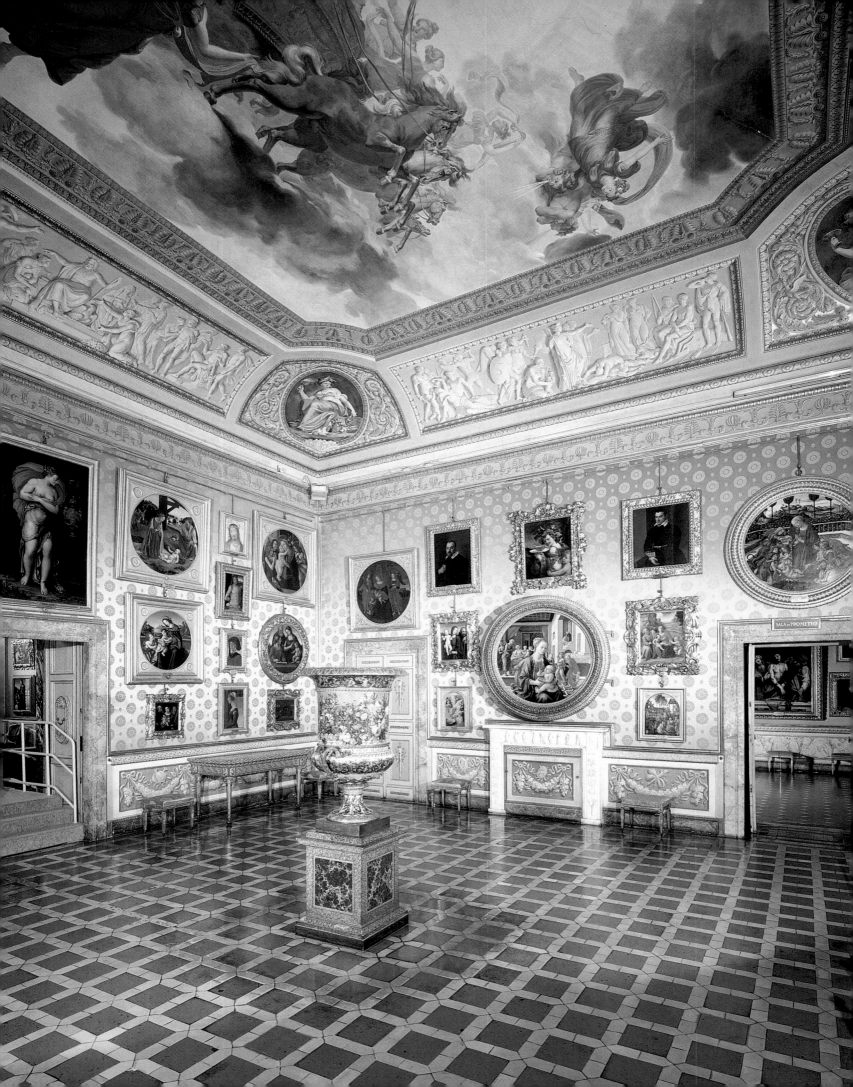

SALA DI PROMETEO

The Seventeenth Century

Seventeenth century artistic culture is emblematically documented by the work of Caravaggio, acquired by Cardinal Leopoldo in 1667, who commissioned the splendid carved frame, and Cristofano Allori chosen from the Medici chamber in 1626 for the collection of Cardinal Carlo de' Medici.

The Seventeenth century begins at the Pitti Palace with Caravaggio's masterpiece, *The Sleeping Cupid*, and is at least as well represented as the century before it. This group of paintings documents the taste of various members of the Medici family for the best contemporary works produced in Italy and Europe.

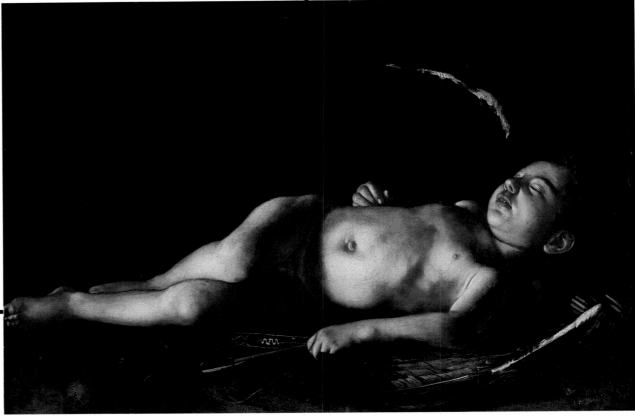

Caravaggio (Michelangelo Merisi)

Sleeping Cupid (canvas, 71 × 105 cm.) has an old inscription on the back which says, "Work of Sr. Michelangelo Merisi da Caravaggio in Malta 1608." It was made for Francesco dell'Antella, a knight of St. John of Jerusalem; he sent it to Florence to his family palace on the Piazza Santa Croce.
Cardinal Leopoldo bought the picture in 1667 and at the same time commissioned for it the splendid carved frame with the attributes of love. The genius of this work, recognized in contemporary sources, comes not simply in the subject, the sleeping cupid which probably refers to the patron's overcoming of his own passions, but also in its elaborate execution. It transforms the classical symbol of beauty and grace into an impiously realistic figure defined by the masterful play of light and shadow.

Cristofano Allori

Judith and Holofernes (canvas, 139 × 116 cm.). The biblical text tells of Judith, the beautiful, young widow who succeeded in saving her hometown from a siege by going to the enemy camp, seducing Holofernes, the commanding general, and then decapitating him. With her maidservant, Abra, she returned home and put the attacking army to flight by showing them the head of their commander. The violent drama of the story is here diluted by the refined sense of detachment of the principal figures in the painting. The significance of the work is more closely tied to the artist's private life than any tragic or heroic evocation of the Old Testament story. Judith is a portrait of Cristofano's mistress, Mazzafirra, and Abra a likeness of her mother. Holofernes's severed head is a self-portrait of the artist. The savvy composition, the elegance of its execution and its rich decorative quality all explain the enormous success the picture enjoyed. This version was delivered, unfinished (the clasp on Judith's mantle is missing), to the Medici *guardaroba* in 1621; in 1626 it was chosen for Cardinal Carlo de' Medici's collection. It was returned to the Pitti Palace on the cardinal's death in 1666, and has become, largely due to the mysterious fascination of the beautiful protagonist, one of the most representative works in the Palatine Gallery.

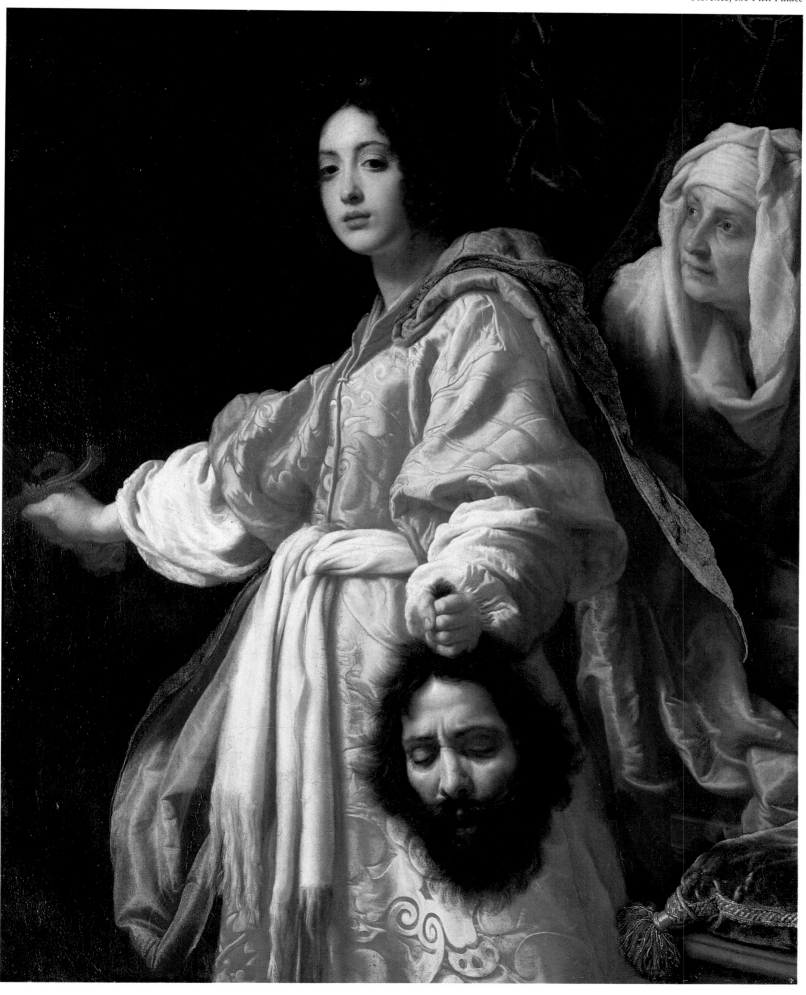

Sala di Marte (Mars Room)

Rubens's work is an interesting juxtaposition to the sober elegance of Seventeenth century Florentine painting, and the Gallery has some of the Flemish artist's more famous works. He is particularly well represented by the large canvas depicting *The Consequences of War* and the panel of *The Four Philosophers*. The Sala di Marte also houses Van Dyck's extremely elegant Portrait of Cardinal Bentivoglio, a stark contrast to the material richness and intense vitality of *The Four Philosophers*.

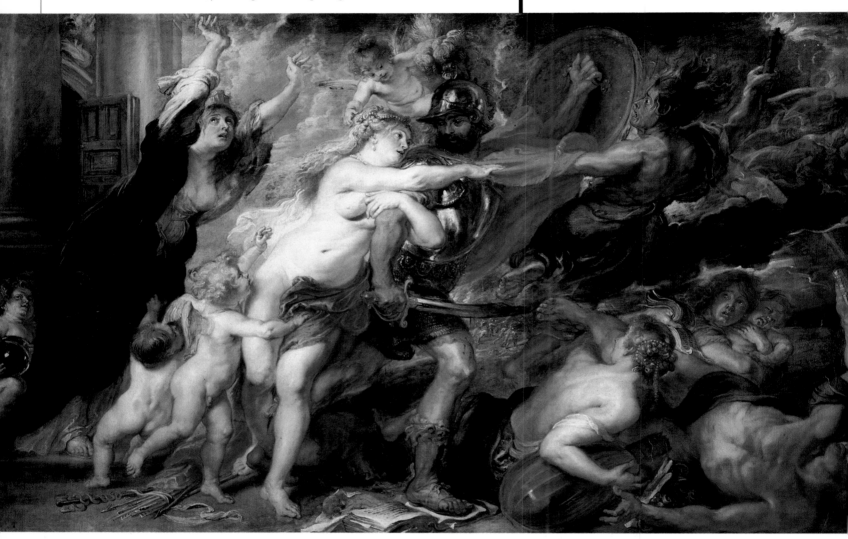

Peter Paul Rubens

The artist himself explained the complex subject of *The Consequences of War* (canvas, 206 × 345 cm.) in the letter that accompanied this painting when it was delivered to Justus Suttermans, the official portraitist at the Medici court and the patron of the picture. It is an allegory of the Thirty Years War which erupted in 1618 (and ended with the Peace of Westphalia in 1648) and was then ravaging Europe. Mars, god of war, is dragged from the arms of Venus by the Furies and then tramples the arts, while the tragic figure of Europe, in mourning, raises her arms in desperation towards the heavens. This ruined painting brilliantly fuses figures and their setting with a Baroque flair that has an immediate impact on the viewer's senses.

The collections of the Palatine Gallery include masterpieces by Peter Paul Rubens, such as The Consequences of War *(1637). These works represent the great season of European Baroque and Flemish painting in contrast with the cold elegance of the Florentine paintings.*

Anthony van Dyck

Guido Bentivoglio (1577-1644) was the apostolic nuncio to Brussels and then Paris; he became a cardinal in 1621 and moved back to Rome where he commissioned this portrait (*Portrait of Cardinal Guido Bentivoglio*, canvas, 195 × 147 cm.) from the young Van Dyck, who was in the Eternal City from 1622 to 1623. Monsignor Annibale Bentivoglio, the papal nuncio to Florence, gave it to Grand Duke Ferdinando II in 1653. The painting is listed as hanging in the Tribuna at the Uffizi from 1653 to 1687; it was then moved to the Palazzo Pitti to become part of Grand Prince Ferdinando's collection.

This work represents the beginning of Van Dyck's very refined use of colour in portraits, something he was to develop more fully in all his work. Here he plays on one colour—cardinal red—in a rich range of shades that is handled with an extraordinary sense of refinement. Titian's influence underlies the presentation of the figure, but it is overlaid with an extremely elegant execution that captures the aristocratic personality of the Cardinal with rare intensity.

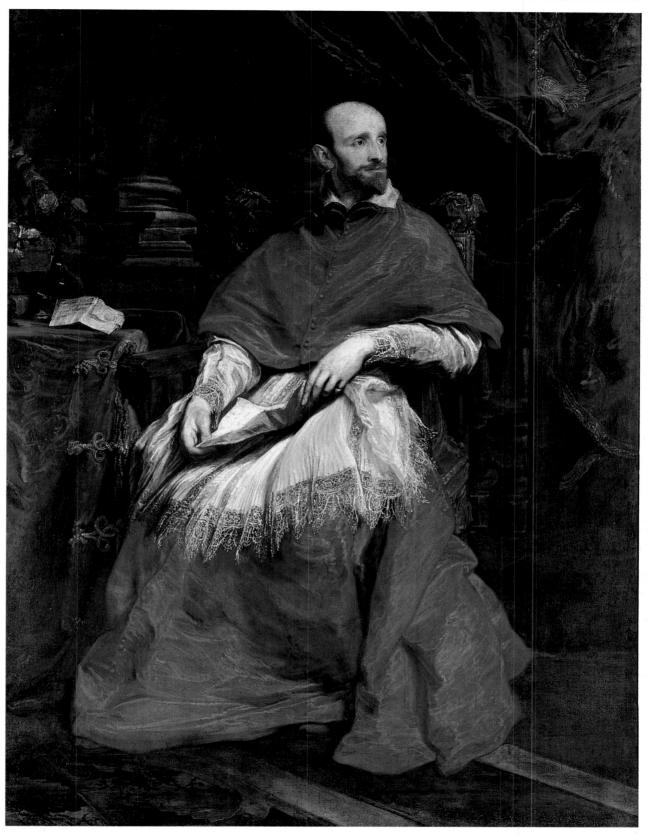

This portrait painted by van Dyck between 1622-23 became part of the princes' collection in 1653 as a gift from the papal nuncio to Annibale Bentivoglio. For some time it was exhibited in the Tribune of the Uffizi, and later it became part of Prince Ferdinando's collection in the Pitti Palace.

Peter Paul Rubens

This masterpiece (*The Four Philosophers,* panel, 164 × 139 cm.) was executed after Rubens returned to Antwerp from Italy, where he had lived from 1600 to 1608 visiting Venice, Genoa, Florence, Mantua and Rome, as homage to the memory of his brother Philip (who died in 1611) and their teacher, Justus Lipsius (who had died in 1606). These two join in a conversation with Rubens himself (standing on the left) and the Humanist Woverius. The work is replete with references to literary and philosophical themes and references; there is a view of Rome in the background, and from the books the four consult identified the bust as Seneca (a special favorite of Lipsius). The four tulips in the foreground, two open and two closed, symbolize the two people who were still living and the two already dead. The group is depicted close to the viewer which emphasizes the naturalism of their poses and the surroundings—the books are placed in a studied disorder on the table covered by a carpet, exquisitely executed with rapid strokes and a richness of impasto that owes much to Rubens's admiration for Titian's work and which charges it with an emotive and vital sense of communication.

Other collections

These masterpieces and others by Rubens and Van Dyck hang in the Gallery with many other examples of paintings by their contemoraries, including portraits by Frans Pourbus the Younger, a number of small landscapes by Paul Bril, works by Brueghel, the Velluti, Frans Francken, Peter van Mol and David Teniers. Together they represent Flemish painting—a style now clearly distinct from Dutch painting—in the Medici collection. With Holland's independence from the Low Countries, the specialized painters of landscapes, portraits, still-lifes, seascapes and genre scenes exercised a fascination especially on Cosimo III de' Medici. He preferred small pictures, and he acquired an impressive number of them during his travels in Holland; indeed his collection of Dutch art is, after that in Turin, the most important in Italy. Rembrandt's *Rabbi* moved from the Pitti to the Uffizi in 1922; nonetheless what remains is a very interesting group of works by first-rate artists—the sophisticated still-lifes by Willem van Aelst, Willem van de Velde's two large, monochromatic pen and ink seascapes, Otto Marseus's evocative and teeming forests and Rachel Ruysch's amazing bouquets of flowers and baskets of fruit. They are hung in the rooms known as the *ala delle colonne*.
The furnishings of the Palatine Gallery provide a sumptuous setting for the paintings. They include the Greek and Roman busts and statues brought to Florence from the Villa Medici in Rome in the second half of the Eighteenth century, busts and statues of the Medici and Hapsburg Grand Dukes which are placed on tables in the rooms or over the doors of the "Statue Gallery". There are works of Nineteenth-century sculpture (such as Canova's *Venus*) or enormous Sévres vases in the middle of the larger rooms, and monumental stone inlaid Baroque tables and elegant neoclassical *consolles* produced by the Opificio delle Pietre Dure founded by the Medici and encouraged by the Hapsburgs.
Within the sumptuous context of the royal residence at the Pitti, the Palatine Gallery is the most precious gem—both because of the works it contains and because of the way they are exhibited. There have been many changes over the almost two centuries of its history, including important losses to the Uffizi (such as Parmigianino's *Madonna of the Long Neck* and Raphael's *Portrait of Leo X*) as well as gains from that gallery (such as the Seventeenth century Florentine works and the Dutch and Flemish paintings). A sense of respect, however, for its splendour has not frozen the Gallery into a slow rigidity but has instead become a vital part of the future of this extraordinary and vital collection.

Rachel Ruysch, *Flowers, fruit and insects*, 1716

Landscape, portrait and still life painters greatly fascinated Cosimo III de' Medici. During his travels he acquired a collection of small Dutch paintings.

The Royal Apartments

Marco Calestrini, coffee table
with inlay in various wood
types, 1791

The Royal Apartments are the mirror image of the rooms of the Palatine Gallery, and they are entered from the other side of the central Sala delle Nicchie. Their name immediately suggests their original purpose as the ruler's living quarters as well as the character of the furnishings which distinguish this part of the palace. The Grand Prince Ferdinando de' Medici, Cosimo III's heir, lived in these apartments throughout the second half of the Seventeenth century and until 1713, shortly after that part of the building facing the piazza was finally completed. He occupied the whole series of rooms behind the façade and facing the interior courtyard up to the Sala di Bona which then connected with the apartment of his wife, Violante of Baveria (today the Appartamento degli Arazzi). In these rooms, too, the Grand Prince arranged his superb collection of paintings.

We have already noted that Pietro Leopoldo, the first of the Hapsburg-Lorraine dynasty to rule Tuscany, chose this half of the *piano nobile* as his family residence, and he moved all the paintings that hung there into the former apartment of the Grand Duke which then became the Palatine Gallery. Court life was no longer characterized by a Baroque magnificence but rather by a sober rationalism that was ever more influenced by the "common sense" of the middle classes, and it is this new sensibility that influenced the decoration of the rooms of the Royal Apartments as well as the choice of furniture, rugs and upholstery in them. With the unification of the Italian Kingdom and Florence's temporary role as its capital (1865-1871), these apartments became the official residence of Vittorio Emanuele II. At the end of the century King Umberto II of Savoy and his wife,

Queen Margherita, now resident in Rome, oversaw the rearranging of the crown's Florentine property (the Pitti Palace and the Medici villas), all of which was meticulously recorded, as was the tradition, in an inventory drawn up in 1911. This, indeed, is the document the museum's staff used to restore the Royal Apartments to their original state which had largely disappeared after the palace was given to the Italian State in 1919. For about sixty years this area was neglected in favour of the three official museums in the palace (the Palatine Gallery, the Gallery of Modern Art and the Silver Museum), and for a variety of reasons it became a splendid but rather casual exhibition of tapestries, furniture and paintings as well as an ideal trove for the necessary decorations for official offices and residences.

The restoration of the furnishings documented in the 1911 inventory began in 1993 after work was completed on the necessary upgrades of the security system in the apartments. That work required that the rooms be totally emptied, and what was put back was certainly no less rich but more homogenous. The royal administration had, in large part, respected the elegant layering of styles in the palace—the late Baroque of the Medici period, the Neoclassical and Biedermeier tastes of the Hapsburg period. The eclecticism of the Nineteenth century allowed for such diversity, and the restoration of the apartments and the recouping of almost all of the objects housed there reflects this.

Facing page
Giovan Battista Foggini, alcove
of the Great Prince Ferdinando,
then transformed into a chapel
in the Lorrainese period

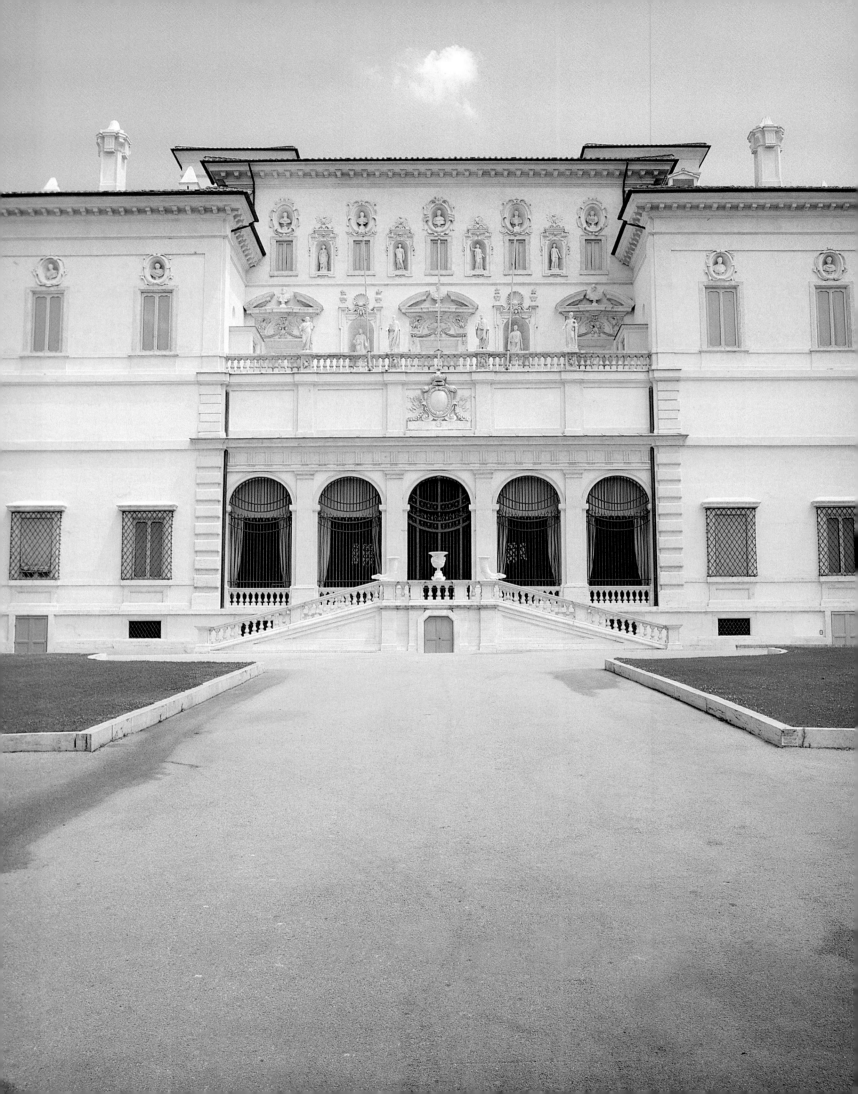

Rome, the Borghese Gallery

Alba Costamagna

The Borghese Gallery (the country house and its collection) was purchased, along with the entire Villa, by the Italian State in 1902.

In the following year, 1903, the original building of the Villa Borghese was irredeemably lost when the park, all the open-air sculptures and the numerous architectures that lend character to the various green areas, as furniture and facilities, were sold to the Municipality of Rome. All that remained as State property was therefore the "Pinciano country house" with its collection of archaeology and art, which had remained intact thanks to the trustee restrictions established by Francesco Aldobrandini Borghese (1833).

The expansion of the city, first in the form of building speculation in the immediate surroundings in the late Nineteenth century, beyond the Aurelian Walls where the Villa Ludovisi had stood, with an ample garden and vineyard (that stretched from the present-day Via Ludovisi and Via Veneto to the end of the current Via Boncompagni towards Piazza Fiume) and then, in the second half of the Twentieth century, due to traffic problems which have affected the area negatively, isolating the monumental Luigi Canina entrance from the Porta del Popolo and the Pincio.

The transit of vehicles in some lanes in the park has mutilated, in a strictly physical but also visual sense, the extraordinary magnificence and unrivalled unity of the park and the small villa as they had been consolidated, in spite of the inevitable modifications and works requested by the Borghese family, in the course of two centuries.

The construction of a "country house" and the cre-

ation of a park in place of the ancient "Vineyard" which the aristocratic Borghese family, originally from Siena, owned outside the Pinciana Gate, was commenced in the second decade of the Seventeenth century on the request of Cardinal Scipione Caffarelli Borghese, nephew of Pope Paul V. As of 1612, with the intensification of the works on the country house and with the arrangement of all the surrounding green areas as a park, the project of Flaminio Ponzio took form; it was completed after his death (in 1613) by the Flemish Vesanzio. Along with these works, others, completed in the time of Scipione, transformed the immediate surroundings of the building, namely the Aviary (designed by Girolamo Rainaldi in the years 1617-19) and the gardens (until about 1620).

The powerful Cardinal Borghese very soon provided for transferring to the villa his marvellous collection which, even if deprived of most of the masterpieces of antique sculpture (which were sold to Napoleon I by Camillo Borghese), may still be admired today, enriched by later acquisitions made by the family.

The museum, since the Eighteenth century considered "the queen of the world's private collections", features some of the greatest masterpieces of painting from the Sixteenth and Seventeenth centuries (Raphael, Titian, Correggio, Dosso, Cranach, Caravaggio, Domenichino, Rubens) and Seventeenth century sculpture (Bernini, Algardi), not to mention the very famous Paolina Bonaparte as the Victorious Venus by Antonio Canova, the museum's most famous attraction ever since it was completed.

I.W.Baur, *View of Villa Borghese*, 1636

Scipione Borghese

A hand-written guide from the Seventeenth century (written in French and probably dated 1677/1681), purchased in 1975 by the Avery Library of the Columbia University of New York and published (1991) with an Italian translation, in the "palazzo della Vigna Pinciana" lists many antique sculptures singularly ("busts of Caesar, of Scipio, of Hannibal... a Seneca in paragone stone", a "dying gladiator", an "Abduction of Ganymede", a "centaur", "Curtius, Roman knight, as he falls with his horse"), as well as some modern ones by Bernini (the *David* and the *Daphne*).
As far as the paintings are concerned, the anonymous author on the contrary makes a moralistic censorship, criticising the "nudity" of the images and the "mixture of "beautiful paintings" and "obscene paintings", true "impurities ... placed there (before the spectator) only to lie in wait for him, and defile his imagination".
This critical attitude represented the exact opposite of the aims pursued by the principal creator of the Borghese collection, Cardinal Scipione (1579-1633), who exercised his power as the nephew of a Pope (Paul V) above all to satisfy his modern passion for collecting and accumulating beautiful works, regardless of the iconography, which could be either profane or religious.
A small number of paintings by Tuscan artists, as well as the *Three Graces* and the *Dream of the Knight* by Raphael and some antique sculptures had been given to Scipione in exchange for his renunciation of the inheritance of his uncles in favour of his cousin Marcantonio. This initial nucleus grew, in very few years, to an impressive collection of ancient marbles and works from the Sixteenth century and the first years of the Seventeenth, purchased, confiscated or commissioned.

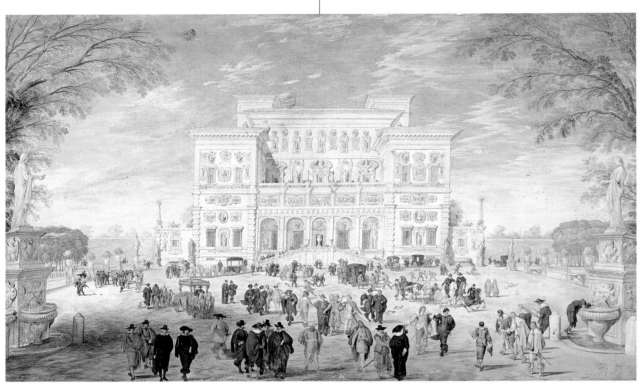

Construction of the villa-museum

In 1614, as soon as the works on the Pinciana "country house" were mostly completed, Cardinal Scipione Borghese moved his paintings from the Palazzo di Borgo (today known as the Torlonia Palace, in Via della Conciliazione) to the new building. A year later, more than 200 sculptures from his archaeological collection began to arrive at the, by then, finished residence, from the Palazzo di Ripetta.
The building thus became the perfect setting for the precious treasures of the nephew of Paul V or rather, to quote a particularly fitting metaphor, if considering the original, quite compact architectural dimensions, "the treasure chest" of Cardinale Borghese.
The morphology and plan of the small Pinciana villa is based on those of Sixteenth century suburban villas (first and foremost the Farnesina Chigi, the quite nearby Villa Medici, the Villa Montalto Peretti, but also the Villa Mondragone at Frascati, bought by Scipione Borghese in 1623) consisting of a rec-

tangular plan underscored by a frontal loggia, embedded between two lateral projecting bodies with a characteristic tower shape.
The Sixteenth century model inspired the facade, decorated by antique sculptures which provided a visual foretaste of the rich antique collection shown in the interiors. The numerous windows and the arches of the loggias (in addition to the one on the ground floor on the main facade, another loggia could be found on the first floor, on the western wall; it was subsequently, in 1624, decorated by Giovanni Lanfranco, who painted the *Council of the Gods)* demonstrate, along with the white hue of the so-called "marmorino" used for the original external plasterwork, the importance attributed to the light. In fact, the light is the "essential" element of the architecture of this "country house", and at the same time it serves as an indispensable filter between the green surroundings and the interiors that today still house the works comprising the Borghese collection.

The schools he was most interested in were those of Tuscan and Roman Mannerists, as well as artists from Emilia and Veneto. Of some artists (like Titian, Paolo Veronese and Dosso Dossi) he carefully chose works representing the different stylistic periods. In 1607 his uncle the Pope gave Scipione 107 paintings, confiscated from Knight d'Arpino. The following year the collection was enriched by the *Deposition* by Raphael (purloined from the church of San Francesco in Perugia and spontaneously assigned to his nephew by Paul V), the collection of Cardinal Emilio Sfrondato and paintings of the Ferrara school purchased through Cardinal Bentivoglio. In 1617 Scipione seized (after having imprisoned Domenichino for some days) the *Hunt of Diana*, arrogantly and tenaciously desired even if it had been commissioned by another

Cardinal, Pietro Aldobrandini. The antique sculptures in Scipione's collection came from chance finds or from the purchase (1607) of the collections of Tiberio Ceoli (formerly at the Palazzo Sacchetti) or the acquisition (1609) of the large collection of Tommaso della Porta (sculptor and a dealer in antiquities). It was precisely from the latter collection that he obtained the famous *Centaur conquered by Love* (today at the Louvre) and the busts of

the *Twelve Cesars* by Giovan Battista della Porta, exhibited in niches in the entrance hall. But along with the paintings and statues acquired in various ways, the collection vaults all the masterpieces commissioned directly from the greatest artists of the period that worked in Rome: Bernini, Caravaggio, Algardi, Lanfranco, Rubens, Guercino, Lavinia Fontana, Cavalier d'Arpino, Baglione, Nicolas Cordier, just to mention some of the most famous names.

Pietro Bernini, *Marcus Curtius*, making use of a horse in Pantelic marble carved in the Classical era, 1618, entry salon

Gian Lorenzo Bernini, *Bust of Scipione Borghese*, 1632

Cardinal Scipione Borghese was the true founder of the collection. He had a highly modern taste for collecting and accumulating beautiful works, both profane and religious.

125

Raphael

The wooden support, consisting of six boards in poplar wood, was restored in the years between 1966 and 1972 (by the Central Restoration Institute) with a difficult and complex intervention, aimed at correcting the serious damage and problems caused by a complicated metal parquetry applied in 1875 by Luigi Lais. A number of diagnostic analyses done in the years from 1997 to 1999, within the context of a project organized by the Editech Multimedia Art srl and the Superintendency of Artistic and Historic Heritage of Rome, aimed at the creation of "digital clinical records", revealed numerous drawings and afterthoughts below the final version of the *Deposition of Christ*, figuratively rendered by Raphael as *Transpostation to the tomb* (oil tempera on wood, 174.5 × 178.5 cm).

The painting comes from the chapel consecrated to the Saviour in the church of San Francesco al Prato in Perugia, and had been commissioned by Atalanta Baglioni to remember her son Grifonetto, assassinated in 1500, shortly before Raphael - as Vasari remembers - left Perugia for Florence, where the artist "prepared the cartoons for said chapel with the intention of going, as he did, to execute it as soon as it was convenient for him". The altarpiece (completed, as witnessed by the date after the signature, in 1507) was completed by a cyma with the *Eternal blessing among angels* by Domenico Alfani (today found at the National Gallery of Umbria in Perugia) and by a monochrome predella depicting the *Three Theological Virtues – Hope, Charity and Faith* (today in the Vatican Picture Gallery). The painting, having aroused the obsessive and possessive collector's avidity of Scipione Borghese, was

purloined from the San Francesco Church on the night of 19 March 1608, to be donated to the Cardinal Nephew. A brief from the uncle, Pope Paul V, sanctioned that Raphael's masterpiece was, in spite of the protests of the citizens of Perugia, to be considered "private property, given to the Prince who is its only Owner". From that year the work represented one of the greatest masterpieces of the Borghese collection. In the early Nineteenth century Camillo Borghese moved the painting, first to Turin (where Napoleon had appointed him Governor-General of the Transalpine Departments) and then to Paris. In 1816 the painting returned definitively to Rome, where it was exhibited in Room IX of the Borghese Gallery, certainly since 1891 (when the catalogue of the entire picture gallery moved from the Palazzo Borghese at Campo Marzio to the Villa Pinciana was completed). No other work by Raphael is accompanied by as many project documents, in the form of numerous preparatory drawings (which are part of the most prestigious collections in Vienna, London, Oxford, Paris, Florence, Chantilly and Lille). And it is precisely by studying the drawings that one may follow the slow transformation of the composition from a *Lamentation*, inevitably static and influenced by the lessons of Perugino and Signorelli (today in the Galleria Palatina in Florence and the Diocesan Museum of Cortona, respectively), to a *Deposition* which is also a tale of the translation of Christ to the sepulchre, commented by a "chorus" of figures divided in two groups. The transition from a "static" representation to a "dramatic" tale (where the exhausted body of the dead Christ becomes the centre of a painful movement, with the gestures, filled with pathos, of the Magdalen,

Mary and the pious women) reveals Raphael's interest in "history". This interest had been awakened in Florence, where the artist saw the compositions of the *Cartoons of the battle* drawn, precisely in that year, by Michelangelo and Leonardo.

Critics have first and foremost underscored the complex relations, often also of derivation, principally with the former for the figure of Christ, his *Pietà* in St. Peter's in the Vatican; for the pious women who support the fainted Mary, the torsion of the Madonna of the *Tondo Doni*; for the monochrome figure of *Charity*, the *Madonna Pitti* at Bargello. But all the same, ancient iconographic precedents may also be found, and more precisely a sarcophagus in the Capitoline Museums, for the *Translation of the Dead Meleager*.

It is therefore a meditated work by Raphael, revised on the basis of the Florentine novelties: a true masterpiece that has nevertheless been dismembered, as it lacks, in its spatial rhythm and conceptual significance, the fundamental relationship with the cyma and the predella. Spatially, because for instance Joseph of Arimathaea is looking upwards, towards a point which today seems indefinite, while this was not originally the case (as he was looking at God the Father) and because, without the reference of the cyma, the landscape of Umbria – thecontemporary stage of the tragedy of Grifonetto and Atalanta Baglioni- appears almost squeezed between Golgotha (to the right) and the stone tomb (to the left).

Also the conceptual significance is left incomplete because, something Locher also recently underscored, the three constitutive elements cannot be evaluated singularly, since Raphael's work was planned as a true

altar "retablo".

In fact, while the "current" significance of the suffering of Atalanta Baglioni is celebrated by the entire composition (see Vasari, ed. Milanesi, vol IV, p. 327: "Raphael, imagining in the composition of this work the pain suffered by the closest and most loving relatives when they lay down the body of a very dear person, who truly embodies the good, the honour, and the values of a whole family") and by the probable "cryptoportrait" of Grifonetto as the young carrier who supports the legs of Christ, the value of the altarpiece as liturgical image and symbol of the agony of a mother, cannot be appreciated without considering the presence of God the Father (driving power and lord of History) on the cyma above, and the representation of *Charity* (in the strictest sense of "compassio Mariae") which in fact vaunts a central position on the predella.

This painting was acquired thanks to Scipione Borghese's obsessive and possessive passion for collecting. It was seized from the church of St. Francis the night of 19 March 1608 to be given to Cardinal Nephew. A note to pope Paul V stated that this masterpiece by Raphael was "a private thing, donated to the prince who is its sole owner."

Raphael

Lady with a unicorn (oil tempera on canvas transported from wood and remounted on wood, 67 × 56 cm) is one of the most enigmatic paintings of the Borghese Gallery. The only certain fact is that it is the portrait of a Florentine lady, as one may infer from the type of dress (the "*gamurra*", a dress with a low neckline, trimmed with velvet ribbons, that shows the shoulders, only just concealed by an impalpable veil). The wide sleeves (the "*forniture*") in red velvet are held up by ribbons (the "*agugelli*") in the same red colour. The blouse, in thin white "renza fabric" issues, with slight folds, from the neckline and, with ample puffs, from the end of the sleeves, in accordance of the Florentine fashion in the early Sixteenth century, that also inspired the hairdo (a long thick braid – the so-called "*coazzone*" - collected behind the shoulders). The valuable jewellery witnesses the lady's high lineage: the small diadem, shaped like a four-leaf clover, with two small pearls, in the hair, in the middle of the parting, the gold chains around the neck with a pendant in the form of a large square-cut ruby set in gold with scrolls in white enamel, surmounted by an emerald and concluded by a large irregular pear-shaped pearl. To this day the identity of the lady is unknown, even if critics have made various attempts, seeking to connect the portrait to some of the noblewomen who were married in the years from 1505 to 1507, and some Florentine commissions entrusted to Raphael. The traditional identification of this painting with the one described in the inventory of the Aldobrandini collection (1682), suggested by Paola Della Pergola in 1959, principally because of the iconography "a seated woman holding a unicorn in her arms", has been disputed due to the size, about thirty centimetres smaller than the actual painting. Verifications of inventories of the Borghese collection from the Seventeenth and Nineteenth centuries have on the contrary revealed that it is almost certainly a matter of the painting which was referred to as depicting St. Catherine of Alexandria or the "*rota*", i.e. the image modified by a subsequent repainting, eliminated in 1936 during a much debated restoration. This intervention, preceded by a series of X-rays which had revealed the presence of a small dog under the unicorn, consisted of the destruction of the old wooden support and the elimination, with a razor blade, of the repainted parts (cape, wheel, palm, hands), also seriously harming the parts painted by Raphael (it is sufficient to mention the ugly scratches on the lady's complexion). The numerous diagnoses carried out on the work recently and published on a CD Rom, have made it possible to recognize five different layers. The first – the one Raphael drew and painted – features the landscape, the sky, a rectangular window and, in the centre, the lady with less voluminous hair lying closer to the neck, with the puffs until the beginning of the sleeves, the veil on the shoulders (narrower than those visible today), the bodice and the belt in light leather, with gold decorations and a gold buckle. Raphael's drawing underneath the painting corresponds to its final coat, with the exception of the form of the eyes and the lips, which are less wide, the point of the nose, which is shorter, and the contours of the face, which is more peaky.

The second layer (executed shortly afterwards) has added: a new drawing, executed on the surface painted by Raphael, with the columns, the plinths, the sleeves, the dog and the hands, and the painting of the columns, the plinths, the added volume of the hair (on the sides of the face and on top of the head), the sleeves and the dog. On the basis of affinities and verifications of the style, the drawing and painting of this layer may be attributed to the Florentine Antonio Sogliani (1492-1544).

Some years later, as the dog had been damaged, a unicorn was added (third layer). In the fourth layer the image has been turned into Saint Catherine, with the addition of wheel, cape, palm and two new hands (the right one is completely redone, the left one repainted). The fifth layer is the one visible today, after the restorations made in 1936, 1959 and 1960, the latter two curated by the Central Restoration Institute.

The attribution to Raphael, suggested for the first time by Longhi (1927 and 1928) who recognized the style of the master despite the repainting that had turned the image into Saint Catherine, is by now generally accepted, and the work is dated about 1506. On the basis of the recent findings of diagnostic analyses, it is presumed that Raphael began painting the Borghese portrait, which then remained incomplete, perhaps due to unforeseen events (the sudden death of the young lady, or the breach of a wedding contract, or the great artist's departure from Florence). The cultural sources of inspiration are Leonardo (*Mona Lisa*, the *Lady with the ermine*) and Flemish painting, meditated through the works of Piero della Francesca.

This painting is certainly one of the most enigmatic in the Borghese collection due to the lack of precise documentary information. A controversial restoration carried out in 1936 removed four layers of painting subsequently added onto to Raphael's painting of around 1506, which can now be seen.

Titian

This very famous painting, a symbol of the Borghese Gallery, only acquired its title, *Sacred and Profane Love* (oil on canvas, 118 × 278 cm), in the late Eighteenth century, when Vasi identified Titian's painting in these terms in his *Instructive itinerary of Rome...* (1791).
During the Eighteenth century, on the contrary, purely descriptive titles had prevailed, as *Two women by a fountain* (Ridolfi, 1648) or *The other great one of the three loves* (Manilli, 1650) or *Divine and Profane Love with an amorino who fishes in a pond* (inventory from 1693). A descriptive criterion of the main figures therefore prevailed, as compared to a synthesis of the symbolic values on which a debate was to commence, especially from the late Nineteenth century until today, with

very important contributions from German, British and Italian critics. While the painting is, *par excellence*, mysterious in terms of the interpretation of the different significant elements, it is also mysterious as far as its origin is concerned. The most accredited theory is that it comes (along with another seventy paintings) from the collection of Cardinal Paolo Emilio Sfondato (nephew of Pope Gregory XIV) purchased in 1608 by Scipione Borghese, even if research of archives has yet failed to uncover a detailed list of the seventy-one works. The shield on the front of the sarcophagus belonged to Nicolò Aurelio, Secretary of the Council of the Ten from 1507 and the shield of the Bagarotto family in the centre of the tank have revealed that the painting was commissioned on the occasion of a

wedding, namely of Nicolò Aurelio and Laura Bagarotto, daughter of a well-known jurist from Padua, (in 1514).
The painting may be interpreted in countless ways, mainly due to the presence of two female figures, one clothed and one nude, considered symbols of two alternative and contrasting moral concepts (above all love and virtue - Virtus and Voluptas) or as two representations inseparably correlated with Venus (the nude figure) who invites the dressed woman (whose white dress has also been identified with Laura Bagarotto's white silk dress, described in a document stored in the archives) to love (visibly represented above the fountain-sarcophagus).
Undoubtedly, the neo-platonic interpretation is the most pertinent and fascinating, as well as being

best suited to the literary circles of the *Asolani* frequented by Titian in his youth, with the exaltation of the Celestial Love (the naked woman who raises the burning flame, symbol of love for the Gods) opposed to earthly love. But beyond the different, possible and endless interpretations, also inspired by the two different landscapes in the background, one flat with a lagoon, herds and signs of a pastoral concert on the right side and a steep, towered one (with a fortress – symbol of Virtus - a knight and two rabbits, symbol of marital fertility) on the left, as well as other symbolic figurative elements such as the flowers, the different types of plants, the same sarcophagus (with the representation of the ancient myth of Venus and Adonis, considered a prefiguration of the passion and triumph of Christ), what counts above

all is the great pictorial charm of the composition. This visual charm was achieved by Titian after careful planning (revealed by the analyses with X-rays and reflectographs carried out within the context of the restoration done in the Laboratory of the Superintendency for the B.A.S. of Rome, curated by R. Dionisi and A. Marcone, under the supervision of M.G. Bernardini and S. Staccioli in the years from 1990 to 1995). The pictorial representation is harmonized on horizontal and vertical lines (the front and the edges of the sarcophagus, the undulating lines of the landscape and the clouds to the right; the trees on the left, the central background of trees, the towered fortress to the left, the belfry to the right and the three main figures). While Titian's palette enables him to enphasise the contrast

The Neoclassical stamp of Antonio Asprucci

The Seventeenth century style interiors, essentially based on the use of light plasterwork with details in travertino stone (for architectural decorations and fireplaces) and "blue and gold" leather was completely transformed, during the last thirty years of the Eighteenth century, in the time of Marcantonio IV Borghese (1730-1800). It was the father of Camillo, future husband of the pretty Paolina Bonaparte (celebrated by Canova's marble sculpture) who commissioned architect Antonio Asprucci to re-arrange the entire building and surrounding garden and park in accordance with the new rules of the Neoclassical period.

The chief transformations of that period comprise the closing of the loggia decorated by Lanfranco, which was turned into a salon (the frescoes were also restored and added to by painter Domenico Corvi); the demolition of the original entrance staircase to the portico (which was only rebuilt within the context of the works done in the mid-Nineties of the Twentieth century, with a philological reconstruction based on a study of the archive documents, in order to equip the basement with all the facilities necessary for the public, such as ticket counters, checkrooms, bar, bookshop and didactic workshop) and the construction of a staircase shaped like the base of a pyramid; the new, extraordinary Neoclassical decoration of vaults, walls and pavements with paintings, stuccos, tempera decorations, bronze friezes, tiny mosaics, overlays with semi-precious stones and rare polychrome marbles, fireplaces.

between the two pretty female figures, one nude and one clothed, also through the chromatic contrasts between red and white hues alternately spread on large areas (the red of the wide, fluttering cape of Sacred Love and that of two small details in the sleeve and the footwear of Profane Love; the white of the narrow ribbon around the thighs of the figure to the right and the white of the ample dress that embraces and covers the figure to the left).
In fact, all that this masterpiece probably wants to convey is the accomplished beauty of the two heroines and the indecipherability of Nature, understood as a phenomenon.
This indecipherability is expressed in Titian's painting through the irresolvable enigma of the light and the moment in time: the morning light that crosses from left to right through the dark forest in the background in the central part of the painting becomes, at the same time, the golden sunset illuminating the evening fog on the lagoon.

This famous painting, symbol of the Borghese Gallery, was acquired in 1608 by Scipione Borghese from the collection of Cardinal Paolo Emilio Sfondato.

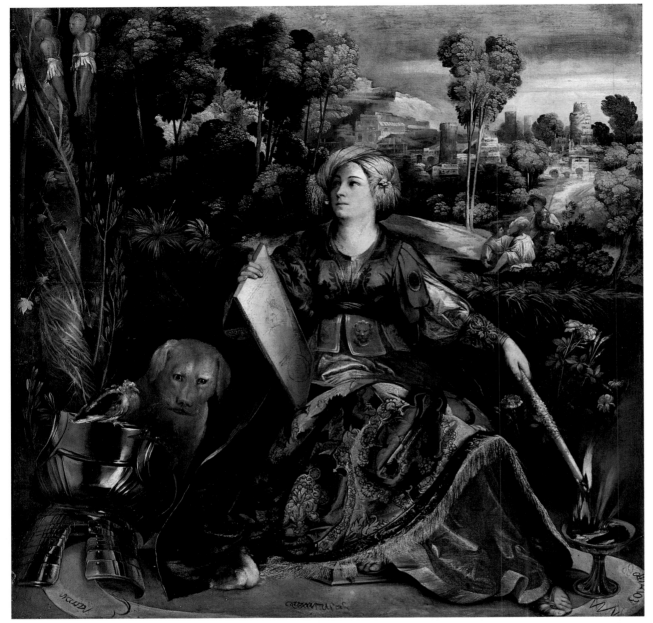

Dosso Dossi (Giovanni Francesco Luteri)

The incomplete *Melissa* (oil on canvas, 170 × 174 cm), 1615-30 is not mentioned in an ancient inventory and was remembered for the first time in 1650 by Manilli, as exhibited in the Gladiator Room (today Room VI): "a Sorceress, who is doing magic" with the attribution to Dosso and Battista Dossi ("it is by the Dossi brothers"). It is also defined as "Sorceress", even it the description is more exhaustive, in an inventory prepared in 1693 for the inheritance of Giovanni Battista Borghese. Only in 1750 does an inventory of the Borghese collection housed by the Palazzo at Campo Marzio list the painting as the "Sorceress Circe", i.e. with the name of the Sorceress (*Odyssey* X, 135 and foll.) who lived in the forests and turned her lovers into animals. This identification is still accepted by many modern critics.

But the most likely identification, which was already anticipated in a fundamental treatise on Dosso and Ariosto by Schlosser from 1900, is that of Melissa, the kindly Sorceress of the *Orlando Furioso* (VIII, 14-15) who frees the Christian and Saracen knights from the palace of the cruel Alcina who had turned them into stones, trees, fountains and animals. According to this interpretation, the group of three soldiers seated in the immediate background and the architectural setting represent a group of knights freed from the spell, and the palace of Alcina. Recent X-ray investigations have confirmed the validity of this iconographic representation; in fact, in the first draft of the painting a knight stood upright on the left side of the Sorceress, dressed in armature but bareheaded, leaning on a spear, with a dog, smaller than in the final version, by his side. It is not difficult to recognize, in this figure exchanging glances with Melissa, the warrior Astolfo, freed from Alcina's spell and returned to possession of the invincible golden spear of Argalia (VIII, 16-17). In Ariosto's poem Melissa is celebrated for her physical beauty and rich garments and is accompanied by flaming torches and astrological signs.

After 1598 Dosso's *Melissa* was taken from the Estense castle by some of the Roman prelates who competed to obtain the paintings of the famous Master from Ferrara, and it is supposed to have been purchased in Rome at a later date, which it is impossible to specify at this point but which must have been before 1650, by the Borghese family, probably by Cardinal Scipione himself, since Manilli's text to a great extent reflects the situation of the Villa Pinciana at the time of the death (1633) of the nephew of Paul V. The final version chosen by Dosso, with the elimination of the physical presence of Astolfo and his symbolic evocation through the empty armature, corresponds to the fable chosen by the master from Ferrara, but also to a liberation from too strict literary limits, in favour of fantasy and a play with enigmas and symbols (in which the work is rich). The rich splendour of the colours is clearly inspired by Titian and confirms the dating to around 1516, when the contract between Dosso and Titian, according to which the former would visit Venice and the latter stay in Ferrara, was renewed.

Caravaggio (Michelangelo Merisi)

The Borghese collection originally included twelve paintings by Caravaggio, a fact which testifies Cardinal Scipione's great interest in the Lombard painter. Just six of them have remained and are all exhibited in Room VIII. The first information on *David* can be found in a payment receipt for a frame made in 1613 by Annibale Durante. In the same year Scipione Francucci describes the painting (see *Canto III* Stanzas 182-188, 1613, ed. Arezzo 1647). But it is Manilli (1650) who mentions the name of the author: "David with the head of Goliath is by Caravaggio; who wanted to portray himself in that head, and who portrayed his Caravaggino as David". Manilli's self-biographic interpretation of the Goliath, confirmed by Ballori (1672) – who retraces its origin to a direct commission entrusted to Caravaggio by Scipione Borghese (and consequently between 1605 and 1606) – has been generally accepted by modern critics, with the only exception of Longhi. The painting seems completely dominated by the thought of a "living death" and the significance of the moral sentence Caravaggio inflicts on himself, by painting his own decollation, is underscored by the initials painted on the sword, "HASOS", a motto of Augustinian origin ("Humilitas occidit superbiam") that prefigures the identification of David with Christ and Goliath with the Devil.

The turning point at the end of the 1700's

Among the names succeeding one another in that crucial thirty-year period we find the artistic Gotha of Rome of those years: Mariano Rossi, Tommaso Conca, Cristoph Unterberger, Anton von Maron, Domenico De Angelis, Gavin Hamilton, Giuseppe Cades, Felice Giani, Johann Wenzel Peters, Giovan Battista Marchetti, Luigi Valadier, Agostino Penna and Vincenzo Pacetti. The iconographic repertory in the vaults illustrated the genealogy of the Borghese family and the amenity of the place, reserving an important place for the contemporary interest in exoticism in the so-called Egyptian Room (the current Room VII). The story of the collection essentially centres on the acquisitions and commissions of Cardinal Scipione who, on his death (1633) left behind him a completely outlined profile for his "Gallery" (celebrated in verses by Scipione Francucci in 1613). Another fundamental event in the formation of the collection was the marriage of Paolo Borghese and Olimpia Aldobrandini (1638), when several works from the collections of Cardinal Salviati, Lucrezia d'Este and Cardinal Ippolito Aldobrandini were added (it is sufficient to mention the *Madonna with candelabrum* by Raphael and the *Portrait of an Unknown Man* by Antonello da Messina).

The museum in the modern era

The impoverishment during the last decade of the Eighteenth century when many masterpieces were sold to rich foreign dealers such as the Englishman Fry and the French Durand, and the irreparable loss provoked by Camillo Borghese who in 1807 sold a large part of the archaeological collection (154 full-figure statues and about 400 other pieces, including the famous *Borghese Vase*) to his brother-in-law Napoleon for a substantial sum.

The latter damage was only to some extent set right by the purchase, in the Parisian antiquity market (1827), of Correggio's *Danae* and the commission of *Paolina Bonaparte as the Victorious Venus* by Canova. During the Twentieth century some important additions further enriched the historical Borghese collection: *Truth* by Bernini and Savoldo's *Tobias and the Angel* (1911).

In the Pinciana building the Neoclassical arrangement of the works, heedful of symmetry and iconography and assuring a harmonized relationship between antique and modern art, had been conserved by the rearrangement in the late Nineteenth century, when all the large sculptures were moved to the ground floor. This plan was respected in 1981, when the paintings kept in the Palazzo di Ripetta were also moved to Villa Borghese.

The historical thread, according to which the paintings are organized in schools, in spite of inevitable incongruities (due to the different size of the rooms and the obstacles represented by the precious Neoclassical elements) decided by Giulio Cantalamessa in the early years of the Twentieth century has essentially been conserved by his successors, until Paola Della Pergola, author of a catalogue of painting which remains essential for any study even today.

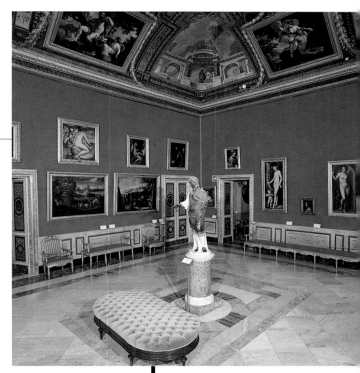

Overall view of Room X

The Egyptian Room (Room VII)

The decoration of this room (realized between 1778 and 1782) reflects the erudite and antiquarian interest in ancient Egypt tipical of the late Eighteenth century. The model of inspiration, namely the Papyrus Room in the Vatican by Anton Raphael Mengs and Christoph Unterberger, had been completed only a few years before (1771-75). Antonio Asprucci used rare and precious materials, such as porphyry and granite, for the pillars and other architectural details. Egyptian symbols and ideograms, also invented ones (based on the Romanized interpretation formulated by Piranesi) accompany the wall paintings by Tommaso Conca and Giovan Battista Marchetti (who executed the architectural squaring) and Giovanni de Pedibus (who painted the floral festoons). In the large painting in the middle of the vault Conca has depicted an *Allegory of ancient Egypt with the goddess Cybele*, while the *Story of Anthony and Cleopatra* is illustrated on the canvases installed under the architrave. Reflecting the exotic iconography, the signature of the author is in Greek characters, followed by the date 1780 sealing the painting (hung above the door leading to the Chamber of Silenus, currently room VIII) depicting *Cleopatra asks for the asp to commit suicide*.

Paolina Bonaparte as the Victorious Venus

On 15 May 1809 Camillo Borghese paid 6000 *scudi* to Antonio Canova for the "reclining statue in marble representing the portrait of Her Imperial Highness Paolina Bonaparte Borghese, our Spouse" and for a bust with the same motif (sent to Paris and known thanks to the plaster model kept in the museum of plaster casts of Possagno, and some copies and variations). The design and the different phases of the execution are well documented by sources like the documents in the archives, the drawings and finally by the plaster model (Possagno, museum of plaster casts). If we are to believe a letter from the Prussian minister Humboldt, the plaster model, with indication of all the "key points", had been completed and exhibited in the artist's study in Rome already in 1804. This plaster model, like all the others, was to serve the assistants in charge of the rough cutting of the marble, before the "final touch", the "sublime execution" that the Venetian sculptor reserved for himself.

The most interesting of the four study drawings (Bassano del Grappa, Civic Museum, F.3.1.1509) documents the study of the relationship between Paolina – Venus, the mattress and the chaise-longue with the curtain.

The symbolic portrait of Napoleon's sister, who was married – in 1803 – to Camillo Borghese, as part of dynastic strategies pursued with determination by the contemporary First Consul, to improve the diplomatic relations between France and the Church State, was sculpted over a three-year period, from 1805 to 1808. In those years Paolina, princess Borghese and since 1804, when Napoleon was crowned Emperor at Notre Dame, Imperial Highness, was the star of society life. In the same period Canova celebrated the Bonaparte family as a new European dynasty with a series of

This famous sculpture by Canova was produced between 1805 and 1808 from a solid block of pure Carrara marble. It is mounted on a stuccoed painted wooden support that hides the mechanism that allows the statue to be fully and slowly rotated.

"official" portrait. In all these portraits of Napoleon's relatives the references to ancient history or classical mythology represented an indispensable expedient aimed at symbolizing victorious and pacifying power (*Napoleon as Mars*, 1803-06, London, Apsley House), maternal authority (*Letizia Ramolino as Agrippina*, 1804-07) or physical harmony and grace (the sister *Elisa Baciocchi as Polyhymnia*, 1812-17; the sister-in-law *Alexandrine Bleschamps as Terpsichore*, 1808-18). This approach, which we may define "mythic-dynastic", involved the choice of the most beautiful goddesses of ancient mythology to celebrate the most famous and prettiest of the newly appointed Emperor's sisters. This iconographic parallel (which Canova preferred to the initial one, i.e. to represent Paolina Bonaparte as Diana) also allowed an explicit homage to the divine mother of Aeneas, a hero the Borghese family counted among its own, mythic, ancestors. Paolina-Venus is represented at the height of

her triumph when she is assigned the concrete symbol of the primacy of her beauty (recognised by Paris as surpassing that of Juno and Minerva), in the form of the golden apple she holds in her left hand. Along with the apple, another emblem of Venus, the dolphin head, appears twice (on the corners of the backrest). Other "signs", on the other hand, indicate the social position of the pretty lady posing for the portrait; the bracelet, the hair ribbon, the embroidery of palms and racemes (engraved on the mattress), the sequin gold decorations on the chaise-longue with stylized rosettes, the phytomorphic decorations and the laurel crown (symbol of the Napoleonic age) represented under the cushion Paolina is resting against on the short side of the dormeuse. The work (h. 92 cm, length 200 cm) is sculpted from a single block of very fine Carrara marble, with the grafting of two triangular forms (on the end of the upholstery and on the backrest). The motif of a nude female body, or one that is partially covered by

veils or drapery, reclining on cushions, has a long figurative tradition, elaborated, especially during the Sixteenth century, by Venetian painters. And Canova himself, a Venetian, had in his youth painted various works, mindful of the "Giorgesque brush", including a *Venus with faun* (1792 ca, Possagno, Museum of Plaster Casts), which has certainly served as basis for *Paolina*. The motif was particularly appreciated by French contemporary culture and extremely topical, since 1800 Jacques-Louis David had portrayed *Madame Recamier* semi-reclined on a meridienne in a position emblematic of female sinuosity and beauty. The wooden chaise-longue on which the body of *Paolina-Venus* and the mattress rest, contribute to the sublimation of the work, as "furniture piece" contrasting with the transparency of the "real skin" (to quote the contemporary Cicognara, biographer of Canova) of the statuary marble. But apart from playing an essential role in the overall picture, the

dormeuse serves to conceal the mechanical system with wheels, concealed by the wooden frame, stuccoed and painted in white and gold – actually dovetailed mobile panels – which, according to Canova's design, made it possible to let the sculpture rotate through 360 degrees.

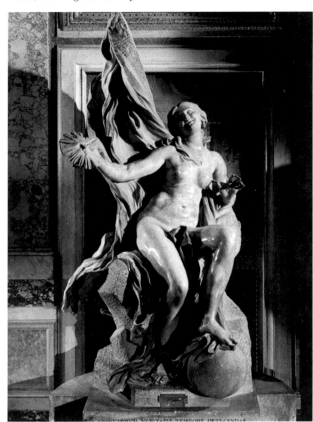

Villa Borghese today

It was this director of the museum who decided, in the Fifties and Sixties, to restore the trustee core of the collection, removing all works from other sources (Corsini, Barberini, territory of Rome and province) which had been moved to the Galleria Borghese, with the intention of creating a "Gallery of masterpieces" (especially in the period of Aldo De Rinaldis).

In 1997 the plan of the exhibition was developed on the basis of two main guidelines: one iconographic, similar to the one developed in the Nineteenth century, inspired by the themes of the sculptures exhibited in the centre of the rooms; and one other based on chronology and schools in every single room on the floor of the picture gallery. This decision was also conditioned by the elimination of all the screens and panels which, introduced during the directorship of Paola Della Pergola, increased the total exhibition surface, but covered four large windows in Rooms X and XX, numerous doors, decorations and Neoclassical architectural elements. The main change with respect to the previous interior arrangement has therefore consisted of the move of Dosso's paintings with metamorphic subjects to Room II, where the Apollo and Daphne is installed, and the hanging of all Caravaggio's paintings in Room VIII.

Correggio (Antonio Allegri)

Danaë (oil on canvas, 161 × 193 cm) became part of the Borghese collection in 1827 when Camillo Borghese, perhaps acting on the advice of his brother Francesco who lived in Paris at the time, bought it for 30,000 francs during the sale of the collection of Féréol de Bonnemaison, dealer and painter. After an initial journey to Florence and a short stop at the Palazzo Borghese-Salviati in Via Ghibellina, the canvas set off once again, in 1827, bound for Rome where it was restored by Pietro Camuccini, brother of Vincenzo. From that time Correggio's canvas was to become the subject of widespread debate (also on the subjects of authenticity and immorality) that was to continue practically throughout the entire Nineteenth century. Evasio Gozzani di San Giorgio, the prudent House Administrator in Palazzo Borghese in Campo Marzio, chose to place the painting in one of the rooms of Camillo's first floor apartment, where it might be shown occasionally and partially, in order to dampen the disputes about the liberality of the painting's iconography. But the prince did not approve of this solution, being fond of showing his acquisitions in public. And the masterpiece by Correggio was therefore shortly afterwards exhibited, with an important gilt frame (different from the current one in neo-Sixteenth century style) by Luigi Siotto "with a grandiose body and two edges and three carved orders; and there are ovolos, a large quantity of leaves, and circles" (gilt with "sequin gold"), "in the Gallery, in front of the *Sacred and Profane Love* by Titian, and we then have a large attendance, both to see it and to ask to copy it" (from a letter from 6 November 1827).

When the painting arrived in Rome to become part of the Borghese collection, it had travelled like few others. The main stages of its journey included Mantua, Spain, Milan (in the collection of Leone Leoni), then once again in Madrid in 1601, then Prague at the court of Rodolfi II, then Sweden with Gustavus Adolphus and then, with Queen Christina, who brought the painting back to Italy, and more specifically to the Palazzo Riario in Rome; finally, it joined the collection of Livio Odescalchi, whose heirs sold the *Danaë* to the Regent of France, with the mediation of Pierre Crozat; it was then taken to England and once more to Paris and, after Camillo had bought it, to Florence and Rome.

Correggio has taken the iconographic theme of the painting from the *Metamorphoses* by Ovid (IV, 611), at the point where he tells about Jupiter who, in love with Danaë, daughter of Acrisius (king of Argos) generates Perseus, turning into a rain of gold. In the painting the rain of gold is collected by Cupid. At the feet of the bed, two *Amorini* (one winged, symbol of celestial love, the other without wings, symbol of terrestrial love) test, on a *paragore* stone, the quality of the love (the point of the arrow).

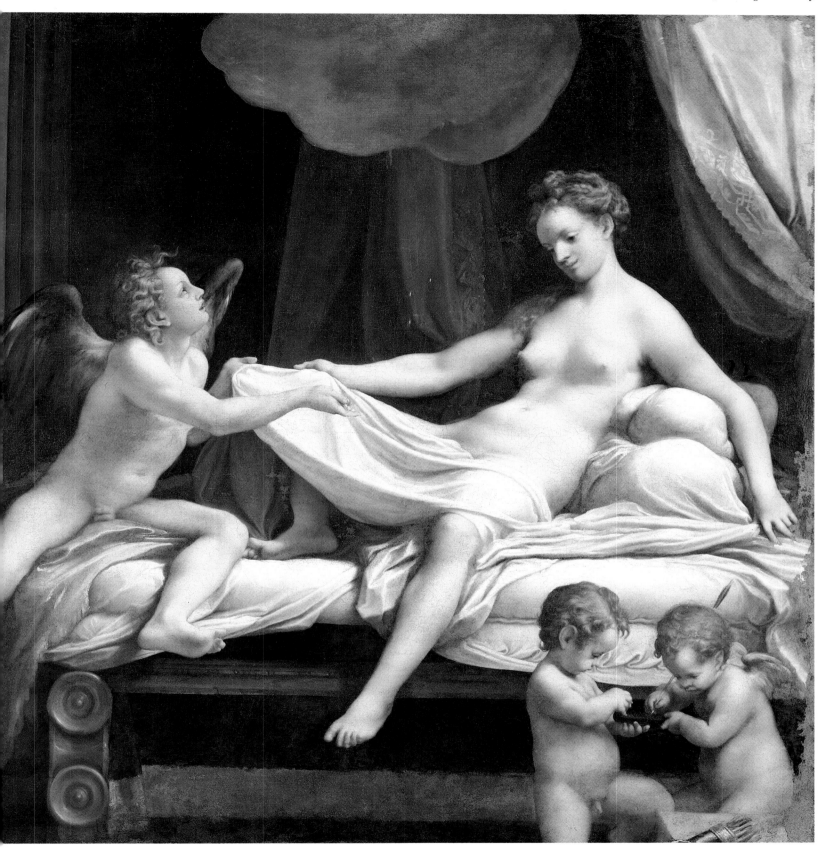

This Danae, *painted by Correggio
in 1530-31 travelled the length
of Europe until it ended up
in the Borghese collection in 1827.
Prince Camillo, husband of Paolina Bonaparte,
acquired it from a Parisian antiquarian.*

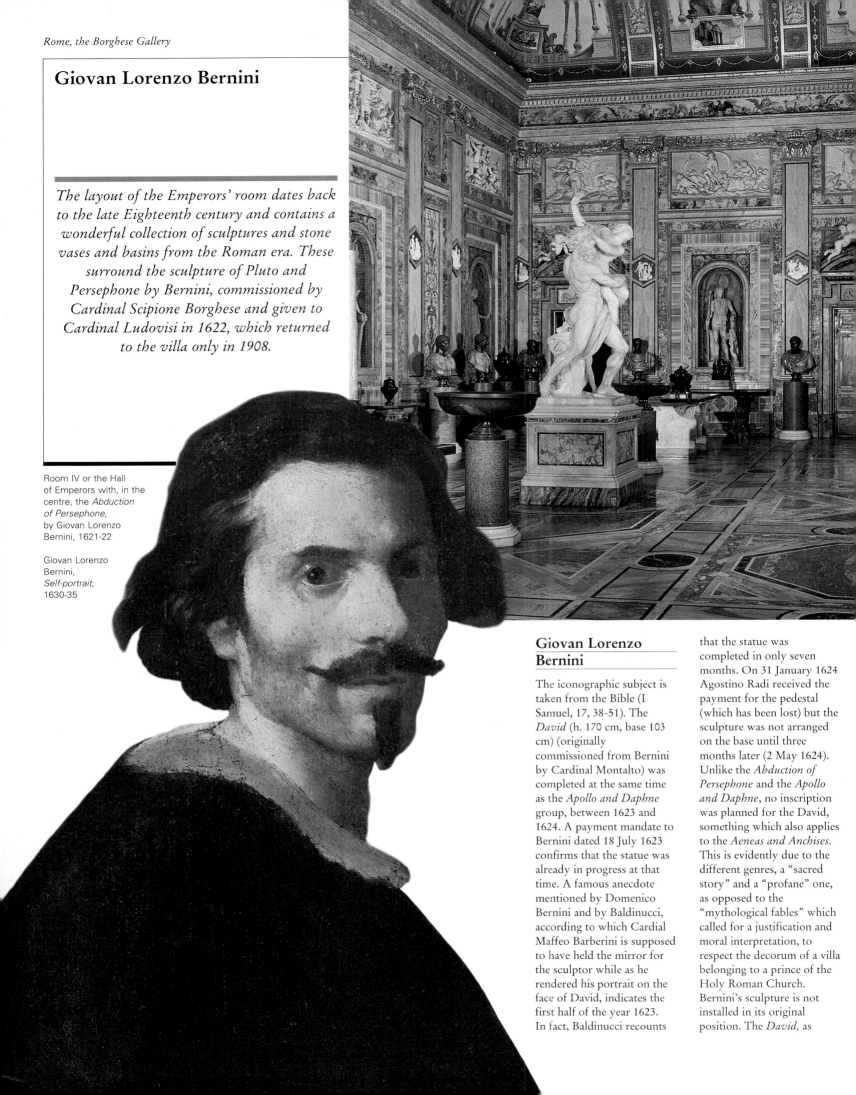

Giovan Lorenzo Bernini

The layout of the Emperors' room dates back to the late Eighteenth century and contains a wonderful collection of sculptures and stone vases and basins from the Roman era. These surround the sculpture of Pluto and Persephone by Bernini, commissioned by Cardinal Scipione Borghese and given to Cardinal Ludovisi in 1622, which returned to the villa only in 1908.

Room IV or the Hall
of Emperors with, in the
centre, the *Abduction
of Persephone*,
by Giovan Lorenzo
Bernini, 1621-22

Giovan Lorenzo
Bernini,
Self-portrait,
1630-35

Giovan Lorenzo Bernini

The iconographic subject is taken from the Bible (I Samuel, 17, 38-51). The *David* (h. 170 cm, base 103 cm) (originally commissioned from Bernini by Cardinal Montalto) was completed at the same time as the *Apollo and Daphne* group, between 1623 and 1624. A payment mandate to Bernini dated 18 July 1623 confirms that the statue was already in progress at that time. A famous anecdote mentioned by Domenico Bernini and by Baldinucci, according to which Cardial Maffeo Barberini is supposed to have held the mirror for the sculptor while as he rendered his portrait on the face of David, indicates the first half of the year 1623. In fact, Baldinucci recounts

that the statue was completed in only seven months. On 31 January 1624 Agostino Radi received the payment for the pedestal (which has been lost) but the sculpture was not arranged on the base until three months later (2 May 1624). Unlike the *Abduction of Persephone* and the *Apollo and Daphne*, no inscription was planned for the David, something which also applies to the *Aeneas and Anchises*. This is evidently due to the different genres, a "sacred story" and a "profane" one, as opposed to the "mythological fables" which called for a justification and moral interpretation, to respect the decorum of a villa belonging to a prince of the Holy Roman Church. Bernini's sculpture is not installed in its original position. The *David*, as

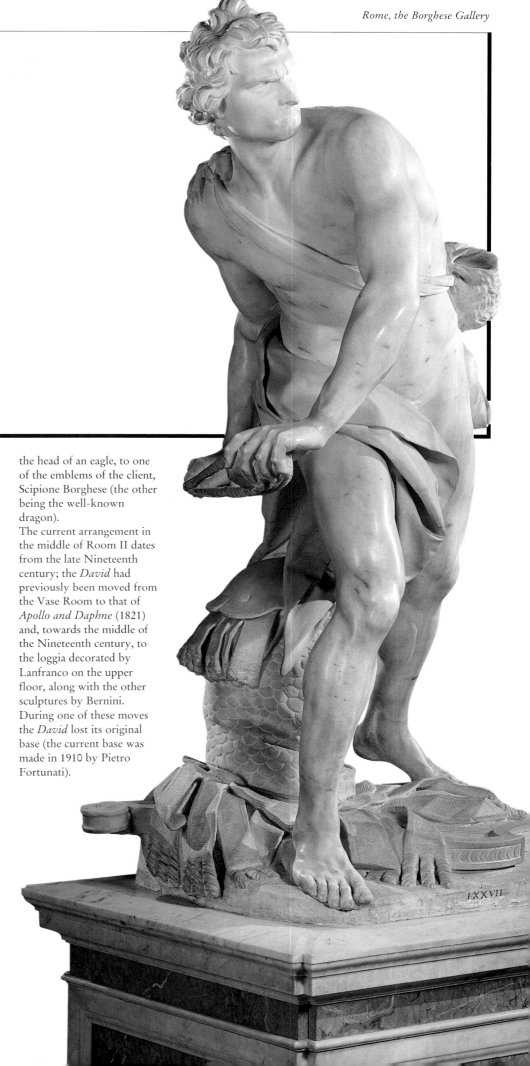

The artist who, more than any other – including Caravaggio – is identified with the Borghese Museum in the collective imagery is undoubtedly Giovan Lorenzo Bernini (1598-1680) who, with the sculptures made in his youth, actively contributed to make the Gallery of Cardinal Scipione "subject of amazement as one of the world's marvels", already in the Eighteenth century. The green outdoor areas, which along with the gigantic herms (in marble, travertino and tufa) commissioned from Pietro Bernini, featured the *Flora* and the *Priapus* (installed in the Theatre of Verzura in 1616, just inside the entrance gate to the Villa), that were both sculpted by the young Giovan Lorenzo. Inside the Pinciano country house, the *Amaltea Goat*, *Aeneas and Anchises with Ascanio*, the *Abduction of Persephone*, *David*, *Apollo and Daphne*, the portraits of *Paul V* and of *Scipione Borghese* (but also the Twentieth-century acquisitions of the *Truth* and the terracotta model for the *Equestrian monument of Louis XIV*) document the incomparable ability of the Neapolitan sculptor to render the tactile and chromatic values of different materials in marble, also during the process of metamorphic transformation (as in the case of *Daphne*) and the sense of a total movement which, in the surrounding space, becomes the action of the chosen representation (historical or mythological).

Manilli mentions in 1650, was exhibited in the first hall, the "Vase Room", against a wall.
Bernini's original project, conceived to be observed from a completely different angle to the current one, is witnessed by the "unfinished" character of the armour and the absence of the left heel ("reconstructed" when it was decided to place the sculpture in a central position, because the marble block used for the sculpture rendered the completion of the foot impossible; on the other hand, this formal incompleteness was by no means visible when the sculpture was placed against a wall). The visitor who entered the first room on the ground floor in the Seventeenth century would see the statue from the angle intended by Bernini, i.e. from the left side. From here one could follow, almost as if in a sequence of frames, the evolution of the torsion of David's body, in a projection which is concluded with the final act of throwing the stone at Goliath, the adversary (here absent) evoked by the aggressive gesture of the young hero - cum - shepherd. As a cultural model for this representation of a progressive movement, in a static pose, one has suggested the *Gladiator* by Agasias of Ephesus, one of the masterpieces of the antiquities collection of Scipione Borghese, at that time exhibited in the Villa Pinciana.
Indeed, the study of antique art is also confirmed by the presence of Saul's armour deposited at David's feet; here Bernini certainly had the two Dioscuri of the Quirinale in mind.
As far as pictorial models are concerned, Bernini's direct source was undoubtedly the *Polyphemus* by Annibale Carracci in the Galleria Farnese, according to a historical and critical interpretation formulated by Bellori as an example of a figure in movement, influenced by Leonardo's theoretic principles. The armoury, inclined in the opposite direction to the torsion of the young Biblical hero, emphasises the dynamism of the action represented by the marble, while the cithara alludes, with its decoration depicting the head of an eagle, to one of the emblems of the client, Scipione Borghese (the other being the well-known dragon).
The current arrangement in the middle of Room II dates from the late Nineteenth century; the *David* had previously been moved from the Vase Room to that of *Apollo and Daphne* (1821) and, towards the middle of the Nineteenth century, to the loggia decorated by Lanfranco on the upper floor, along with the other sculptures by Bernini. During one of these moves the *David* lost its original base (the current base was made in 1910 by Pietro Fortunati).

Giovan Lorenzo Bernini

The iconographic theme of *Apollo and Daphne* (h. 243 cm, base 115 cm) is taken from *Metamorphoses* (I, 452 and foll.) by Ovid. The execution of the sculpture group is defined with certainty by documents in the archives: on 2 August 1622 the marble block was purchased and on 24 November 1625 the final payment of 450 *scudi* to "Knight Giovan Lorenzo Bernini, sculptor" was recorded. The installation, in the current Room III, of the "statue of Daphne" on the pedestal made by Agostino Radi (and paid on 22 September 1625) took place in August 1625.

Between February 1623 and April 1624 (the date on which they were resumed) the advance payments for *Apollo and Daphne* were suspended, simultaneously with the rapid, progressive work on the *David*, that had just been purchased (18 July 1623) with the marble already roughly cut, after the sudden death of Cardinal Alessandro Montalto Peretti who had initially commissioned it.

The piece is sculpted entirely by the author, with an intervention by Giuliano Finelli limited to the base, the red earth, the tree, the leaves and, very probably, the scroll with the skin of the dragon that frames the famous verses by Maffeo Barberini (taken from *Twelve couplets for a Gallery*, composed by the future Pope Urban VIII between 1618 and 1620) "Quisquis amans sequitur fugitivae gaudia formae / fronde manus implet baccas seu carpit amaras": it is a comment on the sculpture group, to indicate the *vanitas* of the beauty and deceit of earthly pleasures, but at the same time an admonition to Scipione Borghese himself, and his unrestrained mania for collecting masterpieces and stupendous works of art regardless of any limit or scruple. The group of *Apollo and Daphne* was immediately recognised by

contemporaries as one of Bernini's outstanding masterpieces "surpassing any imagination" (Baldinucci), due to the extraordinary virtuosity demonstrated in the rendition of various details (the tapering fingers of Daphne that turn into slender and transparent tree leaves, the toes of Daphne's feet which become roots, small, delicate cylinders in marble which on a figurative level accompany the transformation of soft flesh into another reality, that of the hard bark of the laurel). In fact, the marble is moulded in a pictorial sense, with a different treatment of the surfaces and a continuous transition from high polish to extreme roughness, to render visually, through the different transitions of the light, the "colours of shade" to quote an expression used by Bernini himself, the tactile sense of the different materials represented.

Also in this group, like the other sculptures in the Borghese collection, the viewpoint of the observer has been carefully planned, and the parts which are not visible have therefore never been polished (witness, for instance, the upper part of Apollo's hand on the bark, the part of Apollo's back concealed by the arch of the fluttering cape). The group had been designed to be seen from below, with an accentuated ascending movement, suddenly arrested by the masterfully planned barrier of the trunk.

This theatrical approach was fully respected by the Seventeenth-century installation. In fact, in Room III where *Aeneas and Anchises, Apollo and Daphne* were also installed (on the opposite side), according to the latest historical and critical reconstructions, they were placed with the rear side against the wall adjoining the chapel, and faced the centre of the room along the

longitudinal axis.

On the occasion of the redecoration under Asprucci in the Eighteenth century, Bernini's group was moved to the centre of the room under the final control of Vincenzo Pacetti (30 July 1785).

The new central position, along with a rotation of 90 degrees, determined a fundamental change of the base. In fact, the original scroll with the couplets written by Maffeo Barberini was moved to the right side, and an analogous scroll added on the left (also sculpted by Lorenzo Cardelli in 1785); it featured the verses of the *Metamorphoses* inspiring the "fable" sculpted by Bernini, engraved inside the heraldic emblem of the Borghese eagle.

In the middle of the Nineteenth century, the *Apollo and Daphne* was moved to the loggia on the upper floor, where it remained until the end of the century, when all the large sculptures, according to a new arrangement that was to be definitive, were moved to the ground floor.

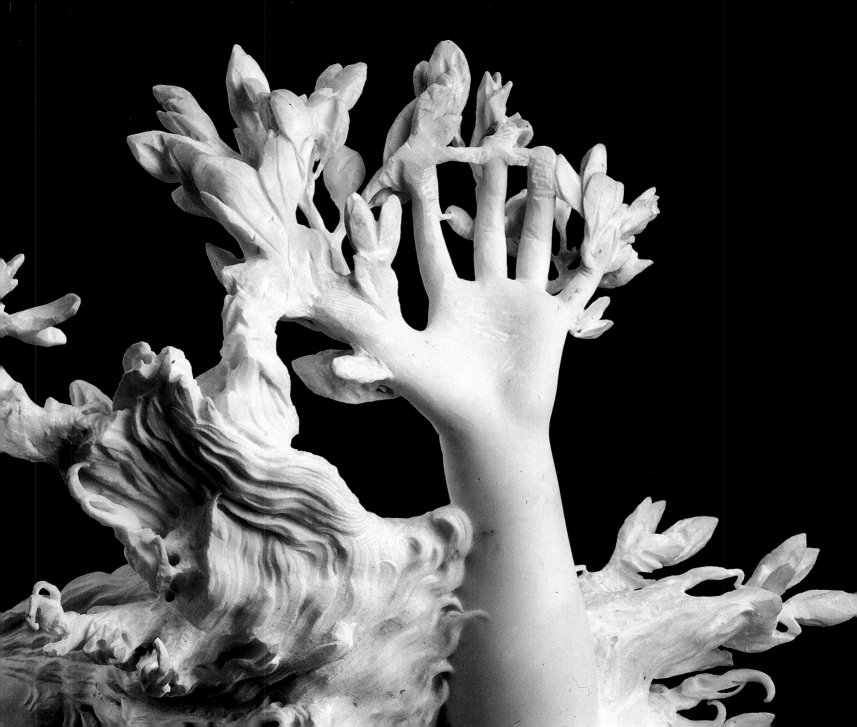

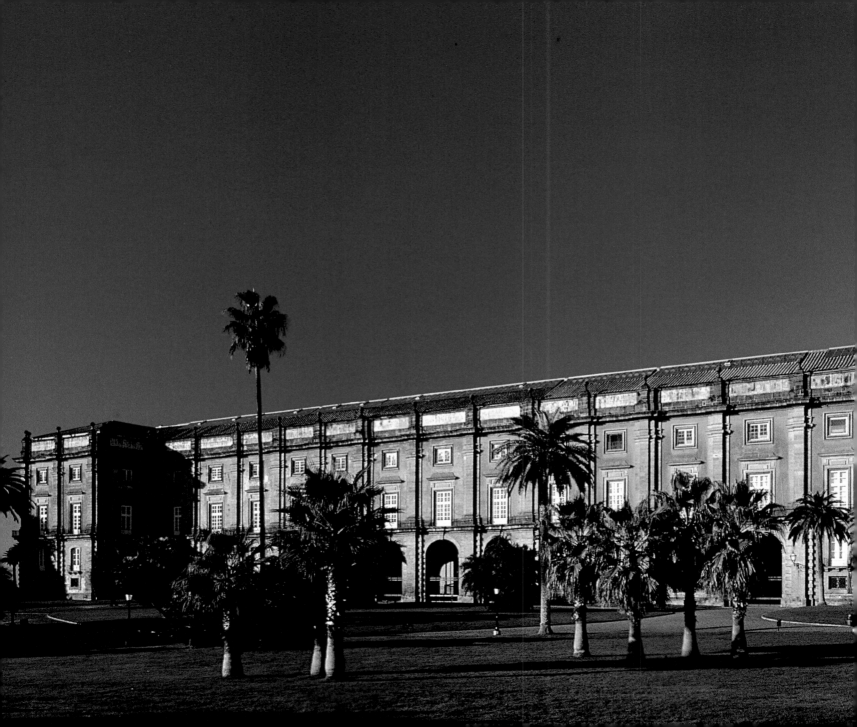

Naples, the Capodimonte Museum

Mariella Utili

The Capodimonte Palace was opened to the public in May 1957 as a museum of medieval and modern art from Neapolitan collections. At that time the *piano nobile*—the building's stately first floor—was arranged as the Appartamento di Stato, the State Apartment, with its all its furnishings and decorations, and the Gallery of Nineteenth-century Art. The upper floor served as the picture gallery with works from the end of the Fourteenth to the Seventeenth centuries.

The present configuration of the museum, the result of work initiated in the 1980s and the renovation of new exhibition galleries, has permitted all departments to reopen, a process that began in 1995. The collection, too, has been reorganized with a focus on one of the unique qualities of the museum—the formation of its collections which began with the Farnese patrimony and was then enhanced by the Bourbons and Savoias and finally by new acquisitions at the end of the Nineteenth century and throughout the Twentieth. The intent is to allow the works themselves to recount the history of the museum.

The first floor contains the Farnese collection and includes later acquisitions that were made in the same areas as the works purchased by that family. The Royal Apartments follow and have been rearranged chronologically, beginning with King Charles and the first Bourbon factories and ending with rooms dedicated to the period of French occupation and then the last of the Bourbon monarchs. Much space has been set aside for the decorative arts which are of particularly high quality given their provenance from the collections of important royal families.

The whole of the second floor is dedicated to the development of art in Naples from the Thirteenth to the Eighteenth centuries. The works exhibited there come mostly from the city itself or from southern Italy; in the early Nineteenth century they became the property first of the royal family and then of the unified Italian state. The gallery areas created out of the attic spaces under the roof houses a selection of paintings and sculptures of the Nineteenth century which then leads, through an exhibition of evocative photographs, to a department of contemporary art which, for the most part, consists of work commissioned to be exhibited at Capodimonte itself.

Charles Bourbon, who became King of Naples in 1734, decided to bring the rich collections of art he had inherited from his mother, Elisabetta Farnese, the last descendant of one of the most prestigious families of the Italian Renaissance, to Naples from the Duchy of Parma and Piacenza. He cautioned, though, with a sense of royal parsimony, that only those objects worth more than the cost of shipping should be sent.

From the time of Pope Paul III and his nephew, Cardinal Alessandro, in the mid-Sixteenth century, members of the Farnese family who were well aware of the prestige that accompanied this activity, had been sophisticated collectors and illuminated patrons of art. Their collection of paintings, sculpture and decorative objects were moved in the second half of the Seventeenth century from the famous Roman palace, designed by Antonio da Sangallo the Younger and then later by Michelangelo, to Parma as the political base of the family was relocated there.

View of the facade
of the Capodimonte palace
that overlooks the garden

The transfer to Naples

The collection continued to grow in Parma under the Farnese dukes, and as a result the city became an obligatory stop on the grand tour of Italy. Charles's decision to transfer the collections, which were legally his personal possessions, to Naples marked the beginning of Parma's decline. At the same time, however, it increased the appeal of his new capital, and there the collection was further enriched by the archaeological finds from Pompeii and Herculaneum. The old palace in the centre of Naples, the seat of the Spanish and then the Austrian viceroys, did not offer the ambitious new king a setting appropriate for displaying his collection. Its quality and importance had been showcased by the famous Ducal Gallery at the Palazzo della Pilotta in Parma, and the objects had been arranged according to contemporary ideas of museology. Thus the decision to build a new residence on the Capodimonte hill, an undeveloped area that was particularly well suited to the king's passion for hunting, coincided with the need to find a fit place for his formidable collection which, with the exception of a few paintings by Titian, Parmigianino, Correggio and Annibale Carracci as well as some gems and medals—including the famous Farnese Cup—were hidden away in storerooms of the royal palace.

The first project was for a vast, rectangular residence designed by Giovanni Antonio Medrano, a military engineer. It was quickly altered to emphasize the important function of exhibiting works of art. The king gathered a commission of experts to oversee the layout of the exhibitions, and with a sense of almost modern museology, they chose the better lit rooms on the building's south side, overlooking the sea, to hang the paintings while interior rooms were designated for the library. Early enthusiasm for the project—which would result, some twenty years later in a real picture gallery that became a favourite destination for famous travellers like Winkelmann, Canova, Goethe and the Marquis de Sade— faded, however, after the foundation stone was laid in September 1738. Construction proceeded slowly, obstructed mostly by the more ambitious project supported by King Ferdinando—who succeeded to the Neapolitan throne after his father left for Spain in 1759— to build a royal residence at Caserta. The architect Ferdinando Fuga finished the sections of the building around the central courtyard and designed the long salons connected to the core of the existing fabric in the 1760s.

The Grand Tour and Naples

Naples is one of the essential waystations of the *Grand Tour*, (the term appears in the 1697 guidebook by Richard Lassels, *An Italian Voyage*), above all for its art and antiquities collected by the Bourbon monarchs and kept, during the Eighteenth century, in the royal palace at Capodimonte. One of the immense number of pilgrims we should mention was Johann Wolfgang Goethe, who at the age of 37, came in 1786 from Rome to Naples, where he struck up a friendship with the painter Hackert. He often wandered up the slopes of Vesuvius to get a good view of the city, and visited its royal collections before leaving for Sicily. In 1788 he returned to Weimar, where he published *Italian Journey,* one of the most fascinating books ever written about Italy. Another visitor of great importance was Johann Joachim Winckelmann who came to Rome from Dresden in 1755 and worked there from 1758 onward, first as librarian to the Vatican, under the great collector of antiquities, Cardinal Albani. In 1762, after many visits to the Bourbon collections, he published an account entitled *On the discovery of Herculaneum*. In 1764 he came to Naples once more, and published a second report.

Angelica Kauffmann, *Portrait of Johann Joachim Winckelmann,* 1764. Zurich, Kunsthaus

Facing page
The Hexagonal Staircase

The building of the Capodimonte Palace, begun in 1738, lasted about twenty years. In the second half of the century it became a destination for illustrious travellers on their "Grand Tour", such as Goethe and the Marquis of Sade, scholars of antiquity like Winckelmann and artists such as Antonio Canova.

The Farnese Collection the nucleus of the Capodimonte collections

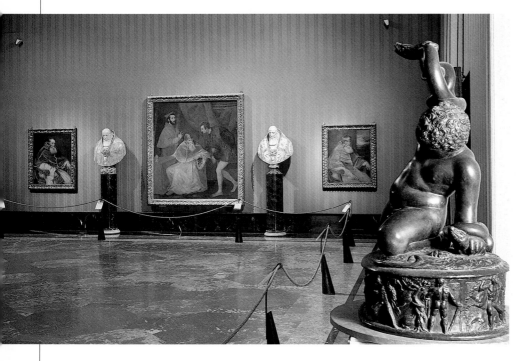

The prestigious Farnese collection is the core around which the collections of Capodimonte were formed. This patrimony was amassed in Rome in the days of Pope Paul III and his nephew Alessandro—"gran Cardinale"—and then in Parma under the Farnese dukes.

This collection is a group of paintings, sculpture and decorative objects executed, for the most part, by artists active in central and northern Italy. It also includes a good number of Flemish works most of which were acquired during a period of close rapport between the Farnese dynasty and Flanders and especially at the time of Margherita of Austria and her son, Alessandro, in the second half of the Sixteenth century. Some of the nothern European paintings, such as those by Brueghel, were confiscated from the nobility of Parma who rebelled against Farnese rule.

The most impressive part of the collection is its large group of Titians— unmatched in most Italian or foreign museums. They are, furthermore, an emblematic expression of the complex relationship that tied the most famous artist of the period to one of the most important families of the Renaissance. Titian painted the pope several times, including the famous portrait of *Paul III and his Nephews*, with a subtle sense of introspection. He did the same in his portraits of other important members of the family, including Paul's son, Pierluigi, and Cardinal Alessandro, for whom he also painted, among other things, the famous *Danae*. Works of the Emilian school have a special place beside the celebrated masterpieces by Masolino, Bellini, Lotto, Rosso, Pontormo, Sebastiano del Piombo and Venusti. The Farnese sought to establish its own prestige in its new home in the Val

View of Titian's Room

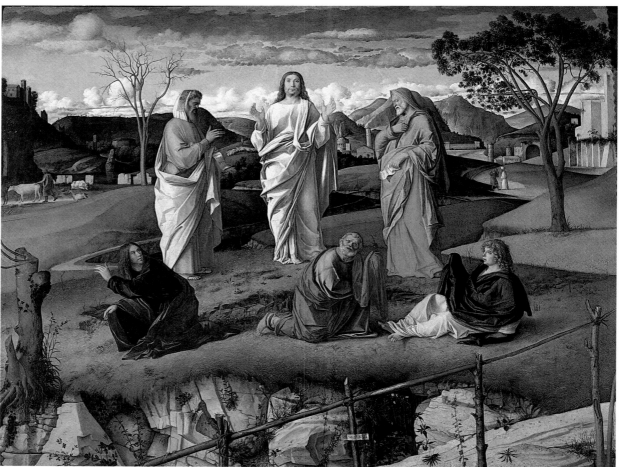

Giovanni Bellini,
Transfiguration, 1480-85

Correggio, *The mystic wedding of Saint Catherine*, 1520 ca

Michelangelo Buonarroti, *Group of squires*, 1546 ca

Padana by means of a shrewd policy of patronage and by acquiring works by local artists of the past. These included a variety of works by Correggio, Parmigianino, Bedoli, Dosso and some of the other Ferrarese masters, but the most important are the numerous works by the Carracci, the artists who were the protagonists, both in the Emilian duchy and the Roman court, of a new painting which united the Classical ideal and a vigorous naturalism. The careers of the three Carracci cousins is documented in the Farnese collection by such works as Ludovico's *Rinaldo and Armida* and Agostino's *Arrigo peloso* as well as Annibale's sensitive

Mystical Marriage of Saint Catherine, his own version of *Rinaldo and Armida*, *Hercules at the Crossroads* and the famous *Pietà*; they are all indisputable evidence of the change in taste and artistic direction that matured at the end of the sixteenth and the beginning of the Seventeenth centuries. The great cartoons by Raphael and Michelangelo— for the Stanza of Heliodorus at the Vatican by the former and the frescoes in the Pauline Chapel by the latter—offer invaluable evidence of the dialectic exchange between the schools of these two artists in Rome in the first decades of the Sixteenth century. The drawings belonged to the Farnese librarian, Fulvio

Orsini, who was himself a sophisticated collector, and he then bequeathed them to Cardinal Odoardo Farnese. The *Group of Soldiers*, a charcoal drawing on nineteen attached sheets of paper, shows three monumental figures from behind conceived for the *Crucifixion of St. Peter* which Michelangelo, already in his seventies, painted between 1546 and 1550. Raphael drew the *Moses Before the Burning Bush* between 1511 and 1514 and, in the vigorous power of the figures, demoustrates a clear affinity for Michelangelo's figural style.

Annibale Carracci, *Deposition*, 1606 ca.

Raphael, *Moses before the burning bush*, 1514 ca

Titian

The *Portrait of Pope Paul III with his Nephews* (oil on canvas, 202 × 176 cm.) is one of the most famous portraits of all time. It represents the Farnese pope with his two nephews, Alessandro and Ottavio, who carried the Pope's ambitions for his dynasty in both the ecclestiastical and secular realms. Although it is a sort of manifesto of the family's ambition and power, Titian never completed it, returning to Venice in May 1546 and leaving it unfinished. There are many hypotheses to explain this. For example, the excessive realism with which the family's intrigues were represented may have offended the papal court, Titian's disillusionment with the Farnese's continual delays in paying for the works he made during his brief stay in Rome, or the Pope's own change in plans for Ottavio, whose marriage to Margherita of Austria had consolidated ties with Charles V, in favour of his younger nephew Orazio, who had been introduced into Francis I's household by way of a promised marriage to Diana of France. Although the unfinished state of the work caused some confusion later about the identity of the figures, it has always been considered emblematic of the family's history. It had, therefore, a place of maximum prominence in the Ducal Gallery in the Palazzo della Pilotta in Parma at the end of the Seventeenth century. An extraordinary symphony of reds and scarlets is accompanied by a rare psychological insight into the individuals portrayed, and it allows us to see something of the character of each. In contrast to Raphael's *Portrait of Leo X with his Nephews*, which was an important reference for Titian's compositon and which he would have known through a copy by Andrea del Sarto that belonged first to the Gonzaga family and then, in the early Seventeenth

century, to the Farnese, Titian stressed the drama of emotions amongst the figures. The painting is thus unique among portraits and was much admired by all the famous visitors to the Farnese galleries at Capodimonte, from Winckelmann to the Marquis de Sade.

The famous paintings by Titian, the Portrait of Paolo III Farnese *(1545-46) and the* Danae *(1544-45) entered the palace of Capodimonte as part of the Farnese heritage when the Infante of Spain Charles Bourbon, son of Elisabetta Farnese and future king of Naples, took up residence there.*

Titian

Danae (oil on canvas, 118.5 × 170 cm.) is one of the most famous and celebrated paintings from the Farnese collection. Cardinal Alessandro commissioned it from Titian for his own room after he had seen and admired the so-called *Venus of Urbino* which the artist painted for Guidobaldo della Rovere in 1538. In 1544, the papal nuncio in Venice wrote to Alessandro and said of the painting that it was "a nude which would bring the devil into the Cardinal of San Silvestro," that is the Dominican Tommaso Badia, a severe critic of the contemporary customs of the Roman curia. Titian began the painting in Venice and finished it in Rome during his brief sojourn at the papal court when he also made several portraits of the pontiff and

members of his family. The canvas was still in his studio at the Belvedere at the Vatican when Giorgio Vasari brought Michelangelo to visit. Vasari later recounted Michelangelo's famous remarks when confronted with the colourism and the "vague and vivacious manner" of the Venetian who, however, was unable in Michelangelo's estimation "to draw well."

It is likely that in Rome it was especially necessary to cloak the real subject of the work in the guise of mythology, transforming a nude figure too compromising for a prelate, no matter how powerful, into Danae. The x-ray of this painting, which identified a variety of *pentimenti* or corrections, supports this hypothesis.

The fame of this painting prompted Ferdinando Bourbon to send it to

Palermo, for its own safety, in 1798 in the face of the French invasion of Naples. It was accompanied by thirteen other famous works, three of which were also by Titian. It was returned to Naples when Ferdinando himself returned to the throne and was hung in the so-called *gabinetto* of obscene paintings in the Royal Bourbon Museum, an area reserved for "licentious" works. It could not be visited on a normal tour of the museum and was accessible only with appropriate authorization. It was stolen by the Nazis along with other well-known works from Capodimonte but was fortunately recovered at the end of the war. The variety of possible sources mentioned for this figure, from Michelangelo's *Leda* to his figure of *Night* for the Medici tombs,

Primaticcio's *Danae* for Francis I's gallery at Fontainebleau or Correggio's for Francesco Gonzaga, suggests that the attraction of this recumbent nude, whose sculptural presence is exalted by a free and sensual sense of colour, is in some way Titian's answer to the figurative style of papal Rome.

Annibale Carracci

This *Hercules at the Crossroads* (oil on canvas, 165 × 239 cm.) has been hung as a sort of emblematic image at the end of the rooms dedicated to the Farnese collection and at the focal point of the perspectival axes which traverse the rooms on the east front of the palace, as if to emphasise its central importance to the whole collection. It was originally intended to go at the centre of the ceiling decoration in the Camerino of Hercules, Cardinal Odoardo Farnese's private study and one of the first rooms Annibale was commissioned to decorate in the Farnese palace after he was called to Rome to fresco the famous gallery in the same building. The iconography of the study, designed by Odoardo and Fulvio Orsini, the family's cultured librarian, hinged on the theme of virtue as expressed through mythological scenes and allegorical figures. At the centre of the ceiling Hercules was forced to choose between Vice, represented by an elegant woman seen from behind who holds the symbols of earthly pleasure—masks, cards and musical instruments—and Virtue who points, instead, to a steep tortuous path while at her feet a poet, crowned with laurel, promises to sing forever of the glory of the hero who chooses the more difficult road.

The perfect balance between Classicism, to which Annibale had direct access in Rome, and naturalism, rooted in his own artistic development, makes this canvas emblematic of the new direction which the artist's work would take in Rome at the beginning of the new century. The recognized importance of this work, which led to its being removed from the ceiling, replaced with a copy and taken to Parma in 1662 with the other Farnese masterpieces, was also behind its later moves to Parma, Naples and Palermo and then back to Naples where it was hung, with Titian's *Danae*, in the Gabinetto of obscene art in the Royal Bourbon Museum.

Annibale executed his famous *Pietà* for Cardinal Odoardo several years later. It, too, is at Capodimonte and was inspired by Michelangelo's marble group in St. Peter's in Rome.

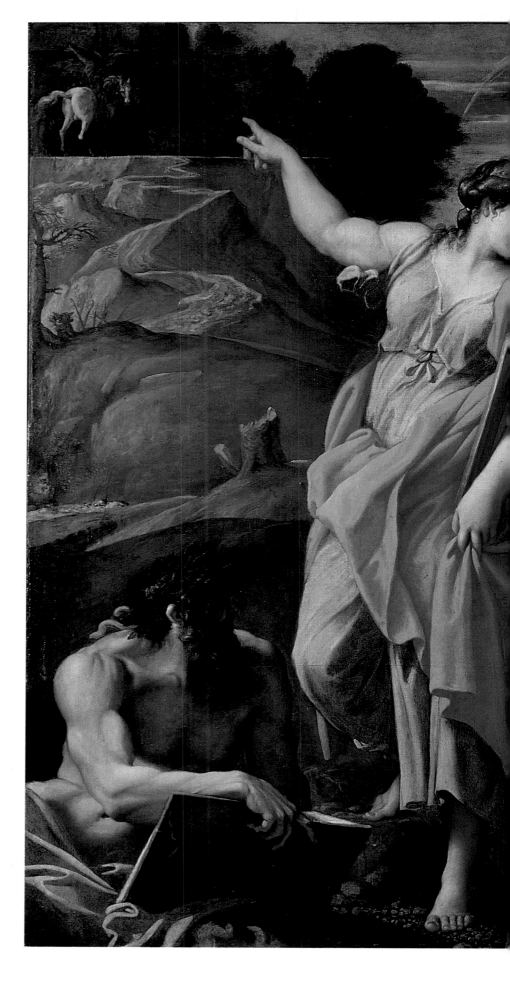

The emblematic painting by Annibale Carracci, also property of the Farnese family, was designed to be the focal point of the Hercules room in the Farnese Palace in Rome. It was planned by Cardinal Odoardo and the learned librarian Fulvio Orsini as an allegorical exaltation of Virtue.

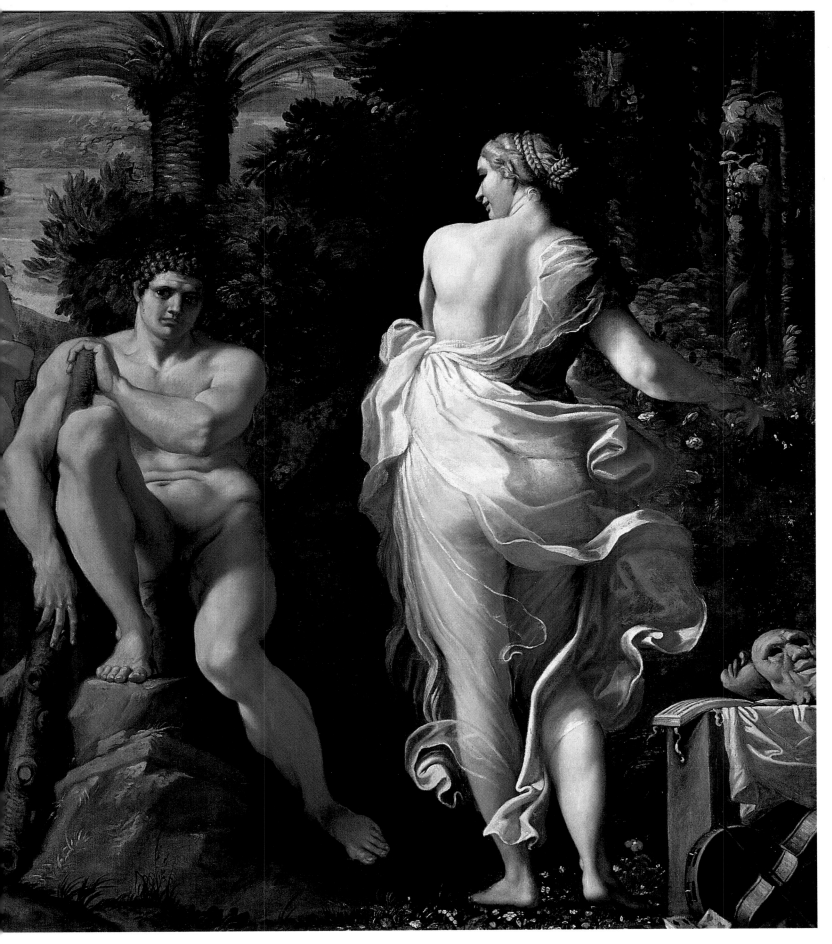

Il Parmigianino
(Francesco Mazzola)

Although identified in old inventories as "a portrait of Antea" or "Parmigianino's lover," or of a well-known courtesan who lived in Rome in the first half of the Sixteenth century and was mentioned by Cellini and Pietro Aretino, there is still uncertainty about her identity. Some scholars have identified her as the artist's servant or his daughter, and others a noblewoman of Parma as, among other things, the apron she wears suggests since it is an article of clothing worn by upper class women especially in northern Italy. Whatever the correct identification, the *Porrait of a Young Woman (Antea,* oil on canvas, 136 × 86 cm.) is one of the most famous and refined images produced not just by this painter from Parma but in Italy in the Sixteenth century. The artist's familiarity with optical deformations—as one sees in his celebrated *Self-Portrait in a Mirror* in Vienna for example—leads him to contrast the fixed abstraction of the perfect oval of the face with the bust, enclosed in an elegant harmony of colour. The latter seems to rotate slightly because of the disproportionate relationship between the right arm and shoulder, on which the fur lies, and the left shoulder which fades into the background. The disagreements over the identity of the sitter are reflected, too, in the debate over the date of the picture which varies from Parmigianino's Roman years (1524-1527) to his maturity, after he returned to Parma, in the mid-1530s. The latter seems more realistic especially because of the obvious links with other works of that period and in particular with the *Madonna of the Long Neck* in the Uffizi. There is a correspondence between "Antea" and the angel on the right of the Virgin—perhaps a portrait of the patron of the Florentine painting.

This work was in the Farnese collection in the Palazzo del Giardino in Parma along with three other famous masterpieces by Parmigianino now at Capodimonte—the *Portrait of Galeazzo Sanvitale*, the *Holy Family* and the extraordinary *Lucrezia*. Once in Naples, the *Antea* was always considered one of the most important works in the Bourbon collections, and as such Ferdinando IV sent it to Palermo to protect it during the French occupation of the city. It was stolen by the Nazis from the abbey of Monte Cassino, where it had been stored during World War II, and was finally recovered in 1945.

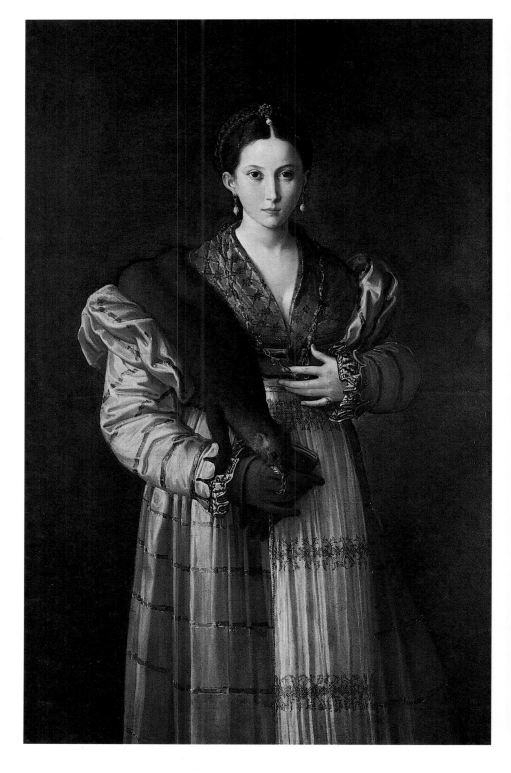

The mysterious and fascinating Antea *by Parmigianino, painted in 1535-37 was one of the most famous pieces in the Bourbon collection. It passed into the dynasty's heritage from the Farnese collection.*

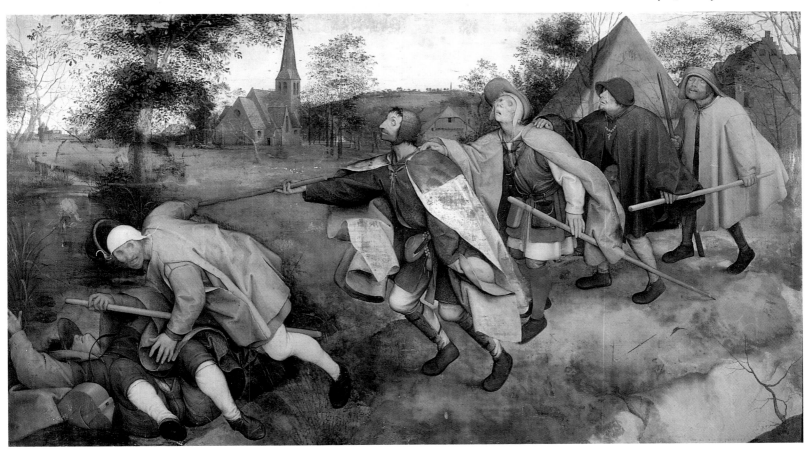

Pieter Brueghel

Parable of the Blind (tempera on canvas, 85.5 × 154 cm.) is the best known of the Flemish paintings in the Farnese collection. It originally belonged to Cosimo Masi, a Florentine nobleman and Cardinal Alessandro Farnese's secretary in Flanders at the end of the Sixteenth century. His collection also included Brueghel's *Misanthrope*. After the 1612 plot by Parma's aristocracy to dislodge the Farnese, in which the Masi participated, the *Parable of the Blind* became part of the Ducal collection when all the property of the rebellious families was confiscated, and it has enjoyed an important position in that collection ever since.

The painting was executed with a diluted tempera and without a preparatory ground on a thin, linen canvas that is visible through the paint in several places, and especially in the cloak of the blind man at the centre of the composition. It is signed and dated 1568, and it is possible to identify the church in the background as that of Saint

Anne which still stands in the village of Pede near Brussels. The powerful incisiveness of the figures results from colour harmonies based on a few dull hues, and the landscape all around them is rendered with a meticulous precision in every detail. The subject matter refers to several passages in the New Testament, and in particular to the admonition to be prudent and to have blind faith in God alone because "when a blind man leads another blind man, they both fall into the ditch". This passage appears in a engraving from a series of prints called *The Twelve Flemish Proverbs* which was certainly a source for Brueghel's painting. There are also classical references, and to Horace in particular, which were well known in the circle Brueghel frequented.

This painting, like so many of the museum's important works, was stolen by the Nazis from the warehouse at Monte Cassino where it had been sent during the war. It was later found in the salt mine near Salzburg and returned to Naples in 1947.

The vast Farnese collection includes numerous Flemish works, including the Parable of the Blind, *painted by Pieter Brueghel in 1568, a work of special importance. Together with the Misanthrope, this painting was part of the collection of Cosimo Masi, secretary to Flanders for Alessandro Farnese. Farnese had taken part in the conspiracy against the dukes in 1612, and consequently all his goods were confiscated.*

The founding of the Museum

At the same time the royal collections had grown to include paintings which celebrated the Bourbon dynasty—portraits and views by artists like Mengs, Angelika Kauffmann, Vigée-Lebrun and Antonio Joli. For the first time, works were acquired by foreign artists who had worked in Naples, painters like Cesare da Sesto, Ribera and Luca Giordano, and whose presence had provided a strong stimulus for the local tradition. Guidebooks and travelogues at the end of the century describe the Museum as some twenty-four rooms dedicated both to important, individual artists and regional schools of painting. It was also governed by a set of regulations issued in 1785 which set its hours and rules about entrances and the responsibilities of its staff; the collection itself, however, remained the personal property of the sovereign. And yet the mission of the museum was both scholarly and didactic, and it also boasted a conservation laboratory that undertook the restoration of such masterpieces as Titian's *Danae*, Annibale Carracci's *Pietà* and Giulio Romano's *Madonna of the Cat*. There were more than seventeen hundred works on display—a tremendous number especially when compared to other museums of its time—in 1799 when French troops invaded the city.

Ferdinando managed to send fourteen masterpieces, his library and the most important pieces of ancient sculpture to Palermo for safekeeping, but in the end the French carried off about 350 works. A portion of these were recovered in the early Nineteenth century through the diligence of Domenico Venusti working on behalf of the king.

The sack of Naples made an indelible mark on the history of Capodimonte, signalling the beginning of its progressive decline throughout the first half of the Nineteenth century. The paintings returned by the French were not rehung on its walls, nor did it house either the works Venusti bought to fill the gaps in the royal collections (such as Guido Reni's *Atalanta* and others by Fra Bartolomeo and Claude Lorraine), or the huge patrimony of the Church that flowed into the royal collections with the suppression of the monasteries giving it a much more strongly Neapolitan character. Instead a new museum was planned that would gather together all of the royal collections, a project more in step with Enlighenment ideas about museums that had been brewing in Europe since the last decades of the Eighteenth century. The old Palazzo degli Studi was judged a better location for this museum than Capodimonte, and the now elderly Fuga was given the job of converting it to that purpose.

Cesare Da Sesto

This large altarpiece (*Adoration of the Magi*, oil on panel, 326 × 270 cm.) was executed for the Congregation of San Nicolò dei Gentiluomini in Messina between 1516 and 1519. It represents the appeal in southern Italy for the modern manner of painting that had been elaborated in Rome in the first decades of the Sixteenth century. With other works by the same artist it became a model for an entire generation of artists who had been won over by the new culture of the Sixteenth century. The clear references to Leonardo, especially in the central group of Madonna and Child and in one of the portraits of an old man, mix with references to the last, famous works by Raphael and Michelangelo in Rome. These are combined the context of a studied landscape in which the classical ruins, a common motif at the time, are prevalent. This altarpiece was one of the first works from southern Italy to enter the royal collections which were still dominated, due to their Farnese provenance, by works of the north and central Italian schools. Its exceptionalness in the context of the Bourbon collections made it an object of particular interest from the time French troops overran the picture gallery at Capodimonte in 1799; it did, however, and likely because of its size, fortunately escape the terrible sacking that followed.
A careful restoration of the work conducted recently attempted to repair the numerous Nineteenth century interventions that had compromised its structural integrity.

The altarpiece was one of the first southern Italian works to become part of the Royal collections which, coming from the Farnese collection, still centred on paintings from central and northern Italian schools.

The National Museum at Capodimonte

The royal palace of Capodimonte was chosen by Charles III and his ministers and rebuilt, starting in the latter part of the fourth decade of the Eighteenth century, with the primary purpose of housing the art collections arriving from Parma and Piacenza. Its site was the hill of Capodimonte, on the edge of a large expanse of woodland in a picturesque position, with panoramic views of the Bay and city below.

The project was given to a military engineer from Palermo, Giovanni Antonio Medrano, joined briefly by the Roman architect Antonio Canevari, shortly afterwards also commissioned to build the royal palace of Portici. Medrano drew up three different projects for the residence at Capodimonte, one of which was chosen in 1738 providing, as we can see documented today in a plan preserved in the Museum, solutions essentially similar to the actual ones: the biggest variation is the absence of the large flight of steps originally planned for the central court but never built. The building is rectangular in plan, and 187 metres long by 87 wide; it rises to two storeys, plus a mezzanine and attics. It has a most impressive aspect along its longitudinal axis, due to the succession of three spacious courtyards, porticoed and interconnected, and opening to the outside through wide arches.

In terms of its views, both interior and exterior, the palace presents facades in the Doric style, and Sixteenth century revival in taste, with a rhythmical arrangement of solid members in grey piperno contrasting with the typical Neapolitan red of the plastered walls, and the series of windows, broad on the first floor and less so in the other storeys. The interior originally featured an endless

succession of rooms for assemblies and petitioners, for the royal apartments, and for the display of the Farnese collections; this series of rooms was interrupted in the centre by a "gallery" two storeys high, and at the palace's corners by salons, also of double height; but the aspect of the first floor today has been altered by various modifications. The services and quarters occupied the more modest parts of the ground floor, the mezzanine and the second floor. When the rulers installed by Napoleon selected this royal palace for their residence, they made it easier to approach with the construction, between 1807 and 1809, of a bridge over the adjacent Hospital district, and the driving through of the Corso Napoleone. The operation was completed in 1824 with the building of the great staircase designed by Antonio Niccolini.

In 1833, under Ferdinando II, further work was taken in hand to complete the palace; for it still lacked most of its northern side, by the third courtyard, which had stopped decades before at first-floor level. In 1835 the main staircase was finally built, to the design of the architect Tommaso Giordano, as well as the hexagonal staircase at the southern end.

Between 1742 and 1745 work also started on the landscaping of a park and gardens in the areas around the palace: the commission was given to the architect Ferdinando Sanfelice, who was replaced at some time between 1763 and 1766 by Ferdinando Fuga. The garden layout is Baroque and theatrical, with five very long avenues of trees radiating from the entrance court, the addition of numerous marble statues and the arrangement of smaller intersecting avenues within a dense natural vegetation, so as to combine the ordered and symmetrical taste of the "Italian" style of garden with the apparently spontaneous look of the "English" style. The many different kinds of palm tree that can be seen today were planted at the end of the Nineteenth century, in accordance with the orientalizing tendency in vogue at that time.

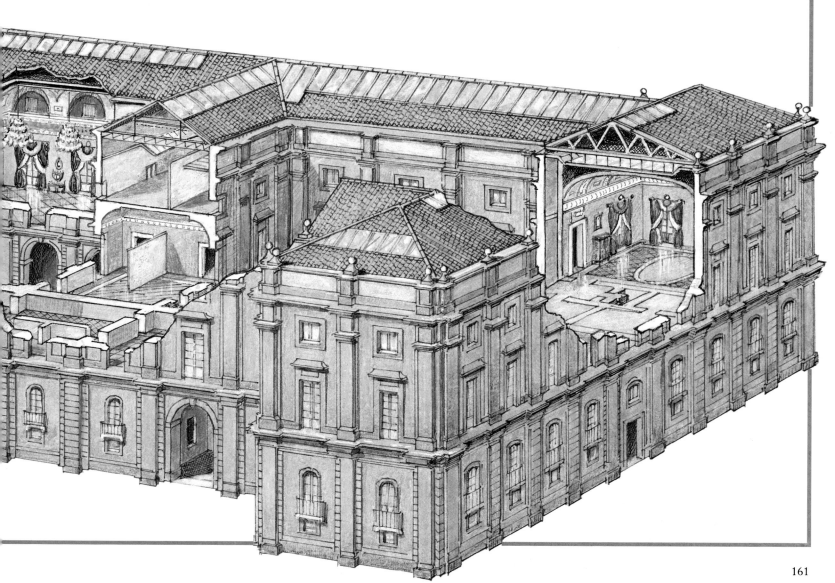

The Royal Apartment

French-Neapolitan crafting, armchair; the upholstery features a view of the Palazzo dell'Eliseo, early decades of the Nineteenth century

One of the historical oddities of Capodimonte is that it alternated, over the course of time, between being a museum and a residence. However intermittent, the latter explains the large amount of furnishings that are today located in the rooms along the east front of the palace's main floor. They are arranged not to reconstruct some presumed original configuration since that changed with each succeeding sovereign over the course of some 200 years, but rather to document the tastes that inspired the furnishing of the royal residence and to evoke something of its atmosphere.

The objects are arranged chronologically, beginning where the Farnese collection ends. One can thus trace the history of the palace through the portraits of the rulers, the furniture and the unique, sophisticated objects which were the products of many royal workshops founded with enlightened determination by the Bourbon kings. They represent, furthermore, a diverse series of sectors from tapestry weaving to arms manufacting, printing and the production of famous porcelains.

The collection of porcelain is particularly important, and it includes noted examples of the Neapolitan works acquired by Kings Charles and Ferdinando. It also has valuable pieces of Meissen, Vienna and Sèvres porcelain which belonged to the Bourbon queens or were gifts to the royals from other European courts.

Large and evocative spaces— the Sala della Culla, the Ballroom and the large north gallery which is today called the Salone dei Camuccini and still has its enormous Neoclassical paintings in their original locations— alternate with more intimate areas such as the bedroom of Francesco I and Maria Isabella of Bourbon and the famous Porcelain Room that was originally made for the palace at Portici in the mid-Eighteenth century. It was moved to Capodimonte after the unification of Italy when Annibale Sacco began to recover and catalogue the decorative objects from the various former royal residences; he also increased the collection using his refined eye to acquire important pieces all of which are now at Capodimonte.

A group of Empire style furniture dates from the period of Murat's rule, when the palace was used as an actual residence. Most notable amongst this collection are a exquisite mahogany *Secretary* which has a model organ tht still works and Joachim Murat's card table.

Facing page
Smoking room or Pompeiian salon

Martin-Guillaume Biennois, games desk, 1807

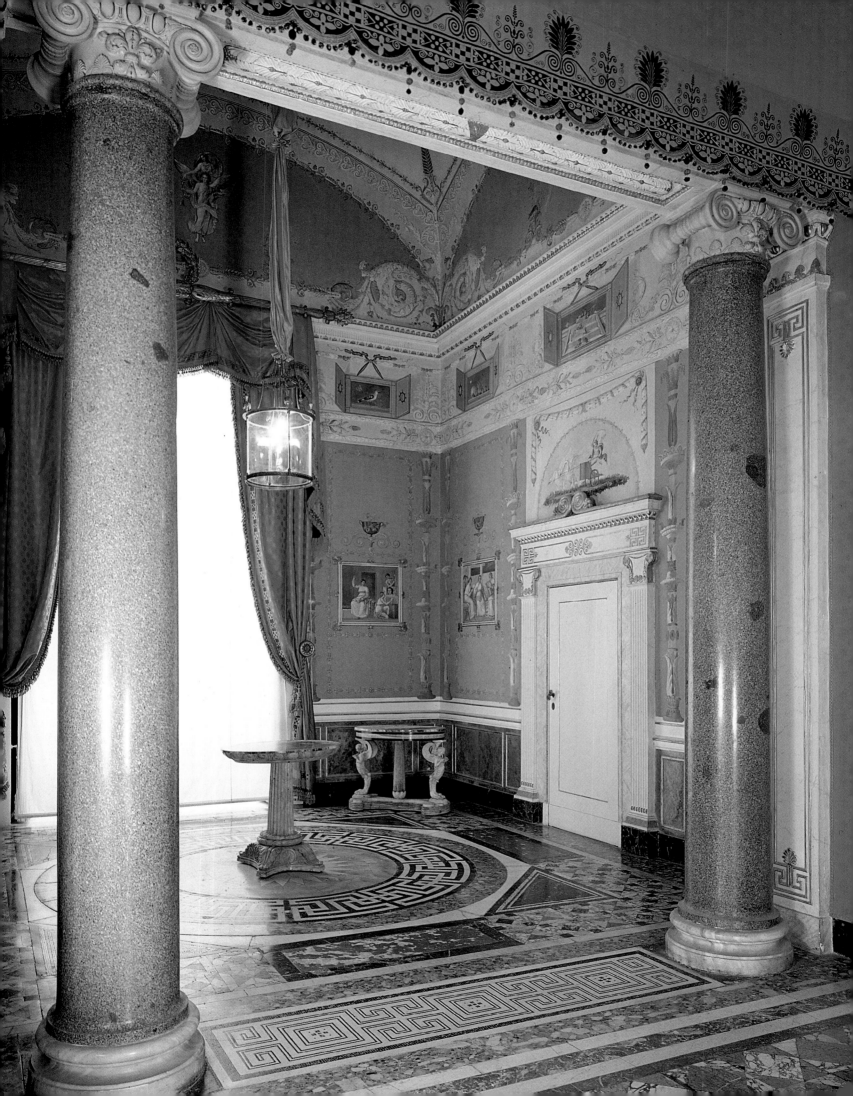

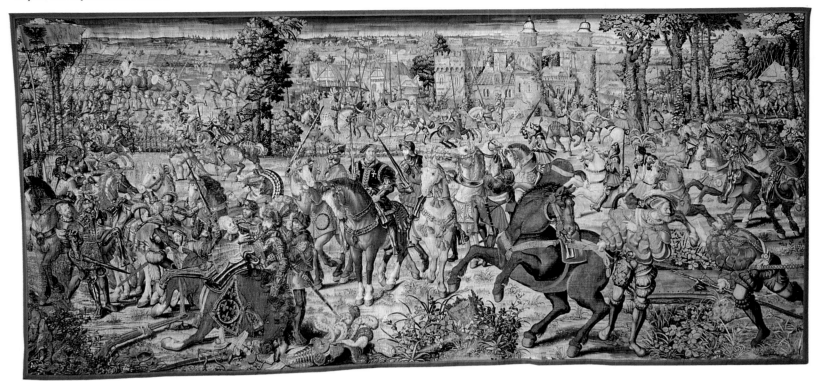

The palace and the collections in the modern era

Capodimonte was given a new lease on life with the accession to the Neapolitan throne first of Joseph Bonaparte and then, in 1806, of Joachim Murat. The palace was chosen as the residence of the court, and its décor was enriched with new and sophisticated and refined furniture and decorative objects. In addition, its connections with the city—the network of streets and roads throughout the hill district—were improved.

The Bourbons, too, once they were restored to the throne, continued to use Capodimonte in addition to their residences at Caserta and Portici as a place to live and entertain. Ferdinando II finished the construction of the building in the 1830s, entrusting this work to the architects Antonio Niccolini and Tommaso Giordano. At the same time Frederick Dehenhardt was called to Naples to transform the vast, open area to the north of the palace—an area not included in Sanfelice's Eighteenth century palace project—into an English style garden then very much in vogue.

The founding of the Royal Bourbon Museum in the centre of Naples had removed any need for the Capodimonte Palace to function as a museum. Substantial change came only after 1860 and the unification of Italy, the accession of the Savoia to the Italian throne and their appointment of Annibale Sacco to manage the royal household in Naples. At this time there was renewed interest in the collections of the museum at least in that there was a perceived need to preserve the patrimony of the works of art and furniture to be found in the various royal residences which were then abandoned and decaying. With a surprisingly modern sensibility especially with regard to the decorative arts, Sacco encouraged the acquisition of important objects, including porcelains and bisques, the royal armoury, a large number of tapestries from the Bourbon workshops, the famous porcelain room from the residence at Portici, an impressive marble floor from a Roman imperial villa on Capri, and then moved them to the hilltop palace. He also succeeded in advancing a project that had also been important to the last Bourbon monarchs, that is to open a museum of contemporary art. In about twenty years he gathered a collection of more than 700 works of art including paintings and sculpture.

The highly important series of tapestries woven in Brussels in 1528-31, immediately after the decisive battle of Pavia between Charles V and Francesco I (1525) to whom they are dedicated, became part of the Neapolitan collection in the middle of the Nineteenth century with the legacy of the entire property of the Avalos family.

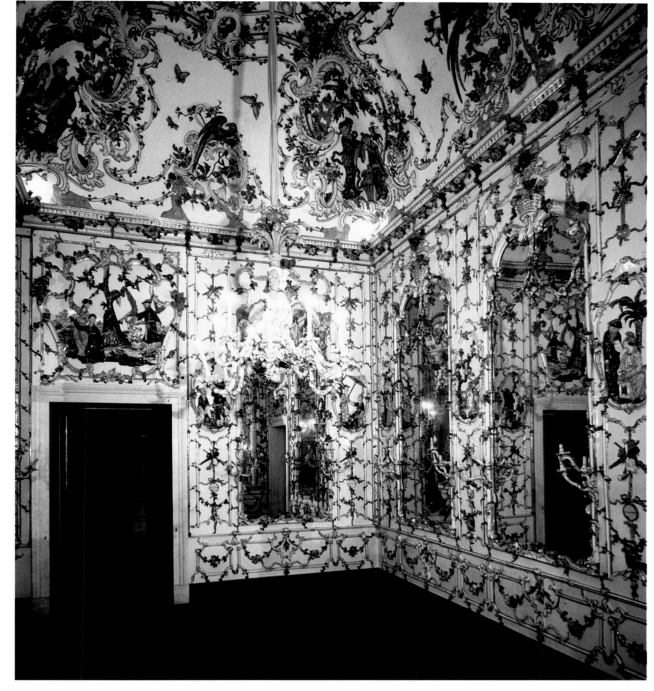

In 1866 Annibale Sacco, director of the Real Casa Savioa, arranged for the transfer to the palace in Naples of the Parlour and the heritage of decorative works of art spread around the various Bourbon residences.

Royal Porcelain Factory at Capodimonte (1741 - 1759)

Charles Bourbon's accession to the Neapolitan throne in 1734 marked a new era for the city. A far-sighted sovereign, Charles pursued an enlightened political course, especially with regard to culture. He reworked the city's urban fabric, undertaking important projects that still mark the city's structure today, and he also created royal factories to make porcelain, arms, armor, tapestries, and printing shops, whose quality of production was very quickly excellent.

This drawing room was made entirely in porcelain with a plaster ceiling for Queen Maria Amalia of Saxony, Charles's wife, in the last years of his reign. It was originally installed in the royal residence at Portici, and in 1866 it was transfered to Capodimonte at the same time that Annibale Sacco, director of the Savoia household, oversaw the transfer of all the decorative objects dispersed amongst the various Bourbon residences and now the property of a unified Italian state. Giuseppe Gricci, master modeller in the factory, was responsible for the incredible decorations on the porcelain tiles, a triumph of interweaving motifs of floral festoons, small monkeys, exotic animals, fruit baskets, groups of musical instruments, scrolls with Chinese characters for good luck and slender figures in a *chinoiserie* style that was very much the vogue in Europe at that time. The chandelier, which was badly damaged during the war, was reconstructed in the mid-1950s during a complete restoration of the room on the occasion of the opening of the museum. At that time, too, the entire room was transferred from the north wing of the palace to its present location.

Masaccio

This *Crucifixion* (tempera and gold on panel, 83 × 63.5 cm.) was acquired from a private collection in 1901 for about 1,000 liras after long negotiations to lower the original asking price of 50,000 lira. The painting was offered for sale with an attribution to Fra Angelico which was then changed to the more generic Florentine school. Suida identified it shortly afterwards as the lost upper central panel of a polyptych that the notary, Ser Giuliano di Colino degli Scarsi, commissioned from Masaccio in 1426 for his family chapel in the church of the Carmine in Pisa. Suida's attribution was based on Vasari's detailed description of the altarpiece which also allowed him to identify other panels, dispersed when the altarpiece was dismembered at the end of the Sixteenth century, and which are now housed in museums in London, Berlin, Pisa and Los Angeles.

The polyptych was a complex structure over five meters tall and had, at its centre, the *Madonna and Child*, now in the National Gallery in London. There was a series of saints, not all of whom have been identified, represented half-length on the upper register and full length in the lateral panels. There was a three-panel predella below, and at the centre, above the Madonna and Child, this *Crucifixion* which is one of the finest examples of the artist's dry, unornamented style. Although it comes near the end of his short career, it is also poised just on the brink of his brilliant intuitions about space and perspective. The extraordinary figure of the Magdalen, her arms extended as if to measure the depth of the field of vision, was probably added later as is suggested by the more liquid sense of the paint and the halo that is simpler than the more elaborate ones of the other figures.

The restoration undertaken in the mid-1950s recovered both the brilliant colour of the original and the image

of the tree of life that had been hidden by the tablet inscribed with the I.N.R.I. and added in the Seventeenth century. The body of Christ is powerfully suggestive with his head set down in his chest to correct the distortion of the viewing angle as one looks into the pinnacle. The sorrowful Virgin, too, has a majestic sense of monumentality. She is wrapped in an intensely blue cloak that makes a strong contrast to the vivid red of the Magdalen's robes.

Colantonio

A large altarpiece was described as in a chapel in the Franciscan church of San Lorenzo Maggiore in Naples as late as the middle of the Seventeenth century. It had a representation of *Saint Francis Giving his Rule to the Brothers and the Followers of Saint Claire* (tempera on panel, 176 × 150 cm.), *Saint Jerome in his Study* (tempera on panel, 125x151 cm.) below it and a series of saints and blesseds on the lateral piers. These ten figures had already, perhaps, been dispersed into a variety of collections over the course of the Eighteenth century, while the two principal panels suffered different fates: the *Saint Jerome* entered the Royal Bourbon Museum in 1808 and the *Saint Francis* the collection of the Pinacoteca Nazionale in 1922. Ferdinando Bologna was the first to offer a hypothesis on the original appearance of the altarpiece and the circumstances of its execution, between 1444 and 1446. It was painted by the most important Neapolitan artist of the Fifteenth century and commissioned by Alfonso of Aragon whose emblems appear in the work.

The documents talk of a Colantonio who learned the art of painting from René of Anjou himself, and who was also supposed to have had the young Antonello da Messina in his workshop. This background explains the influence of Burgundian-Flemish culture in his work. It is, furthermore, the element that unites the two compositionally different panels of the San Lorenzo altarpiece. The *Saint Francis* panel also shows the evident influence of contemporary Spanish painting in vogue at the Aragonese court in Naples.

The vigorous naturalism of the faces, the books and the drapery and the intense still-life passages related to Flemish painting are combined with a new and luminous sense of space and an emphasis on the sculptural quality of the figures. These qualities consitute a milestone in the history of southern Italian painting.

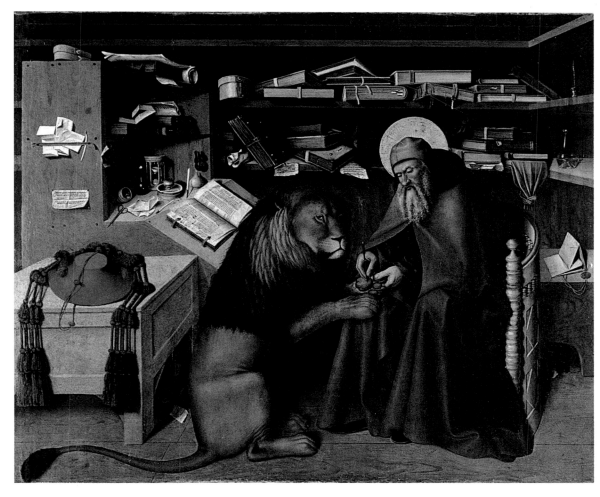

From museum to palace

When the Royal Capodimonte Museum was re-opened to visitors, the building had come full circle functioning at least in some way as it had been intended to more than 100 years earlier. It did, however, occupy a subordinate position to the more important museum in the centre of Naples. It had come to be known as the National Museum, and it continued to struggle, in vain, with insurmountable problems including the especially vexing disparity between the size of the collection and the space available to display it.

The palace became a residence again at the beginning of the Twentieth century; King Vittorio Emanuele III spent happy time at this hilltop residence, and in about 1910 it was given to the Duke of Aosta and his family. This younger branch of the House of Savoy lived there more or less permanently until the end of World War I, thus once again closing its art collections to the public. Only after the World War II and the recovery of the works stolen by the Nazis was Capodimonte again to function as a museum, even though many important cultural figures in Italy, including Benedetto Croce, had decried its closure from the early part of the century on.

Once Capodimonte had been abandoned by the Dukes of Aosta and become the property of the state, there was a new project to make it into a museum for paintings and objects from the medieval until the modern period, and this impetus was part of a renewed enthusiasm across Italy to rebuild its patrimony. In 1925 the library was moved from the National Museum to the Royal Palace, but the picture gallery—the Pinacoteca—at the museum continued to play a secondary role to the impressive collection of antiquities notwithstanding the attempts by such illustrious scholars as Frizzoni, Ricci, Adolfo Venturi and Filangieri di Candida to reorganize that collection.

Bruno Molajoli, the courageous guardian of Naples' artistic patrimony thoroughout the terrible years of war, began the project to renovate Capodimonte into a museum. He entrusted the architectural work to Ezio de Felice and the design of the exhibition to Ferdinando Bologna, Raffaello Causa and Oreste Ferrari. Thus the most important collection of medieval and modern art in southern Italy, and amongst the most modern in terms of the way it was exhibited, opened on May 5, 1957. Over the years the collection has grown thanks to a number of donations as well as the transfer of especially important works from local churches in the area to Capodimonte in oder to protect them. The latter group includes Simone Martini's *St. Louis of Toulouse Altarpiece*, Titian's *Annunciation* and Caravaggio's *Flagellation*.

The work by Simone Martini, painted in 1317 for the church of San Lorenzo Maggiore in Naples, was transferred to the museum for conservation purposes in 1921. It became a fundamental element in the development of the Capodimonte museum dedicated to southern Italy and the interrelations among the various schools of painters in the south.

Simone Martini

Simone Martini painted this large altarpiece of *Saint Louis of Toulouse* (tempera and gold on panel, 309 × 188.5 cm.), which comes, according to Neapolitan archival sources, from the church of San Lorenzo Maggiore, in 1317, the year when Louis of Anjou, bishop of Toulouse, was canonized. Louis was the second son of Charles II and heir to the crown of the Kingdom of Naples. He renounced his birthright in favour of his brother Robert, depicted kneeling on the right, so that he could join the Franciscan order. Subtle and complex political and religious circumstances lie behind this work.

Ferdinando Bologna has pointed out that it is more than a painting intended to solidify Robert of Anjou's legitimate claim to the Neapolitan throne, but rather a celebration of Louis, an ardent follower of the Spiritual branch of the Franciscan order and a noted critic of papal power. The image stresses the saint's qualities of humanity and obedience, including a respect for the ecclesiastical doctrine rather than Franciscan ideals of poverty. Louis's canonization must have been the result of a careful negotiations between the Angevin court, anxious to boast a saint in the family, and the papal curia, which was trying to avoid any visible signs of support for the extreme position of the Franciscan spiritualists. This also explains the extremely precious quality of the whole altarpiece, which is a magnificent work of carpentry, decorated on the reverse side with the Angevin lilies. It also accounts for the sophistication and pomp of the image which comes in part from the use of rare and valuable materials such as the *eglomisé* clasp and other decorative elements. The painting must have had an even greater sense of richness before the decoration of the cope was either removed or altered. The predella scenes from the life of the saint offer the closest link with Simone's frescoes in the Chapel of Saint Martin at Assisi. This is especially true in the new spatial quality and greater plasticity of the figures, both clear signs of Giotto's influence.

The artist's signature on the upper part of the predella is divided into pairs of letters which alternate with the coats-of-arms of the Hungarian Angevins. The work was moved for precautionary reasons to the Pinacoteca of the National Museum in 1921and from there to Capodimonte. It is amongst the most important landmarks in the development of the figurative arts in southern Italy and, at the same time, of the strong ties between the museum and city around it.

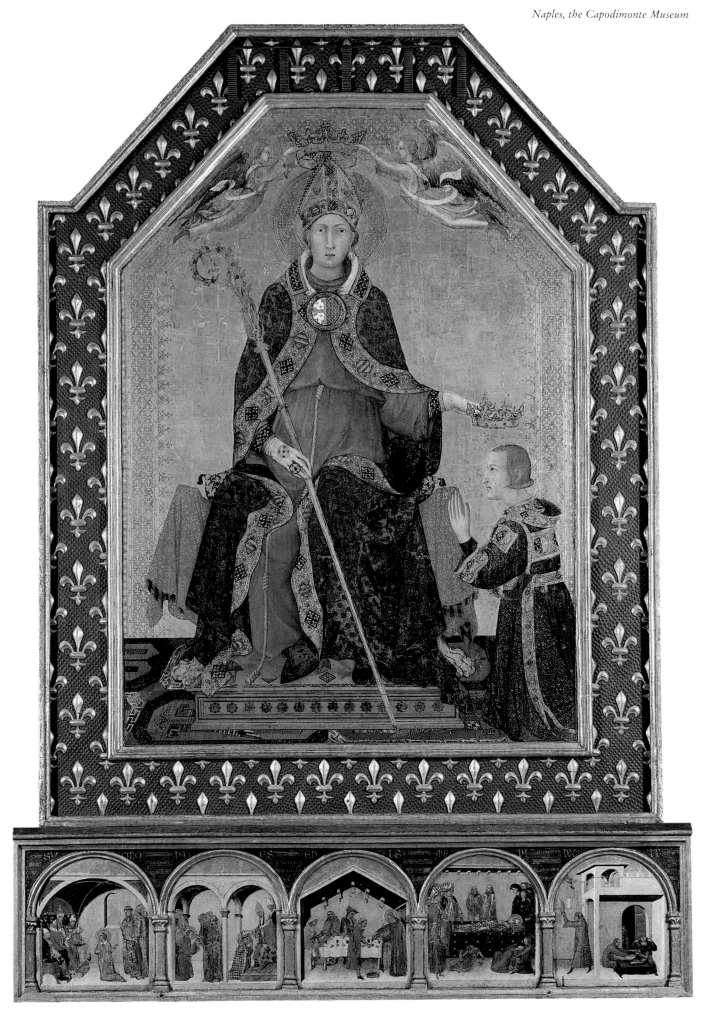

Caravaggio's painting, painted in 1607-10 for the chapel of St. Francis in San Domenico Maggiore, entered the Capodimonte collection in 1972 for security reasons. This painting allowed the museum to include the development of the Caravaggio school in Naples.

Caravaggio (Michelangelo Merisi)

This *Flagellation of Christ* (oil on canvas, 266 × 213 cm.) was commissioned for the De Franchis chapel in the Neapolitan church of San Domenico Maggiore. The first payment documents date its beginning to May 1607. X-rays of the painting revealed the presence of a face over the shoulder of the torturer on the right. It has been suggested that this is a portrait of the patron, although it is also possible that Caravaggio was simply reusing an old canvas, a practice not uncommon

in his workshop. It is likely that this painting, begun in 1607, was finished and also altered from the original design after Caravaggio returned to Naples in 1610. The similarities of the physiognomies to the master's Sicilian works confirms this suggestion. The interpretation of the meaning of this canvas has alternated between mystical and religious meanings and, more plausibly, interpretations within the context of the Neapolitan Dominican's anti-rigorist political and ideological ideals. If the Dominicans were not the patrons of the

work, their views were certainly close to those of Caravaggio. The careful naturalism of the work gives life to an image with an extraordinary visual impact; it is in every way revolutionary with regard to the contemporary figurative canon. Christ's powerful, twisted torso is struck by a realistic, brilliant light that seems, in turn, to illuminate the figures of his torturers, dragging them out of the shadows with passages of incredible intensity. The vigour of the representation, which omits all non-essential elements, accentuates the drama of this profoundly human and immediate event

over the representation of the divine.
The *Flagellation* was moved to the museum as a security precaution in 1972, and it has become one its most representative works, a true key to the profound changes that swept the figurative arts over the course of the Seventeenth century.

The Gallery of Rare Things

Capodimonte traces the origins of its extraordinary collections to those of the royal families. This fact explains the remarkable variety of its collections which include both masterpieces of painting and sculpture and the whole spectrum of the decorative arts. The latter are represented by objects of supreme sophistication and are the result of a sensitive strategy of collecting, first by the Farnese family, then by the Bourbon and Savoia courts.

The so-called Galleria delle Cose Rare—the Gallery of Rare Things—had its beginnings in the Palazzo della Pilotta in Parma where, in the early Eighteenth century, it housed objects of decorative art. At the Capodimonte it is located amongst the rooms dedicated to the Farnese collection, and it includes an extraordinary group of ivories, pottery, silver, crystal, amber, semiprecious stones, coins and medals. Together these objects, regardless of their original function, testify perhaps even better than the paintings both to the tastes of a specific period and the incredible talent and the great technical ability in working a variety of precious materials that lies behind their manufacture. Before the present arrangement of the collection, only some of these objects were on public display. The long period of study and research behind the new exhibition allowed the provenance of individual pieces to be identified; it also permitted a reconstruction of a sort of "chamber of wonders" that recalls in some way that they were originally displayed as described in the old Farnese inventories.

The pivotal object in the collection is the famous *Casket*, a splendid example of Sixteenth century goldsmithing; it belonged to Cardinal Alessandro and was perhaps a container for valuable manuscripts. Many of the most refined objects, fashioned in silver, were intended to answer the taste for sumptuously laid tables. This was the case with the so-called *Tazza Farnese* a cup which Annibale Carracci engraved with a *Drunken Silenus* for Cardinal Odoardo Farnese at the end of the Sixteenth century. This motif was then repeated by Francesco Villamena on a silver breadbasket, better known of the *Farnese Basket*. There are elegant fruit bowls of rock crystal as well as a large number of single pieces that once belonged to larger sets; the purity of the crystal is as surprising as the refined quality of the carving.

The collection of maiolica includes the blue and gold table service made in the last quarter of the Sixteenth century by the workshop of Castelli d'Abruzzo with Cardinal Alessandro's coat-of-arms and a number of plates made in Urbino and decorated in elegant colours with Raphaelesque motifs. There is also a large group of ivories from Flanders and Germany. The collection includes, furthermore, numerous curious and extravagant objects including a valuable mechanical trophy with a *Diana and the Stag*, a wind-up centrepiece made by German goldsmiths, tiny but incredibly naturalistic wooden carvings from Germany and elegant Asian jugs carved from agate or rhinoceros horn.

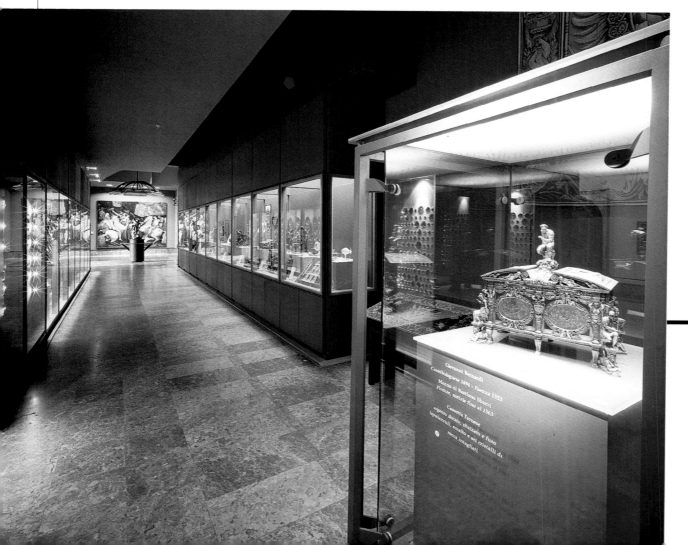

Manno di Bastiano Sbarri and Giovanni Bernardi

The Farnese collection includes the Gallery of Rare Things the name of which comes from the Pilotta Palace in Parma. At the beginning of the Eighteenth century this name was given to the room for rare objects parallel to the picture gallery. It includes an extraordinary collection of ivories, ceramics, silver, crystal, amber, semi-precious stones, coins and medals.

An absolute masterpiece of Sixteenth century goldsmithery, this *Farnese Casket* (49.5 cm. high) was made for Cardinal Alessandro Farnese between 1548 and about 1551 by the Florentine goldsmith, Manno di Bastiano Sbarri, a pupil of Cellini, and Giovanni Bernardi who engraved the rock crystal ovals set on the four sides of the box after drawings by Perino del Vaga.

It has been suggested, among many hypotheses, that this extraordinary casket, which is completely decorated on the interior, was meant to hold valuable manuscripts, perhaps the famous *Book of Hours* illuminated for the cardinal by Giulio Clovio in 1546 and today at the Pierpont Morgan Library in New York. It is also possible that this object was made with no practical purpose in mind, as a symbol of luxury and ostentation and intended only to satisfy the taste for precious materials and precision craftsmanship of a collector as sophisticated as Cardinal Farnese.

Although there are no specific comparisons to be made, scholars have stressed the influence of Francesco Salviati and the group of goldsmiths that worked with him on this piece. Manno and Salviati were, moreover, friends and could often be found in the same place at the same time.

The engraved rock crystals are also extraordinary; they are set on the sides of the casket in lapis lazuli and decorated with mythological subjects linked to the four gods—Pallas Athena, Mars, Diana and Mercury—who sit at the four corners of the box. They were executed by Giovanni Bernardi, who also made many functional objects in precious materials for the Farnese family, some of which are in the gallery of decorative arts from the Farnese collection at Capodimonte.

The Capodimonte Museum today

The historical importance of contemporary art at Capodimonte brought Alberto Burri's *Grande cretto nero* to the museum in 1978. It also opened the way for a series of exhibitions of recent work by artists that has become the heart of the museum's important department of contemporary art. Capodimonte is, furthermore, the only museum of Old Master art that can boast a contemporary collection.

Although Capodimonte has been the centre of important curatorial and conservation activities, evident in the important restorations, studies and exhibitions of international significance it has generated, it has not been able to stem either the unrelenting decay of the building resulting from absolutely inadequate resources, or its alienation from the city which is itself plagued by ever more serious problems. Extraordinary funding in the second half of the 1980s, however, allowed a massive renovation of the old infrastructure of the museum to bring it up to new norms for security and conservation. This project also led to a complete reorganization of the collections aided by the addition of new exhibition spaces and a systematic cataloguing of all their holdings.

The present configuration of the Capodimonte museum is a result of this renovation. The choice to reorganize the works according to the history of the museum and its collections led to a philosophy of exhibiting that accentuates provenance as well as the historical, chronological and geographical circumstances of the individual works. Thus the history of the works of art and the history of the collections can be fully integrated. The path through the Farnese collection, for example, continues naturally into the rooms of the Royal Apartments where a series of small rooms adjoining the large salons houses the most important objects made during the Bourbon and Murat periods. The second floor is dedicated entirely to the Neapolitan gallery, an exhaustive survey of figurative art in the south from the end of the Thirteenth until the Eighteenth centuries, and the attics were transformed into exhibition spaces for both an important selection of Nineteenth century works and the contemporary collection. New spaces, finally, have been dedicated to the extraordinary collection of graphic works housed in the Department of Prints and Drawings as well as service areas for the modern demands made on museums. This new arrangement of the museum was the result of the passion and enthusiasm of a team of art historians under the direction of Nicola Spinosa who all came of age at Capodimonte in the last twenty years. It was accomplished in slow steps beginning in 1995, and its purpose was simply to increase the number of visitors to the museum and to make the relationship between the institution and the public more dynamic.

The walkways: new exhibition space for the museum's graphic works

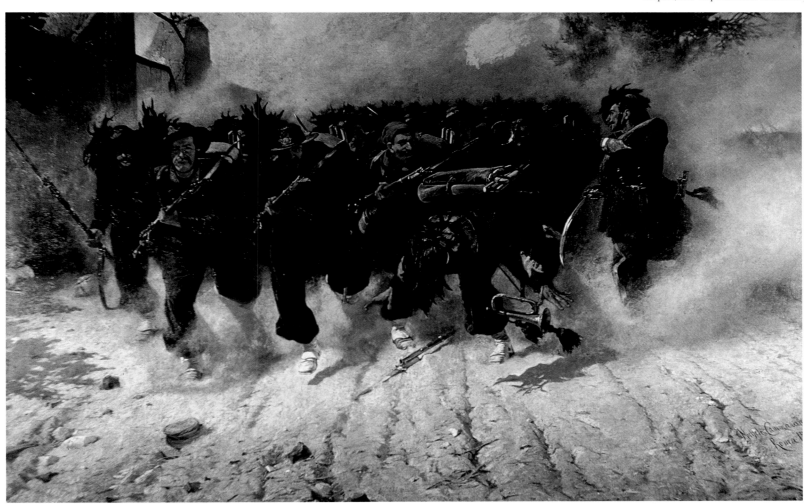

Michele Cammarano

The Breach at Porta Pia (oil on canvas, 290 × 467 cm.) is surely the most spectacular of the Nineteenth century paintings at Capodimonte, due in part to its enormous size. The canvas, which the artist patriotically called *Savoia, Savoia*, was first exhibited at the Second Italian Exhibition of Fine Arts in Milan and was then purchased by King Vittorio Emanuele II. It was subsequently exhibited at the Universal Exposition in Vienna and at the Italian exposition in London, where it received the recognition desired.
Cammarano himself participated in the political events beginning in 1860. He was involved in Garibaldi's exploits in the National Guard's battle against banditry. This scene at Porta Pia was made the day after the event and after the artist had come back to Rome from Paris where he had been particularly influenced by the works of Courbet and Géricault. Avoiding any attempt to create a landscape, the artist focuses all interest on the impetuous advance of the *Bersaglieri* who, in the clever composition of the work, seem to be running directly at the viewer.
Cammarano's interest in themes taken from contemporary political events led him to paint other large, historical compositions which, with his representations of popular subjects, effectively document the realistic trend in Neapolitan painting in the second half of the Nineteenth century.

The Capodimonte National Museum contains various collections, some of which have only been made available to the public view in recent years. These include the remarkable collection of Neapolitan Nineteenth century works, from landscapes to large canvases of contemporary history, such as the moving painting by Michele Cammarano dedicated to the breach of the Pia Gate in 1870.

The Neapolitan Gallery

Battistello Caracciolo, *Christ at the column*, 1625

Giovan Battista Recco, *Still life with goat head*, 1650 ca

The whole of the second floor is dedicated to a broad panorama of Neapolitan figurative art and, more generally, of southern Italian art from the end of the thirteenth to the Eighteenth centuries. This gallery fulfils the goal of an old project that originally dated from Murat's reign to create a "Gallery of National Painters." This gallery, however, offers considerably more works than were available when Capodimonte was opened to the public as a museum in the middle of the Twentieth century. The suppression of the religious orders and the sequestering of the church and monastic furnishings by the Crown profoundly changed the make-up of the royal art collection in Naples by firmly anchoring it to the Southern school which had never been represented in the Farnese collection. Thus in the early years of the Nineteenth century, numerous examples of the local figurative tradition literally flowed into the royal collections; they were almost always religious works, and with time they were supplemented by important acquisitions, sometimes of whole collections (such as that of the Avalos at the end of the Nineteenth century) that further enriched the holdings of the museum still located at the Palazzo degli Studi. More recently, many more extraordinary works of art have been transferred to the museum galleries for precautionary reasons. This journey through the history of the art of Naples and South Italy underscores the crucial role that the city played in the Mediterranean basin. It was always a crossroads of culture and the arts as well as a major player, from the time of the Angevins and the Aragonese, till the period of the viceroys and that of the Bourbon monarchs, in the fruitful artistic exchanges that mark the culture of Europe. Milestones in this cultural exchange include very important paintings by famous foreign artists whose work had an essential influence on the development of the local school—from Simone Martini's celebrated *Saint Louis of Toulouse* altarpiece to Cesare da Sesto's *Adoration of the Magi*, Titian's *Annunciation* for San Domenico Maggiore and Caravaggio's extraordinary *Flagellation of Christ*. Next to these, the works of Roberto di Oderisio, Colantonio, Andrea Sabatini, Polidoro da Caravaggio, Marco

Paolo Porpora, *Flowers with glass cup*, 1655 ca

The Neapolitan gallery offers a wide overview of figurative painting from Naples, and more generally, from southern Italy, from the end of the Thirteenth to the Eighteenth centuries.

Mattia Preti, *Saint Sebastian*, 1657

Francesco Solimena, *Portrait of Prince Tarsia Spinelli*, 1741 ca

Cardisco, Francesco Curia, Fabrizio Santafede and then, in the Seventeenth century, of Battistello Caraccioli, Massimo Stanzione, Bernardino Cavallino, Jusepe Ribera, Mattia Preti, Luca Giordano and finally Francesco Solimena and Gaspare Traversi, demonstrate that the ever changing local style drew its life-blood, its impetus to create an original language, from the examples of work from the most important artistic centres, not just in Italy but across the entire Mediterranean basin. Naples then offered itself in turn as an important interlocutor in this complex web of artistic exchanges and influences.

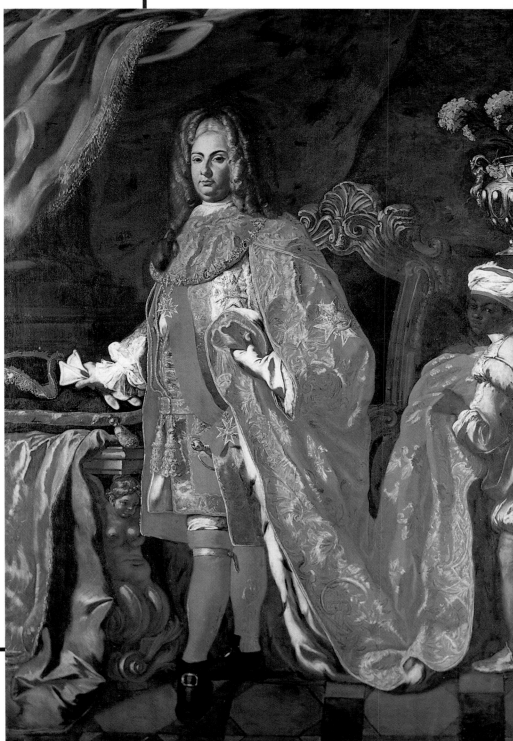

Bernardo Cavallino, *Saint Cecilia*, mid-Nineteenth century

Jusepe de Ribera

Ribera's presence in Naples played a determining role in the development of painting throughout the Seventeenth century. Capodimonte has some of the most important works he made for numerous churches and private collections in Naples. His interpretation of naturalism owes a large debt to Caravaggio, yet he formulates a new way of seeing light and materials as one can see in the enormous *Trinitas terrestris* executed for the church of the Trinità delle Monache, the extraordinary *Saint Jerome and the Angel of Judgment* and the powerful *Apollo and Marsyus* which was once in

the Avalos collection. The *Drunken Silenus* (oil on canvas, 185 × 229 cm.) was acquired in 1653 from the wealthy Flemish merchant, Gaspar Roomer, a cultivated collector who had at least eight works by Ribera in his Neapolitan palace at Monteoliveto.
Nicola Spinosa noted that the rephrasing of this classical subject as a genre scene is unique. It is characterized by a strong ironic stamp, at the same time lucid and grotesque, which we find in no other Italian painter of those years. It is likely that amongst the various interpretations of this subject Ribera chose to represent the version of the bacchanalia decribed in

Ovid's *Fasti*. He omitted, however, the principal figures, Priapus and the nymph Lotis, and attracted as always to the grotesque and bizarre, painted Silenus and his ass whose braying calls attention to and reveals Priapus's true intentions. The canvas is strongly evocative, and the imposing figure of the god occupies the whole of the foreground, creating one of the most powerful images of the fertile naturalistic tradition in Seventeenth century Naples.

The drunken Silenus *was acquired in 1653 by the wealthy Flemish merchant Gaspare Roomer, whose collection in the Naples villa in Monteoliveto contained eight paintings by the master. It testifies to the artist's unmistakable influence on local figurative painting in the Seventeenth century.*

Luca Giordano

Giordano's vast production is represented at Capodimonte by a large group of paintings that spans the whole of his career. They also testify to his continual stylistic development and his incessant references to the traditions of ancient and contemporary painting, translating them in a free and airy manner that marked an affirmation of the Baroque in the figurative arts in southern Italy. Giordano never stopped reinventing an absolutely unique language. This is evident in both his large altarpieces for the city's churches—for example the famous *Madonna del*

Baldacchino, once in Santo Spirito di Palazzo, a luminous and brilliant composition strongly influenced by Bernini—and his mythological and secular subjects—including, amongst others, his *Apollo and Marsyas* which hangs today next to Ribera's picture of the same subject and which inspired Giordano in "a repeated comparison with the older master" that marked the course of his career. Indeed he drew on the "generative sources of modern art" as Preste Ferrrari, the best known student of the artist's work, has noted.
This painting of *Lucretia and Sextus Tarquinius* (oil on canvas, 138 × 187 cm.)

represents the moment when she is trying to fend off the advances of the Etruscan Sextus Tarquinius, whose violations would drive her to suicide. Although dramatic, the story loses any sense of violence in Giordano's interpretation. The scene is used, instead, as an opportunity for something sensuous, with the lovely female nude seen in the foreground and the richly and carefully described materials in the background allowing a play of light that creates enormously refined pictorial effects.
This work was hung with a *Sleeping Venus* which is depicted in a pose that is a mirror image of Lucretia. Venus is also a strongly

sensuous figure, and the early documents speculate that the artist's wife was the model for both figures. Both paintings were originally in the collection of Andrea d'Avalos, Prince of Montesarchio and the suppressor of the Masaniello revolt. The entire collection was bequeathed in the middle of the Nineteenth century to the Picture Gallery at the National Museum and from there it was moved to the museum at Capodimonte.

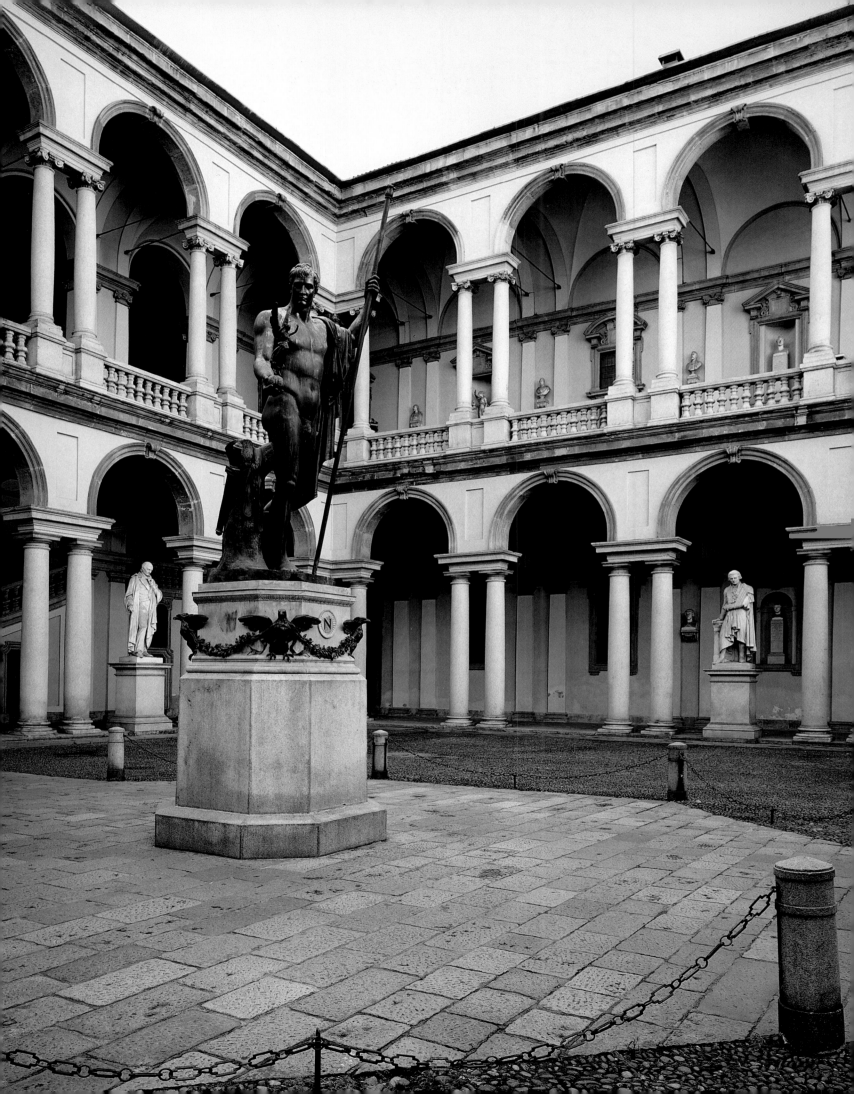

Milan, the Brera Gallery

Luisa Arrigoni

The Brera Palace is a major cultural centre. This is not only thanks to the Art Gallery it houses, but also the stimulating presence of prestigious cultural institutes. It is home to the Academy of Fine Arts that was founded by Maria Teresa of Austria in 1776 and developed in the Napoleonic era. With its highly successful annual exhibitions, it was a cultural attraction throughout the Nineteenth century. The National Library, founded in 1770, transferred to the Brera Palace in 1773. It contains over one million volumes, as well as manuscripts, incunabula and codices from the fourteenth and Fifteenth centuries. Here you can also find the Observatory, where important research in astronomy and the development of advanced technology is currently being carried out, and the Botanical Gardens created in 1781 that have been undergoing renovation since 1998.

The Brera Gallery is undoubtedly one of the most important museums in Italy.

This is not only due to the quality of the works of art it contains, but above all to the original and intrinsic nature of its collections, coming from all over Italy.

As well as the masterpieces of ancient art, acquired initially as a result of the immense commitment of important persons linked institutionally to the Gallery, and later to the patronage of private individuals and the Friends of Brera Association, throughout the Nineteenth century the museum was enriched with extraordinary collections of contemporary art, such as the Jesi Fund.

For more than two centuries there were intense modifications to the Gallery both architecturally and as a museum, with a consequent continuous reorganisation of the rooms. Following the Second World War, Brera achieved a structure which, due also to the most recent corrections to its layout, is in harmony with the original nature of the institution.

The challenge Brera must face today, together with all international museums, is essentially the need to keep pace with the times, in order to satisfy the ever-new requirements of contemporary culture. For this reason, as well as carrying out its institutional role as a museum, i.e. conservation and research, important projects have been launched aimed at promoting culture and art. These include educational laboratories, temporary exhibitions, scientific cataloguing, and also the creation of an infrastructure able to welcome an increasingly numerous public.

View of the courtyard with a bronze statue of Napoleon Bonaparte by Antonio Canova

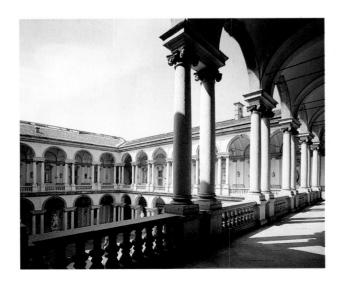

Cardinal Monti's collection at the Brera Gallery: the evolution of the collection from 1811 to 1906

Even if people pay attention to the captions and where the paintings come from to understand the history of the collection, whoever visits the Brera Gallery will have difficulty in appreciating the importance for the Brera gallery of the collection gathered by Cardinal Cesare Monti in the Eighteenth century. Nor will they get an idea of the events that in 1811, 1896, and 1906 brought to Brera about forty of the two hundred works from that famous collection, mentioned in all the Milanese printed guides up to the beginning of the Nineteenth century as one of the "marvels" that travellers should not miss when visiting the city. The Monti-Brera connection started with Andrea Appiani in 1802. The painter had entered into the graces of the young consul Bonaparte from whom he received continuous commissions and public appointments until he became General Commissioner of Theatre and Fine Arts. That year, in full Jacobin climate, he was nominated as expert of the Cisalpine government to carry out one of the periodical inventories of the Monti collection, bequeathed in 1650 for the perpetual use of the archbishops of Milan. The audit, prescribed in the cardinal's will, allowed the artist to get to know in all its aspects one of the most prestigious and representative collections of Italian figurative art, in particular art from Genoa, Lombardy, Veneto and Emilia, from the Sixteenth and Seventeenth centuries. This in-depth knowledge is documented in the "Appiani" inventory which is still essential for any research on the matter. This first inventory was followed by another in 1810. the political climate was very different, the archbishops' quarters were temporarily vacant and Appiani, who had been curator of the Brera Gallery since 1807, was carrying out a brilliant and frenetic activity as "State collector" to transform the little gallery, annexed to the Fine Art Academy for the students' use, into a great national museum. This programme was inspired by the democratic and populist ideas of the French Revolution, but more particularly by the cultural propaganda of the new imperial power in search of legitimisation. The Monti collection, with its Leonardesque and Raphaelian paintings (as they were considered at the time), could have been very useful. In April 1811, after a brief disagreement with Count Giuseppe Stampa di Soncino, heir to the Cardinal, had been resolved, with the full support and encouragement of His Imperial Highness Prince Viceroy of Italy Eugenio di Beauharnais, 23 paintings and drawings chosen by Appiani, including *Portrait of a young man* by Andrea

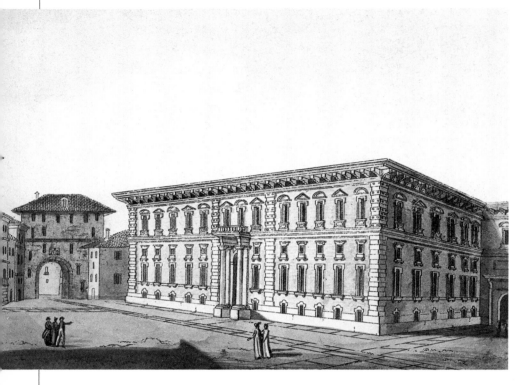

View of the Brera Palace in the early Nineteenth century, L. Bertarelli Civic Prints Collection, Milan

View of the Gothic facade of the Santa Maria di Brera, 1760

Solario, *Christ and the adulteress* and *Moses saved from the waters* by Bonifacio Veronese, *The baptism of Christ* by Paris Bordon, and *The penitent Magdalen* by Giulio Cesare Procaccini were moved from the Archbishop's Palace to Brera, to be placed for "public advantage and instruction" next to the great altarpieces that had filled the four solemn Napoleonic rooms since 1809. Many works "of lesser importance", according to the taste of the time, moved from Brera to the Archbishop's palace, changing irrevocably a collection that had remained in tact since its beginning.

This requisition considered as an exchange was followed by more paintings being removed from the collection, this time by Giuseppe Bertini. Since 1882, when the Gallery was separated from the Academy, he had been its director. The cultural climate had changed again.

Apart from the usual consideration of public approval as a priority for action, it was no longer a matter of requisitioning but rather of intervening to ensure a better conservation of the Cardinal's collection, kept in conditions of pitiful abandon. The role of the Brera Gallery was that of a public institution committed to a better protection of the paintings. Bertini had a reputation as connoisseur and collector and was an expert in restoration. After having blocked a maximalist anticlerical project to devolve the entire collection to the Brera Gallery, helped by Gustavo Frizzoni, collector and art historian, and by Luigi Cavenaghi, the greatest restorer of the time, he obtained sixteen paintings and drawings, from the young Correggio's *Adoration of the Magi*, to the *Martyrdom of Saints Rufina and Seconda* by Cerano, Morazzone and Giulio Cesare Procaccini (the famous "trio painting",

a manifesto of the Counter Reformation in Lombardy), to Bramantino's *Madonna and Child*, and Paris Bordon's *Holy Family with St. Ambrose.* In exchange, other works from Brera were conceded and a guarantee was given to maintain and restore all that remained in the Archbishop's palace. Far from being a repetition of a previous experience, this operation testified to a change in historical and civic awareness and a new philology in the field of art which would soon lead to a law for national protection, the principles of which are still applied today. In 1906 the last group of four paintings from the Monti collection was delivered, but this was a minor event. The only interesting fact was that the choice was entrusted to Pitro Toesco, at that time inspector for the Milanese Monuments and Fine Arts Office.

Appiani, appointed curator of the Brera Picture Gallery in 1807, became a brilliant and active "State collector" in order to turn the small gallery annexed to the fine arts academy and intended for the students, into a great national museum.

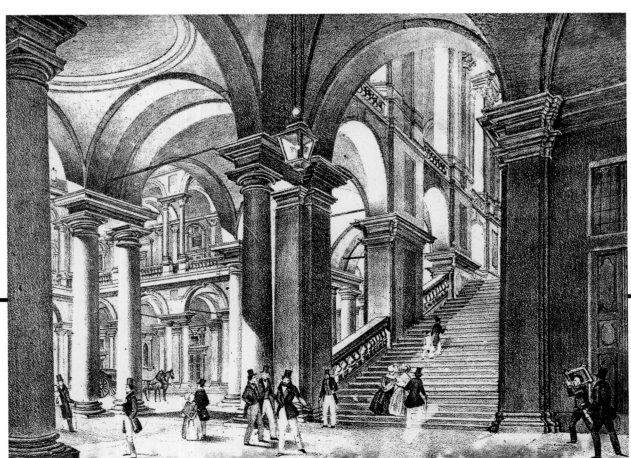

View of the main staircase of the Brera Palace, L. Bertarelli Civic Prints Collection, Milan

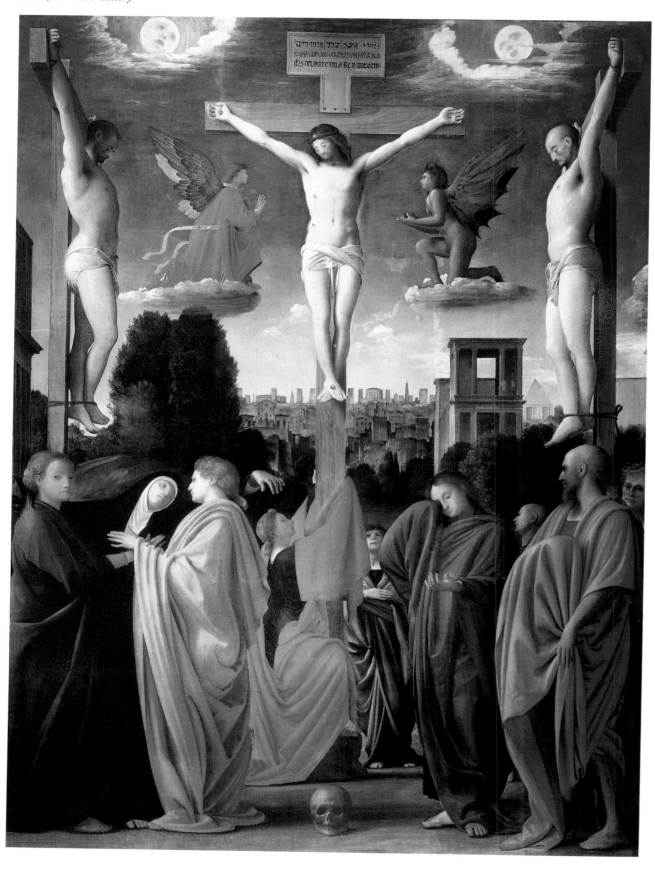

Bramantino (Bartolomeo Suardi)

The *Crucifixion* (oil on canvas, 372 × 270 cm.) by Bramantino is a remarkable work both in terms of the affirmation of Lombardy Sixteenth century Classicism and the artistic journey made by this painter. It certainly belongs to an era after the artist's stay in Rome (1508), probably at the beginning of the second decade of the Sixteenth century.

Throughout the Nineteenth century it was considered to be a work by Bramante, however in 1871 Cavalcaselle suggested it should be attributed to Bramantino and this has never been doubted since.

The scene is set out so that it is vertically divided into two distinct sections, the right and the left. Its symmetry is not purely formal but also, as we shall see, moral. What divides the scene is Christ's cross; the two thieves are at the sides, with the good thief on the left, in correspondence with the Sun and the angel on the cloud, and the bad thief on the right, in correspondence with the Moon and the Devil. At the foot of the cross in the foreground on the left is the group of the Madonna with the holy women, in contrast to the group of over-dressed people on the other side. The unusual iconography, which positions the group with Mary in a decentred position on the left, comes from Flemish and German iconography.

The urban landscape that forms the background is the manifesto of an architectural conception of the author and therefore an irreplaceable clue to the less known aspect of his art, even more than a real building such as the Trivulzio chapel in San Nazaro, which has reached us in an imperfect and altered form. The original destination of the painting is unknown, but it probably belonged to the Trivulzio palace in via Rugabella. In 1806 it was already at Brera, where it was exhibited between about 1841 and 1861.

The history of a palace

Brera Palace stands on the site of a Fourteenth century convent of the *Umiliati* order. In 1572 it passed into the hands of the Jesuits, who set up a college there. They entrusted the architect Martino Bassi with the task of expanding it. The building we see today owes its form to a later renovation aimed at created a new, grand building. The project was initiated by Francesco Maria Ricchino (1627-28), but the new works were only started in 1651. The work was interrupted at his death up to the point of the main entrance. His son Gian Domenico and the architects Girolamo Quadrio and Pietro Giorgio Rossone carried on the project initially, but only with Piermarini was it completed as far as Brera Square.

The building faces onto this little square, echoing the design of the large windows and exposed brickwork. The body of the edifice corresponds to the ancient church of Santa Maria di Brera, incorporated into the building by Pietro Gilardoni in 1809 with the subsequent demolition of the Tuscan style black and white stone façade with sculptures by Giovanni di Balduccio.

The heart of the Gallery is the large courtyard that in olden times was known as the "school" courtyard, and later the "honour courtyard". It is characterized by a double row of serlianas, with Tuscan capitals at the bottom and Ionic capitals at the top, divided by elegant columns in pink granite in the style of the Roman College (1583-85) and the Borromeo College of Pavia (c. 1561).

A great double staircase rises from the courtyard up to the gallery, where there is a precious anthology of Nineteenth century Lombardy sculpture, and from here one enters the Art Gallery.

The contribution of the "Milanese" Maria Teresa of Austria

The origin of the Art Gallery is inextricably linked to the Academy of Fine Arts founded in 1776 by Maria Teresa of Austria, and of which it was an integral part. The first core of the collection was essentially made up of plaster casts, statues, and engravings used by the students as models.

The collection, opened in 1803, was enriched with works coming mainly from closed down churches in Lombardy and other departments of the Italian Kingdom, including some of the most important paintings, such as the *Wedding of the Virgin* by Raphael and the *Crucifixion* by Bramantino.

The Wedding of the Virgin by Raphael, 1504

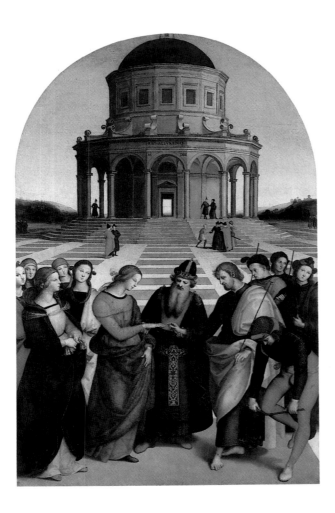

Opened in 1803 – with Giuseppe Bossi as secretary – the collection was built up mainly with works from closed churches in Lombardy and other districts of the Kingdom of Italy, including some of the most important paintings as the Wedding of the Virgin *by Raphael or the* Crucifixion *by Bramantino.*

Cariani
(Giovanni Busi)

The *San Gottardo altarpiece* (oil on canvas, 270 × 211 cm.) comes from the church of San Gottardo in Bergamot for which it was commissioned by the School of St. Joseph in 1517. Recent documentary investigations have made it possible to date its creation before the second decade of the Sixteenth century. The altar step depicting *The Flight into Egypt* was completed instead one year later. It has been separated from the altarpiece and is today part of a private collection in Bergamo.

The altarpiece is structured on three levels that correspond with the diminishing the depth of field. It depicts the *Sacra Conversazione*, against the background of a rural landscape and distant view of Bergamo Alta with the convent of San Gottardo which disappeared at the end of the Eighteenth century. At the centre there is the Madonna with Child, raised up with respect to the straggling group of onlookers. A reference to the city of Bergamo is the presence of Saint Grata, recognisable because she is holding the cut-off head of Saint Alexander, and presumably Saint Adleida on the extreme right. She was also a martyr and protector of the city. The central position of St. Joseph is due to the owners of the chapel; St. Augustine on the left and St. Filippo Benizzi with a book in hand, are a clear allusion to the order of the Servites, as the former was founder of the Rule and the latter was a Servant of Mary. The interest of the canvas is not limited to the bright colours of the mantles and skin tones. The correct chronological collocation causes a shock to the certainties so far acquired regarding, on the one hand, the relations with Bergamo culture and with Lorenzo Lotto in particular; on the other hand the nature of

Cariani's use of colour and consequently the relationship with Titian and Palma il Vecchio.

We need only recall that in 1518 Lotto had not yet completed his Bergamo altarpieces – which is why they could not be a point of reference as was often thought – whereas as far as relations with Giorgionesque culture are concerned, which is where Cariani comes from, the romantic and Titian-like nature of the painting has been revealed.

Some altarpieces by Palma constitute the iconographic precedent, although more crammed in their configuration.

Even the positioning of the landscape creates a new dimensional relationship with the figures to the point that it shares a role with the subject. This is a reference to the bucolic themes treated by Giorgione, or to the *Rural Concert* by Titian at the Louvre, while the blatantly Lombard search for a popular realism of tone perhaps springs from the chronologically close *Martinengo Altarpiece* by Lotto (1516).

The San Gottardo altarpiece took on the role of a precise and solid guide in the formation of a Bergamo language, thanks to the progressive settling of a new generation of Venetians in the city, and the development of the theme of the holy altarpiece within the Venetian environment. The work was immediately placed on the altar of St. Joseph, and soon removed following the disastrous fire that destroyed the church of San Gottardo in 1529. It was later placed on the third altar after the church was rebuilt. Requisitioned by the French in 1797 it stayed in Bergamo in the Palazzo Nuovo until 1803. It reached Brera in 1805.

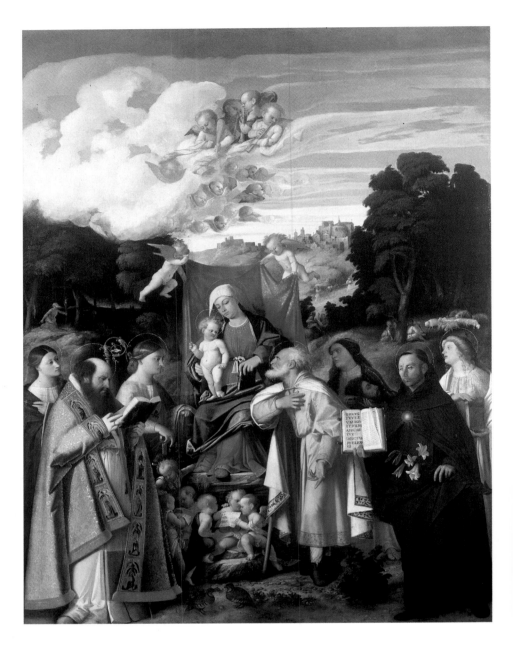

Among the numerous acquisitions dating from the Bossi management, the San Gottardo Altarpiece, *by Cariani, formerly in Bergamo, became part of the Brera collection in 1805. Moreover, Andrea Appiani deserves credit for having acquired a masterpiece by Tintoretto,* The finding of the body of Saint Mark.

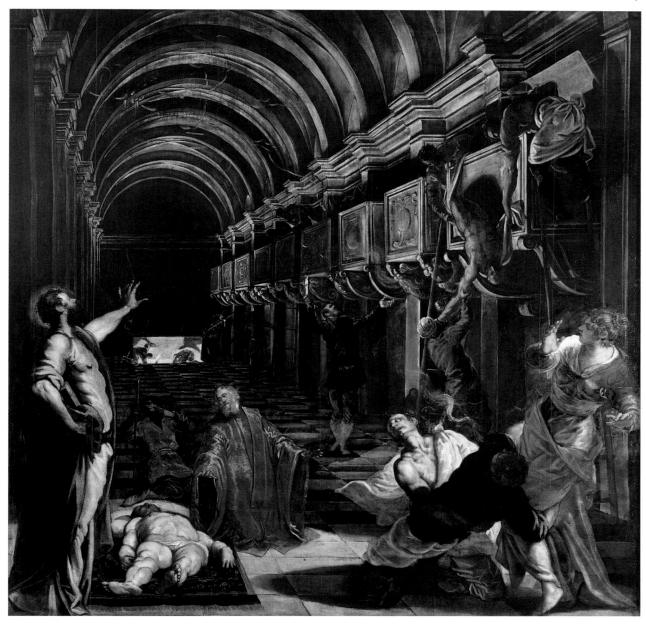

Tintoretto (Jacopo Robusti)

The finding of the body of St. Mark (oil on canvas, 396 × 400 cm.) belonged to the Great School of St. Mark in Venice. After its closure in 1807 it was placed temporarily in the balloting room of the ducal Palace, and later in 1811 passed to its current location in Milan where it arrived with ten centimetres cut from the top. Between 1847 and 1866 it was temporarily deposited with the church of St. Mark in Milan.
Together with other canvases today in the Gallery of the Venice Academy, it was part of a cycle depicting *Stories of St. Mark,* hung on the walls of St. Mark's School in Venice and initiated by Tintoretto in 1584 with the *Miracle of the slave.*
This painting is one of Tintoretto's most important mature works for its spatial and lighting effects. It was created between 1562 and 1566. The work was commissioned by the doctor and scholar Tommaso Rangone, who was then the *guardiano grande* of the School and appears in two other canvases from the cycle. In this case he is depicted in the guise of a haloed knight kneeling at the centre of the scene in the middle distance.
There is some disagreement in the artistic literature regarding the identification of the scene: for some it is the *Stealing of St. Mark's body* which according to the tradition happened in 828 in Alexandria perpetrated by two Venetian merchants. The gesture of the saint, depicted on the left with his left arm raised, should mean the end of the search in front of his own body that has been found. However, the protagonists of the theft are missing as well as any reference to buildings from the past. Others believe that the composition recalls a later moment, i.e. in 1094 when of St. Mark's basilica was rebuilt and the Venetians were still uncertain whether or not to dedicate it to St. Mark, whose relics they had lost in the meantime. As his body was not found, in spite of the searches, the saint appeared after days of prayer in the basilica pointing to the place where he was buried. The moment at which he was found was accompanied by a series of miraculous events such as the healing of the blind and the possessed, a theme which corresponds well with purpose of the School in terms of hospital and assistance.

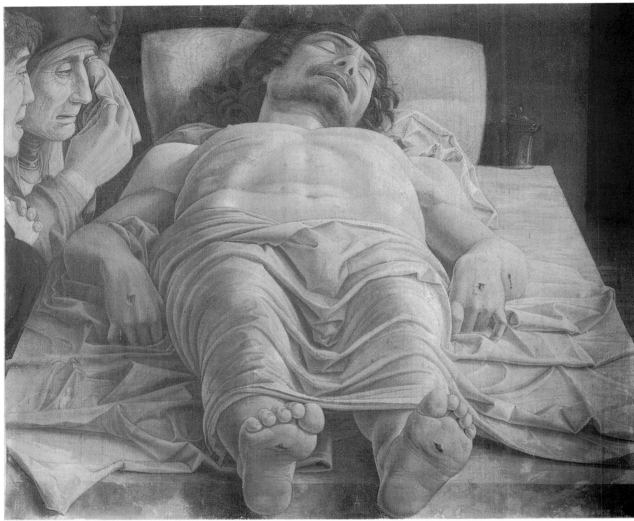

Andrea Mantegna

Andrea Mantegna's *Dead Christ* (distemper on canvas, 68 × 81 cm.) is incomparably famous, to the point that it has become the symbol of Italian Fifteenth century painting, particularly for the virtuosity of its perspective. The painting also contains interesting iconographic implications.

The canvas depicts the body of Christ half covered by the shroud and lying on a stone slab identified as the so-called unction stone. The position of the hands seems designed to highlight the still open wounds, while the feet inclined asymmetrically seem to refer to their asymmetric and overlapping position on the cross.

The head is resting on a silk cushion on the right of which there is the jar of ointment. On the left there are three sorrowful figures - the Madonna drying her tears and St. John the

Apostle. The third figure, only partly visible, could be Mary Magdalen. The scene is set in a closed space, illuminated by a strong light coming from the right. In the background, there is a dark doorway which is probably the entrance to Christ's tomb.

Chronologically, this canvas probably comes after Mantegna's work in the Camera degli Sposi of the Ducal Palace (1465-74), where three *putti* foreshortened from below to above on the ceiling of the room in some way prefigure what is depicted here. New hypotheses consider it to have been done between the end of the seventies and the early eighties of the Fifteenth century.

As far as the foreshortening is concerned, this work represents a consistent development and a natural consequence of the research Mantegna had already carried out, distinguishing

himself in a conscious but utterly independent way from the experiments in perspective by Paolo Uccello, and also by the Venetian environment of Jacopo Bellini.

The perspective structure of the work contains blatant incongruities that prevent a unified point of view of the entire composition. The horizon of the slab and the body of Christ is in fact placed 50 centimetres above the upper limit of the canvas, while the side figures and the jar of ointment are observed from above. The body of Christ itself presents obvious irregularities if we consider that given the point of view proposed, the feet should have been bigger and the head smaller.

Mantegna gets around this obstacle probably by using a "sensory" correction of the image, similar to what our perceptive system does when faced with such

foreshortenings. To do so he probably uses parallel projection. In this way he avoids shrinking the body in perspective, treating it in an isometric manner. It is therefore not a "realistic" vision of the subject, but a mediation, almost a compromise, between naturalistic and perspective realism and respect for the harmony and proportions of the human body.

In 1807 the painting arrived in Milan as part of the collection of Giuseppe Bossi, acquired in Rome with the help of Antonio Canova. When Bossi died the painting passed into the hands of his heirs, who in 1824 donated it to the Brera Academy.

Carlo Crivelli

The canvas is signed CAROLVS CRIVELLVS VENETVS MILES PINXIT MCCCCLXXXXIII. Apart from the signature, on the step there is the inscription "[...]PE FRA IACOBVS DE FABRO ET FRA ANGEL[...] SERRA COMITVS GVARDIANVS COMPLETA FVIT". Positioned in January 1490 as the main altarpiece in the church of San Francesco a Fabriano and completed three years later, the *Crowning of the Virgin* (oil on wooden board, 225 × 255 cm.) is the last famous work by Crivelli. According to the contract this large wooden structure was to have the crowning of the Virgin flanked by two saints on each part as the central panel, an upper cyma with the *Pietà* (oil on wooden board, 128 × 255 cm.) and an altar step. In the canvas of *The Crowning*, Christ and the Virgin are seated on a high throne in multi-coloured marble raised by a step decorated on the front with two cornucopias brimming with fruit always used by the artist as Christological symbols. Between the cornucopias are symbols of the sun and the moon, an allusion to life passing under the protection of faith. In the upper part the Eternal, with the dove of the Holy Spirit, places a crown on the heads of the Madonna and Christ, while the gesture of the latter accompanies the crowning of the Mother. The Eternal, inside a mandorla, is surrounded by heads of cherubs, while two angels hold up a precious damask drape in the background. On the sides of the central group are the Saints Venanzio, John the Baptist, Catherine of Alexandria, Augustine (or Bonaventure), Francis and Sebastian, while the other angelic figures accompany the scene playing musical instruments.

The first purchases

The main champion of the Gallery's development at this time was Giuseppe Bossi, secretary from 1801 to 1807. Thanks to him there was a large increase in the collection and a new layout of the rooms, with exhibitions of portraits and self-portraits of artists and modern works, especially by grant-holders of the Academy.

The layout soon proved inadequate for the pressing need for more space. In 1806 the project to annex the Fourteenth century church of Santa Maria di Brera was approved, signed by Pietro Gilardoni. This was then divided internally into two floors (1808-9). The upper floor was divided into four large rooms which are still called Napoleonic today, and which are the fulcrum of the new Art Gallery.

In 1808 the compilation of the Napoleonic Inventory began. This registers the entry of paintings up to 1842, and is still today an irreplaceable study source.

Appiani, a state collector

Bossi was followed as curator by Andrea Appiani, under whom a series of highly important frescoes was acquired, removed from sites mainly in

Milan and by various artists: Marco d'Oggiono, Gaudenzio Ferrari, Bernardino Luini, Vincenzo Foppa, as well as paintings by Tintoretto, Mantegna and Titian. At the beginning of the second decade of the Eighteenth century, the Brera Gallery boasted over eight hundred works, arranged at various heights to entirely cover the walls of the Napoleonic rooms. The aim was to create a collection that represented a reference point for the study of Italian art, and an alternative to the collection choices made on a purely local scale by other institutions, as in Bologna and Venice.

Following the Restoration, efforts began to bring back into Italy the works stolen and taken to France, and to restore those works taken away from the Papal State and brought to Milan.

Important donations

In the early Nineteenth century, thanks to private donations, new masterpieces reached the Brera Gallery such as Mantegna's *Dead Christ* and the *Supper in the Pharisee's house* by Paolo Veronese. In 1885, the donation of over 80 paintings by Pietro Oggioni (including Crivelli's *Coronation of the Virgin*) helped make Brera into an anthological collection of national interest.

In the first half of the Nineteenth century the Brera collection was enriched with new masterpieces, often thanks to private donations, for instance the Dead Christ *by Mantegna and the* Dinner in the house of the Pharisee *by Paolo Veronese. In addition, the donation of about 80 paintings by Pietro Oggioni in 1855 (including the* Crowning of the Virgin *by Crivelli) contributed to make Brera an anthological collection of national interest.*

The collection of drawings

Leonardo da Vinci,
Head of Christ

The Drawings collection is an integral but little known part of the Brera collection. It originated in 1901 when, after a long delay, the Academy applied the Ministry of Public Instruction's decree from 1882 that rendered the Gallery independent and granted it the entire artistic heritage of the Academy with the exception of contemporary things and teaching materials such as plaster casts. The Academy handed over to the director Corrado Ricci 585 drawings by masters from Bologna, but also from Pesaro, Rome, Marche and Venice from the Sixteenth to the Eighteenth century, mostly from the Eighteenth century collection of Filippo Acqua di Osimo, sold to Brera in 1857 by the nephew and heir Francesco Acqua. Until recent years, in the absence of specific research, it was thought that drawings of Brera came from Carlo Bianconi, an erudite Bolognese collector particularly of drawings and prints, and Secretary of the Milanese Academy from 1778 to 1801. This hypothesis was formulated in 1937 by G.A. Dell'Acqua on the basis of a large number of works on paper by painters from Emilia from the Seventeenth and Eighteenth centuries, which seemed to indicate Bianconi's taste and choice. The hypothesis also concerned the purchase in 1802 of some cartoons by Donato Creti, Ludovico Carraci and belonging to Guido Reni, all exhibited in the rooms of Brera. Only recently in 1986 the purchase document of the Acqua collection was found by D. Pescarmona, director of the Drawings Collection, who also noticed the initials "F. A." on many of the works on paper and antique double bottoms. This finding contradicted the Bianconi hypothesis and lead to a series of studies that revealed more information about the collector from Marche and clarified the cultural reasons for his choices. Soon after the Seventeenth century drawings and Eighteenth century nudes were found in the Academy that Bianconi had acquired as teaching material for the Academy.

The Drawings collection does not merely consist of the Acqua collection and these events, however. For the sake of completeness, we should recall other acquisitions apart from the cartoons of Bianconi. *The gift* (1799) by Venanzio de Pagave who brought to Brera the great cartoon with the *Adoration of the shepherds* by Bernardino Lanino, the acquisition (1813) from the Maggiore hospital in Milan of the famous and highly reproduced *Head of Christ* long thought to be a study by Leonardo for the head of the Redeemer in *The Last Supper* in Santa Maria delle Grazie, the legacy (1876) of two rare drawings by Morazzone of the Marquis Massimiliano Stampa Soncino, the beautiful *half-length St. John the Baptist* by Andrea Solario, an over-used baptismal image, acquired (1901) by the Milanese merchant Antonio Grande who later donated 19 works on paper by ancient masters. Then there are the drawings requisitioned from the Monti collection at the Archbishop's palace, others donated between 1903 and 1911 by Luca Beltrami and collectors such as Francesco Dubini, Guido Cagnola, Giulio Sambon and Gustavo Frizzoni.

The collection of drawings at Brera is small but not of marginal interest thanks to the quality of the works on paper and the events connected with collections. It opens up possibilities for further discoveries in the highly reserved and too often deserted sector of the study of drawings.

Display criteria evolve

From 1850-51 there had been a general reordering of exhibits, with new works coming from deposits and others conceded in deposit to churches of the province.

With the final separation from the Academy in 1882, the Brera Gallery began its independent history under the curatorship of Giuseppe Bertini, and later Corrado Ricci (1898-1903). Ricci was responsible for a new renovation in exhibition criteria, with a more rational use of the rooms, and above all the creation of skylights for the interior lighting. The works were arranged in a more similar way to how they are now, using all the rooms facing onto the main courtyard for exhibition purposes, and acquiring the whole corridor that connects the current entrance with the Napoleonic rooms. The paintings were grouped by school and in chronological order. The new Brera Gallery set out in this way was inaugurated in 1903.

Under the first curatorship of Ettore Modigliani (1908-14) important new acquisitions were made, particularly of signed works – Bergognone, Zenale, Piazzetta, Moretto, Baschenis and so many others – interrupted between 1915 and 1918 by the evacuation of all the works to Rome and during Modigliani's second mandate (1918-24) by a kind of lull.

Private donations

The pace changed with the constitution of the Friends of Brera and Milanese Museums Association. This became the preferred channel for social patronage through which important new works entered the museum (in 1939 Caravaggio's *The Supper at Emmaus*).

During the Second World War, while the paintings were sheltered in deposits in northern and central Italy, Palazzo Brera was damaged by bombing.

Caravaggio (Michelangelo Merisi)

The style and execution suggest that the *The Supper at Emmaus* (oil on canvas, 141 × 175 cm.) was done in Zagarolo (Rome) after Merisi's flight from Rome, in September 1606.
Jesus is presented from the front, behind the table, blessing the bread that has just been broken, while the faces of the two characters seated reveal the first inkling of recognition. As a counterpoint to the expressive tension of these faces are the astonished faces of the innkeeper and the old lady, standing just behind. Caravaggio painted another *Supper at Emmaus*, now held

at the National Gallery in London, which has several differences compared to the version in Brera. Firstly, the setting is less bright, in keeping with the progressive emphasis on the contrast between light and shade in the artist's later works. The window where the light comes from is outside the frame, but is realistically reflected in the jug on the table. The light illuminates the scene from the left like a spotlight, contrasting with the earthy tones in the background assimilated by the preparatory layer – a technique typical of the post-Roman period – and acting as a dramatic element in the intensity of the moment. The gestures are however

more restrained than in the London version, more composed and less emphatic; Christ is no longer young and beardless, but a mature and meditative man. The moment described in the picture is different in the two paintings: here the bread has already been broken, and Jesus' gesture almost seems to take on the meaning of a farewell. The brush strokes are rapid and basic, and similar to the underlying sketch. They aim at a fundamental and sentimental quality, and focus particular attention on certain realistic details of the scene, such as the Ushak style Anatolian carpet on the table, the tablecloth on which the bread and jug rest, the signs of poverty in the people

standing, and the difference between the delicate hands of Jesus and the dark and rough hands of those seated.
The painting was sent to Rome to be sold and was bought by Ottavio Costa, who was certainly an intermediary for the Patrizi. It appears in their inventory

drawn up by Cavalier d'Arpino, in 1624. It was still in Rome in the Patrizi house in 1912. It was finally purchased in 1939 when it belonged to Patrizio Patrizi, and was donated to the Brera Gallery by the Association of the Friends of Brera and Milanese Museums.

The arrival of private donations – fundamental to the creation of Brera – took on another dimension with the foundation, in 1926, of the Association of the Friends of Brera and the Milanese Museums, which became a preferred channel of social patronage through which new important works entered the museum (for example, in 1939, The Supper at Emmaus *by Caravaggio)*

Fernanda Wittgens and the Brera Gallery in the 1950's

Fernanda Wittgens (1903-57), Curator of the Lombardo Galleries and director of the Brera Gallery from 1947 to 1957, was a woman of great intelligence and culture, energetic and wilful, capable of farsightedness and always consistent in her studies as in her commitments in her life and work. She had a decisive role on the history of Brera which still today bears the stamp of the choices she made in the post-war reconstruction years and much of the 1950s. These choices concerned the ordering of the works, how they were hung and presented, and also the creation of a cultural policy attentive to the "social role of art" through education and the organization of exhibitions that left their mark in that era.

She graduated in 1928 with Paolo d'Ancona with a dissertation on "The art books of painters from the Nineteenth century". That same year she entered Brera as a temporary worker, introduced to Ettore Modigliani by Mario Salmi. She immediately got on well with Modigliani, curator of the Galleries and Monuments of Lombardy and director of the Museum since 1908. She was a great organizer but also a serious scholar who kept up with the times. Between 1928 and 1935 she took part in a vast restoration programme of the Fourteenth and Fifteenth century frescoes from the Lombardy oratories and churches. In 1930 she participated with Modigliani in the organization of the great and unrepeatable "Exhibition of Ancient Italian Art" in London, ordered by Mussolini, and she was awarded an honour by the British for her work. In 1935, when Modigliano, a liberal and a Jew, was removed from Brera for antifascism, Wittgens remained and continued his work. In 1939 she was the first woman in Italy to win the competition to become director of personnel for monuments, museums, galleries and architectural sites. In 1941 she was given the job of running the Brera Gallery. Filled with ideals of democracy and mindful of the liberal and libertarian tradition of il Risorgimento, during the difficult war years she found herself on the side of the opposition. She was close to Ferruccio Parri and Justice and Liberty. Confident in the prestige of her cultural superiority, her friendships, and her public role, together with a group of friends, including the collector Gianni Mattioli (with whom after the war she would share the passion for and commitment to modern Italian art, she became a reference point for the expatriation into Switzerland of political refugees and Jews. However, she did not neglect her work at Brera where all the paintings were moved away into safe places. In 1944 she was arrested and condemned for helping the Jews. She only came out of prison when Italy was liberated in April 1945. She went back to her job in 1946, once again with Modigliani who was reinstalled in his position, but who died soon after. She established a plan for the rebuilding of the Milanese museums damaged in the war: Brera and its Academy of which she is the Commissioner, but also the Poldi Pezzoli museum, the Sforzesco Castle, the Ambrosian Gallery, and the Modern Art Gallery. In 1950 the rebuilding of Brera where thirty out of thirty-four rooms had been bombed, was completed. Thanks to the "relentless dynamism" of Fernanda Wittgens who literally "terrorized the bureaucrats of the Ministry" as Antonio Greppi, first mayor after the war was to experience, and on the basis of the project by Piero Portaluppi, who had already been responsible for a historical reorganization in 1924, the museum was

The reconstruction commenced in 1946, initially entrusted to Franco Albini by the Superintendency; with the arrival of superintendents Ettore Modigliani (1946-47) and Fernanda Wittgens (1947-57) Albini was replaced by Piero Portaluppi, responsible for the reconstruction of the entire picture gallery. The works were completed in 1950 and the gallery, with the historical exhibition arrangement planned by Wittgens, was inaugurated in the same year.

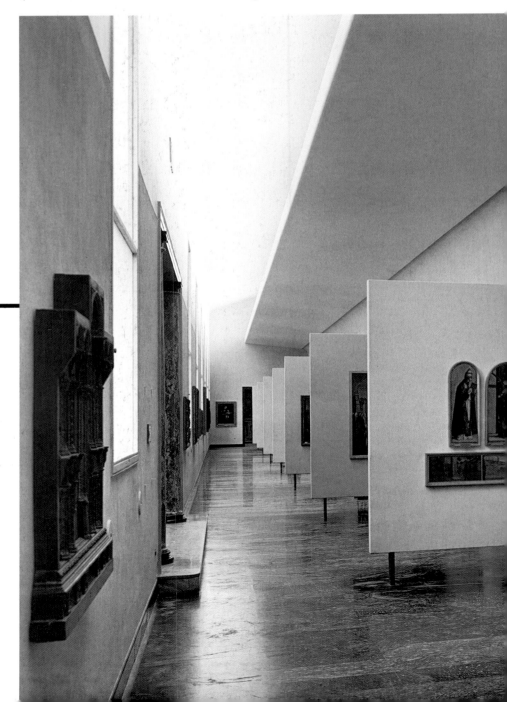

totally renovated. The décor was grand and luxurious, with an aristocratic and restrained modernity. This was the result of careful restoration work and studied positioning of the works of art (the Eighteenth century room and the "shrine" of Piero della Francesca, Bramante and Raphael were examples). However, the technological aspects were not neglected (lighting and heating) nor were the services by means of the creation of a restoration room and modern photographic and radiology laboratory, the first in Italy to experiment with the new diagnostic techniques on works of art.

The accent on functional lucidity and neutrality was based on the deep-rooted conviction that it was necessary to intervene on the basis of the "difficulty in subordinating the architecture to the paintings", reconciling historical tradition with modernity, and at the same time leaving space for an elitist taste in the precious materials which still today characterize Brera. "The *aulic* harmony of Brera", as Wittgens put it in her inaugural speech, was "highlighted by the highly precious marble that we have obtained, with authorization of the Ministry, from the Semi-

precious Stone Works of Florence. The trail of modern marble in the Gallery is studded with the rarest Medicean blue marble, a treasure unique to Italy…oriental violet breccia… African black…Siena yellow". But there was more. Guided by a new awareness for protection and conservation, Wittgens (who brought to Brera the entire cycle of Fourteenth century frescoes from the Mocchirolo oratory and succeeded in obtaining from Vico Baer the *Self portrait* of Boccioni which since then has been the final work visitors see in the Gallery) worked to make the museum not only a place

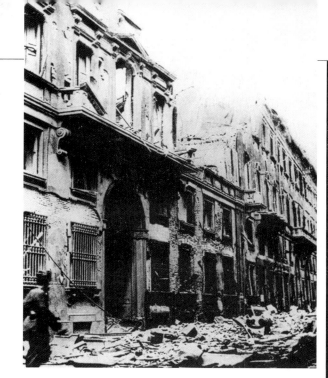

of preservation of historical memory, but also a "living museum" with a social function, something for everyone.

In 1951 she started up new educational projects that became an example. The number of visitors to Brera and that she herself often guided round, was enormous: children from primary and junior school, but also their teachers, the Recreational Clubs from the large Milanese industries, white collar workers from companies, factory workers and artisans. The teaching staff were chosen from young University teachers

and were trained by the Museum. They had to be "able to speak a plain but not amateurish language, at the same time historical and aesthetic". The educational events took place during the day and in the evening. She organized exhibitions of ancient art to attract international attention to Italian artistic culture and at the same time promote Twentieth century art exhibitions to show, in spite of prejudice due to Fascism, the vitality of Italian contemporary art.
She died of an incurable disease during which she hardly ever left her desk.

Above
Buildings of Via Brera after Second World War bombings

Interior design by Franco Albini of the rooms dedicated to Venetian and Lombard painting, 1949-50

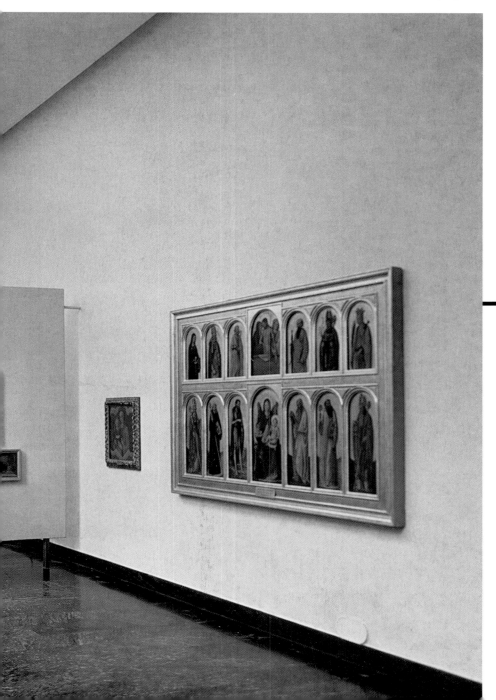

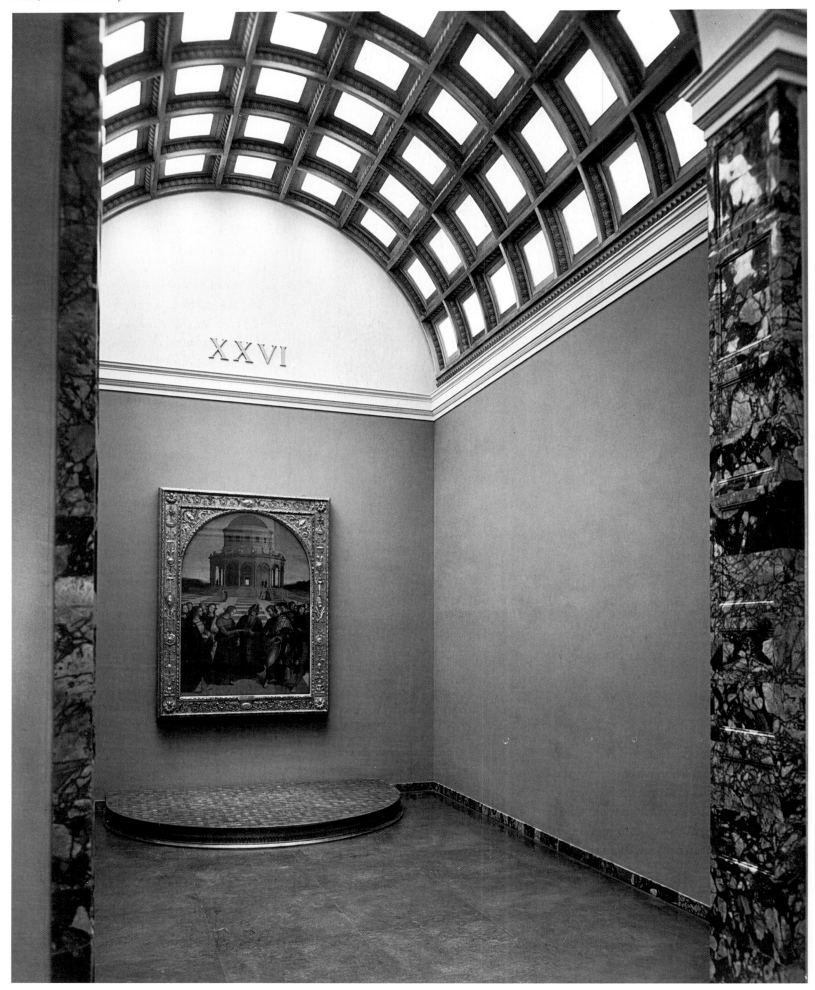

XXVI

Carlo Carrà

Mother and son (oil on canvas, 90 × 59.5 cm.) was donated to the Brera Gallery as part of the collection of Emilio and Maria Jesi. It arrived in 1942 as *The enchanted room* through the Barbaroux Gallery of Milan. It is undoubtedly one of the key works from the metaphysical paintings by Carlo Carrà.

Carrà arrived in Ferrara in 1917 on military service, and met Giorgio de Chirico and his brother Alberto Savinio. This sparked off a new period of creative fervour commonly known as the "metaphysical season". The rediscovery of Giotto became the guideline for a new and intense formal sentiment. This was developed through experimentations that leant not so much on the dynamism that had characterized the previous Futurist poetics, but on the research into ancestral, archetypal forms.

The desire to figuratively rename objects and things and isolate them in compositions that defy common sense indicates a reappropriation of reality, its underlying and primitive forms, its simplest structure, with a kind of brutal primitivism.

In some cases Carrà's metaphysics takes the shape of an exploitation of de Chirico's repertoire, but it expresses the definite will to look for a fundamental and new relation between forms and space, colour and light.

Interior design by Piero Portaluppi of the Room XXVI for *The Wedding of the Virgin* by Raphael, 1950

The donation made by Guido Cagnola in 1947 opened the new season of post-war acquisitions, which included important donations of contemporary art: from 1976 to 1984 Maria Jesi donated to the museum, in the name of her deceased husband Emilio, her collection of works by Italian and foreign artists from the Nineteenth century which included Boccioni, Carrà, Morandi, Modigliani, Arturo Martini, De Pisis, Severini, Mafai, Scipione, Rosai and Soffici.

Reconstruction

From 1946 on, reconstruction work began. This was initially entrusted to Franco Albini by the Monuments and Fine Arts Office. Albini built the wing that includes Rooms VII, and IX-XIV. He was followed by Piero Portaluppi, together with the curators Ettore Modigliani (1946-7) and Fernanda Wittgens (1947-57). Portaluppi was responsible for the reconstruction of the entire Brera Gallery, a reconstruction inspired by ideas of grand décor carried out thanks to the use of ancient marble from the Semi-precious Stone Works of Florence.

The entrance hall and was enlarged by introducing concrete pillars, while the skylights were redone using new technologies; heating with panels was installed. The works were finished in 1950, the same year that Wittgens' now historical layout was inaugurated.

With Guido Cagnola's donation in 1947 of his own library together with the canvas of Lorenzetti's *Madonnna and Child,* a new season of post-war acquisitions began. The acquisitions from then on were above all merit of private initiatives and direct intervention by the State, while in 1951 a small research and restoration laboratory was set up, with a photographic and radiological laboratory attached.

However, in 1974 serious difficulties linked essentially to lack of staff and the unsuitableness of the rooms led the new curator Franco Russoli (1973-77) to close the Brera Gallery and to denounce the conditions in an exhibition "For Brera" held in Rooms XXXVIII-XXVII, thus inverting the route of the museum and proposing a new layout.

Nevertheless the collection was further enriched with important new donations, particularly of contemporary art: in 1976 Maria Jesi, in memory of her husband Emilio, donated a first part of her private collection of Italian and foreign artists of the Twentieth century, including Boccioni, Carrà, Morandi, Modigliani, Arturo Martini, De Pisis, Severini, Mafai, Scipione, Rosai and Soffici (the donation was only completed in 1984). Thus the museum opened itself to the Twentieth century, thanks also to the initiative of Riccardo and Magda Jucker who in 1976 alsodonated to Brera about twenty important Futurist works, later acquired by the Civic Museum of Contemporary Art (Cimac).

The Great Brera

In 1976-77 the programme "Great Brera" was at last initiated, with the intention of opening the Gallery up to new cultural and functional needs with the promotion of educational activities, temporary exhibitions, and book sales. At the same time a new exhibition, "Museum On Trial" confirmed the choices made in 1974 from a museological point of view. The walls were painted dark green, ceilings were made lower by means of drapes, and paintings were lit with spotlights.

The frescoes by Donato Bramante were presented in a new arrangement all together in one room, and ancient works were exhibited next to interpretative copies by contemporary artists. Meanwhile new architectural work was carried out to make new space available from the adjacent Citterio building.

A new refurbishment campaign from 1978 onwards re-established the uniform beige colour and substantially restored the rooms to the way Wittgens had arranged them, with minimal variations regarding to the Seventeenth and Eighteenth century Flemish and Genoese paintings, Nineteenth century paintings and Venetian paintings from the Fifteenth century.

In 1979 Vittorio Gregotti laid out Room XXXVI-II with the Jucker and Jesi collections, while the offices occupying Room XIX were removed, Room XXII was completed with a new brickwork ceiling , and, along with other rooms, fitted with a skylight.

The new availability of space led to a redistribution of the Romagna , Ferrara and Bolognese paintings, while work was continued in the ancient Astronomer's apartment (Piero della Francesca and Raphael rooms) acquired by the Brera Gallery in 1975.

The Albini gallery (Rooms VII, IX-XIV) was assigned to Lombardy painting of the Fifteenth and Sixteenth centuries, and the new wing housed small Venetian paintings. About three hundred paintings were moved, with subsequent corrections to the lighting.

Work carried on in the first room by Portaluppi: the corridor which before was composed of two areas was made into one and covered with a barrel vault. At the same time the ancient windows were reopened. Seventeenth and Eighteenth century landscapes were placed in this room together with portraits of artists. It is not hard to detect in this uninterrupted series of rearrangements and layouts a lack of a precise taste or orientation, and in the meantime the Citterio building was covered.

Piero della Francesca

The *Montefeltro altarpiece* (wooden board, 284 × 172 cm.) is undoubtedly the most important *Sacra Conversazione* of the Fifteenth century. It had an immediate influence on Italian art from Antonello da Messina to Giambellino, and from Bramante to Raphael. Using an iconography of the Madonna and saints inside a church, a northern motif, Piero della Francesca deals with the great problem of reconciling characters with architecture. However, the proportional relations within the composition are somewhat forced by a little cut made to the canvas on the right side and a larger one on the left side, but not at the top, while it is assumed that at the bottom one of the horizontal beams that make up the board is missing.

The master stages the Sacred Conversation imagining it to take place at the point in which the nave and the transept cross: Federico da Montefeltro, the Count of Urbino, is kneeling before the Virgin and surrounded by six saints positioned at the sides in groups of three. On the left are John the Baptist pointing to the Child with his right hand, Bernard, and Jerome who beats his chest with a stone. On the right side Francis holds a crystal cross while with his left hand he holds open his tunic to reveal the wound in his side, Peter the Martyr has a head wound from which blood is oozing, and there is a white-haired apostle variously identified as Andrew, Paul, or more probably John the Evangelist.

Between the saints and the Virgin there are four archangels. Federico is depicted in splendid armour, strictly in profile and with his hands joined. On the shoulder-piece of his armour an arched window is reflected, a detail of great realism that links the altar-piece indissolubly with the area it was intended for

inside the church. The mace, the gauntlets and the helmet, reflecting a distorted image of the offerer, are placed at the feet of the Virgin.

The Virgin is depicted praying and seated on a *sella plicatilis;* the Child is lying on her lap: his sleep as well as the coral necklace around his neck represent the foreshadowing of his death. In the background of the painting is a wall with apse covered by a barrel vault lacunar ceiling lined with multi-coloured marble mirrors and pillars. In the basin, suspended from a shell by a golden chain, hangs an ostrich egg, symbol in medieval times of divine grace and probably an allusion to the miraculous maternity of the Virgin. Apart from Federico's hands, repainted with insistent realism by one of the Flemish artists engaged in redecorating the ducal cabinet, identified as Pedro Berruguete, the canvas is entirely by della Francesca. It was possibly painted before 1474 as Federico does not appear decorated with the orders awarded him in the summer of that year – the Garter and the Ermine - and begun after the birth of Guidobaldo and the death of Battista Sforza, Federico's wife (1472).

There is controversy regarding the date as well as the original site of the altar-piece, which entered Brera in 1811. It came from the church of San Bernardino, which Federico chose for his tomb, from the main altar where it certainly hung at least from the beginning of the Eighteenth century.

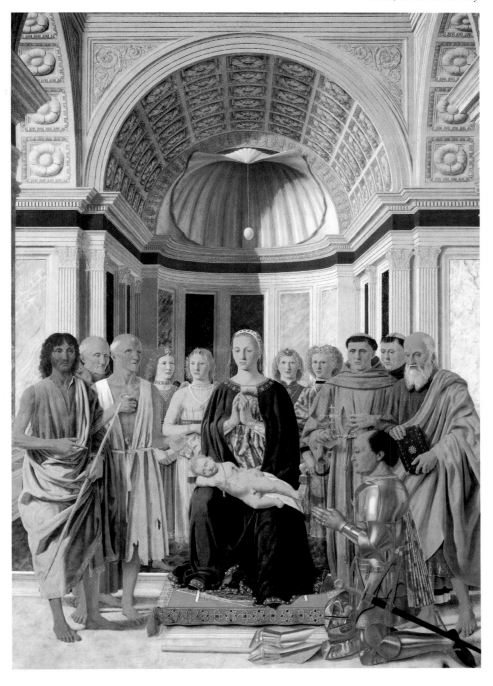

In 1975 the Picture Gallery purchased the ancient Astronomer's Apartment, where the rooms dedicated to Piero della Francesca and Raphael have been installed.

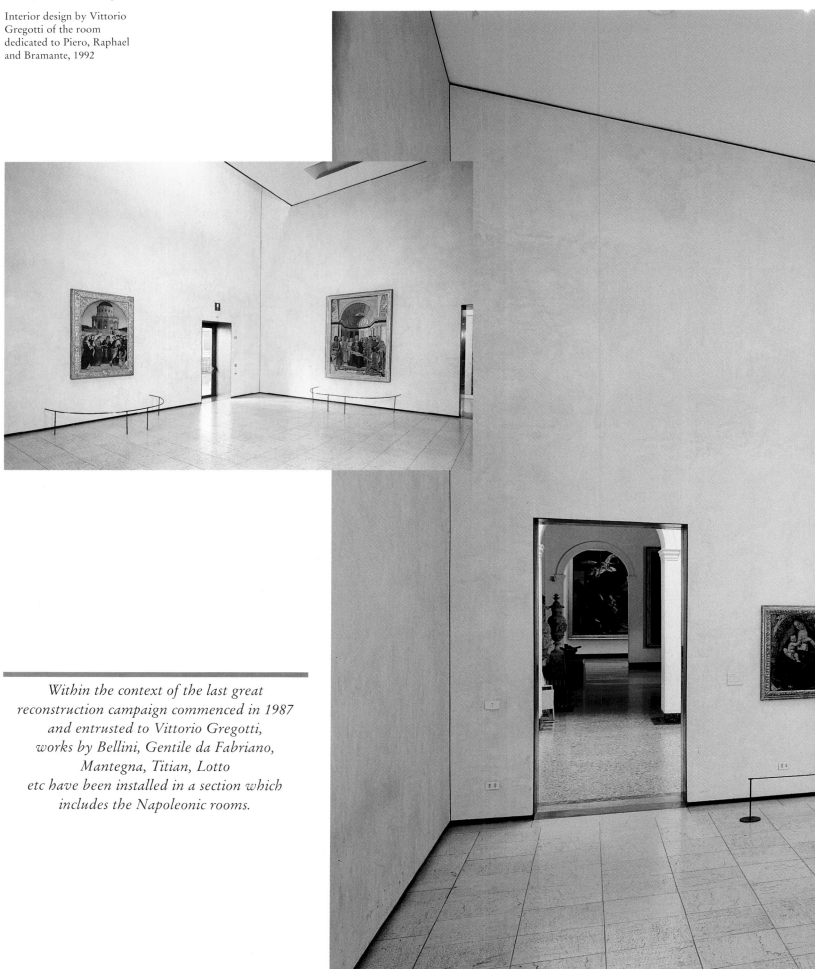

Within the context of the last great reconstruction campaign commenced in 1987 and entrusted to Vittorio Gregotti, works by Bellini, Gentile da Fabriano, Mantegna, Titian, Lotto etc have been installed in a section which includes the Napoleonic rooms.

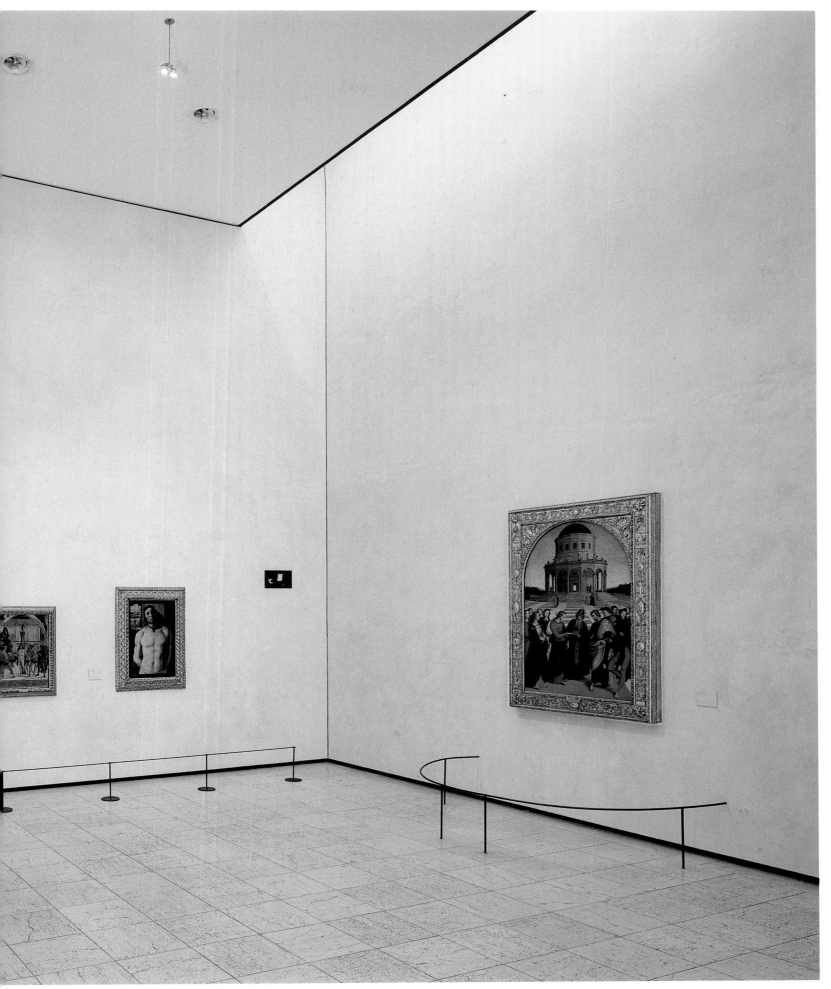

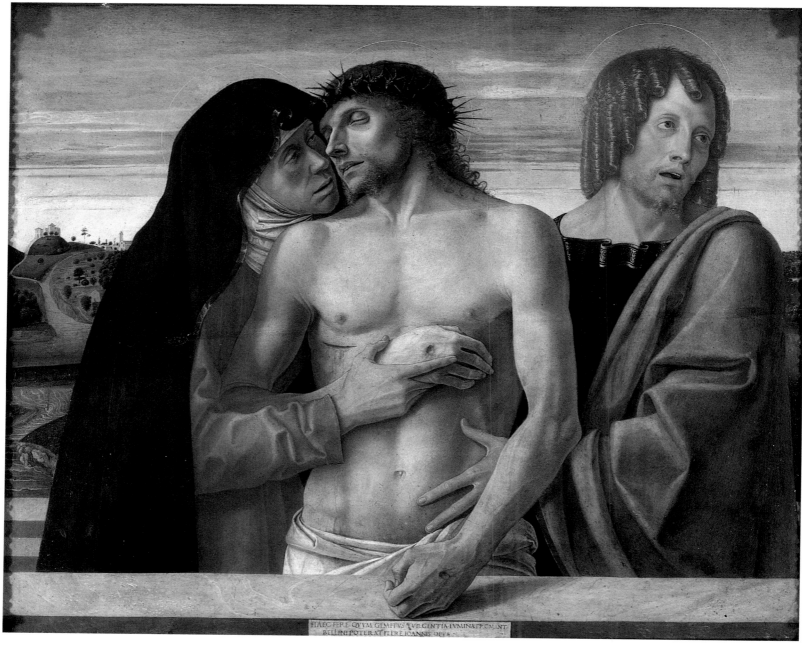

Giovanni Bellini

The painting was registered in 1795 in the Sampieri Gallery in Bologna (1795) and arrived at the Brera Gallery in 1811, donated by Eugenio di Beauharnais.

The theme of the *Pietà* (distemper on wooden board, 86 × 107 cm.) was certainly not new to Giovanni Bellini when he set out to paint the panel now conserved in Brera. In fact not only is this is the third example in the Bellini catalogue, it is also a subject that this artist, and all the major Venetian artists, dealt with several times, almost as if it were a test with which to measure their increasing abilities in time.

What is certain is that critics unanimously agree that this is Bellini's first masterpiece for the skilful balance between form and expression, and between the solemn and majestic disposition of volumes in the figures and the bright colour tones. The panel depicts a group of three figures with Christ at the centre, held up by Mary and St. John the Evangelist, to the left and right respectively. The three figures are cut out just under the sarcophagus which occupies the whole painting horizontally, according to an iconography of the *Imago Pietatis*. This constitutes a prototype for Bellini that was to have great success.

The group dominates the entire composition; only a small piece is taken up with the foreshortened landscape to the left of the Madonna, while a sky full of clouds dragged horizontally provides the background in the upper quarter of the painting, above the heads of the figures. The figures are arranged asymmetrically, thanks to the poses of the bodies and the movements of the faces. St. John, with his left hand on Christ's stomach, faces elsewhere, beyond the canvas, almost as if to escape from the painful image of Christ. Christ is at the centre with his left arm hanging in front of his body; his lifeless hand rests on the edge of the

sarcophagus. His right arm is folded across his chest in a pose like that of his Mother who holds him up. Their faces meet, symbolically united in a narrative unity. However, the languidly pathetic expression of the Mother, with her half-closed mouth as if she had just spoken words destined to be unanswered, contrast with the silent abandonment of the dead Christ. Thus between them there is not so much a dialogue of glances as an interior monologue by the Virgin.

The strength of the canvas is not so much in the relationship between these two faces as in the play of hands. These represent

Bellini's favoured means of expression. Here there is the exhibited presence of the wounds of the Redeemer, the realism of the turgid veins on his forearms, and lastly the intimate emotional relationship created between the figures and the landscape, dominated by a sense of painful silence.

Interior design by Vittorio
Gregotti of the room
dedicated to Giovanni Bellini
and Andrea Mantegna, 1996

Works by Bellini,
Gentile da Fabriano,
Mantegna,
Titian, Lotto and
others are hung in a
section that includes
the Napoleonic rooms,
renovated during the
last rebuilding project.

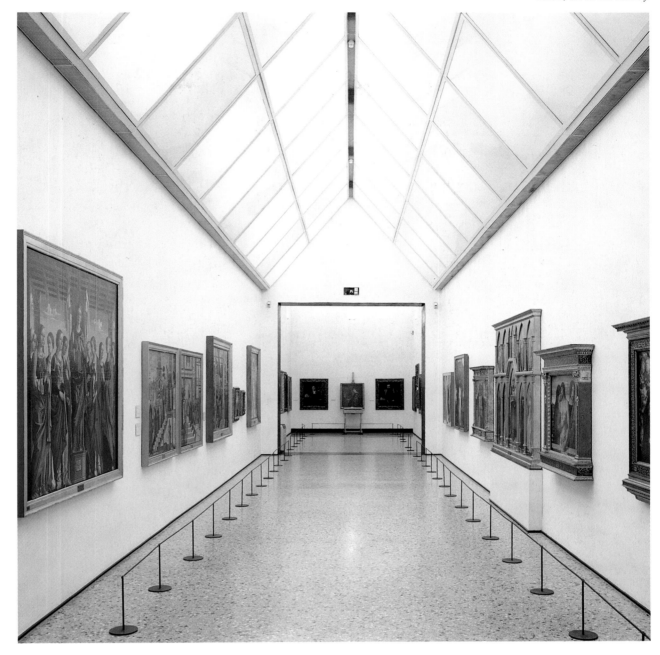

The last renovation

The last large-scale renovation project began in 1987. Vittorio Gregotti was responsible for works that mainly involve Rooms II-VII and the Napoleonic rooms. A new layout was created, while changes made to the arrangement of the other rooms allowed works that had previously been stored in deposit to be exhibited.
Room I was known as the Fresco Gallery as up until the seventies it housed Fifteenth and Sixteenth century frescoes from the Lombardy area. Today it temporarily houses paintings from the Jesi donation, especially from the first three decades of the century. It is followed by a section (Rooms II-XIX) that includes the Napoleonic rooms (VIII-XV) containing Lombardy paintings and fres-

coes from the Fifteenth and Sixteenth century with works by Bellini, Gentile da Fabriano, Mantegna (Room VI), Titian, Lotto, Cima da Conegliano, Bartolomeo Montagna, Vivarini, Bramante, Vincenzo Foppa, and then (Room XIX) the Leonardesque Boltraffio, Solario, Luini and Cesare da Sesto.
While Room XX houses paintings from Ferrara and Emilia from the Fifteenth century, the following Rooms (XXI-XXIII) contain the Fifteenth century polyptychs from the Marche (XXI), including Carlo Crivelli, and again works from Emilia and Ferrara up to the Sixteenth century, as well as the Brera's storerooms.

Bernardo Bellotto

The two *Views* (*View of Villa Perabò later Melzi in Gazzada* and *View of Gazzada*, oil on canvas, 64.5 × 98.5 cm.) in the Brera Gallery have always been considered Italian masterpieces by Bernardo Bellotto, painter of views and nephew of Canaletto. After 1747, the year he left for Dresden, the artist never returned to his homeland. He spent his mature artistic years at the service of the elector of Saxony, August III, and later Maria Teresa of Austria, the Bavarian elector and finally Stanislaw August Poniatowski, the king of Poland, for whom he painted not so much views of Venice as his uncle had done for English clients, but views of their own cities: Dresden, Munich, Vienna, Warsaw. The two *Views* at Brera represent the height of his stay in Lombardy in 1744. This visit turned out to be a crucial moment both for Bellotto and for local landscape painting. Due to a series of coincidences, until a few years ago the patronage of the two paintings was connected with the name of the Melzi family: five of the eleven Lombardy views by Bellotto entered the famous Villa Melzi in Vaprio d'Adda and the Melzi family were owners of the Gazzada villa during the Nineteenth century. Recently the Eighteenth century owners of the villa were identified as Gabrio and Giuseppe Perabò from Varese. This fact annuls the hypothesis that the works were commissioned by the Melzi family and suggests that the clients were instead these aristocrats from Varese who are also linked to Cardinal Giuseppe Pozzolonelli, a great collector and Bellotto's first Lombard client. As far as the first view is concerned, *View of Villa Perabò later Melzo in Gazzada,* careful analyses made during recent restoration work reveal that the only part prepared with rigorous geometrical drawing is in fact the villa. The most novel element is the very white and pure light coming from the left. It is the light of dawn captured as it rises, shining on the walls of the villa and highlighting it amidst the surrounding lush vegetation. The importance of this choice is great, as Bellotto abandons the extemporal splendour of other landscape painters, especially his uncle Canaletto, by deciding to fix the painting in a precise moment of the day: this is a fundamental step towards the birth of modern landscape painting. The villa is steeped in the light of dawn and the light produces long shadows that envelop the woods in the background in an aura of mystery. The hyperrealism of traditional landscape painting is here replaced with the focus on a sentimental and subjective element. Unlike the second *View*, this one is more like a caprice for its lack of geographic accuracy. Bellotto subjectively places elements of the landscape that do exist, but he groups them in a new way that emphasises and force all the attractions of the place inside the frame: the cabin in the foreground, the Varese lake with the village of Bodio on its banks, the Monte Rosa group of moumtains.

In the second view, which is a *pendant* of the first, there is no visible underlying design and the painting is perfectly consistent with the reality of the place: one can see the church spire and the little church of Santa Croce currently used as a transept for the new church and some rural cottages.

The principle of landscape painting as a photograph of a memorable place is here blatantly contradicted by the ordinariness of the village and the absence of any desire to ennoble it, the image is resolved in the expression of a day-to-day serenity. What Bellotto manages to communicate, especially to the artists of the Brera Academy where his paintings arrived in March 1831, bought by the antiquarian and restorer Alessandro Brison, is in particular the attempt to look at day-to-day landscapes, moving his easel from the alleys of the city to the open air of the surrounding countryside, and elevating the anecdotal to the level of the sublime. Apart from these innovations, Bellotto's painting distinguishes itself from Canaletto's work for its acute sense of phenomenal effects and a less distinct vision overall but at the same time more detached and attentive to details, at times somewhat misty and melancholy. These two paintings foreshadow the European turn soon to be taken in the first two official landscapes painted for Carlo Emanuele III in Turin (*Royal Palace and View of the ancient bridge on the Po*) which are the first examples of a "formal" landscape not merely for private consumption, but in any case tinged with a certain amount of intimacy that connects them with the Brera paintings.

What Bellotto managed to communicate, expecially to the artists of the Brera Academy where his paintings arrived in March 1831, after being by the antiquarian and restorer Alessandro Brison, was the study of daily landscapes.

Francesco Hayez

The last moments of the doge Marin Faliero on the lead staircase (oil on canvas, 238 × 192 cm.) takes its inspiration from Byron's 1821 drama of the same name, which Delacroix had already used for his famous *Beheading of Marin Faliero* in the Wallace Collection in London.

Hayez however contrasts Byron's political rehabilitation with an intense psychological and existential involvement in the tragedy of the individual oppressed by iniquitous power games. Marin Faliero, doge of Venice in 1354, was beheaded the following year accused of having conspired against the government of the city.

At the bottom of the dramatic staircase unfolds the drama of the doge stripped of his symbols of power and, condemned to death, on the point of bowing his head to the axe of the executioner, while the other surrounding principal characters observe the scene from up on a balcony decorated with arches.

Under the Austrian domination, especially after the events of 1820, censorship imposed reference to themes from past history in literature and figurative arts with representations of popular revolts or past events (as in *The inhabitants of Parga abandon their land*, 1826-31, Brescia, Tosio Martinengo Art Gallery). The crisis in the painting of history prompted Hayez to adopt a more European and select romantic repertoire linked to the history of Venice.

In this picture of Faliero the painter passes on to posterity his own self-portrait: the gesture of the painter protagonist who stretches out his hand framed by a purple cuff towards the instrument of his condemnation is like a denunciation certainly not extraneous to the national and European conscience. Proof of this is the inclusion of the painting in the international exhibitions in Munich (1869), Vienna (1873), and Milan at the National exhibition of 1872. The picture can thus be interpreted as a gesture of bitter faith in the "progressive" possibilities of that history to which he had dedicated his artistic militancy, placing the artists side by side with the vast number of disillusioned people of the period following unification. In this superb composition rich with figurative echoes of the Venetian tradition and, in a certain sense, exemplary of Nineteenth century historicism, there is also a formal coldness reminiscent of Munich Academicism and poses and gestures typical of melodrama. In this sense the dramatic use of the staircase is very effective, as well as the desolate loneliness of the drape in the foreground.

The painting was donated by the artist to the Brera Academy in 1867 after have been triumphantly presented at the exhibition of that year. It passed to the Gallery in 1882. Brera also conserves two preparatory sketches of the page boy holding the cushion on the left.

The great painting by Hayez was donated to the Academy of Brera by the artist in 1867 after having been triumphantly presented at the exhibition of that year, and was installed in the Picture Gallery in 1882. Two preparatory drawings for the page who holds the cushion on the left are also part of the Brera collection.

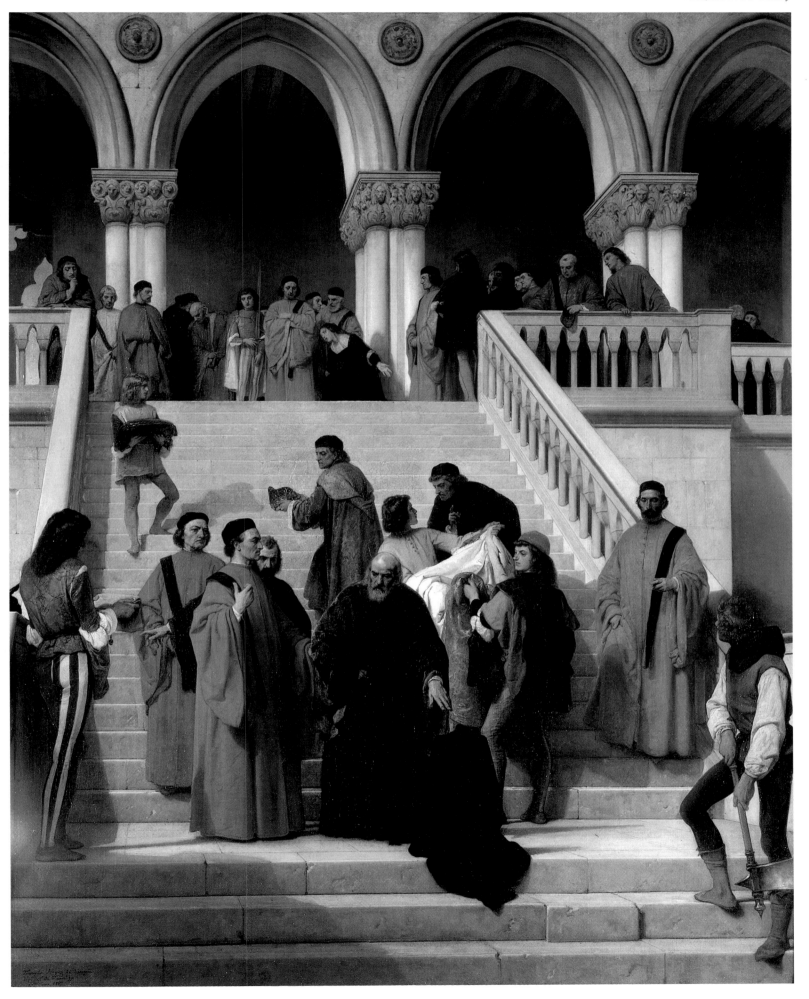

Giuseppe Pellizza da Volpedo

Swollen river (oil on canvas, 275 × 450 cm.) was recently donated to the Brera Gallery (1986) and is one of the preparatory versions of the imposing painting *The fourth estate* in the Civic Gallery of Modern Art in Milan. The work was done using the divisionist technique and was developed by the artist over a ten-year period in which he produced various versions. These versions are connected by the progressive expunction of descriptive elements of the scene in favour of the exaltation of a message of absolute value, which transcends the particular situation.

In the various stages of development the picture had different titles: *Ambassadors of hunger* developed in some sketches from 1891 to 1894 was the original idea of Pellizza, i.e. to represent a fact that occurred, in this case the non-violent protest of peasants from Vercelli due to the famine. The place chosen for the scene is the square of Volpedo, in front of the Malaspina building that belonged to the most important landowner of the village. The artist used his co-citizens as models, getting them to wear work clothes and depicting them in various studies.

This was followed by *Swollen river,* an intermediate version for which the master did a series sketches from real life, notes, and photographs until the painting was done in 1896. The title clearly assumes a symbolic value, while the lines of the surroundings tend to disappear and the sky takes on a stormy tone. The figures almost disintegrate into the colour, translucent, while only those in the foreground are well defined. In this way the picture has a vividness and genuineness of vision that relates it to the sketches. The final version finally takes the name of *The march of the workers* in 1897 and

The fourth estate in 1901. It no longer represents a chance event, but a tangible and known reality that is valid beyond the limits of space and time. Indeed, thanks to the ideological value of the picture, it becomes a symbol of the workers' movement. The protagonists are the worker friends and farm labourers, but they are simplified in their arrangement and number: the sun is in their faces, their bare hands are stretched forward united in protest. The group that starts the march almost as if to meet the spectator is made up of three figures who represent the three ages of man; the woman holding a naked baby in her arms symbolises the future generation as well as family values.

In this version the sky is more gloomy and the shadows are longer, while the surroundings are barely suggested. The impression of movement in the painting is very strong: the crowd's steps forward are emphasised by their advancing in close ranks, fading into the background. Here the divisionist brushstroke is more rigorously used, with small touches of colour that lend the surface an extraordinary vitality through a kind of vibration of light.

The chosen theme links Pellizza's painting with other works in verist style in which, through the depiction of contemporary social facts, the artist deals with political situations with the clear intention of denunciation. Examples of this are *The speaker of the strike by Emilio Longoni* (1891, Pisa, private collection) or the bronze high reliefs by Vincenzo Vela *The victims of labour* (1882, Rome, National Gallery of Modern Art).

The fourth estate was exhibited at the Quadriennale in Turin in 1902. It met with little enthusiasm from the critics at the time and was returned to the artist unsold. Instead

the novelty of the painting was immediately felt by the "popular" press who made it their own and circulated it, having understood the clearly symbolic and ideological content of the closely knit crowd of workers marching towards the conquest of their won rights.

The tradition of donations has continued with Stream, *donated to the Picture Gallery in 1986. It is one of the preparatory versions of the impressive canvas depicting* The fourth estate *on show at the Civic Gallery of Modern Art of Milan.*

The theme rooms

Room XXIV was completely renovated by Gregotti between 1983 and 1984. This created a new space for some of the most important paintings in Brera, including Piero della Francesca's *Brera Altarpiece,* Raphael's *The Wedding of the Virgin,* Bramante's *Christ at the pillar,* and Signorelli's *The Milk Madonna* and *The Flagellation of Jesus.*

After the fifteenth and Sixteenth century paintings from central Italy, including those by Bronzino, come the Bolognese works of the Seventeenth century, in particular Carraci and Guido Reni (while Room XXIV is dedicated to Caravaggio's *Supper at Emmaus),* followed by Seventeenth century Italian Lombard and Flemish works (Rooms XXXI-XXXIII). The next rooms contain Eighteenth

century Italian (XXXIV) and Venetian (XXXV) paintings, and finally genre paintings and Italian portraits from the Eighteenth century.

The last two rooms of the Brera Gallery are dedicated to Italian Nineteenth century works including *The Kiss* by Hayez, *Swollen river* by Pelizza da Volpedo, and Boccioni's self portrait from 1908.

Display criteria used at Brera

Brera Palace was built in the second half of the Fifteenth century. In 1571 it was converted into a Jesuit school and later renovated by Ricini in the first half of the Seventeenth century. It was not to be completed until the end of the development of the Brera was Giuseppe Bossi. Between 1801 and 1807, due to the didactic purposes of the new gallery, he proposed a selection of works with the particular aim of showing the artistic activity of painters who were collecting grew among the middle classes. The Brera Gallery reflected this trend by crowding the walls of the gallery with paintings from top to bottom. This kind of arrangement can be clearly seen in the painting reproduced here depicting the Hall of Columns at the end of the Nineteenth century. Only in 1892, with the separation from the Academy, under the direction of Giuseppe Bertini and later Corrado Ricci, radical changes were made in the way paintings were exhibited in Brera. With the coming of the new century, skylights were created to let in light from above, allowing the paintings to be seen fully. The paintings were also grouped together in schools in a strict chronological order. A larger number of rooms were also made available. In this way the walls were no longer overcrowded so each painting had enough space to be seen.

In 1924 the famous Milanese architect Piero Portaluppi was asked to completely re organise the rooms of the gallery. Unfortunately, all of Portaluppi's work was completely destroyed when the building was bombed during the second world war, though all its masterpieces had been removed. Rebuilding began in 1946 with work done by the architect Franco Albini. Portaluppi was later asked to rebuild the entire gallery. The whole museum was endowed with a grand and luxurious style. Some of the masterpieces were completely isolated from the other exhibits in small, specially made rooms. This

The relationship between a museum and its public is created through the display of works arranged in themes along a display route.

General view of the Hall of Columns in the Brera Palace as it is arranged today

Eighteenth century by Giuseppe Piermarini. Since 1803 it has housed the Brera Picture Gallery. As is clear from its history, the building was not originally designed to contain collections of pictures and works of art. It was only with the closing of religious orders in the late Eighteenth century and the setting up of the Academy of Fine Arts that an art gallery became necessary for students' use. A major contributor to the

his contemporaries. With the development of the Academy and donations made to it, the Brera Gallery was soon in need of new exhibition space. In 1806 the church of Santa Maria di Brera was demolished and divided internally into two floors. The architect Pietro Gilardoni created four rooms in the upper floor that still exist today, known as the "Napoleonic Rooms". During the Nineteenth century the taste for

created the effect of a cabinet of wonders, whose origins go back to the curiosity cabinets and *Wunderkammern* of the Renaissance. Portaluppi's layout aimed at exalting the masterpieces and being in itself a work of art.

In the early seventies, in keeping with new trends in museums at the time, all the walls were painted very dark green. The skylights were covered with drapes and spotlights were fitted.

Only with the new work begun in 1978 was the upgrading of Brera fully undertaken. Apart from the new layout of the rooms of Brera Palace, the gallery inside the Citterio building was enlarged. This project the work of architect James Stirling.

The new layout of the Brera rooms by Gregotti Associati (1983-92) completely restored the spaces designed by Piero Portaluppi, Franco Albini and

Ignazio Gardella. As for the other rooms, the project reinterpreted the structural layout of the building, and the design of the exhibition spaces was simplified. The lighting was created from above, and the flat skylights were replaced with raised skylights. The walls were treated with white cement and marble powder. The floors were done in "Venetian terrace" style. This layout was based on the most innovative choices

in museum design, and highlights the importance of the relation between walls and paintings. The final choice was therefore for something neutral where nothing must distract the observer's gaze from the works of art.

View of the Hall of Columns in the Brera Palace as it was arranged in the late Nineteenth century

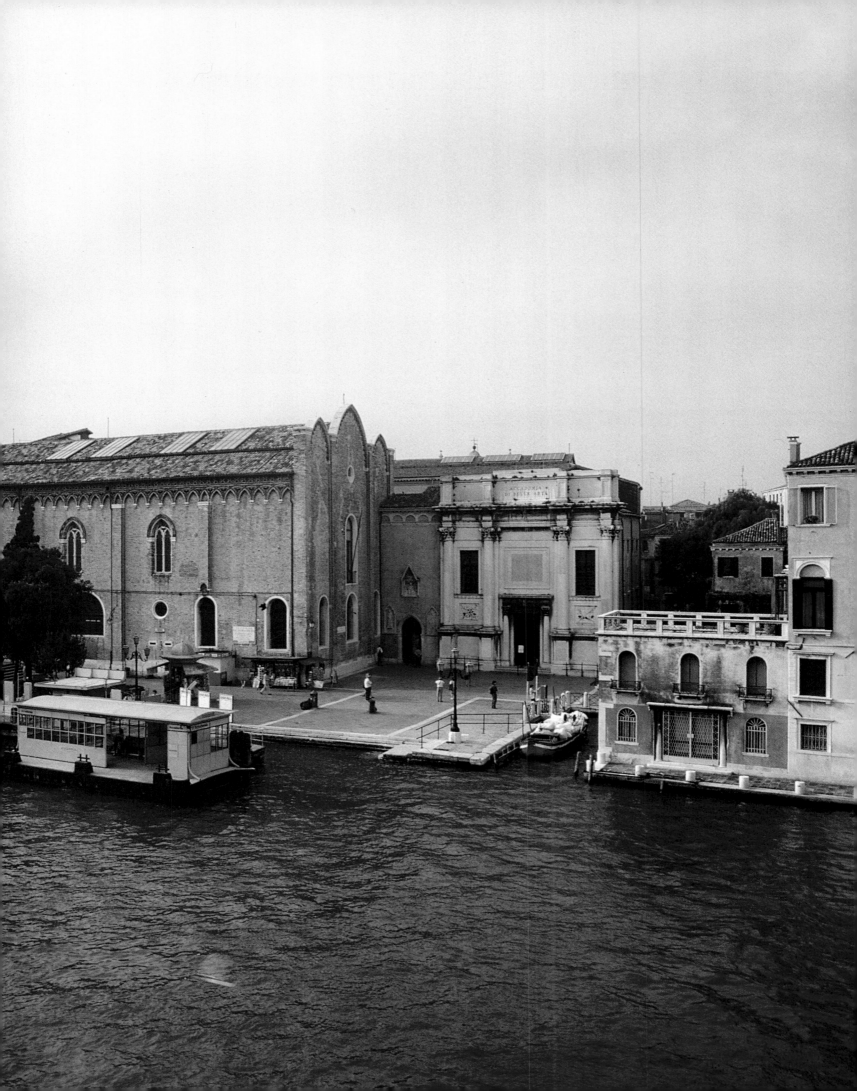

Venice, the Accademia Galleries

The Accademia, the most important *pinacoteca*—or picture gallery—in Venice and surrounding Veneto, is the museum *par excellence* in the region. This institution was born of political necessity and became an important tool to safeguard the city's historical and artistic patrimony. With the exception of the public sculpture gallery in the Marciana Library (now the Archaeological Museum), which was a gift of the Grimani family in 1593, the Signoria or government of Venice had no similar tradition of public collections except the few and not very interesting paintings that accumulated over the centuries in the Doge's Palace.

The fall of the Venetian Republic in 1797 marked the beginning of the suppression of the city's public magistracies and religious institutions, first by the provisional government and then by the Austrians. This policy was substantially continued after Venice was annexed to the Italic Kingdom in the wake of the treaty of Pressburg signed on December 26, 1805, and then in the successive decrees of 1806, 1808 and 1810.

The works of art that had belonged to these institutions, when they were not alienated, dispersed or even destroyed in order not to inflate the market, were transferred to the Brera Academy in Milan or were taken to decorate the various residences of the Viceroy. An unfortunately small part of them, given the huge number of objects in circulation, was entrusted to the Accademia, in Venice, which was founded by decree on December 12, 1807. The founding mission of this new institution was principally to teach art, but it did include a picture gallery which was to be organized for the benefit "of those who were painting." The attempt to bring an international dimension to the Accademia's collection—and it was and continues to be a collection representing a single school of art—lasted throughout the whole of the Nineteenth century. When the gallery became autonomous at the end of the century and its didactic purpose came to an end, it was precisely the single focus of the collection which was so interesting and which makes the Venetian *pinacoteca* unique in the world.

The Galleries

The museum's policy over the course of the Twentieth century grew from this circumstance: its Nineteenth century paintings were concentrated in the Museo d'Arte Moderna (the Museum of Modern Art) at the Ca' Pesaro and Flemish paintings as well as sculpture in the G. Franchetti Gallery at the Ca' d'Oro.

The division of the Accademia's collection, however, was motivated not simply by a desire to define its holdings in a particular way but also because of the chronic lack of space it suffers. This has led, over the years, to the storage of even important works of art outside the museum itself. Exhibition space at the Accademia, however, is being doubled with the removal of the art school, and the project for the "Grandi Gallerie" includes the laborious process of reassembling those alienated works. At the moment one can trace the highlights of Venice's extraordinary figurative tradition in the splendid rooms on the first floor of the Accademia and in the galleries above.

Paolo Veneziano

The central panel of the *Polyptych* represents the coronation of the Virgin with scenes from the life of Christ in the lateral panels. In the pinnacles above are images, on the left, of the *Pentecost, St. Matthew, St. Clare Taking the Veil, St. John, and St. Francis Giving his Clothes to his Father*, and on the right, *St. Francis Receiving the Stigmata, St. Mark, the Death of St. Francis, St. Luke*, and *Christ the Judge*; and at the centre and above, the prophets *Isaiah* and *Daniel*.

The Franciscan imagery and especially the little figure of a nun in the *Death of St. Francis*—probably the patron of the altarpiece as work comes from the Venetian church of Santa Chiara—date this work to about 1350. Veneziano's habit of mixing Western motifs with Byzantine characteristics of Venetian art is well documented and can be traced to his *Coronation of the Virgin* of 1324 in the National Gallery in Washington, D.C. The Accademia panel, however, is more complicated in its decorative motifs and in the heavier emphasis on the Byzantine qualities. The new stress on the Byzantine in the artist's work has led to the suggestion that he may have travelled to Constantinople where these tendencies would have been reinforced.

There is a remarkable difference between the small, lateral scenes and the large and extraordinarily refined calligraphic quality of the figures in the central panel figures. This marked disparity, however, is not enough to suggest the presence of another hand given the consistently high quality of the overall composition. Instead it seems that the artist is alternating the lavish, courtly language of Byzantium in the central panel, with its fixed, iconic quality that is well-suited to an event outside of human time and space, with specific references to western art in the narrative scenes.

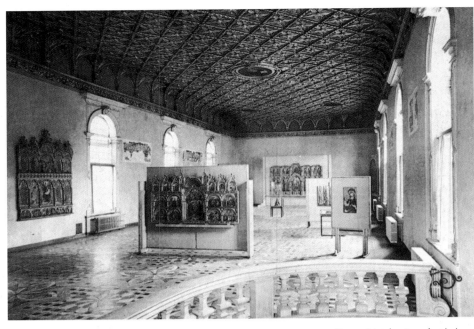

Room I in the Accademia in Venice, designed by Carlo Scarpa, 1950-52

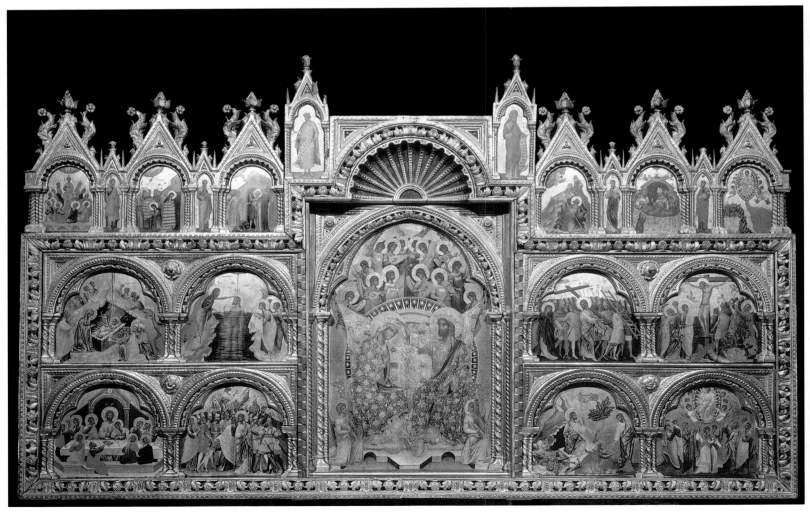

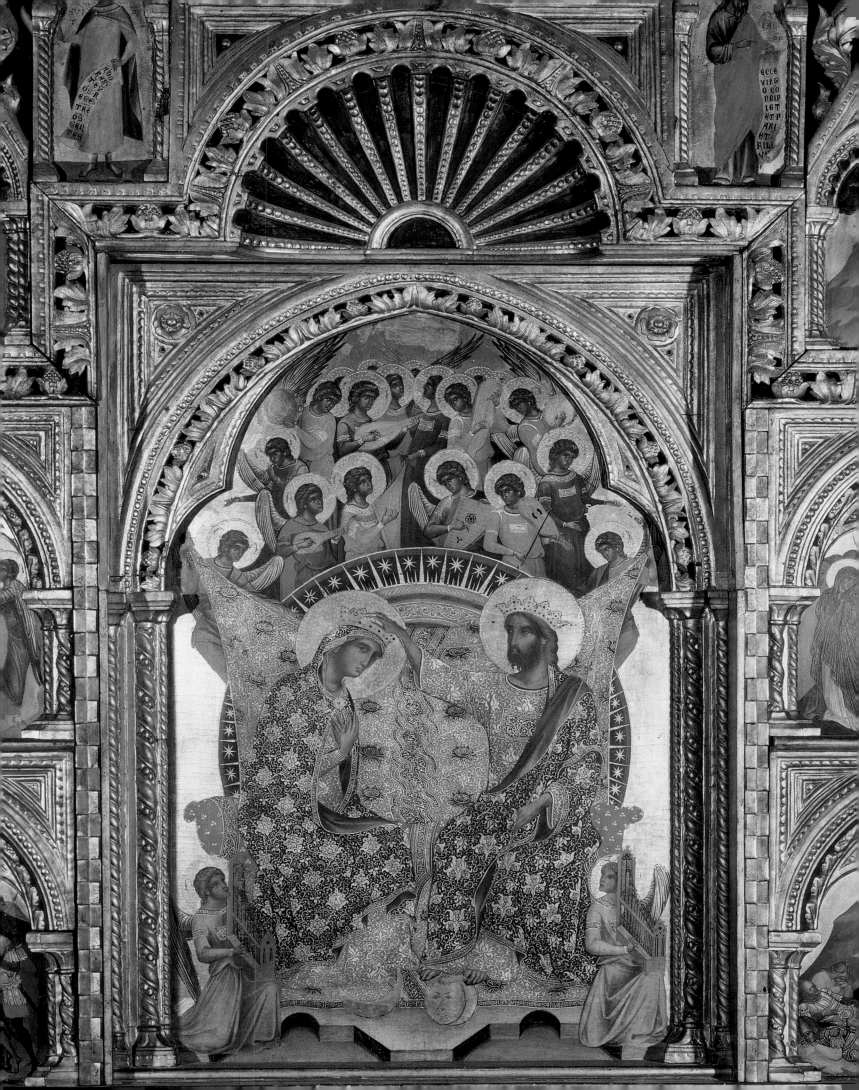

Change of location

At the beginning of the Nineteenth century, the Venetian Academy moved from the Fonteghetto della Farina at San Marco, its historical location, to the agglomeration of buildings that consisted of the monastery of the Lateran Canons, designed by Andrea Palladio in 1561, the church of Santa Maria della Carità, rebuilt by Bartolomeo Bon between 1441 and 1452, and the Scuola Grande of Santa Maria della Carità, founded in 1260 as the first of the Venetian *scuole*, or lay associations.

The architect Giannantonio Selva was commissioned to redesign the complex of buildings in 1811. The church was emptied of all its furnishings and divided both horizontally and vertically. Its Gothic windows were walled up and skylights were cut in the roof; five large rooms were created on the ground floor for the school and two above for exhibitions. A passageway was opened through the foundation wall of the Sala dell'Albergo creating a corridor that connected the various buildings of the complex to a small staircase.

The Scuola della Carità had already undergone some minor renovations in the Eighteenth century as well as major work carried out by Giorgio Massari and Bernardino Macaruzzi. The atrium on the ground floor was completely renovated in 1766, and the façade had been rebuilt a few years earlier with a large door at its centre that no longer corresponded to the old staircase which was then demolished. The twin ramps which lead up to the Chapter Room (Sala I) were built according to Macaruzzi's designs.

The small façade that connects the church and *scuola* remains, as does the red Verona marble doorway with the once coloured statues of the *Virgin and Child with the Faithful*, sculpted by Marco Zulian in 1435, and *Saints Christopher and Leonard*, dated to 1378. The Fourteenth century portal, now walled in because it serves no practical purpose, remains intact in the courtyard. It is surmounted by a lunette of colored stone with the symbol of the Scuola della Carità which commemorates the plague of 1348.

*The Sala dell'Albergo has conserved
its ceiling in gilt, colourful moulded plaster and
carved wood, with the Eternal Father
in the centre (probably taken, in the late Fifteenth
century, from an existing ceiling in
the chapterhouse destroyed by a fire)
and the four Evangelists in the corners.*

Titian, *Presentation
of the Virgin in the Temple*,
in the Sala dell'Albergo

The church of Santa Maria della Carità as laid out by Gino Fogolari after World War I

Current arrangement of the interior of the same church

Bernardo Bellotto

The Rio dei Mendicanti and the Scuola of San Marco (canvas, 41 × 59 cm.) was part of Gerolamo Manfrin's Venetian collection (listed in Pietro Edward's inventory), and the Accademia purchased it in 1856. Formerly thought to be a work by Canaletto, it is now unamimously accepted as by the young Bellotto at a time before his trip to Rome, probably at the beginning of 1741.

This view shows the Rio dei Mendicanti, also the subject of a famous picture by Canaletto now in the Ca' Rezzonico, with the Scuola of San Marco in the background. Some emphasis is also given to the Palazzo Dandolo on the right, and there are several figures sitting on its foundations. In addition to the exceptional "photographic" quality of the image, the play of light is extraordinary. It is bright in the distance, hot on the Scuola and the piazza and contrasting on the houses along the canal. Bellotto uses Canaletto's repertoire with both real skill and a certain amount of liberty, creating a masterpiece that was often reproduced by the last generation of Venetian copyists, including Francesco Zanin and Vincenzo Chilone.

The work by Bernardo Bellotto comes from the collection of Gerolamo Manfrin, as Pietro Edwards, first curator of the collections, notes in the catalogue of the Galleries.

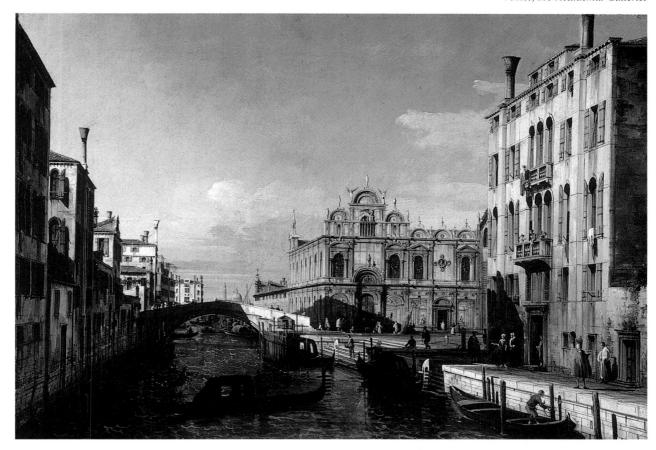

The rebuilding of the Scuola

The chapter room still has its rectangular, coffered ceiling decorated with scrolled acanthus leaves and, at the centre, the head of an angel with eight wings. This unusual motif confirms the legend that Ulisse Aliotti (which means, literally, eight wings), the *guardian grande* of the scuola in 1461 and thus certainly also the sponsor of the work on the room, had wanted to be remembered in this way. The ceiling was executed between 1461 and 1484 by Marco Cozzi from Vicenza; he was inscribed as a member of the *scuola* in these same years. Originally the ceiling also had five relief panels representing the *Madonna della Misericordia* and the symbols of the other *scuole grandi* in the city.

The Sala dell'Albergo also has its original, coffered ceiling of carved, gilded and polychrome wood and, at the centre, *God the Father* (which was likely reused from an earlier ceiling in the chapter room destroyed by a fire). The four Evangelists appear in the corners of the ceiling.

The convent, which had already been greatly restored after a fire in 1630, was not greatly altered in this first phase of the Accademia's construction. Selva kept most of what was there; he closed the arcades of the Ionic loggia to make a larger exhibition area, although he left the rounded arches open as windows. The cells on the uppermost floor were also reworked in order to create space for the engraving studios and living quarters for the instructors.

The first group of paintings and sculptures in the Accademia's collection were those that had belonged to the old academy; they were gifts and reception pieces used to admit a candidate to the institution.

It also included the works that had decorated the buildings incorporated into the new seat of the Accademia, and especially the *scuola* and the church as well as part of the collection belonging to Abbot Filippo Farsetti—a passionate collector—of plaster casts of ancient works and original terracotta *bozzetti* not sold at the time of his death by his great-nephew, Anton Francesco, to Czar Paul I of Russia. Farsetti's collection was acquired for the Accademia by the Austrian government in 1805.

Because the first curator of the collections, Pietro Edwards, often did not act quickly enough, some important works taken from Venice to Milan and significant ensembles were, absurdly, dismembered. Nonetheless, Leopoldo Cicognara, the President of the Accademia, worked hard to save the best of the works which had become the property of the state but were still *in situ*.

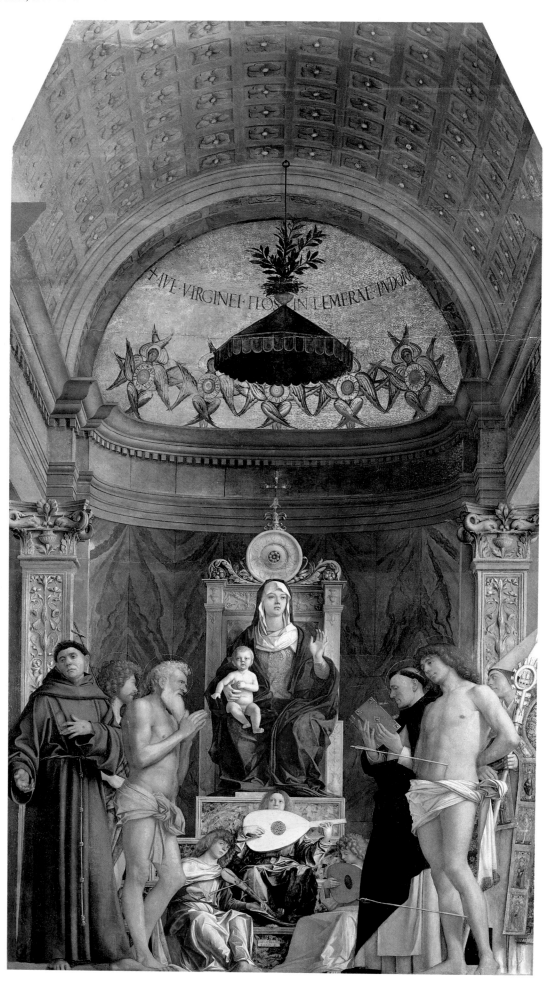

Giovanni Bellini

This work was originally installed in the church of San Giobbe, on the altar of the same name—the second on the right. The *San Giobbe Altarpiece* (panel, 471 × 292 cm.), which excited the admiration of its contemporaries and became a model for later altarpieces, is today fifty centimetres shorter than its original size. Originally the saints would have stood directly on the altar table. The presence of the plague saints, Sebastian and Roch, indicate that the work must have been executed in relation to an outbreak at the end of the 1470s and probably in 1478. This date corresponds with Vasari's statement that it was this work in particular that assured Bellini of the commission in 1479 to replace the destroyed canvases in the Ducal Palace. This work was certainly influenced by Bellini's likely acquaintanceship with the Franciscan mathematician, Luca Pacioli, a friend of Piero della Francesca and Leonardo da Vinci. The large niche is almost a symbolic representation of the Basilica Marciana from which the artist took the gilded mosaics in the half-dome of the apse, the marble decorations and even the seraphim who each hold an inscription that reads *ave gratia plena*. The life-sized figures within the niche are configured in a pyramidal form; within this pyramid the three small angels make a second and smaller one, and the triad of saints on the right and the left are similarly arranged in a triangular scheme.

The presidency of Leopoldo Cicognara

Edwards compiled the first catalogue of the 200 or so works in the Galleries in January 1812. In the same year Bonifacio de' Pitati's *The Rich Epulonius* was acquired from the viceroy Eugenio Beauharnais through the Grimani brothers.

At Cicognara's suggestion and for their own preservation, three altarpieces by Giovanni Bellini, Carpaccio and Basaiti were moved to the Accademia from the church of San Giobbe, and Titian's *Assumption of the Virgin* was transferred from the church of the Frari.

The sculptor Canova's intervention led to the return of the works of art Napoleon had taken with him from Venice to Paris. Paris Bordon's *Giving of the Ring to the Doge* and Jacopo Tintoretto's *Miracle of the Slave* from the now-suppressed Scuola of San Marco were also sent to the Accademia as were Paolo Veronese's *Feast in the House of Levi* from the monastery of Santi Giovanni e Paolo and his *Madonna and Child with Saint Zaccharias*.

Private donations also contributed to the growth of the Gallery's collections; Girolamo Molin's in 1816; Felicità Renier's in 1833, although it was not executed until 1850; and in the rich collection of Girolamo Contarini in 1838.

Bonifacio de' Pitati called Veronese, *The parable of the rich man*

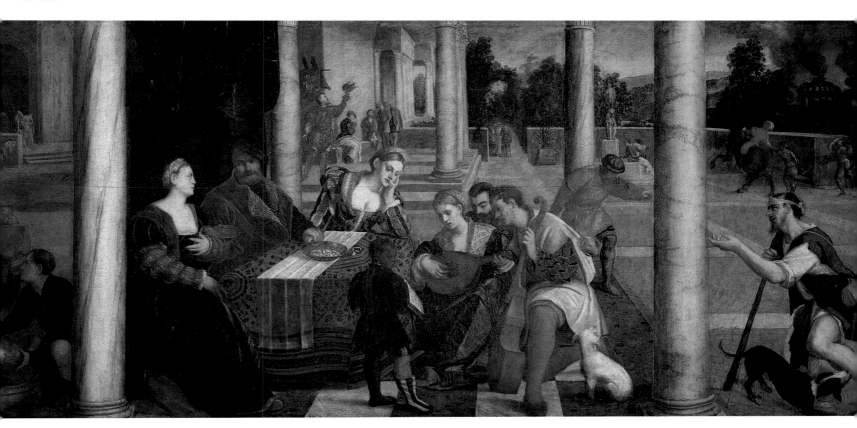

In 1812 Viceroy Eugenio Beauharnais purchased, the Rich Man *by Bonifacio de' Pitati; from the Grimani brothers, in the years 1815-16, on the suggestion of Cicognara, three large altarpieces were removed from the church of San Giobbe, and the great* Assumption *by Titian from the Frari.*

Paolo Caliari, called Veronese

Feast in the House of Levi (canvas, 555 × 1310 cm.) was executed for the refectory at the monastery of Santi Giovanni e Paolo to replace a *Last Supper* by Titian which was lost, along with the building itself, in a fire in 1571. It was paid for by one of the friars, Andrea De'Buoni or Buono, who also contributed to the cost of reconstructing the refectory itself. According to the inscription on the base of the pier on the left, work on the canvas was finished on April 20, 1572. Three months later, on July 18, the painter was brought before the Inquisition accused of heresy for having strayed too far from the traditional canon in depicting this vast composition alluding to the Last Supper. Questioned especially about the meaning of several figures—"the one with the bleeding nose," "the buffoon with a parrot on his hand," "the one who has a [piron] taking care of his teeth," "the soldiers dressed like Germans,"—Veronese defended his use of artistic license, "we painters…take the same license as do poets and madmen". Furthermore, all that was considered indecent was depicted "outside the place where they were dining" and in any case he was obliged to follow the example of his betters, citing among them Michelangelo himself. He was evidently unaware of the rules regarding religious art that had been approved by the Council of Trent only ten years earlier. His spirited defence notwithstanding, the trial ended with the injunction that Veronese correct and amend the painting within three months and at his own expense, "ita ut conveniat ultima coena…Domini." The only correction he made, however, likely with the cooperation of the patrons, the learned Dominican friars, was to add an inscription to the top of the pier which carries the date at its bottom, "fecit D. Covi Magnum Levi - Luca Cap. V," in order to avoid scandal. It does indeed say in Luke 5, "…there was, at the house of Levi a great banquet."

Analysis of pigment sections, X-rays, and infra-red photographs and especially reflectographs all confirm that there are no substantial corrections to the painting and that those that can be identified pertain to the creative process itself—for example variations in and over-painting of architectural details and slight adjustments to the profiles of the diners. A page who held a puppy with his right hand and extended his left arm across the plane of the table was painted out as Zanetti noted in 1771; the artist preferred to leave the white table cloth unobstructed. With regard to the injunction of the Inquisition, Veronese only added the inscription that alludes to the banquet hosted by Levi, thus justifying all the "indecencies" he painted including the loaf of bread on the table just in front of Levi in the form of a mask with eyes, ears and a wide-open mouth, mocking the stupidity of humankind.

At the fall of the Republic, the French commissioners chose not to take Jacopo Tintoretto's recently restored *Paradise* for the Louvre, substituting the *Feast in the House of Levi*, which was evidently in a bad state of repair, for it. Sent back to Venice in 1815, it was placed in the Accademia.

Although the sheer size of the composition suggests the presence of several hands, the exceptional use of colour and stylistic quality, the technique in the lower area of the figures and the extraordinary graphic skill in the architectural elements make it impossible to insist that assistants were at work here with Veronese. The artist's exploration of banqueting scenes concludes, in the *Feast in the House of Levi*, with a careful balance between the setting and the figures and appears truly to be "the best and most mature example of this kind of painting."

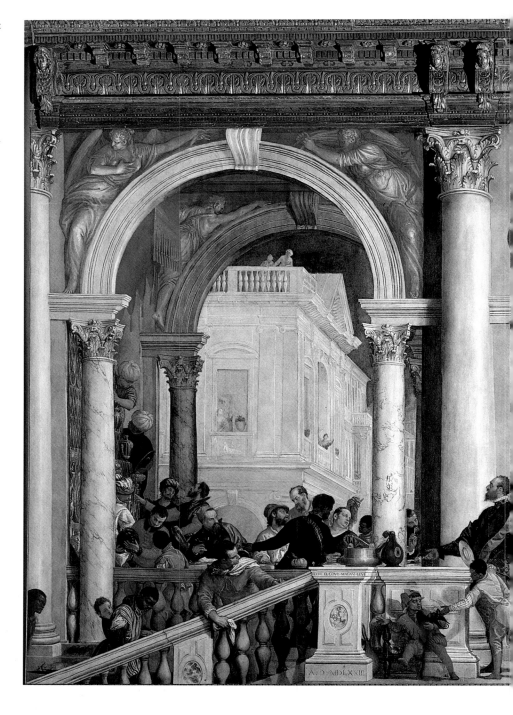

Thanks to the keen good offices of Canova,
the works Napoleon had taken
to Paris were also returned to Venice.
The Galleries received, among others,
the Saint Mark frees a slave *by Jacopo Tintoretto*
from the school of Saint Mark,
(that had been soppressed in the meantime),
and the Feast in the House of Levi
by Veronese, from the convent
of Saints John and Paul.

Drawings in the Accademia

The Accademia acquired Giuseppe Bossi's prestigious collection of drawings in 1822 through the efforts of Abbot Luigi Celotti, a dedicated collector and dealer, and despite the Brera Gallery's desire to have the same collection. Bossi was an extraordinarily cultured man who had contacts with much of the aristocracy and many of the intellectuals of his time. He was a painter and lecturer, and he held the post of secretary of the Brera Academy from 1801 to 1807. He owned a rich collection of drawings that included extraordinary sheets by Leonardo (including his *Vitruvian Man* and studies for the *Battle of Anghiari*), Michelangelo, Raphael, Dürer and Rembrandt and as well as Sixteenth and Seventeenth century drawings from the Italian schools of Bologna, Rome, Tuscany, Liguria and Lombardy and also the French, German and Flemish schools. Celotti also arranged for the acquisition, in 1824, of the 602 drawings by the architect Giacomo Quarenghi who had worked for a long time at the court of Catherine II in Russia; this collection is now the richest and most important deposit of his work anywhere. Over the course of the Nineteenth and Twentieth centuries, additions to the collection

Leonardo da Vinci, *Vitruvian man*

have included in particular the works of Eighteenth century Venetians; in 1882, for example, the Accademia acquired fourteen caricature heads by G.B. Piazzetta which are amongst the most beautiful of this type of drawing the artist made. In 1920 the Accademia exercised its right to pre-empt private sales, and it bought an album of 134 drawings by Sebastiano Ricci which was being auctioned off with other items from the estate of the sculptor Dal Zotto. This

album's twin was in the library of Anton Maria Zanetti the Elder, a Venetian collector and connoisseur, and is now in the Royal Collection at Windsor Castle, and it is so important because it contains examples of a variety of drawing techniques, from preparatory sketches to sheets for connoisseurs. On November 20, 1926, the Accademia again exercised its preemptory rights and purchased 140 drawings by Venetian and other Italian artists of the

Giambattista Piazzetta

Acquired through the dealer Ehrenfreund, there is an inscription on the back of the original canvas with the date 1740 written in an Eighteenth century hand that has been generally accepted by scholars. This is one of the artist's most famous works, and here he concludes his research into pastoral themes which began some years earlier with the *Pastoral Scene* (Chicago, Art Institute) and *Idyll on the Beach* (Cologne, Wallrat-Richartz Museum), both of which were commissioned by Field Marshal

Schulenburg. All three are part of the artist's felicitous period of light, luminous colours that his contemporaries defined as "sunny light."
This work is universally known as the *Fortune Teller* (canvas, 154 × 115 cm.), a title suggested by the pose of the woman on the left who seems to be pointing at the other woman's hand. There have, however, been many interpretations—political, symbolic and even a narrative telling of the stirring of love between the two youths on the right or at least in one of them. The fascination of the *Fortune Teller* resides in its subtle

grace, in the sensual light which floods it, in the extraordinarily refined colour relationships and in the serene knowledge of the woman at the centre, the sister, despite her rustic attire, of Giambattista Tiepolo's heroines.

In the Nineteenth and Twentieth centuries the collection was mainly enriched with Venetian paintings from the Eighteenth century, including works by G.B. Piazzetta and a "study block" by Canaletto that represents the most important collection of documentary sketches by the artist.

Seventeenth and Eighteenth centuries which had been presented for export and sale in Paris by Baron Ugo Salotti of Mori. In 1949 Guido Gagnola made a generous gift to the Accademia of a sketchbook by Canaletto, who is otherwise underrepresented in the gallery. The book contains the most important collection of the artist's documentary drawings. The holdings of Canaletto's drawings was further enlarged about ten years later with eight sheets with documentary sketches from the collection of A. Viggiano of Venice and formerly in the Corniani degli Algarotti collection. The gallery bought thirty-three drawings by Egidio dall'Oglio in 1981; they are the first secure examples of the graphic work of this student of G.B. Piazzetta. And finally, in August 1994, the Ministry exercised its right to preempt a sale to acquire fourteen more drawings by G.B. Piazzetta, formerly in the Alverà Collection. Thus although it contains only 3,143 works, the Accademia's collection of drawings is considered amongst the most important in the world for the extraordinary quality of its material.

Canaletto, *View of a porch*, 1765

The arrangement of the Galleries by Carlo Scarpa

In the years immediately after World War II, Carlo Scarpa, the director of the galleries, began a restructuring that signaled the end of an exhibition philosophy that had remained unchanged since the beginning of the century. Work on Scarpa's project began in 1945 and lasted for fifteen years, until 1960. Given the limitations of space and the set locations of some very large canvases, the goal was to reduce the number of works displayed and create a more logical circulation within the museum.

In 1955 Rooms IV and V were finished; they contain many of the museum's smaller masterpieces, including Giorgione's *Tempest* which was rescued from the dramatic isolation it endured in the years before World War II. Some fifty years later, Scarpa's arrangement of the museum, which has been preserved and even restored everywhere except the church where the central panels he had installed were removed to allow for a larger exhibition space, remains intact and appreciated for the overall formal coherence and rigorous beauty of its design.

The intervention by Carlo Scarpa was initially characterized by a drastic elimination of period interiors, tapestries, skirting boards and frames in style, which were replaced by natural plasterwork, wood in warm hues etc.; all materials were carefully chosen and skilfully combined.

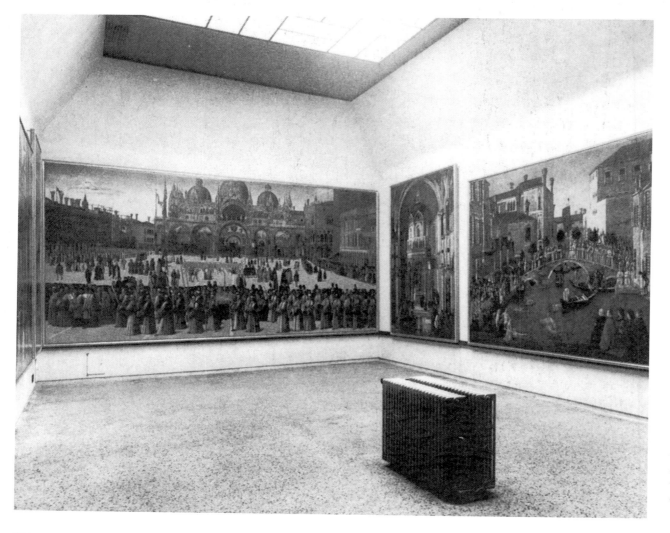

Giorgione

The Tempest (canvas, 82 × 73 cm.) was commissioned from the artist by his friend, Gabriele Vendramin, for his *camerino delle anticaglie* or curio room. Marcantonio Michiel saw it there in 1530. It was also recorded in an inventory made by Vendramin's heirs in 1567 and in another of 1601. The latter is the last documentary reference to the *Tempest* until 1855 when Burckhardt noted it in the Palazzo Manfrin. The Manfrin sold their collection of paintings in 1856, but this work was only acquired by Prince Giovanelli in 1875. His nephew Alberto inherited it and later sold it to the government for the Accademia in 1932.

There have been innumerable intrepretations of the subject of this work which was hard even for the artist's contemporaries to decipher. It may represent Venus or perhaps the discovery of Paris or Moses, it might also be an allegory of the forces of nature or an image of Venus and Mars. The argument that it represents Adam and Eve nursing Cain, is less plausible given that the supposed snake at Eve's feet is just a root. The most plausible interpretation identifies the youth whose multi-coloured tights indicate that he is a member of the Compagnia della Calza, as was Gabriele Vendramin himself who was little more than twenty when the work was commissioned in 1505. There are also many iconographical similarities with some of the images in Francesco Colonna's famous book, the *Hypnerotomachia Poliphili*, published in Venice by Aldo Manuzio in 1499. This painting is a work that was certainly produced in a refined Humanist circle in Venice; its members would have been very fond of hidden subject matter which could be understood only by an educated few.

Vittore Carpaccio

The *Miracle of the Relic of the Cross on the Rialto Bridge* (canvas, 363 × 406 cm.) was part of a cycle that decorated the walls of the Sala dell'Albergo in the Scuola di San Giovanni Evangelista, which housed a relic of the True Cross given to the confraternity in 1369 by Filippo de Mezières, grand chancellor of the kingdom of Cypress. The cycle celebrated the miracles attributed to this relic. The most detailed documentary source for the paintings is a pamphlet published in 1590 which describes the miracles and gives the name of each artist as well as the year his work was executed.
When the association was suppressed in 1820 this and the other works were sent to the Accademia. Carpaccio's canvas tells the story of a madman cured, with the help of the relic by Francesco Querini, patriarch of Grado. The documents record, too, that in 1544 Titian, described as "prudente messer Tizian pictor" cut away a strip of the canvas on the lower left to accommodate a recently opened door that led to the "Albergo Nuovo." This lacuna was then later arbitrarily filled, as we see in a preparatory drawing in the Albertina in Vienna, for the figure seen from behind and the small boy to the right. The miracle, which is witnessed by the Venetian patricians and members of Scuola and Compagnie della Calza represented in the foreground, passes unobserved by the kaleidescopic view of the city itself, seen at one of its crucial intersections and at a time roughly contemporary with Jacopo de' Barbari's map of Venice. The Rialto bridge is still the wooden one built in 1458 with a drawbridge at the centre to allow for larger ships to pass under it; it collapsed in 1524 and was replaced by the stone bridge still there today. The insignia of the the Albergo dello Storione

and the loggia, a meeting place for those who went to the market, is visible on the left. We can identify on the left the Fondaco dei Tedeschi destroyed by fire in 1505, the Ca' da Mosto with its still extant ground floor portico as well as the bell towers of San Giovanni Crisostomo and Santi Apostoli, the latter rebuilt in 1672. A comparison with the punctilious, analytical realism of the other canvases reveals even more strongly Carpaccio's sense of colour and the extemporaneous narrative quality of his work. The most plausible date for this canvas is 1494, the same as that given in the Sixteenth century pamphlet. An X-ray of this work reveals a lovely preparatory drawing in metal point on a ground of gesso and glue beneath the painted surface.

As part of his first works,
Scarpa united the draperies depicting
the Miracles of the Cross *in a room that
had been constructed specifically
in 1940 (Room XIX)
alongside the corridor leading
to the Orsola Room,
and the two rooms, reserved for very
closely linked cycles of works,
were connected by a small gallery.*

The Galleries and Carlo Scarpa

Work on Scarpa's project (1945-1960) included the drastic elimination of period settings, dated furnishings, wooden bases and imitation cornices. They were replaced with neutral plasters with a special texture, warm wood tones, jute, fustian, iron and glass—materials all carefully selected and juxtaposed. In 1947 the scenes of the *Miracles of the Cross* were hung together in a room that had been especially constructed for this purpose in 1940 (Room XIX) beside the corridor that leads to the Ursula Room. The two rooms meant for the

exhibition of closely related cycles of work were also connected by a small balcony. This was the first intervention here, and the room was improved in 1959-1960 when it was given its present configuration. In 1947, too, the exemplary arrangement of the Ursula Room was finished; the pre-existing mixture of historical truth and falsehood was eliminated as were the series of small, Eighteenth century rooms, in order to create a single, large open space. A year later fifteen paintings were hung on moveable panels in the church, the walls of which were stripped

down to the original decorations and then illuminated by four new skylights, in an arrangement that was meant to look like a temporary installation in full respect of the surviving architectural structure. Room I was reorganized between 1950 and 1952; its windows, closed over the course of the Nineteenth century to enlarge the space for exhibiting works, were reopened and the surviving fragments of late Fourteenth century century frescoes in the room were restored. At the same time the view into the badly proportioned room that had housed

Interior design of the rooms dedicated to Giorgione and Bellini (Rooms IV and V)

Titian's *Assumption of the Virgin* (returned to the Frari in 1919) was blocked with a masonry wall on which Lorenzo Veneziano's *Lion* polyptych was hung. The new entrance, with its now famous compass, was built between 1950 and 1953, and Rooms IV and V were finished in 1955.

The *Stories of Saint Ursula* laid out by Gino Fogolari after World War I.

Interior design of the *Stories of Saint Ursula*, by Vittore Carpaccio (Room XXI)

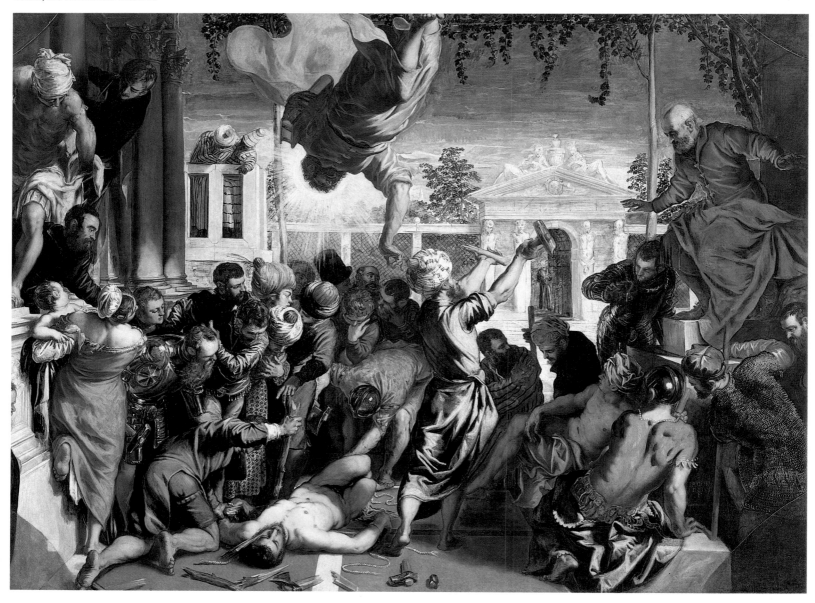

Tintoretto (Jacopo Robusti)

Saint Mark Liberating a Slave (canvas, 416 × 544 cm.) is the first painting Tintoretto made for the Chapter Room in the Scuola Grande of San Marco. It was taken to Paris in 1797 and sent back to Venice in 1815, when it was put at the Accademia because the *scuola* had been suppressed in the meantime.
As early as November 30, 1542, the Scuola of San Marco had decided to decorate its chapter room with a series of canvases depicting scenes from the life of Saint Mark. This work was probably commissioned in 1547 when Marco Episcopi, whose daughter, Faustina, would later marry the artist, was the *guardian*

grande of the institution. It was finished by April 1548 when Aretino, writing to Tintoretto, was able to sing its praises.
The miracle represented comes from Jacopa da Voragine's *Golden Legend*, according to which a Provençal knight's slave, condemned to being blinded and having his legs broken because he had gone to venerate the saint's relics against his master's wishes, was miraculously freed. Admiration for the work with its strongly foreshortened figure of Mark and its unexpected, intense use of colour was immediate as, too, was criticism of it. Ridolfi (1648) tells us that there was a debate among the members of the Scuola about whether to keep it and that an

indignant Tintoretto took it back to his studio. After tempers were soothed, it was returned.
The artist's diverse interests come together in this work, and especially his study of Michelangelo through a series of methodical drawing exercises, as well as the strength of a vision which could not but produce wonder and discomfiture at the same time. The complexity of the space, which moves from the large figures in the foreground to the delicate architecture in the background, is matched by violent contrasts of light and shadows and the double light source—one from outside the painting to the right and the other from the depths of the picture itself. The viewer is "immediately involved in and made a

participant of the events". Vasari (1568) pointed out that there are a number of portraits inserted in this work including Tintoretto himself as the young, bearded man on the left, Aretino in the figure between the columns on the left and Tommaso Rangone, a famous doctor and *guardian grande* of the Scuola in the solitary figure in the left foreground. The latter is the only identification that can be sustained.
There is a studio copy of this painting in the Pinacoteca in Lucca and another copy, attributed in part to Antonio Zannoni, in the Uffizi. There is a third but smaller copy in the sacristy of the church of the Tolentini in Venice.

*The Galleries of the Accademia
have been continually enriched.
The* Portrait of a gentleman *by Lorenzo Lotto
was purchased in 1930 from
the collection of Count Eduardo
di Rovero in Treviso.*

Lorenzo Lotto

Formerly in the collection of Count Eduardo di Rovero in Treviso, this painting was acquired in 1930. The carefully studied introspection and subtle melancholy of this young gentleman makes this perhaps Lorenzo Lotto's most masterful portrait. The most recent restoration of the *Portrait of a Nobleman in His Study* (canvas, 98 × 111 cm.), which has suffered some surface abrasion, revealed the special cool tonality of the colour, the objects behind the sitter, a bag and perhaps a horn which had not been decipherable before as well as the lower part of the figure's body which had only been easily visible in the X-ray. The sitter is caught at a moment when he, distracted from his reading, is absorbed in recondite and consuming thought. The light coming from the left reveals a very lovely still-life of objects with symbolic meaning—an ink well, a green lizard, a letter with a broken seal, and the rose shedding its petals— on the desk. This repertoire of allegorical symbols, probably alluding to a lost love as the ring placed on the table seems to confirm, is also evidence of the artist's refined culture.

It has been suggested that the sitter is Alessandro Cittoliní who, with Lotto, witnessed Sebastiano Serlio's will on April 1, 1528, at the Dominican convent of Santi Giovanni e Paolo in Venice where the artist was staying at the time. This work is close to the *Portrait of Andrea Odoni* dated to 1527 and now at Hampton Court.

Italian museums

The following is a list of museums of special interest for the particularity and richness of their collections. The list is divided into regions (from northern to southern Italy), with museums listed in alphabetical order. The list is a select choice from over 2,770 museums in Italy. For greater clarity, it is divided into four different types of museum.

1. *Museums that spring from the collections of royalty, princes, aristocrats and the upper middle classes, often housed inside the historical buildings they originate from. In most cases these museums are picture galleries, followed by collections of antiques and sculpture.*	**Piedmont**	**Agliè**	Museo del Castello Ducale Piazza Castello 2	*Archaeological museum and picture gallery*
		Nichelino	Museo di Storia, Arte ed Ammobiliamento Palazzina di Caccia di Stupinigi Piazza Principe Amedeo 7 Stupinigi	*Museum of decorative arts (furniture and carriages) and picture gallery*
		Saluzzo	Museo Civico di Casa Cavassa Via San Giovanni 5	*Picture gallery and collections of fine art*
		Stresa	Palazzo Borromeo - Isola Bella	*Picture gallery and collections of fine art*
			Palazzo Borromeo - Isola Madre	*Picture gallery and collections of fine art*
		Turin	Armeria Reale Piazza Castello 191	*Savoy collection of arms*
			Galleria Sabauda Via Accademia delle Scienze 6	*Picture gallery*
			Palazzo Reale	*History museum, furniture, picture gallery*
	Liguria	**Genoa**	Galleria di Palazzo Reale Via Balbi 10	*Picture gallery*
			Galleria Nazionale di Palazzo Spinola Piazza Pellicceria 1	*Picture gallery*
	Lombardy	**Mantua**	Galleria e Museo di Palazzo Ducale Piazza Sordello 40	*Picture gallery and collections of fine art and archaeology*
			Museo Civico Viale Te	*Archaeological museum and picture gallery*
			Museo di Palazzo d'Arco Piazza C. d'Arco 4	*Picture gallery and museum of decorative arts and furniture*
		Milan	Pinacoteca Ambrosiana Piazza Pio XI 2	*Picture gallery and collections of fine art*
		Monza	Pinacoteca Civica Villa Reale	*Picture gallery*
		Teglio	Museo Nazionale Palazzo Besta Via F. Besta	*Archaeological museum and picture gallery*

	Tremezzo	Museo di Villa Carlotta Via Regina 2	*Picture gallery and museum of decorative arts*
Veneto	Rovigo	Accademia dei Concordi Piazza Vittorio Emanuele II 14	*Archaeological museum and picture gallery*
	Venice	Basilica di San Marco Piazza San Marco	*Museum of sacred gold-plate, collections of fine art, archaeology, picture gallery*
		Biblioteca Nazionale Marciana Piazzetta San Marco 13	*Exhibitions of codices and manuscripts*
		Galleria della Fondazione Querini Stampalia Castello 4778 Santa Maria Formosa	*Picture gallery and museum of decorative arts and furniture*
		Palazzo Ducale Piazzetta San Marco	*Picture gallery and furniture museum*
		Pinacoteca e Museo dei Padri Armeni Mechitaristi Isola di San Lazzaro degli Armeni	*Archaeological museum, picture gallery and collections of fine art*
	Verona	Museo Lapidario Maffeiano Piazza Bra	*Museum of archaeology, art, history and documentation*
Trentino-Alto Adige	Trent	Castello del Buonconsiglio Monumenti e Collezioni Provinciali Via Bernardo Clesio 5	*Museum of archaeology, art, history and documentation*
Friuli-Venezia Giulia	Trieste	Castello di Miramare	*History museum, furniture*
Emilia-Romagna	Ferrara	Casa Romei Via Savonarola 30	*Art museum*
		Civico Museo di Schifanoia Via Scandiana 23	*Archaeological museum and picture gallery*
		Palazzina di Marfisa d'Este Corso Giovecca 170	*Art museum*
	Fontanellato	Museo della Rocca Sanvitale Piazza Matteotti 1	*Picture gallery and furniture museum*
	Modena	Galleria Estense Piazza Sant'Agostino	*Picture gallery and collections of fine art*
	Parma	Galleria Nazionale Piazza della Pilotta 5	*Picture gallery*
	Piacenza	Collegio Alberoni Via Emilia Parmense 77	*Picture gallery and collections of fine art*
	Reggio nell'Emilia	Galleria Civica Anna e Luigi Parmeggiani Corso Cairoli 2	*Picture gallery*
	Traversetolo	Fondazione Magnani Rocca Via Vecchia di Sala 18 Mamiano	*Picture gallery and collections of fine art*
Tuscany	Florence	Galleria Corsini Via del Parione 11	*Picture gallery and collections of furniture and decorative arts*
		Galleria degli Uffizi e Corridoio Vasariano Piazzale degli Uffizi	*Picture gallery and collections of fine art and archaeology*
		Museo degli Argenti Piazza Pitti	*Museum of gold craft*
		Palazzo Vecchio e Quartieri Monumentali Piazza della Signoria	*History museum, furniture, picture gallery*
		Villa Medicea La Petraia Via della Petraia 41	*Picture gallery and furniture museum*

Latium	**Rome**	Galleria Borghese Piazza Scipione Borghese 5	*Collections of archaeology and fine art, picture gallery*
		Galleria Colonna Via della Pilotta 17	*Collections of archaeology and fine art, picture gallery*
		Galleria d'Arte Antica Corsini Via della Lungara 10	*Picture gallery*
		Galleria Doria Pamphilj Piazza del Collegio Romano 2	*Collections of archaeology and fine art, picture gallery*
		Galleria Pallavicini Via XXIV Maggio 43	*Collections of archaeology and fine art, picture gallery*
		Galleria Spada Piazza Capo di Ferro 13	*Picture gallery*
Campania	**Caserta**	Appartamenti Storici del Palazzo Reale e Museo Vanvitelliano Via Donet 2/a	*History museum, furniture, collections of fine art and picture gallery*
	Naples	Museo di Palazzo Reale Piazza Plebiscito 1	*History museum, furniture, collections of fine art and picture gallery*
		Museo e Gallerie Nazionali di Capodimonte Via Milan 2	*History museum, furniture, collections of fine art and picture gallery*
		Museo Principe Diego Aragona Pignatelli Cortes Riviera di Chiaia 200	*Museum of applied arts*

2.
Museums based on legacies of private collectors, purchases by public institutions and placing of works in museums, architectural and sculptural fragments, fragments of paintings and other artefacts resulting from the transformation of urban centres (from mid-Nineteenth century on) and the closure of monasteries and convents (Napoleonic laws).

Valle d'Aosta	**Aosta**	Museo Archeologico Regionale Piazza Roncas	*Archaeological museum*
Piedmont	**Alessandria**	Pinacoteca Civica Via Tripoli 16	*Picture gallery and collections of fine art*
	Asti	Pinacoteca Civica e Museo Civico Corso Alfieri 357	*History museum, documentation, collections of fine art and picture gallery*
	Casale Monferrato	Museo Civico Via Cavour 5	*Archaeological museum, collections of fine art and picture gallery*
	Cherasco	Museo Civico Giovan Battista Adriani Via Ospedale 40	*Archaeological museum, collections of fine art and picture gallery*
	Novara	Galleria d'Arte Moderna Paolo e Adele Giannoni Via Fratelli Rossetti 20	*Picture gallery*
	Savignano	Museo Civico e Gipsoteca Calandra-Galateri Via San Francesco 17	*Archaeological museum, collections of fine art, picture gallery, collection of plaster casts by the sculptor Calandra*
	Turin	Fondazione Accorsi Via Po	*Musum of decorative arts, furniture, picture gallery*
		Museo Civico di Arte Antica e Palazzo Madama Piazza Castello	*Museum of decorative arts and picture gallery*
	Varallo	Pinacoteca Via Don P.Calderini 25	*Museum of decorative arts and picture gallery*
	Verbania	Museo del Paesaggio Via Ruga 44	*Picture gallery*
	Vercelli	Museo Camillo Leone Via Verdi 30	*Archaeological museum, picture gallery*
		Museo Francesco Borgogna Via Borgogna 8	*Picture gallery and collections of fine art*

Liguria	**Genoa**	Galleria di Palazzo Bianco Via Garibaldi 11	*Picture gallery and collections of fine art*
		Galleria di Palazzo Rosso Via Garibaldi 18	*Picture gallery and collections of fine art*
		Museo dell'Accademia Linguistica di Belle Arti Largo Pertini 4	*Picture gallery*
		Raccolta Frugone Villa Grimaldi Fassio Via Capolungo 9 Nervi	*Picture gallery*
	La Spezia	Museo Civico d'Arte Antica, Medievale e Moderna Amedeo Lia Via Prione 234	*Picture gallery and collections of fine art*
	Savona	Pinacoteca Civica Corso Mazzini	*Picture gallery*
Lombardy	**Bergamo**	Pinacoteca dell'Accademia Carrara Piazza Carrara 82/a	*Picture gallery*
	Brescia	Museo della Città Via Musei 81/b	*Archaeological museum, decorative arts, collections of fine art*
		Pinacoteca Civica Tosio-Martinengo Piazza Moretto 4	*Picture gallery*
	Castellanza	Museo Pagani Via Gerenzano 70	*Picture gallery*
	Chiari	Fondazione Morcelli- Repossi Via B. Varisco 9	*Picture gallery*
	Como	Musei Civici: Museo Archeologico Paolo Giovio e Museo Storico Giuseppe Garibaldi Piazza Medaglie d'Oro 1	*Museum of archaeology, history and documentation, picture gallery*
	Crema	Museo Civico di Crema e del Cremasco Via Dante 49	*Museum of archaeology, ethnography, history and documentation, picture gallery*
	Cremona	Museo Civico Ala Ponzone Via U.Dati 4	*Archaeological museum, collections of applied arts, picture gallery*
	Gallarate	Civica Galleria d'Arte Moderna Via Milan 21	*Picture gallery*
	Gazzada Schianno	Raccolta di Villa Cagnola Via Cagnola 17/19	*Picture gallery and collections of fine art*
	Lissone	Civica Galleria d'Arte Contemporanea Piazza Libertà	*Picture gallery*
	Lodi	Museo Civico Corso Umberto 63	*Archaeological museum, picture gallery*
	Lovere	Galleria dell'Accademia di Belle Arti Tadini Via Tadini 22	*Archaeological museum, picture gallery*
	Milan	Civico Museo d'Arte Contemporanea (CIMAC) Piazza Duomo 12	*Picture gallery*
		Galleria d'Arte Moderna Via Palestro 16	*Picture gallery*

	Milan	Musei Civici del Castello Sforzesco Piazza Castello	*Collections of archaeology , decorative arts, picture gallery*
		Museo Bagatti Valsecchi Via del Gesù 5	*Museum of decorative arts and furniture*
		Museo del Design - Collezione Permanente del Design Italiano 1945-1990 Viale Alemagna 6	*Museum of applied art*
		Museo del Duomo Piazza Duomo 14	*Collections of fine art and picture gallery*
		Pinacoteca di Brera Via Brera 28	*Picture gallery*
	Monza	Museo Filippo Serpero del Tesoro del Duomo Piazza Duomo	*Museum of gold craft, picture gallery*
	Pavia	Musei Civici Viale XI Febbraio	*Museum of archaeology, ethnography, history and documentation, picture gallery*
	Sondrio	Museo Valtellinese di Storia e Arte Via Quadrio 27	*Picture gallery and collections of fine art*
	Suzzara	Galleria Civica d'Arte Contemporanea Via Guido da Suzzara 48/b	*Picture gallery*
	Varese	Musei Civici - Castello di Masnago Galleria Civica di Arte Contemporanea Via Manguelfo - Masnago	*Collections of fine art and picture gallery*
Trentino-Alto Adige	**Bolzano/Bozen**	Museo Civico Via Cassa di Risparmio 14	*Ethnography museum and collections of fine art*
	Bressanone/Brixen	Museo Diocesano Piazza Vescovile	*Collections of fine art and picture gallery*
	Riva del Garda	Museo Civico Piazza Cesare Battisti 3	*Archaeological museum, picture gallery*
	Rovereto	Museo Civico Borgo Santa Caterina 43	*Museum of archaeology, ethnography and natural history*
		Galleria Museo Fortunato Depero, Via della Terra 53	*Picture gallery*
Veneto	**Bassano del Grappa**	Museo Civico Piazza Garibaldi 4	*Museum of archaeology, history and documentation, picture gallery*
	Belluno	Museo Civico Piazza Del Duomo 16	*Archaeological museum, picture gallery*
	Feltre	Galleria d'Arte Moderna Carlo Rizzarda Via del Paradiso 8	*Museum of artistic ironwork, picture gallery*
		Museo Civico Via Luzzo 23	*Museum of archaeology, history and documentation, picture gallery*
	Padua	Musei Civici agli Eremitani Piazza Eremitani 8	*Archaeological museum and picture gallery*
	Treviso	Museo Civico Luigi Bailo Borgo Cavour 24	*Archaeological museum and picture gallery*
	Venice	Civico Museo Correr Piazza San Marco 52 Procuratie Nuove	*Museum of history, decorative arts and documentation, picture gallery*

	Venice	Collezione Peggy Guggenheim Dorsoduro 701	*Picture gallery of* *contemporary art*
		Galleria Giorgio Franchetti alla Ca' d'Oro Cannaregio 3932 Calle Ca' d'Oro	*Picture gallery*
		Galleria Internazionale d'Arte Moderna Santa Croce 2078	*Picture gallery*
		Gallerie dell'Accademia Dorsoduro 1050 - Campo della Carità	*Picture gallery*
	Verona	Fondazione Museo Miniscalchi-Erizzo Via San Mammaso 2/A	*Picture gallery*
		Museo Civico di Castelvecchio Corso Castelvecchio 2	*Archaeological museum* *and picture gallery*
	Vicenza	Museo Civico - Pinacoteca di Palazzo Chiericati Piazza Matteotti 37	*Picture gallery and* *collections of fine art*
Friuli-Venezia Giulia	**Cividale del Friuli**	Museo Archeologico Nazionale Piazza Duomo 13	*Archaeology, history* *and documentation* *museum, picture gallery*
	Gorizia	Musei provinciali di Gorizia - Sedi di Borgo Castello Borgo Castello 13	*History and documentation* *museum, picture gallery*
	Gradisca d'Isonzo	Museo Documentario della Città Via Bergamas 30	*Archaeology, history,* *and documentation museum*
	Pordenone	Museo Civico d'Arte Corso Vittorio Emanuele II 51	*Picture gallery*
	Trieste	Civico Museo di Storia e Arte e Orto Lapidario Via Cattedrale 15	*Archaeology and history* *museum, and picture gallery*
		Civico Museo Pasquale Revoltella e Galleria di Arte Moderna Via Diaz 27	*Picture gallery*
	Udine	Civici Musei e Galleria di Storia e Arte Antica Piazza della Libertà	*Picture gallery and* *collections of fine art*
Emilia-Romagna	**Bologna**	Collezioni Comunali d'Arte Piazza Maggiore 6	*Picture gallery and* *collections of fine art*
		Galleria Comunale d'Arte Moderna Piazza della Costituzione 3	*Picture gallery*
		Museo Morandi Piazza Maggiore 6	*Picture gallery*
		Pinacoteca Nazionale Via della Belle Arti 56	*Picture gallery*
	Carpi	Museo Civico Giulio Ferrari Piazza Martiri 68	*Archaeology and ethnography* *museum, picture gallery*
	Cento	Pinacoteca Civica Via Matteotti 16	*Picture gallery*
	Cesena	Pinacoteca Comunale Via Aldini 26	*Picture gallery*
	Ferrara	Pinacoteca Nazionale Corso Ercole I d'Este 21	*Picture gallery*
	Forlì	Pinacoteca Civica Corso della Repubblica 72	*Archaeological museum* *and picture gallery*

	Imola	Pinacoteca Comunale Via Sacchi 4	*Picture gallery*
	Modena	Museo Civico di Storia e Arte Medievale e Modena Piazza Sant'Agostino 337	*Picture gallery*
	Piacenza	Galleria d'Arte Moderna Ricci Oddi Via San Siro 13	*Picture gallery*
		Musei di Palazzo Farnese Piazza Cittadella	*Museum of archaeology,* *history, decorative arts and* *documentation, picture gallery*
	Pieve di Cento	Pinacoteca Comunale Piazza A. Costa 10	*Picture gallery*
	Ravenna	Museo Nazionale Via Fiandrini	*Archaeological museum,* *picture gallery*
		Pinacoteca Comunale Via Roma 13	*Picture gallery*
	Reggio nell'Emilia	Musei Civici Lazzaro Spallanzani Via Spallanzani 1	*Museum of archaeology, history,* *natural history and* *documentation, picture gallery*
	Rimini	Museo della Città Via Luigi Tonini 1	*Archaeological museum,* *picture gallery*
Tuscany	**Arezzo**	Museo Statale d'Arte Medievale e Moderna Via San Lorentino 8	*Picture gallery*
	Fiesole	Museo Bandini Via G. Duprè 1	*Picture gallery and* *collections of decorative arts*
	Florence	Donazione Contini Bonacossi Piazza Pitti	*Picture gallery*
		Galleria d'Arte Moderna Piazza Pitti 1	*Picture gallery*
		Galleria dell'Accademia Via Ricasoli 60	*Picture gallery*
		Museo Bardini e Galleria Corsi Piazza de' Mozzi 1	*Picture gallery and* *collections of applied arts*
		Museo Marino Marini Piazza San Pancrazio	*Collections of sculpture* *and drawings*
		Museo Nazionale del Bargello Via del Proconsolo 4	*Collections of sculpture* *and decorative arts*
		Raccolta d'Arte Contemporanea Alberto Della Ragione Piazza della Signoria 5	*Picture gallery*
	Livorno	Museo Civico Giovanni Fattori Via Sant'Jacopo in Acquaviva	*Picture gallery*
	Lucca	Museo e Pinacoteca Nazionale di Palazzo Mansi Via Galli Tassi 43	*Picture gallery*
		Museo Nazionale di Villa Guinigi	*Archaeological museum* *and picture gallery*
	Montepulciano	Museo Civico di Palazzo Neri Orselli Via Ricci 15	*Museum of archaeology,* *history and documentation,* *picture gallery*
	Pisa	Museo Nazionale di San Matteo Piazza San Matteo in Soarta 1	*Picture gallery*
	Pistoia	Centro di Documentazione e Fondazione Marino Marini Corso Silvano Fedi 72	*Collection of sculpture* *and drawings,* *documentation centre*

	Pistoia	Museo Civico Piazza del Duomo 1	*Picture gallery and museum of decorative arts*
	San Gimignano	Museo Civico Piazza del Duomo	*Picture gallery and museum of decorative arts*
	Siena	Collezione Chigi-Saracini Via della Città 89 Pinacoteca Nazionale Via San Pietro 29	*Picture gallery and collections of decorative arts* *Picture gallery*
	Volterra	Pinacoteca e Museo Civico Via dei Sarti 3	*Picture gallery, museum of archaeology and decorative arts*
Marches	**Ancona**	Museo Archeologico Nazionale delle Marche Via Ferretti 1	*Archaeological museum*
	Ascoli Piceno	Pinacoteca Civica Piazza Arringo	*Picture gallery*
	Jesi	Museo Civico Archeologico Piazza A. Colocci Pinacoteca Civica Via XX Settembre 10	*Archaeological museum* *Picture gallery*
	Macerata	Pinacoteca Comunale Piazza Vittorio Veneto 2	*Museum of archaeology, ethnography and picture gallery*
	Pesaro	Musei Civici Piazza Toschi Mosca 29	*Picture gallery and museum of decorative arts*
	Recanati	Pinacoteca Civica Via Colloredo Meis	*Museum of archaeology, history and documentation, picture gallery*
	Urbino	Galleria Nazionale delle Marche Palazzo Ducale Piazza Duca Federico	*Picture gallery*
Umbria	**Assisi**	Pinacoteca Comunale Via della Cannoniera 22/a	*Picture gallery*
	Foligno	Pinacoteca Comunale di Palazzo Trinci Piazza della Repubblica	*Picture gallery*
	Gubbio	Museo Civico e Pinacoteca Comunale Piazza Grande	*Archaeological museum and picture gallery*
	Perugia	Galleria Nazionale dell'Umbria Corso Vannucci	*Picture gallery*
	Spoleto	Pinacoteca Comunale Piazza del Municipio 1	*Picture gallery*
	Todi	Museo - Pinacoteca Piazza del Popolo	*Museum of archaeology, history and documentation, picture gallery*
Latium	**Ardea**	Museo Giacomo Manzù Via Sant'Antonio 1	*Collection of sculpture and drawings*
	Arpino	Fondazione Umberto Mastroianni Piazza Municipio 33	*Picture gallery*
	Rome	Galleria Nazionale d'Arte Antica Palazzo Barberini Via Quattro Fontane 13	*Picture gallery*

	Rome	Galleria Nazionale d'Arte Moderna Viale delle Belle Arti 131	*Picture gallery*
		Musei Capitolini e Pinacoteca Piazza del Campidoglio	*Archaeological museum and picture gallery*
		Museo Nazionale di Castel Sant'Angelo Lungotevere Castello 50	*Picture gallery*
		Museo Nazionale di Palazzo Venezia Via del Plebiscito 118	*Picture gallery*
Abruzzo	**Chieti**	Museo d'Arte Costantino Barbella Via De Lollis 10	*Picture gallery*
	L'Aquila	Museo Nazionale d'Abruzzo Viale Castello	*Archaeology and natural history museum, picture gallery*
Campania	**Capri**	Museo Diefenbach Certosa di San Giacomo	*Picture gallery*
	Naples	Museo Nazionale di San Martino Largo San Martino 5	*Museum of history and documentation, decorative arts, picture gallery*
	Sorrento	Museo Correale di Terranova Via Correale 50	*Archaeological museum and picture gallery*
Puglia	**Bari**	Pinacoteca Provinciale Via Spalato 19	*Picture gallery*
	Barletta	Museo Civico e Pinacoteca Giuseppe de Nittis Piazza Castello	*Archaeological museum and picture gallery*
	Ruvo di Puglia	Museo Nazionale Jatta Piazza G. Bovio 35	*Archaeological museum*
Basilicata	**Matera**	Museo Nazionale Archeologico Domenico Ridola Via D. Ridola 24	*Archaeological museum*
Sicily	**Catania**	Museo Civico Castello Ursino Piazza Federico di Svevia	*Archaeological museum and picture gallery*
	Cefalù	Fondazione Culturale Mandralisca Via Mandralisca 13	*Archaeology and natural history museum, picture gallery*
	Messina	Museo Regionale Viale della Libertà 465	*Archaeological museum and picture gallery*
	Palermo	Civica Galleria d'Arte Moderna Empedocle Restivo Via F. Turati 10	*Art museum*
		Galleria Regionale della Sicilia Palazzo Abatellis, via Alloro 4	*Picture gallery*
	Siracusa	Galleria Regionale di Palazzo Bellomo Via Capodieci 14/16	*Picture gallery*
	Trapani	Museo Regionale Conte Agostino Pepoli Via Conte A. Pepoli 200	*Archaeological museum and picture gallery*
Sardinia	**Cagliari**	Galleria Comunale d'Arte Viale Regina Elena	*Picture gallery*
		Pinacoteca Nazionale Cittadella dei Musei Piazza Arsenale	*Picture gallery and ethnographic museum*

3. *Archaeological museums and contemporary art galleries, and museums that gather and exhibit cultural heritages not necessarily linked to art history, such as historical and scientific museums.*	**Valle d'Aosta**	Fenis	Castello di Fénis	*Castle Museum, furniture*
	Piedmont	**Bra**	Museo Civico Craveri di Storia Naturale Via Craveri 15	*Natural history museum*
		Pinerolo	Museo Nazionale dell'Arma di Cavalleria Viale Giolitti 5	*Specialist museum*
		Rivoli	Museo d'Arte Contemporanea Piazza Mafalda di Savoia	*Contemporary art collections*
		Turin	Galleria Civica d'Arte Moderna e Contemporanea - GAM Via Magenta 31	*Picture gallery and contemporary art collections*
			Museo Egizio Via Accademia delle Scienze 6	*Archaeological museum*
			Museo Nazionale del Cinema Piazza San Giovanni 2	*Specialist museum*
			Museo Nazionale dell'Automobile Carlo Biscaretti di Ruffia Corso Unità d'Italia 40	*Specialist museum*
			Museo Nazionale del Risorgimento Italiano Via Accademia delle Scienze 5	*Documentation museum*
	Liguria	**Altare**	Museo del Vetro e dell'Arte Vetraria Via Restagno 2	*Specialist museum*
		Genoa	Museo d'Arte Orientale Edoardo Chiossone Piazzale Mazzini 4/n	*Museum of decorative arts orientali*
			Museo del Tesoro di San Lorenzo Piazza di San Lorenzo	*Museum of gold craft*
	Lombardy	**Casalmaggiore**	Museo del Bijou Via A. Porzio 9	*Specialist museum*
		Garlate	Museo della Seta Abegg Via Statale 490	*Specialist museum*
		Laveno Mombello	Museo Internazionale del Design Ceramico Lungolago Perabò 5	*Museum of decorative arts*
		Milan	Acquario Civico e Stazione Idrobiologica Viale Gadio 2	*Natural history museum*
			Musei Civici del Castello Sforzesco: Raccolte d'Arte Applicata - Museo degli Strumenti Musicali Piazza Castello	*Museum of decorative arts*
			Museo Nazionale della Scienza e della Tecnica Leonardo da Vinci Via San Vittore 21	*Museum of science and technology*
			Museo Teatrale della Scala Via Filodrammatici	*Specialist museum*
		San Benedetto Po	Museo dell'Abbazia di Polirone Piazza T. Folengo 23	*Archaeological museum*
		Vigevano	Museo della Calzatura Pietro Bertolini Corso Cavour 82	*Specialist museum*

Trentino-Alto Adige	**Rovereto**	Archivio del Novecento Corso Rosmini 53	*Collections of contemporary art and documentation centre*
	Trent	Museo di Arte Moderna e Contemporanea di Trento e Rovereto (MART) Via R. da Sanseverino 45	*Picture gallery and collection of contemporary art*
Veneto	**Nove**	Museo Civico della Ceramica Piazza De Fabris 5	*Museum of decorative arts*
	Treviso	Raccolta dei Manifesti Salce Palazzo Scotti	*Museum of graphic art*
	Venice	Museo d'Arte Orientale Santa Croce 2078 - Campo San Stae	*Collections of oriental art*
		Museo dell'Arte Vetraria Fondamenta Giustinian 8 Isola di Murano	*Museum of decorative arts*
		Museo del Merletto di Burano Piazza Galuppi 184 Isola di Burano	*Museum of decorative arts*
		Museo del Settecento Veneziano Ca' Rezzonico Dorsoduro 3136	*Museum of furniture, buildings and art gallery*
	Vestenanova	Museo dei Fossili di Bolca Via San Giovanni Battista 50 Bolca	*Natural history museum*
Friuli-Venezia Giulia	**Aquileia**	Museo Archeologico Nazionale Via Roma 1	*Archaeological museum*
Emilia-Romagna	**Bologna**	Museo Aldrovandiano Via Zamboni 35	*Museum of natural history, history and documentation*
		Museo d'Arte Industriale e Galleria Davia Bargellini Strada Maggiore 44	*Museum of decorative arts*
	Dozza	Rocca Sforzesca Piazzale della Rocca 1	*Museum of ethnography, decorative arts and picture gallery*
	Faenza	Museo Internazionale delle Ceramiche Viale Baccarini 19	*Museum of decorative arts*
	Ferrara	Museo Archeologico Nazionale di Ferrara Via XX Settembre 122	*Archaeological museum*
		Museo d'Arte Moderna e Contemporanea Palazzo Massari Corso Porta Mare 9	*Picture gallery and collections of contemporary art*
	Imola	Museo delle Armi e delle Maioliche della Rocca Sforzesca Piazzale Giovanni dalle Bande Nere	*Museum of decorative arts and documentation*
	Luzzara	Museo Nazionale delle Arti Naif Cesare Zavattini Via Villa Superiore 29	*Picture gallery*
	Rimini	Museo delle Sculture Extraeuropee Delfino Dinz Rialto Piazza Malatesta	*Ethnographic museum*

Tuscany	**Arezzo**	Museo Archeologico Nazionale Gaio Cilnio Mecenate Via Margaritone 10	*Archaeological museum*
	Cortona	Museo dell'Accademia Etrusca Piazza Signorelli 8	*Archaeological museum and picture gallery*
	Florence	Biblioteca Medicea Laurenziana Piazza San Lorenzo 9	*Library*
		Gipsoteca Piazzale di Porta Romana 9	*Collection of sculptures*
		Museo Archeologico Via della Colonna 36/38	*Archaeological museum*
		Museo dell'Antica Casa Fiorentina Via Porta Rossa 13	*Museum of furniture and decorative arts*
		Museo delle Porcellane Giardino di Boboli	*Museum of decorative arts*
		Museo dell'Opificio delle Pietre Dure Via degli Alfani 78	*Museum of decorative arts*
	Montelupo Fiorentino	Museo Archeologico del Territorio e della Ceramica Via Sinibaldi 45	*Archaeological museum and decorative arts*
	Pescia	Gipsoteca Libero Andreotti Piazza del Palagio 7	*Collections of sculptures and documentation centre*
	Pisa	Museo delle Sinopie Piazza del Duomo	*Picture gallery*
	Prato	Centro per l'Arte Contemporanea Luigi Pecci Viale della Repubblica 277	*Collections of contemporary art*
		Museo del Tessuto Piazza del Comune	*Specialist museum*
	Sesto Fiorentino	Museo Richard Ginori della Manifattura di Doccia Viale Pratese 31	*Museum of decorative arts*
	Volterra	Museo Etrusco Guarnacci Via Don Minzoni 15	*Archaeological museum*
Marches	**Macerata**	Pinacoteca del Novecento Italiano di Palazzo Ricci Via D.Ricci 1	*Collections of contemporary art*
	Tolentino	Museo dell'Opera di San Nicola - Museo delle Ceramiche - Museo degli Ex voto - Museo del Presepio Piazza San Nicola	*Museum of decorative arts and picture gallery*
Umbria	**Assisi**	Museo della Basilica di San Francesco - Tesoro e Collezione Perkins Piazza San Francesco 2	*Museum of decorative arts and picture gallery*
	Città di Castello	Fondazione Palazzo Albizzini Collezione Burri Via Albizzini 1	*Collections of contemporary art*
	Deruta	Museo Regionale della Ceramica Piazza dei Consoli	*Museum of decorative arts*
	Orvieto	Museo Claudio Faina Piazza del Duomo 29	*Archaeological museum*
		Museo dell'Opera del Duomo Piazza del Duomo	*Museum of sculpture and decorative arts*

	Perugia	Collezioni Dottori-Beuys Piazza Podiani 11	*Collections of contemporary art*
		Museo Archeologico Nazionale dell'Umbria Piazza Giordano Bruno 10	*Archaeological museum*
Latium	**Cerveteri**	Museo Nazionale Archeologico Cerite Piazza Santa Maria	*Archaeological museum*
	Latina	Galleria d'Arte Moderna e Contemporanea Via Umberto I	*Picture gallery and collections of contemporary art*
	Nemi	Museo delle Navi Romane Via di Diana 13	*Archaeological museum*
	Palestrina	Museo Archeologico Prenestino Piazza della Cortina	*Archaeological museum*
	Rome	Museo Boncompagni Ludovisi per le Arti Decorative Via Boncompagni 18	*Museum of decorative arts*
		Museo Nazionale d'Arte Orientale Via Merulana 248	*Museum of oriental art*
		Museo Nazionale delle Arti e Tradizioni Popolari Piazza G. Marconi 8	*Ethnographic museum*
		Museo Nazionale Etrusco di Villa Giulia Piazzale di Villa Giulia 9	*Archaeological museum*
		Museo Nazionale Preistorico Etnografico Luigi Pigorini Piazza G. Marconi 14	*Archaeological and ethnographic museum*
		Museo Nazionale Romano Aula Ottagona Via G. Romita	*Archaeological museum*
		Museo Nazionale Romano Palazzo Altemps Piazza Sant'Apollinare 44	*Archaeological museum*
		Museo Nazionale Romano Palazzo Massimo alle Terme Largo di Villa Peretti 1	*Archaeological museum*
		Museo Nazionale Romano Terme di Diocleziano Viale E. De Nicola 79	*Archaeological museum*
		Museo Ostiense Viale dei Romagnoli 717 Ostia Antica	*Archaeological museum*
	Sperlonga	Museo Archeologico Nazionale di Sperlonga Via Flacca km 16.600	*Archaeological museum*
	Tarquinia	Museo Nazionale Piazza Cavour 1	*Archaeological museum*
	Tuscania	Museo Nazionale Tuscanese Via della Madonna del Riposo	*Archaeological museum*
Abruzzo	**Castelli**	Museo della Ceramica Contrada Convento	*Museum of decorative arts*
	Chieti	Museo Archeologico Nazionale d'Abruzzo Villa Comunale n.2	*Archaeological museum*
Molise	**Isernia**	Museo Archeologico Santa Maria delle Monache Corso Marcelli 8	*Archaeological museum*

Campania	Benevento	Museo del Sannio Piazza Santa Sofia	*Archaeological museum and picture gallery*
	Ercolano	Antiquarium Corso Resina	*Archaeological museum*
	Naples	Acquario e Stazione Zoologica Anton Dohrn di Napoli Villa Comunale 1	*Natural history museum*
		Museo Nazionale della Ceramica Duca di Martina Via Cimarosa 77	*Museum of decorative arts*
	Ravello	Museo del Corallo Piazza del Duomo 9	*Museum of decorative arts*
	Vietri sul Mare	Museo della Ceramica Vietrese Via Nuova Raito - Raito di Vietri	*Museum of decorative arts*
Puglia	Brindisi	Museo Archeologico Provinciale Francesco Ribezzo Piazza Duono 3	*Archaeological museum*
	Lecce	Museo Provinciale Sigismondo Castromediano Viale Gallipoli 28	*Archaeological museum and picture gallery*
	Taranto	Museo Archeologico Corso Umberto 42	*Archaeological museum*
Calabria	Cassano allo Jonio	Museo Archeologico Nazionale della Sibaritide Contrada Casablanca - Sibari	*Archaeological museum*
	Crotone	Museo Archeologico Nazionale Via Risorgimento 120	*Archaeological museum*
	Reggio di Calabria	Museo Nazionale Piazza De Nava 26	*Archaeological museum*
Sicily	Agrigento	Museo Archeologico Regionale Contrada San Nicola	*Archaeological museum*
	Caltagirone	Musei Civici e Pinacoteca Luigi Sturzo - Mostra Permanente della Ceramica Via Roma 10	*Archaeological museum, decorative arts and picture gallery*
		Museo Regionale della Ceramica Via Giardino Pubblico	*Museum of decorative arts*
	Gela	Museo Archeologico Corso Vittorio Emanuele I	*Archaeological museum*
	Gibellina	Museo Civico d'Arte Contemporanea Viale Segesta	*Collections of contemporary art*
	Marsala	Museo Giuseppe Whitaker Posta Spagnola - Mozia	*Archaeological museum*
	Palermo	Museo Archeologico Regionale Antonino Salinas Piazza Olivella	*Archaeological museum*
	Syracuse	Museo Archeologico Regionale Paolo Orsi Viale Teocrito 66	*Archaeological museum*
Sardinia	Cagliari	Museo Archeologico Nazionale Cittadella dei Musei Piazza Arsenale	*Archaeological museum*

		Cagliari	Pinacoteca Nazionale Cittadella dei Musei Piazza Arsenale	*Picture gallery and ethnographic museum*
		Sassari	Museo Archeologico-Etnografico Giovanni Antonio Sanna Via Roma 64	*Archaeological museum, ethnography and picture gallery*

4. *Homes and studios of artists, houses of poets and literary figures, homes of historical personalities, particular museums that combine the quality of the collections they exhibit with the atmosphere of a private home.*	**Piedmont**	**Agliè**	Villa "Il Meleto" di Guido Gozzano Villa Gozzano	*Historical museum and documentation*
		Ameno	Collezione Calderara Via Bardelli 9 - Vacciago	*House and collections of contemporary art*
		Asti	Museo Alfieriano Corso Alfieri 3375	*Historical museum and documentation*
		Rima San Giuseppe	Museo Gipsoteca Pietro Della Vedova	*Historical museum and documentation*
		Santena	Museo Cavouriano Piazza Visconti Venosta 1	*Historical museum and documentation*
		Santo Stefano Belbo	Casa-Museo Pavesiano Via C. Pavese 20	*Historical museum and documentation*
		Stresa	Museo Storico di Antonio Rosmini Corso Umberto I 15	*Historical museum and documentation*
		Volpedo	Studio di Giuseppe Pellizza Via Rosano 1	*Historical museum and documentation*
	Liguria	**Albisola Superiore**	Museo Manlio Trucco Corso Ferrari 194	*Historical museum and documentation*
		Albissola Marina	Fabbrica-Casa-Museo G. Mazzotti 1903 Viale G. Matteotti 29	*Historical museum and documentation*
	Lombardy	**Bergamo**	Museo Donizettiano Via Arena 9	*Historical museum and documentation*
		Gardone Riviera	Fondazione Il Vittoriale degli Italiani - Museo Dannunziano del Vittoriale Via Vittoriale 12	*Historical museum and documentation*
		Lecco	Villa Manzoni, Sezione Manzoniana e Galleria d'Arte dei Musei Civici di Lecco Via Don Guanella 3 - Caleotto	*Historical museum and documentation*
		Lonato	Museo Casa del Podestà Fondazione Ugo Da Como Via Rocca 2	*Museum of furniture and decorative arts*
		Mantua	Casa di Andrea Mantegna Via G. Acerbi 47	*Historical museum and documentation*
		Milan	Casa di Alessandro Manzoni Via G. Morone 1 Museo Poldi Pezzoli Via Manzoni 12	*Historical museum and documentation Museum of decorative arts and picture gallery*
		Rovetta	Museo della Fondazione Fantoni Via Fantoni 1	*Collections of sculptures, drawings and documentation centre*
		Varese	Museo Ludovico Pogliaghi Via del Santuario Santa Maria del Monte	*Archaeological museum, decorative arts and picture gallery*

Veneto	**Arquà Petrarca**	Casa di Francesco Petrarca	*Historical museum and documentation centre*
	Possagno	Gipsoteca Museo Canoviano e Casa Natale del Canova Piazza Canova 84	*Collections of sculptures, drawings, documentation centre, picture gallery*
	Venice	Casa Goldoni Calle dei Nomboli 2793	*Museum of furniture, fashion, applied arts, documentation centre*
		Museo di Palazzo Fortuny San Benedetto 3780	*Picture gallery and documentation centre*
Friuli-Venezia Giulia	**Trieste**	Civico Museo Mario Morpurgo De Nilma Via Imbriani 5	*Picture gallery*
		Civico Museo Sartorio Largo Papa Giovanni XXIII 1	*Picture gallery*
Emilia-Romagna	**Bologna**	Casa di Giosuè Carducci Piazza Carducci 5	*Museum of history and documentation*
	Busseto	Casa Natale di Giuseppe Verdi Via Roncole Verdi 1)	*Museum of history and documentation*
	Ferrara	Casa di Ludovico Ariosto Via Ariosto 67 a	*Museum of history and documentation*
	Parma	Casa Natale di Arturo Toscanini Via Tanzi 13	*Museum of history documentation*
	San Mauro Pascoli	Casa Natale di Giovanni Pascoli Via Pascoli 46	*Museum of history documentation*
	Traversetolo	Museo Renato Brozzi Piazza Vittorio Veneto 30	*Collections of sculptures, decorative arts and documentation centre*
Tuscany	**Arezzo**	Museo di Casa Vasari Via XX Settembre 55	*Picture gallery*
	Caprese Michelangelo	Museo Michelangiolesco Via del Capoluogo 1	*Museum of history documentation*
	Certaldo	Casa di Giovanni Boccaccio Via Boccaccio	*Museum of history documentation*
	Fiesole	Museo Duprè Via G. Duprè 19	*Collections of sculpture and drawing*
	Florence	Casa Buonarroti Via Ghibellina 70	*Archaeological museum, history and documentation, picture gallery*
		Casa di Dante Via Santa Margherita 1	*History museum and documentation*
		Fondazione di Studi di Storia dell'Arte Roberto Longhi Via Fortini 30	*Picture gallery and documentation centre*
		Museo Horne Via dei Benci 6	*Museum of decorative arts and picture gallery*
		Museo Stibbert Via Stibbert 26	*Museum of decorative arts*
		I Tatti Fondazione Bernard Berenson	*Picture gallery and documentation centre*
	Portoferraio	Museo Nazionale delle Residenze Napoleoniche Piazza Napoleone	*History museum and documentation*

	Portoferraio	Villa Napoleonica di San Martino Galleria Demidoff San Martino	*Museum of furniture*
	Viareggio	Museo Villa Puccini Via Puccini 266 Torre del Lago Puccini	*History museum and documentation*
	Vicchio	Casa Natale di Giotto Vespignano	*History museum and documentation*
	Vinci	Casa Natale di Leonardo Via Anchiano	*History museum and documentation*
Marches	**Recanati**	Biblioteca Privata Leopardi Via Leopardi 14	*History museum and documentation*
	Urbino	Casa Natale di Raffaello Via Raffaello 57	*History museum and documentation*
Latium	**Rome**	Casa di Wolfgang Goethe Via del Corso 18	*History museum and documentation*
		Casa Museo Giorgio de Chirico Piazza di Spagna 31	*History museum and documentation*
		Museo Canonica Viale P.Canonica 2	*Collections of sculpture and drawings, documentation centre*
		Museo Hendrick Christian Andersen Via Pasquale Stanislao Mancini	*Collections of sculpture and drawings, documentation centre*
		Museo Mario Praz Via Zanardelli 1	*Museum of decorative arts, furniture and picture gallery*
Abruzzo	**Pescara**	Museo Casa Natale di Gabriele D'Annunzio Corso Manthonè 101	*History museum and documentation*
Sicily	**Catania**	Casa Museo Giovanni Verga Via Sant'Anna 8	*History museum and documentation*
Sardinia	**Nuoro**	Museo Deleddiano Via Deledda 42	*History museum and documentation*

Bibliography

Turin, Egyptian Museum

1825
Champollion J.F., "Descrizione del R. Museo Egizio", in *Calendario generale pe' Regi Stati*, 2.
1852-55
Orcurti P.C., *Catalogo illustrato dei monumenti egizi del R.Museo di Torino*, 2 Volumes, Turin
1872
Fabretti A., *Il Museo di Antichità della R.Università di Torino*, Turin.
1878
Barucchi I., "Museo della R. Università di Torino a. 1816-32. Inventario del Museo di Antichità", in *Documenti inediti per servire alla storia dei Musei d'Italia*, Ministero della Pubblica Istruzione, I, Florence-Rome.
1880
Vidua C., "Catalogue de la collect. d'antiq. de mons. Le chev. Drovetti, a 1822", in *Documenti inediti per servire alla storia dei Musei d'Italia*, Ministero della Pubblica Istruzione, Florence-Rome.
1882-88
Fabretti A., Rossi F., Lanzone R.V., *Regio Museo di Torino. Antichità egizie*, Turin.
1931-38
Farina G., *Il Regio Museo di Antichità di Torino. Sezione egizia*, Ministero dell'Educazione Nazionale, Rome.
1963
Scamuzzi E., *Il Museo Egizio di Torino*, Turin.

1974-78
Roccati A., *Il Museo Egizio di Torino*, Ministero della Pubblica Istruzione, Rome.
1977
Occhio di Ra-Introduzione alle antichità egizie, Turin.
1981
Curto S., Guglielminotti B., Perletto Monterisi A., Leospo E., Rigotti G. e G.M., *Progetto di un museo egizio per le scuole*, Turin.
Roccati A., editor, *La riscoperta dell'Egitto nel secolo XIX: i primi fotografi*, Turin.
1983
Orsini M.R., editor, *Catalogo della Biblioteca egittologica del Museo Egizio di Torino*, Milan.
Curto S., Donadoni Roveri A.M., Roccati A., *Museo Egizio*, Turin.
1984
Curto S., *L'antico Egitto nel Museo Egizio di Torino*, Turin.
Rossi F., *I monumenti egizi del Museo di Antichità di Torino*, Turin.
1985
D'Amicone E., editor, *Toccare l'arte. Il Museo Egizio*, Turin.
D'Amicone E., editor, *Un itinerario nella storia dell' Egitto antico. Il Museo Egizio di Turin*, Turin.
1990
Curto S., *Storia del Museo Egizio di Torino*[3], Turin.
Donadoni Roveri A.M., "Il Museo Egizio di Torino", in S. Donadoni, S. Curto, A.M.Donadoni Roveri, *L'Egitto dal Mito all'Egittologia*, Milan.

Naples, the National Archaeological Museum

1757-92
Le Antichità di Ercolano esposte, Volumes I-VIII, Stamperia Reale Borbonica, Naples.
1819-23
Finati G.B., *Il Regal Museo Borbonico*, Naples.
1822
Giustiniani L., De Licteriis Fr., *Guida per lo Real Museo Borbonico*, Naples.
1841
Alvino F., *Description des Monuments du Musée Royal Bourbon*, Naples.
1874
Monaco D., *Guide Général du Musée National de Naples, suivant le Nouvel Arrangement*, Naples.
1876
Migliozzi A., *Nuova Guida Generale del Museo Nazionale di Napoli secondo i più recenti riordinamenti corredata di un'appendice riguardante Pompei e la Certosa di S. Martino*, Naples.
1908
Ruesch A., editor, *Guida illustrata del Museo Nazionale di Napoli*, Naples.
1925-28
Ruesch A., editor, *Compendio della guida illustrata del Museo Nazionale di Napoli*, Naples.
1824-27
Niccolini A., editor, *Real Museo Borbonico*, 16 Volumes, Naples; second edition, with modifications, 9 Volumes, Rome, 1837-1845.

Vulpes B., *Illustrazione di tutti gli strumenti chirurgici scavati in Pompei ed Ercolano*, Naples.
1854
Ceci C., *Museo Nazionale*, Naples (II ed. *Piccoli bronzi del Real Museo Borbonico*, Naples 1858).
1866
Fiorelli G., *Catalogo del Museo Nazionale di Napoli, Raccolta pornografica*, Naples.
Fiorelli G., *Catalogo del Museo Nazionale di Napoli, Medagliere, VI, Matrici, punzoni e conii della R. Zecca*, Naples.
Fiorelli G., *Catalogo del Museo Nazionale di Napoli, Collezione Santangelo, Monete greche*, Naples. 1867
Fiorelli G., *Catalogo del Museo Nazionale di Napoli, Collezione Santangelo, Monete del Medio Evo*, Naples.
Fiorelli G., *Catalogo del Museo Nazionale di Napoli, Raccolta epigrafica I, Iscrizioni Greche e Italiche*, Naples.
1868
Helbig W., *Wandgemälde der vom Vesuvius verschütteten Städte Campaniens*, Leipzig.
1869
Fiorelli G., *Catalogo del Museo Nazionale di Napoli, Armi antiche*, Naples.
1870
Fiorelli G., *Catalogo del Museo Nazionale di Napoli, Medagliere, I, Monete greche*, Naples.
Fiorelli G., *Catalogo del Museo Nazionale di Napoli,*

Medagliere, II, Monete romane, Naples.
1871
Fiorelli G., *Catalogo del Museo Nazionale di Napoli, Medagliere, III, Monete del Medio Evo e moderne*, Naples.
1872
Heydemann H., *Die Vasensammlung des Museo Nazionale zu Neapel*, Berlin.
1928
Spinazzola V., *Le arti decorative in Pompei e nel Museo Nazionale di Napoli*, Milan.
1932
Elia O., *Pitture murali e mosaici nel Museo Nazionale di Napoli*, Rome.
1938
Pernice E., *Gefässe und Geräte aus Bronze (Die hellenistische Kunst in Pompeji, VI)*, Berlin.
1941
Breglia L., *Catalogo delle oreficerie del Museo Nazionale di Napoli*, Naples.
1954
Siviero R., *Gli ori e le ambre del Museo Nazionale di Napoli*, Naples.
1963
De Franciscis A., *Il Museo Nazionale di Napoli*, Cava dei Tirreni-Naples.
1964
Grant M., Mulas A., *Eros a Pompei, il Gabinetto segreto del Museo di Napoli*, Milan.
1977
Da Palazzo degli Studi a Museo Archeologico. Catalogo della Mostra storico-documentaria del Museo Nazionale di Napoli, Naples.
1983
Valenza Mele N., *Museo Nazionale di Napoli. Catalogo delle lucerne in bronzo*, Naples.
1984
Il Museo Archeologico Nazionale. Napoli (Guide pratiche Garolla), Milan.
1986-89
Le collezioni del Museo Nazionale di Napoli, Rome.
1994
De Caro S., *Il Museo Archeologico Nazionale di Napoli*, Naples.
1995-96
All'ombra del Vesuvio. Le collezioni del Museo Archeologico Nazionale di Napoli, Mostra Kunsthalle Bonn 1995, Petit Palais Paris.
1999

De Caro S., *Il Museo Archeologico Nazionale di Napoli. Guida alle collezioni*, Naples.
De Caro S., Cappelli R., *Il Museo Archeologico Nazionale di Napoli. Guida breve*, Naples.
2000
De Caro S., Cappelli R., *Il Gabinetto Segreto del Museo Archeologico Nazionale di Napoli*, Naples.
2001
Il tesoro del Cardinale. La collezione Borgia, exh. cat. Velletri-Naples.
La collezione egiziana del Museo nazionale di Napoli, Naples.
De Gemmis M., Esposito M.-R., *Il Museo Archeologico Nazionale di Napoli. Guida per bambini*, Naples.
Camodeca G., Solin H., *Catalogo delle iscrizioni latine del Museo Archeologico Nazionale di Napoli. Roma et Latium*, Naples.

Florence, the Uffizi

1733-71
Quadreria Medicea, ou Tableaux de la galerie des Medicis, gravés d'après les dessins de Fr. Petrucci, par Mogalli, Picchianti, Lorenzini, Gregori, Florence.
1752-62
Moucke F., *Serie di ritratti degli eccellenti pittori dipinti di propria mano che esistono nella I.R. Galleria di Firenze con le vite in compendio dei medesimi* (4 Volumes), Florence.
1779
Bencivenni Pelli G., *Saggio storico della R. Galleria di Firenze* (2 Volumes), Florence.
1782
Lanzi L., *La R. Galleria di Firenze accresciuta e riordinata per comando di S.A.R.*, Florence.
1817-31
Reale Galleria di Firenze illustrata. I Quadri di storia (Volumes I-III); II *Quadri di vario genere*; III *Ritratti di pittori* (Volumes I-IV); IV *Statue, bassorilievi, busti e bronzi* (Volumes I-III); V *Cammei e intagli* (Volumes I-II), Florence.
1841-67
Ranalli F., *Imperiale e reale Galleria di Firenze. Storia della pittura dal suo risorgimento*

in Italia dimostrata coi monumenti della Reale Galleria di Firenze (6 Volumes), Florence.
1901
Ricci C., Frizzoni G., *La Galleria degli Uffizi in Firenze*, Bergamo.
1920
R. Galleria degli Uffizi. Elenco dei dipinti, Florence.
1921
R. Galleria degli Uffizi. Elenco delle sculture, Florence.
1923
Poggi G., *R. Galleria degli Uffizi. Catalogo dei dipinti*, Florence.
1952
Salvini R., *La Galleria degli Uffizi, guida per il visitatore e catalogo dei dipinti con notizie e commenti*, Florence.
1957
Becherucci L., *Tesori della Galleria degli Uffizi*, Milan.
1958
Mansuelli G.A., *Galleria degli Uffizi. Le sculture*, Rome.
1974
Berti L., *Inaugurazione della donazione Contini Bonacossi. Itinerario*, Florence.
Negrini S., *Galleria degli Uffizi*, Milan.
1977
Borea E., Petrioli Tofani A.M., Langedijk K., *La quadreria di Don Lorenzo de' Medici*, exh. cat., Poggio a Caiano, Florence.
1979
Gli Uffizi, Florence.
1982-83
Berti L., Caneva C., Ciardi Dupré Dal Poggetto M.G., Gregori M., *Gli Uffizi* (2 Volumes), Florence.
1990
Petrioli Tofani A.M., Michelucci G., *Gli Uffizi. Progetti per il nuovo museo*, Florence.
1991
Godoli A., Natali A., *Gli Uffizi. La Sala di Leonardo*, Florence.
1992
Natali A., *Gli Uffizi. La Donazione Balla*, Florence.
1994
Gregori M., *Uffizi e Pitti. I dipinti delle gallerie fiorentine*, Udine.

Florence, the Pitti Palace

1978
Tiziano nelle Gallerie fioren-

tine, exh. cat., Florence, Palazzo Pitti, 23 December 1978-31 March 1979.
1982
La Galleria Palatina. Storia della quadreria granducale di Palazzo Pitti, editor Marilena Mosco, exh. cat., Florence, Palazzo Pitti, 23 September-31 January 1983.
1984
Raffaello a Firenze. Dipinti e disegni nelle collezioni fiorentine, exh. cat., Florence, Palazzo Pitti, 11 January-29 April.
1986
Andrea del Sarto (1486-1530). Dipinti e disegni a Firenze, exh. cat., Florence, Palazzo Pitti 8 November 1986-1 March 1987.
1989
M. Chiarini, *Gallerie e Musei statali di Firenze. I dipinti olandesi nel Seicento e nel Settecento*, Rome.
M. Lucco, *Le tre età dell'uomo*, Florence.
1991
Raffaello a Pitti. "La Madonna del baldacchino" storia e restauro, exh. cat., Florence, Palazzo Pitti, 23 June-15 September.
1992
E. Colle, editor, *I mobili di Palazzo Pitti. Il primo periodo lorenese. 1737-99*, Florence.
1993
E. Colle, *Gli Appartamenti Reali di Palazzo Pitti. Una reggia per tre dinastie: Medici, Lorena e Savoia. Tra Granducato e Regno d'Italia*, Florence.
M. Chiarini, S. Padovani, editor, *Gli Appartamenti Reali di Palazzo Pitti*, Florence.
1996
S. Padovani, ed., with M. Scudieri and G. Damiani, *L'età di Savonarola. Fra' Bartolomeo e la "Scuola di San Marco"*, exh. cat., Florence, Palazzo Pitti and the Museo di San Marco, 25 April - 28 July 1996, Venice.
1997
D. Bodart, *Rubens e la pittura fiamminga del Seicento nelle collezioni pubbliche fiorentine*, exh. cat., Florence, Palazzo Pitti, 22 July 1997 - 9 October 1997.
2000
E. Colle, *I mobili di Palazzo Pitti. Il secondo periodo lorenese. 1800-1846*, Florence.
M. Chiarini, editor, *Palazzo*

Pitti. L'arte e la storia, Florence.

Rome, the Borghese Gallery

1650
Manilli I., *Villa Borghese fuori di Porta Pinciana descritta da Iacomo Manilli Romano Guardarobba di detta Villa*, Rome.
1713
Bernini D., *Vita del Cavalier Gio. Lorenzo Bernino, descritto da Domenico Bernini suo figlio*, Rome; Ediart, Perugia 1995.
1823
Cicognara L., *Biografia di Antonio Canova*, Venice.
1823-24
Cicognara L., *Storie delle sculture*, Volumes I-VII, Prato.
1906
Vasari G., *Le Opere di Giorgio Vasari, con nuove annotazioni e commenti di Gaetano Milanesi*, Tomo IV, Florence (ed. Florence 1973), pp.109-129 ("Vita di Antonio da Correggio") pp. 311-416 ("Vita di Raffaello da Urbino").
1912
Baldinucci F., *Vita del Cavalier Giovanni Lorenzo Bernini scultore, architetto e pittore*, Florence 1682, editor A.Riegl, Vienna.
1927
Longhi R., in "Vita Artistica", p.168.
1928
Longhi R., *Precisazioni nelle Gallerie Italiane I, La R. Galleria Borghese*, Rome, pp.144-159.
1954
Faldi I., *Galleria Borghese. Le sculture dal secolo XVI al XIX*, Rome.
Ferrara L., "La stanza di Elena e Paride", in *Rivista dell'Istituto Nazionale di Archeologia e Storia dell'Arte*, n.s. III, pp. 242-256.
1955
Della Pergola P., *Galleria Borghese. I dipinti*, vol. I, Rome.
1959
Della Pergola P., *Galleria Borghese. I dipinti*, vol. II, Rome.
1968
Longhi R., *Saggi e ricerche, 1925-28*, vol II, a. 1927, ed. Florence, pp.322-323, 325-326.
1972-73
Ferrara L., Staccioli S., Tantil-

lo A.M., *Storia e restauro della Deposizione di Raffaello*, Rome.
1976
Bellori G.P., *Le Vite de' pittori, scultori e architetti moderni*, Rome 1672, editor E.Borea, Turin.
1978
Arizzoli Clemente L.P., "Charles Percie et la salle égyptienne de la villa Borghese", in *Piranèse et les Français, Actes du Colloque à la Villa Mèdicis*, Rome, pp.1-32.
1984
Raffaello nelle raccolte Borghese, exh. cat., Rome, Galleria Borghese, 1984.
Reinhardt V., *Kardinal Scipione Borghese (1605-1633). Vermögen, Finanze und sozialen Aufstieg eines Papstnepoten*, Tubingen.
1991
Bernardini M.G., editor, *La Danae e la pioggia d'oro. Un capolavoro di Antonio Allegri detto il Correggio restaurato*, Rome.
Connors J., Rice L., editor, *Specchio di Roma Barocca. Una guida inedita del XVII secolo*, II ed., Rome.
1991-92
Gregori M., *Michelangelo Merisi da Caravaggio. Come nascono i capolavori*, exh. cat., Florence, Palazzo Pitti, Galleria Palatina, 12 December 1991-15 March 1992; Rome, Palazzo Ruspoli, Fondazione Memmo, 26 March-24 May 1992.
1992
Paul C., "Mariano Rossi's Camillus Fresco in the Borghese Gallery", in *The Art Bulletin*, LXXIV, pp. 297-326.
Raffaello e Dante, exh. cat., Casa di Dante in Abruzzo, Castello Gizzi, Torre de' Passeri (Pescara), editor K. Herrmann Fiore.
1993
Gonzalez Palacios A., *Il gusto dei principi. Arte di corte del XVII e del XVIII secolo*, Milan.
Gonzalez Palacios A., "La stanza del Gladiatore", in *Antologia di Belle Arti*, 43, pp. 5-33.
1994
Coliva A., editor, *Galleria Borghese*, Rome.
Locher H., *Raffael und das Altarbild der Renaissance. Die

"Pala Baglioni" als Kunstwerk im sakralen Kontext*, Berlin.
1995
Tiziano. Amor Sacro e Amor Profano, exh. cat., Rome, Palazzo delle Esposizioni, 22 March-22 May.
Gonzalez Palacios A., "The Stanza di Apollo e Dafne in the Villa Borghese", in *The Burlington Magazine* 137, pp. 529-549.
Kalveram K., "Die Antikensammlungen des Kardinals Scipione Borghese", in *Römische Studien der Bibliotheca Hertziana*, vol.XI, Wörms am Rhein.
1997
Di Macco M., editor, *Le delizie di Stupinigi e della "Danae" del Correggio. Camillo Borghese tra Impero e Restaurazione*, Turin.
Herrmann Fiore K., editor, *Apollo e Dafne del Bernini nella Galleria Borghese*, Milan.
Herrmann Fiore K., *Guida alla Galleria Borghese*, Rome.
Strinati C., editor, *Venere vincitrice. La sala di Paolina Bonaparte alla Galleria Borghese*, Rome.
1998
Bernini Scultore. La nascita del Barocco in Casa Borghese, exh. catalogue, editor A.Coliva and S. Schütze, Rome, Galleria Borghese, 15 May-20 September.
Costamagna A., *La dea Paolina. Il ritratto di Paolina Bonaparte come "Venere Vincitrice" alla Galleria Borghese*, Rome.
1998-99
Humphrey P., Lucco M., *Dosso Dossi. Pittore di Corte a Ferrara nel Rinascimento*, exh. cat., editor A.Bayer, Ferrara, Civiche Gallerie d'Arte Moderna e Contemporanea, 26 September-14 December 1998; New York, The Metropolitan Museum of Art, 14 January-28 March 1999; Los Angeles, The J.Paul Getty Museum, 27 April-11 July 1999.
L'Anima e il Volto. Ritratto e fisiognomica da Leonardo a Bacon, exh. cat., editor F.Caroli, Milan, Palazzo Reale, 30 October 1998-14 March-1999.
2000
Costamagna A., *Raffaello, Dama con liocorno. Scheda clinica. Indagine storico-artistica. Indagini scientifiche,

CDRom, editor Editech Multimedia Art srl, Edindustria SpA, Rome.
Moreno P., Stefani C., *Galleria Borghese*, Milan.
2001
Mangia P., *Il ciclo dipinto delle volte. Galleria Borghese*, Rome.

Naples, the Capodimonte Museum

1876
Alberti A., *Guida illustrativa del Real Museo di Capodimonte*, Naples.
1884
Sacco A., *R.Museo di Capodimonte*, Naples.
1948
Molajoli B., *Musei e opere d'arte attraverso la guerra*, Naples.
1957
Molajoli B., *Notizie su Capodimonte*, Naples.
1961
Molajoli B., *Il Museo di Capodimonte*, Naples.
1966
Doria G., Causa R., editor, *La reggia di Capodimonte*, Florence.
1982
Causa R., editor, *Le collezioni del Museo di Capodimonte*, Milan.
1987
Muzii, R., *I grandi disegni italiani nella collezione del Museo di Capodimonte*, Milan.
1994
Spinosa N., editor, *Museo e Gallerie Nazionali di Capodimonte. La collezione Farnese. La scuola emiliana: i dipinti. I disegni*, Naples.
Spinosa N., editor, *Museo Nazionale di Capodimonte*, Naples.
1995
Spinosa N., editor, *Museo e Gallerie Nazionali di Capodimonte. La collezione Farnese. I dipinti lombardi, liguri, veneti, toscani, umbri, romani, fiamminghi. Altre scuole. Fasti Farnesiani*, Naples.
1996
Spinosa N., editor, *Museo e Gallerie Nazionali di Capodimonte. La collezione Farnese. Le arti decorative*, Naples.
1999
Leone de Castris, P., *Museo e Gallerie Nazionali di Capodimonte. Le collezioni borboniche e post-unitarie. Dipinti

dal XIII al XVI secolo, Naples.

Spinosa, N., *Capodimonte*, Naples.

Milan, the Brera Gallery

(1908)

Malaguzzi Valeri F., *Catalogo della R Pinacoteca di Brera*, Bergamo, n.d. reprint (1914).

1935

Modigliani E., *Catalogo della Pinacoteca di Brera*, Milan, (reprinted with integration and modifications 1950, 1966).

1942

Morassi A., *La Regia Pinacoteca di Brera*, Rome.

1961

Dell'Acqua G.A., Russoli F., *La Pinacoteca di Brera*, Milan.

1971

Meiss M., *La Sacra Conversazione di Piero della Francesca*, Florence.

1973

De Vecchi P.L., *Lo Sposalizio della Vergine di Raffaello*, Florence.

1977

Mulazzani G., Dalai Emiliani M., Matalon S., Brambilla Barcilon P., Gallone A., *Donato Bramante. Gli Uomini d'arme*, Florence.

1978

Romeno G., Binaghi M. T., Collura D., *Il maestro della Pala Sforzesca*, Florence.

1979

Scotti A., *Brera 1776-1815. Nascita e sviluppo di una istituzione culturale milanese*, Florence.

1980

Bertelli C., *Brera. Milano*, Milan.

1981

Dell'Acqua G. A., *La donazione Jesi*, Milan.

1984

Bertelli C., Lopez G., *Brera dispersa. Quadri nascosti di una grande raccolta nazionale*, Milan.

1986

Disegni Lombardi del Cinque e Seicento della Pinacoteca di Brera e dell'Arcivescovado di Milan, exh. cat., Florence.

1987

Marani C., *Leonardo e i Leonardeschi a Brera*, Florence.

1988-96

General catalogues of The Brera Gallery paintings, F. Zeri

and F. Mazzocca editors

– *Pinacoteca di Brera. Scuole lombarda e piemontese 1300-1535*, Milan 1988.

– *Pinacoteca di Brera. Scuole lombarda, ligure e piemontese 1535-1796*, Milan, 1989.

– *Pinacoteca di Brera. Scuola veneta*, Milan 1990.

– *Pinacoteca di Brera. Scuola emiliana*, Milan, 1991.

– *Pinacoteca di Brera. Scuole dell'Italia centrale e meridionale*, Milan, 1992.

– *Pinacoteca di Brera. Dipinti dell'Ottocento e del Novecento. Collezioni dell'Accademia e della Pinacoteca. 2 Volumes*, Milan, 1993-94.

– *Pinacoteca di Brera. Scuole straniere*, Milan, 1995.

– *Pinacoteca di Brera. Addenda e apparati generali*, Milan, 1996.

1989

Tardito R., *Brera. Storia della Pinacoteca e delle sue collezioni*, Florence.

Coppa S., *La pittura lombarda del Seicento e del Settecento nella Pinacoteca di Brera*, Florence.

1990

Humphrey P., *La pittura veneta del Rinascimento a Brera*, Florence.

1992

Marani P. C., *La Crocefissione di Bramantino. Storia e restauro*, Florence.

1995

Disegni emiliani dei secoli XVII-XVIII della Pinacoteca di Brera, exh. cat., Milan.

1997

Agosti G., Ceriana M., *Le raccolte storiche dell'Accademia di Brera*, Florence.

Daffra E., Trevisani F., *La Pala di San Bernardino di Piero della Francesca*, Florence.

1998

Arrigoni L., Daffra E., Marani P.C., *Pinacoteca di Brera*, Milan.

Venice, the Accademia Galleries

1955

Moschini Marconi S., *Gallerie dell'Accademia di Venezia. Opere d'arte dei secoli XIV e XV*, Rome.

1962

Moschini Marconi S., *Gallerie dell'Accademia di Venezia. Opere d'arte del secolo XVI*, Rome.

1970

Moschini Marconi S., *Gallerie dell'Accademia di Venezia. Opere d'arte dei secoli XVII, XVIII, XIX*, Rome.

1980

Battisti E., *Le origini religiose del paesaggio veneto, in Esistenza mito ermeneutica. Scritti per Enrico Castelli*, Rome-Padua, (*Archivio di Filosofia*, 1980. no. 1).

1981

Pallucchini R., *La pittura veneziana del Seicento*, 2 Volumes, Milan.

1982

Nepi Scirè G., *Storia della collezione dei disegni*, Milan.

1985

Nepi Scirè G., Valcanover F., *Gallerie dell'Accademia di Venezia*, Milan.

1988

Nepi Scirè G., editor, *Gallerie dell'Accademia. Nuove Acquisizioni*, Venice.

1990

Giovanni Gerolamo Savoldo, Milan.

F. Valcanover, editor, *Tiziano*, exh. cat., Venice.

Lucco M., editor, *La pittura nel Veneto. Il Quattrocento*, 1-2 Volumes, Milan.

Goffen R., *Giovanni Bellini*, Milan.

Safarik E. A., *Fetti*, Milan.

1991

Gentili A., *Giovanni Bellini, la bottega, i quadri di devozione*, in "Venezia Cinquecento", 1-2.

Humphrey P., *Carpaccio. Catalogo completo dei dipinti*, Florence.

Nepi Scirè G., *I capolavori dell'arte veneziana. Le Gallerie dell'Accademia*, Venice.

Rossi P., *Francesco Maffei*, Milan.

Scarpa Sonino A., *Marco Ricci*, Milan.

1992

Brown B.L. and Marini P., editors., *Jacopo Bassano ca 1510-1592*, exh. cat., Bologna.

Dall Poggetto P.D., editor, *Piero e Urbino. Piero e le arti rinascimentali*, exh. cat., Venice.

Martineau S., editor, *Andrea Mantegna*, exh. cat., London.

Leonardo & Venezia, exh. cat., Milan.

Lucco M., editor, *La pittura nel Veneto - Il Trecento*, Milan.

Ferrari O. and Scavizzi G., *Lu-*

ca Giordano. *L'opera completa*, 2 vols., Naples.

Fortini Brown P., *La pittura nell'età di Carpaccio. I grandi cicli narrativi*, Venice.

Nepi Scirè G., "Venezia e la pittura intorno al 1500," in *Leonardo & Venezia*, exh. cat., Milan.

1993

Laclotte M., editor., *Le siècle de Titien*, exh. cat., Paris.

Mariuz A., Pavanello G. and Romanelli G.D., editors, *Pietro Longhi*, exh. cat., Milan.

Gemin M., Pedrocco F., *Giambattista Tiepolo. Dipinti. Opera completa*, Verona.

Humphrey P., *The Altarpiece in Renaissance Venice*, New Haven and London.

Nepi Scirè G., *Le Gallerie dell'Accademia*, Rome.

Thiebault D., "Le Christ à la colonne d'Antonello de Messina," *Le dossier des Musée du Louvre*, Paris.

1994

Fiaccadori G., editor, *Bessarione e l'Umanesimo*, exh. cat., Naples.

Rossi P., Nepi Scirè G., editors, *Jacopo Tintoretto. Ritratti*, exh. cat., Milan.

Hope C., "A new Documento about Titian's Pietà", in *Sight & Insight: Essay on Art and Culture in Honour of E. H. Gombrich at 85*, London.

Sgarbi V., *Carpaccio*, Milan.

Nepi Scirè G., *I teleri della Sala dell'Albergo nella Scuola di San Marco*, Venice.

Nepi Scirè G., *Le Gallerie dell'Accademia di Venezia*, Venice.

Scarpa Sonino A., *Jacopo Amigoni*, Cremona.

1995

Bernardo Strozzi, Genova 1581/82-Venezia 1644, exh. cat. (editors E. Gavazza, G. Nepi Scirè, G. Rotondi Terminiello), Milan.

La pittura nel Veneto. Il Settecento, text by R. Pallucchini, Milan.

Tiziano, Amor Sacro e Amor Profano, exh. cat., Milan.

Splendori del Settecento veneziano, exh. cat., Milan.

Benati D., editor, *Il Trecento riminese*, Milan.

Ballarin A., *Jacopo Bassano. Scritti 1964-1995*, (editor V. Romeni), 5 Volumes, Cittadella.

Cohen C. E., *The Art of Gio-*

vanni Antonio da Pordenone, Cambridge.

Nepi Scirè G., *Guida alla Quadreria*, Venice.

Pignatti T., Pedrocco F., *Veronese. Catalogo completo*, 2 Volumes, Milan.

1996

Lucco M., editor, *La pittura nel Veneto. Il Cinquecento*, 3 Volumes, Milan.

Tiepolo, exh. cat. (editor K. Kristiansen), Milan.

Anderson J., *Giorgione peintre de la "Brièvete poetique". Catalogue raisonnè*, Paris.

Gentili, *Le storie di Carpaccio. Venezia, i turchi, gli ebrei*, Venice.

1997

Il soffitto degli Scalzi di Giambattista Tiepolo, in "Quaderno della Soprintendenza per i Beni Artistici e Storici di Venezia", 21, Venice.

Lorenzo Lotto il genio inquieto del Rinascimento, exh. cat., Milan.

Goffen R., *Titian's Women*, New Haven-London.

1998

Campbell S., *Cosmè Tura di Ferrara*, Yale.

Nepi Scirè G., *Gallerie dell'Accademia di Venezia*, Milan.

1999

Aikema B., Brown B. L., Nepi Scirè G., editor, *Il Rinascimento a Venezia e la pittura del Nord al tempo di Bellini, Dürer, Tiziano*, Cinisello Balsamo.

Nepi Scirè G., Perissa Torrini A., *Da Leonardo a Canaletto. Disegni alle Gallerie dell'Accademia*, Milan.

2000

Mason S., *Carpaccio. I grandi cicli*, Milan.

Nepi Scirè G., *Carpaccio. Storie di Sant'Orsola*, Milan.

Nepi Scirè G., in *Carlo Scarpa - Mostre e Musei 1944-1976; Case e paesaggi 1972-1978*, Milan, pp. 92-103.

Pedrocco F., *Tiziano*, Milan.

Pedrocco F., Pignatti T., *Giorgione*, Milan.

Tempestini A., *Giovanni Bellini*, Milan.

Valcanover F., *Tiziano*, Milan.

Goffen R., Nepi Scirè G., editor, *Il colore ritrovato: Bellini a Venezia*, Milan.

2001

Kowalczyck B.A., da Cortà Fumei M., editor, *Bernardo Bellotto 1722-1780*, Milan.

Photographic credits